Temples and Towns in Roman Iberia

The publisher gratefully acknowledges the generous contributions to this book provided by the University of Vermont and by the Program for Cultural Cooperation between Spain's Ministry of Culture and United States' Universities.

Temples and Towns in Roman Iberia

The Social and Architectural Dynamics
of Sanctuary Designs from the Third Century B.C.
to the Third Century A.D.

William E. Mierse

UNIVERSITY OF CALIFORNIA PRESS

Berkeley Los Angeles London

University of California Press
Berkeley and Los Angeles, California

University of California Press, Ltd.
London, England

Library of Congress Cataloging-in-Publication Data

Mierse, William E.
 Temples and towns in Roman Iberia : the social and architectural
dynamics of sanctuary designs from the third century B.C. to the
third century A.D. / William E. Mierse.
 p. cm.
 Includes bibliographical references and index.
 ISBN 0-520-20377-1 (alk. paper)
 1. Temples, Roman—Spain. 2. Architecture, Roman—Spain.
3. Architecture, Iberian. 4. Architecture—Expertising—Spain.
I. Title.
NA335.S6M54 1999
726'.12'09366—dc21
 97-46951
 CIP

Printed in the United States of America
9 8 7 6 5 4 3 2 1

To my parents, who did not live to see this project finished.
They always offered their support in all that I did.

CONTENTS

ILLUSTRATIONS

FIGURES

PLATES

Following page 304

ACKNOWLEDGMENTS

There are many people who need to be thanked for their help in making this book possible. It began as a dissertation. I always received enthusiastic and warm support from my adviser and friend Professor Rolf Winkes, and I offer him special thanks. The initial readers of the manuscript, Professor Diana E. E. Kleiner and Professor R. Ross Holloway, offered useful suggestions for improving the original manuscript. At Brown University I have always found interested and good listeners, and over the years I have benefited from the thoughtful comments of Martha Joukowsky of the Center for Old World Archaeology and Art and the Department of Anthropology, Kermit Champa of the Art Department, Brian McConnell of the Center for Old World Archaeology and Art, and the late David Kossoff of the Department of Hispanic and Italian Studies. Florence Friedman of the Rhode Island School of Design Museum of Art, Mary Hollinshead of the University of Rhode Island, Joanna Ziegler at Holy Cross College, and colleagues at the University of Vermont have assisted by listening to certain ideas and offering their views on particular aspects of the study. Thanks are also owed to Christopher Ratté of New York University, Crawford Greenewalt Jr. of the University of California at Berkeley, and Anton Bammer of the Ephesus excavations, who during the summer of 1989 gave me their time and discussed some of my ideas about the relationship between Asia Minor and Spain.

In Spain, I have always been well treated and aided by the staffs of the libraries of the German Archaeological Institute, the Instituto Rodrigo Caro, the Archaeological Museum in Barcelona, and the archaeology faculty of the University of Barcelona. I have appreciated the warm encouragement that I have received from my colleagues in Spain, especially José Luis de la Barrera Antón of the National Museum of Roman Art in Mérida, Eva M.

Koppel of the Archaeological Museum in Tarragona and the University of Barcelona, Robert Risch of the Universidad Autónoma in Barcelona, Walter Trillmich of the German Archaeological Institute in Madrid, and Theodor Hauschild of the German Archaeological Institute in Lisbon.

My greatest thanks for unending patience and great help in moving the manuscript from a dissertation to a book go to Professor Robert Knapp of the Classics Department of the University of California at Berkeley. Professor Knapp has read several versions of the manuscript and has offered valuable insight into places for improvement and areas in need of particular attention. I must also thank the Press's anonymous readers who took the time and trouble to make valuable suggestions for improvement to the manuscript. The manuscript editor, Carl Walesa, has done a fine job treating a difficult manuscript. I also want to thank Mary Lamprech, the University of California Press house editor, who has maintained faith in this project and has fought to see it completed. Obviously, I have made all decisions, and any errors that appear here are completely mine.

There are many financial sources that have made this study possible since it began in 1984. The initial research was funded by a generous grant from the Joukowsky Family Foundation of Brown University. The David and Ruth Kossoff Fund of the Department of Hispanic and Italian Studies at Brown helped defray the costs of photographs. Post-dissertation research was funded in 1987 with a summer travel grant from the American Philosophical Society, and twice—in 1989 and 1992—the University of Vermont through its University Research Grants program funded summer travel for aspects of the work.

Both this book and the dissertation from which it emerged are a direct result of the influence of my wife, Helen Wagg. It was she who first really introduced me to Spain and made me appreciate its wealth of material. Her infectious love of Spain and of the Spanish people first made me consider the Iberian Peninsula as a place to pursue Roman studies. Over the years she has shared with me her extensive knowledge of the people, the country, the culture, and the language. Together we have explored the material that forms this study. It was Helen who figured out how to get from point A to point B using a bus or a train, or hitchhiking. She taught me to consult the local farmers where I might find "los mármoles," and she never complained even when trains left us at stations in pitch darkness three kilometers from the nearest town. She helped me measure stones at Azaila on a freezing-cold morning in December and walked with me through the heat of a Tunisian summer day to see the temples at Thuburbo Maius. Without Helen there would have been no dissertation and later there would have been no book. Most important, the pleasure that comes from field research became true joy, since there was someone with whom to share it.

Finally, I must thank one more person. I would never have entered this field at all had it not been for Professor George M. A. Hanfmann. Professor Hanfmann hired me in 1978 to assist him in writing the final report for an NEH grant that he had received to fund work on the Sardis excavations in Turkey. From that position of research assistant he moved me to coauthorship status on his final volume on Sardis, *Sardis from Prehistoric to Roman Times.* He saw in me potential that had not been seen by others, and because of his encouragement and unfailing support I entered the field of classical studies. I owe him a great debt of thanks. His death has left for me a void that will never be filled.

ABBREVIATIONS

AA	*Archäologischer Anzeiger*, in *Jahrbuch des [kaiserlichen] deutschen archäologischen Instituts*
AE	*Augusta Emerita: Actas del Simposio internacional conmemorativo del bimilenario de Mérida, 16–20 de noviembre de 1975.* Madrid, 1976.
AEspA	*Archivo Español de Arqueología*
AIEC	*Anuari de l'Institut d'Estudis Catalans*
AJA	*American Journal of Archaeology*
ANRW	H. Temporini, ed. *Aufstieg und Niedergang der römischen Welt.* Berlin, 1972–.
Architecture et société	P. Gros, ed. *Architecture et société de l'archaïsme grec à la fin de la république romaine.* Paris and Rome, 1983.
ArqEsp	*Arqueología Espacial.* Teruel, 1984. Vol. 1, *Aspectos generales y metodológicos;* vol. 2, *Estudios diacrónicos y paleolíticos;* vol. 3, *Del epipaleolítico al bronce medio;* vol. 4, *Del bronce final a la época ibérica;* vol. 5, *Época romana y medieval.*
Arqueología de las ciudades modernas	*Arqueología de las ciudades modernas superpuestas a las antiguas.* Madrid, 1985.
Los asentamientos	*Los asentamientos ibéricos ante la romanización.* Madrid, 1986.
BAR	*Biblical Archaeology Review*
BCH	*Bulletin de Correspondance Hellénique*
BRAH	*Boletín de la Real Academia de la Historia*

Los bronces	Museo Nacional de Arqueología—Madrid. *Los bronces romanos de España.* Madrid, 1990.
BSAA	*Boletín del Seminario de Estudios de Arte y Arqueología* (Universidad de Valladolid)
CA	*Caesaraugusta*
Caesardunum 20 (1985)	*Actas du colloque: Les débuts de l'urbanisation en Gaule et dans les provinces voisines, Paris, ENS, 18–19–20 mai 1984* (= *Caesardunum* 20 [1985])
CIL	*Corpus Inscriptionum Latinarum.* Berolini, 1863–.
Ciudades augusteas	*Simposium de las ciudades augusteas de Hispania.* 2 vols. Zaragoza, 1976.
CNA	*Congreso Nacional de Arqueología*
Les cryptoportiques	R. Étienne, ed. *Les cryptoportiques dans l'architecture romaine (École Française de Rome, 19–23 avril 1972).* Paris, 1973.
EAE	Excavaciones Arqueológicas en España
Les empereurs	A. Piganiol and H. Terrasse, eds. *Les empereurs romains d'Espagne: Madrid-Itálica, 31 mars—6 avril 1964.* Paris, 1965.
Les enceintes	École Antique de Nîmes. *Les enceintes augustéennes dans l'occident romain (France, Italie, Espagne, Afrique de Nord).* Nîmes, 1987.
Los foros	*Los foros romanos de las provincias occidentales.* Madrid, 1987.
García y Bellido	*Homenaje a García y Bellido.* Vols. 1–4. Madrid, 1979. In *Revista de la Universidad Complutense* 18, nos. 115–118 (1979).
HA	W. Trillmich, Th. Hauschild, M. Blech, N. G. Niemeyer, A. Nünnerich-Asmus, and U. Kreilinger, eds. *Hispania Antiqua: Denkmäler der Römischerzeit.* Mainz am Rhein, 1993.
Hellinismus in Mittelitalien	P. Zanker, ed. *Hellininsmus in Mittelitalien: Kolloquium in Göttingen, 5. bis 9. Juni 1974.* 2 vols. Göttingen, 1976.
Hispano-Roman Town	M. Bendala Galán, ed. *The Hispano-Roman Town.* Tarragona, 1993.
Homenaje	*Homenaje a Sáenz Buruaga.* Madrid, 1982.

HSCP *Harvard Studies in Classical Philology*

IGR *Inscriptiones Graecae ad Res Romanas Pertinentes.* Paris, 1901.

ILS H. Dessau, ed. *Inscriptiones Latinae Selectae.* Berolini, 1892–
 1916.

JRA *Journal of Roman Archaeology*

JRS *Journal of Roman Studies*

JSAH *Journal of the Society of Architectural Historians*

Kaiser Augustus *Kaiser Augustus und die verlorene Republik: Eine Ausstellung im
 Martin-Gropius-Bau Berlin, 7. Juni–14. August 1988.* Berlin,
 1988.

MCV *Mélanges de la Casa de Velázquez*

MEFRA *Mélanges de l'École Française de Rome, Antiquité*

Miscel.lània *Miscel.lània Arqueològica a Josep M. Recasens, abril 1992.*
 Tarragona, 1992.

MM *Madrider Mitteilungen*

NAH Noticiario Arqueológico Hispano

OCD *Oxford Classical Dictionary.* Eds. N. G. Hammond and H. H.
 Scullard. Oxford, 1978.

PIR E. Klebs, H. Dessau, E. Groaz, and A. Stein, eds. *Prosopographia
 Imperii Romani Saeculi I, II, III.* Berolini, 1897–1898, 1933–.

RdA *Revista de Arqueología*

RE A. Pauly, G. Wissowa, and W. Kroll, eds. *Real-Encyclopädie der
 klassischen Altertumswissenschaft.* Stuttgart, 1893–.

La religión *La religión romana en Hispania.* Madrid, 1981.

Roman Papers *Roman Papers.* Vol. 1, ed. E. Badian. Oxford, 1978. Vol. 2,
 ed. E. Badian. Oxford, 1979. Vol. 3, ed. A. R. Birley. Oxford,
 1984. Vol. 4, ed. A. R. Birley. Oxford, 1988.

Social Complexity B. Cunliffe and S. Keay, eds. *Social Complexity and the Development
 of Towns in Iberia from the Copper Age to the Second Century A.D.*
 Oxford, 1995.

Stadtbild W. Trillmich and P. Zanker, eds. *Stadtbild und Ideologie: Die
 Monumentalisierung hispanischer Städte zwischen Republik und
 Kaiserzeit. Kolloquium im Madrid von 19. bis 23. Oktober 1987.*
 Munich, 1990.

CHAPTER ONE

The Arrival of Rome

By 206 B.C. the Roman Senate found itself the owner of the Iberian Penin-
sula. In 197 B.C. two provinces were created from the new territory: Hispa-
nia Citerior (Nearer Spain) in the northeast and Hispania Ulterior (Farther
Spain) in the south. The legendary wealth of the land attracted both peace-
ful and belligerent exploiters. Livy's lists of the booty taken from the pen-
insula read in a manner strangely like the later sixteenth-century accounts
of the conquest of the Americas.

In time, Roman exploitation turned to Roman residence, particularly in
the south (fig. 1). Here Roman and Italian merchants and later escapees
from the social disorders of the Italian world found a comfortable environ-
ment. The mixing of colonials and locals generated renewed urban devel-
opment and a cosmopolitan life open to new arrivals.

There was no specific Republican policy toward the newly acquired ter-
ritory.[1] The land and its people were open to exploitation by those with
power. At the same time, there was little attempt to force or even encourage
a particular type of Romanization, at least one that can be recognized in the
archaeological record. As long as the local communities remained passive,
they were free to continue in their traditional manner and build as they saw
fit.[2] The result of this indifference was the fostering of several local archi-
tectural experiments in which the new political reality is reflected in new
architectural forms.

1. For the most recent treatments in English of the conquest and early Romanization of the
peninsula see Curchin 1991; Keay 1989, chaps. 1–2; Richardson 1986; Dyson 1985, chaps. 5–
6; Knapp 1977. For a general overview in Spanish see Montenegro Duque and Blázquez 1982.
 2. For revolts see Dyson 1975, pp. 138–175.

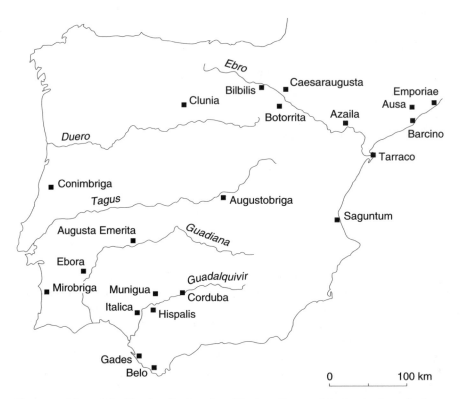

Figure 1. Map of the Iberian Peninsula, with sites discussed in the text marked

NEW FORMS

Italica

Italica (Itálica, Santiponce; see fig. 2), located in the Baetis (Guadalquivir) River valley about 16 km from Hispalis (Sevilla), was the first settlement to be founded by the Roman occupation forces, under the command of Scipio Africanus, in 206 B.C.[3] If R. Knapp is correct, the city was not intended to be a bastion for Romanization but rather a protective outpost for the Romans, who were mostly concerned about another possible Carthaginian invasion.[4]

The initial settlement incorporated two hills. The discovery of a kiln on a hill called Cerro de San Antonio led the excavator, J. M. Luzón Nogue, to conclude that one hill was used primarily for occupation and the other for

3. Appian, *Iberica* 7.38. 4. Knapp 1977, pp. 113–115.

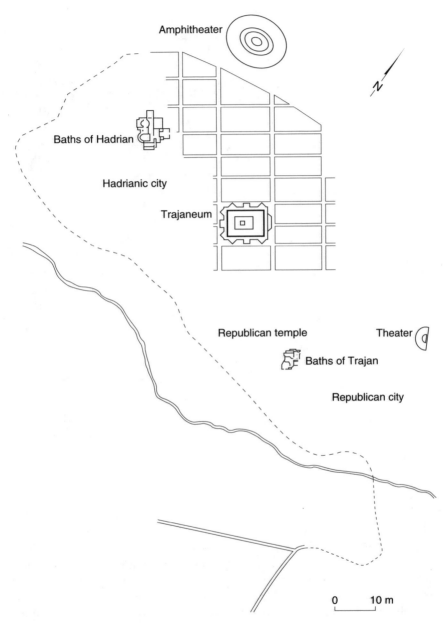

Figure 2. Plan of Italica (after León Alonso 1986, fig. 1)

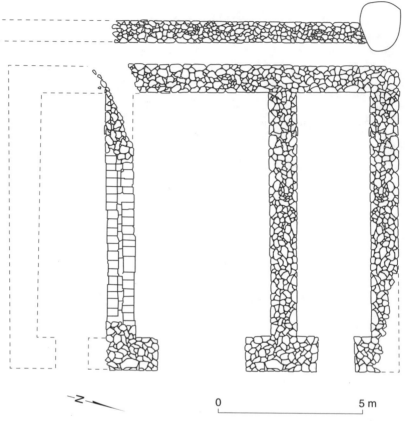

Figure 3. Plan of the Republican temple at Italica (after Bendala Galán
1982, fig. 21)

industrial enterprises.[5] This hypothesis was reinforced by the discovery on
the other hill, Los Palacios, of a possible temple structure (fig. 3).[6]

The structure could not be completely freed, but enough was revealed to
show a plan of two parallel chambers oriented east-west with an opening on
the east end.[7] They have a length of 8.80 m. The north chamber is the nar-
rower, 2.50 m; the south, 4.85 m. A modern ditch cuts diagonally east-west
across the south chamber and has destroyed a portion of the southwest cor-
ner of the south room. However, enough was preserved to allow M. Bendala

5. Luzón Nogue 1973, p. 16.

6. Blanco-Freijeiro and Corzo Sánchez 1976, p. 150.

7. Excavations were undertaken during the summer of 1973. Bendala Galán 1982, pp. 29–
75; idem 1975, pp. 861–868.

Galán, the excavator, to conclude that the corner did not form the outer edge of the structure; rather, it is the interior corner to a still more southerly chamber. Another wall of concrete, though without apparent contact with the main structure, parallels the back, west, wall running north-south.

What remains of the construction are three rows of irregular stones that formed the socles to walls. The lowest row is of larger stones; the two rows above, of stones of diminishing size. The structure is preserved to its highest in the south. On top of the third row of stones, slabs of slate and small stones were employed to form a bedding for the wall above. Slate slabs were placed along the edges to create a regularity to the exterior face of the walls.[8] Atop the socle must have stood adobe walls with a thickness of about 1 m. Bricks averaging 0.40 m × 0.28 m were laid in a regular and orderly fashion, joined and plastered with clay and coated with lime.[9] The floors are of tramped earth. The building techniques are all Iberian rather than Roman.[10]

The relationship of the wall that runs parallel to the north wall and the structure itself is not clear. It is slightly thinner, 0.70 m. The passageway between the two walls is 0.85 m. It could have joined with the main buildings to form a separate rear room,[11] or it could have defined the temenos for the temple.[12]

Sondages dug in front of the complex uncovered amphorae and other ceramic fragments that provided a mid-second-century B.C. date for the use of the space.[13] The construction itself sat atop virgin soil.[14] There are traces of a lime flooring, ca. 0.10 m thick, extending over much of the area in front of the building and forming a courtyard.[15] The structure was destroyed at least once by fire, after which the site was replastered and reused.[16]

Bendala Galán has concluded that this was a capitolium temple built during the first phase of Italica's history.[17] Though only two of the required three cellas have been unearthed, he posits that the wall of the southwest corner of the south chamber continues to form the rear wall of a third, parallel room, probably with dimensions similar to those of the north chamber. Luzón Nogue's work on the hill of San Antonio has clarified the relationship between the two zones of the early city by showing that San Antonio, with its pottery kiln, had to be the industrial rather than the religious, cultural, or

8. Bendala Galán 1975, p. 862.

9. Ibid., p. 865. See also León (1977–1978, p. 144), who notes that the brick size represents a reduction of the *sesquipes* recommended by Vitruvius (2.3) of ca. 0.44 m × 0.29 m.

10. Roldán Gómez 1987, pp. 91–92. 11. Bendala Galán 1975, p. 865.

12. Bendala Galán 1989–1990, p. 19.

13. Bendala Galán 1975, pp. 867–868 n. 6.

14. Ibid., p. 864.

15. Ibid. 16. Ibid., p. 865.

17. Most recently, Bendala Galán 1989–1990, pp. 17–20.

civic center of the original settlement. Further, Bendala Galán maintains that after its destruction, the temple was reincorporated into a later temple on the site.

It is generally assumed that what Bendala Galán unearthed must be regarded at the least as a native attempt at monumental-temple construction.[18] Knapp has suggested that in its first centuries of existence the Roman or Italian population of Italica may well have been overwhelmed by the native.[19] Hadrian's reference to the city's special *leges et mores* could indicate that the town did possess a marked admixture of local cultural traditions. In his excavations on Cerro de San Antonio, Luzón Nogue did not encounter what he considered a true Roman level until his third stratum, which was immediately below the surface level of Imperial remains. Bendala Galán has argued that this temple should be dated to the preceding periods—the late third and early second centuries B.C.,[20] Luzón Nogue's levels 1 and 2— before a completely Roman settlement had been formed.

Italica is a problem in the history of the Romanization of the Iberian Peninsula. It stands out as distinct from the native settlements conquered or assimilated. Immaterial of its initial status, the town from its foundation represented an intentional blending of native and foreign cultures. There may not have been a major settlement on the site prior to the building of Italica, but there was a native culture in the area. Native pottery has been found in the upper strata of Luzón Nogue's excavations. This does not indicate the native refusal to integrate, since Iberian styles of pottery and sculpture lasted well into the Roman period;[21] rather, it may suggest a degree of cultural exchange and interaction between the two groups. Excavations on the Iberian Peninsula are revealing a strong native survival even in territories under intense Romanizing pressures well into the first century A.D.[22] The construction techniques used for the temple suggest some native involvement in the building itself.

What is certain about the Italica temple is that it has no surviving precedents on the peninsula. Its typology sets it apart. A three-chambered complex of rooms that share no direct means of intercommunication and must be entered from the front looks like a capitolium temple. As such, the

18. Blanco-Freijeiro and Corzo Sánchez 1976, p. 150. Bendala Galán's identification of the temple as a capitolium has not received universal support, though no real alternative designations have been offered. See Canto 1985, pp. 137–148; Pena 1984, pp. 50–53; Blech 1982, p. 140 n. 36.

19. Knapp 1977, p. 113.

20. Bendala Galán 1989–1990, p. 19; idem 1975, pp. 867–868.

21. García y Bellido 1980, pp. 45–52, 92–114.

22. M. Downs, "Late Iberian and Early Roman Settlement Patterns in the Guadalquivir River Valley," *AJA* 96 (1992), p. 359; S. Keay, "The Romanization of Towns in Baetica," *AJA* 95 (1991), p. 336.

temple has precedents elsewhere in territory conquered by the Romans and settled with colonies. At both Cosa and Signia, capitolia of the triadic type were constructed—in Cosa, probably about 150 B.C.[23]

The definition of a true capitolium is more involved than just the three-cella plan. Ideally there should be evidence that the cult of the temple was the standard triad of Jupiter, Juno, and Minerva. No such supporting evidence exists at Italica. The only suggestion of cultic activity at Italica before the Augustan period is a terra-cotta acroterion sculpture of Potnia Theron.[24] The capitolium temple type was an Italic invention and belongs to the Italo-Etruscan tradition of temple construction. It needs a podium as a basic architectural feature, which places the cult chambers higher up and promotes the axial sensibility. Moreover, there should be a deep pronaos preceding the cellas. The remains at Italica do not sit on a podium, nor is there evidence for a pronaos. Finally, the capitolium temple should sit on the highest point of land, commanding a view of the city and surrounding territory, as does the capitolium temple at Cosa. The Italica temple does sit on a hill slope, and it can be argued that it somewhat fulfills this requirement.[25]

That the iconography for the Capitoline Cult was known in Republican Iberia can be shown by means of both numismatic and epigraphic evidence. A sesterce issued by Gades sometime during the late Republican or early Augustan era shows on its reverse the image of a temple modeled on the capitolium reverse type of the issues of Volteius in Rome from the seventies B.C.[26] The reference is probably to the great capitolium temple in Rome, but the image indicates that the physical structure—a temple on a podium with three distinct cellas, represented on the coin by three closed doors—was understood at Gades.[27] There is also the specific mention of the Capitoline Cult of Jupiter, Juno, and Minerva recorded on the *Lex Coloniae Genetivae Juliae*.[28] The coin and the inscription are evidence for the cult in the late Republican era—a century after the date of the Italica temple, according to Bendala Galán. If the Italica structure is a capitolium temple, it

23. Boethius 1978, p. 131. In his justification for the identification of the Italica temple as a capitolium type, Bendala Galán offered comparisons with the capitolia at Carteia, Belo (Bolonia), and Almenara near Saguntum. The Belo comparison must be dismissed since the actual remains are for three distinct temples, all dating from a later period; see chap. 4 infra. Almenara exists exclusively in literary references of Polybius, without any architectural evidence to support the comparison. The remains for the temple at Carteia are now acknowledged to be of Augustan date by the excavators; see Woods 1969, pp. 251–256.

24. García y Bellido 1979, pp. 18–19, fig. 11.

25. For the definition of a capitolium temple see Barton 1981, pp. 259–342.

26. Price and Trell 1977, pp. 65–70, 243, no. 12; Beltrán 1953, pp. 45–48.

27. Mierse 1993, pp. 37–57.

28. S.v. Osuna in Wolch's descriptive catalog in Grimal 1983. See also Hardy 1912, pp. 7–60.

would be among the earliest such temples in the Roman world, contemporaneous with that at Cosa.[29]

There are other problems with the identification of the temple at Italica as a capitolium type. It may have been the case that until the first century of the Empire, only towns with the status of *colonia* had the privilege of erecting capitolium temples.[30] In its first state, Italica would not have not possessed adequate rank to raise a capitolium temple.[31] Initially the town was little more than a military outpost.[32] Bendala Galán has argued that the early date for this foundation, coupled with the fact that the town was outside of Italy, might have nullified such a consideration.[33]

The lack of any identifiable architectural elements other than the possible three-cella plan makes it difficult to accept Bendala Galán's view. In no way does this rather modest tripartite structure at Italica resemble the second-century capitolium at Cosa with its high podium and deep pronaos.[34] The later capitolia in Cisalpine Gaul share in common with the Italian forms the high podia and grand staircases in addition to the tripartite division.[35]

There is only one temple that resembles the Italica temple in plan: the temple at Cuicul in North Africa, dating from the early second century A.D.[36] However, there are significant differences. In the Cuicul temple, the superstructure is raised on a high podium and has a pronaos. The stairs are not aligned on axis with the cellas, and the chambers are entered through individual doors. In the plan of the Italica temple there is no indication of a means of communication among the three cellas. The cellas of the Cuicul temple are separated by pairs of columns between pilasters, allowing movement between adjacent spaces.[37]

The temple at Cuicul can in no way be related to the temple at Italica. The two structures are separated by too many centuries. The temple at Cuicul does give evidence of representing an architectural type used in North Africa, the three-chambered non-capitolium temple.[38] A. Lézine classifies these as tripartite temples without podia. In their developed form, as at

29. Barton (1981, p. 261) dates the first capitolium at Pompeii to the third century B.C.; that at Ostia may be earlier than the first century but it is not clear (p. 263); Aquinum may be second century B.C. (p. 265); Terracina, first century B.C. (p. 266); that at Narbo is Augustan (p. 267). The remaining capitolia in North Africa and on the Iberian Peninsula, except that at Saguntum, are Imperial (pp. 270–331, and infra).

30. Barton 1981, p. 278 n. 46; Todd 1985, p. 57.

31. Knapp 1977, p. 113. Initially Italica probably had peregrine status.

32. Corzo Sánchez 1982, pp. 299–319.

33. Bendala Galán 1989–1990, p. 20. 34. Boethius 1978, p. 131.

35. Mansuelli 1971, pp. 128–134, esp. 134. Mansuelli holds that the capitolia of Cisalpine Gaul lack a true typology.

36. Cuicul: Barton 1981, p. 286. 37. Barton 1981, p. 286, fig. 6b.

38. Ibid., pp. 273–274.

Sbeitla in Tunisia, the three chambers share no means of intercommunication. Each room opens separately onto a shared colonnaded plaza.[39] Other examples are known from Thuburbo Maius, Dougga, and Bulla Regia. Lézine even suggests that Vespasian's Temple of Peace in Rome could have been inspired by these North African forms. As late as the reign of Hadrian, a temple with three cellas, but not a capitolium, was repaired at Utica.[40]

Lézine has argued that these tripartite temples from North Africa, all built under Roman rule, reflect the survival of a Punic building form. Phoenician religion did have a triadic element, with its notion of a major deity flanked by two lesser deities.[41] The temples perhaps were developed not in the Phoenician homeland itself but elsewhere in the eastern Mediterranean,[42] where there are ruins of multichambered shrines without podia.[43] Only one tripartite example from the Phoenician area is known, a temple from Byblos dated to the mid–third millennium B.C.—too early to have influenced patterns in the West.[44] However, it was probably the Phoenicians who later carried to the West the formal design idea[45] as a manifestation of a tripartite cult. The tripartite temples without podia found in North Africa cannot be accepted as capitolia any more than can be the Italica temple.[46] Their isolated distribution within the old Punic area underscores the probable Eastern origin of the design.[47]

In her analysis of the tripartite temple plans, A. Altherr-Charon has noted distinct differences between the Italic types and the Eastern forms. The Italic temples display a preference for height over width. The Eastern examples tend to be wider rather than higher and are often associated with courtyards.[48] It is impossible to know the height-to-width ratio for the temple at Italica, though the lack of any podium would argue that height was not a

39. Lézine 1963, p. 102. 40. Lézine 1968, p. 134.

41. Ibid.; Trell 1984, pp. 122–128. The tripartite significance in Phoenician religion no doubt survived into Carthaginian cult; Charles-Picard 1954, p. 160.

42. Altherr-Charon 1977, pp. 389–440.

43. For the major temples at Byblos and Sidon see A. Parrot, M. Chéhab, and S. Moscati, *Die Phönizier: Die Entwicklung der phönizischen Kunst von der Anfängen bis zum Ende des dritten Punischen Krieges* (Munich, 1977), pp. 47–49, 104–107.

44. M. Dunand, *Fouilles de Byblos,* vol. 2 (Paris, 1939), pp. 895–899, fig. 1007.

45. Altherr-Charon 1977, p. 413.

46. Temples without podia and non-capitolium temples of three cellas on podia have been identified as far east as Tripolitania; Brouquier-Reddé 1992, pp. 228–229, 234.

47. G. Charles-Picard (*Comptes rendus des séances de l'academie des inscriptions et belles lettres* [Paris, 1964], p. 180) has tried to argue for an Italic source for the tripartite designs. However, the lack of the Italic podium for the North African structures argues against such a design source. See also Lézine 1968, p. 134 n. 7; J. B. Ward-Perkins, "Pre-Roman Elements in the Architecture of Roman Tripolitania," in *Libya in History: Historical Conference, 16–20 March 1968, Benghazi-Beruit, Faculty of Arts, University of Libya* (Benghazi, 1970), pp. 108–109.

48. Altherr-Charon 1977, p. 404.

major concern of the builder. The traces of plastering with lime of the area in front of the temple may evince the existence of a sacred courtyard before the temple proper.[49]

The Italica temple—if ultimately a result of Punic influence and representative of an Eastern tripartite temple type—is the oldest such example known in the West. It provides the missing link between developments of the type in Egypt, Cyprus, Delos, and Cyrene during the second and early first millennia B.C.[50] and the Romanized triple-cella temples of North Africa. In plan, the Italica temple is closest to that of the second-century B.C. temple of the Poseidoniastes of Beirut on the island of Delos. Though this design is a bit more complex, with a pronaos and columns *in antis,* the two temples share the three long, parallel cellas opening onto a court.[51] The temple on Delos served the needs of a Phoenician merchant community resident on the island.[52] It must be stressed that the Italica temple is probably earlier and could not have been influenced by the Delos design. The comparison shows only that both temples could have been derived from the same eastern Mediterranean prototype.

There is no evidence for a Punic settlement at Italica prior to the establishment of the Roman city. Yet Italica was located in an area within the radius of Punic influence if not direct colonization. Punic materials are known from Italica and elsewhere in the south.[53] The strength of the Punic presence and of Punic religion outlasted the Roman conquest in both North Africa[54] and Iberia. The popularity of the older architectural forms in North Africa is to be seen perhaps in the tripartite shrines without podia that must have been used for non-Roman cults and were being constructed well into the Imperial period. On Iberian soil the sustaining of the old Phoenician cult of Melqart as Heracles Gaditanus into the reign of Hadrian testifies to the continued viability of Punic forces. Some of the earliest Roman coinage from the south-coast cities bears neo-Punic legends.[55] A Punic survival could

49. A. Lézine, "Résistance à l'hellenisme de l'architecture religieuse de Carthage," *Les Cahiers de la Tunisie* 7 (1959), pp. 247–261.

50. Altherr-Charon 1977, pp. 389–440.

51. Bendala Galán (1989–1990, p. 19) has argued for a pronaos in wood for the Italica temple.

52. Altherr-Charon 1977, pp. 401–402; G. Charles-Picard, "Observations sur la Société des Poseidoniastes de Berytos et sur son histoire," *BCH* 44 (1920), pp. 263–311.

53. Finds of Punic material in the vicinity include objects from Carmona (Blázquez 1968, p. 107, no. 3); an amulet in the form of a serpent head supposedly from Italica (*Annual of the British School at Athens* 43 [1948], p. 64, plate 46); ivory combs and plaques of Punic inspiration from the Los Alcores hills along the Guadalquivir, in the collection of the Hispanic Society of America, nos. D500–D718 (*The Hispanic Society of America Handbook, Museum and Library Collections* [New York, 1938], p. 57).

54. Brouquier-Reddé 1992, pp. 267–270.

55. Mierse 1993, p. 37.

well lie behind the tripartite temple at Italica. In the early second century
B.C., it would not be a survival necessarily since the conquest was quite re-
cent. It may be that local builders with Punic training from elsewhere in the
south were commissioned to build a temple to the capitolium triad and bor-
rowed a Punic form to do the job. The syncretism of Punic cults with Latin
cults is known from other media later in the Republican period. Or, equally
possible, the temple could have been constructed to satisfy the cultic needs
of a Punic portion of the population who had moved into the new founda-
tion of Italica. The Italica temple would then have been in a position anal-
ogous to that of the Temple of the Poseidoniastes on Delos.

THE COLONIAL REACTION

Emporiae

Emporiae (Emporión, Empúries), or Ampurias, located on the northeast
coast of Spain north of Barcelona and at the south end of the large bay
known as the Gulf of Rosas, occupies a slight rise near the small town of
L'Escala. There is a long natural harbor that opens directly onto the sea
and into which the river Fluvià empties. The excavations of the site have re-
vealed three urban nuclei (fig. 4): the early settlement, the Hellenistic city,
and the Roman town. The earliest settlement, Palaiapolis (perhaps Kypsela),
was an offshore island where today stands the village of Sant Martí d'Em-
puries. The strait separating island from mainland has silted in over the
centuries to form the present peninsula.[56] It may have been on the island
that the earliest temple was located, probably that of Artemis of Ephesos.[57]
Excavations conducted in the first half of the nineteenth century on the
beach uncovered remains of what was identified as a temple of Bacchus. But
the remains have long since vanished, and only J. D. Botet y Sisó's account
records the discovery.[58] In 1929 P. Bosch Gimpera and J. de C. Serrá Rafols
spoke of the island as having the remains of a temple and identified it as the
site of the city of Kypsela mentioned in the *Ora maritima*.[59] They suggested
that a bit of frieze with two addorsed sphinxes in archaic style, which had
been found in the village of Sant Martí d'Empuries, might have come from
the archaic temple. A column and base in granite have been discovered in
the same general area as the relief, but the island has revealed no more ar-
chitectural evidence to support the hypothesis for the early settlement,[60]

56. See the plan in Botet y Sisó 1879. 57. Ripoll i Perelló 1983, p. 43.

58. Botet y Sisó 1879, pp. 6–7.

59. Bosch Gimpera and Serrá Rafols 1929, n.p. The *Ora maritima* by Avienus appears in an
edition by Mangas and Plácido (1994) and in one by Schulten (1922). See also Berthelot
1934.

60. Almagro 1962.

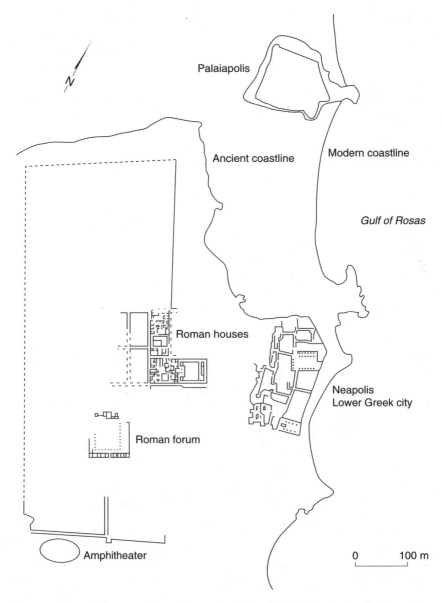

Palaiapolis

Ancient coastline

Modern coastline

Gulf of Rosas

Roman houses

Neapolis
Lower Greek city

Roman forum

Amphitheater

0 100 m

Figure 4. Plan of the coastline at Emporiae (after Ripoll i Perelló 1982a)

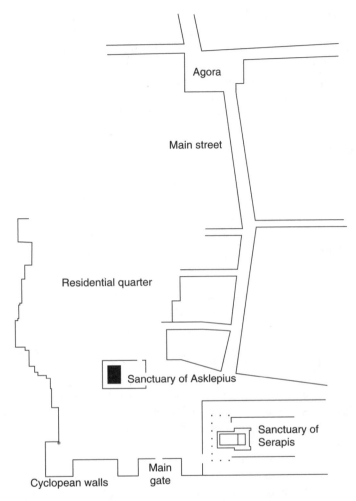

Figure 5. Plan of Neapolis, with main sanctuaries marked (after Ripoll i Perelló 1982a, plate 3; and Aquilué, Mar, and Ruiz de Arbullo 1983, fig. 2)

and M. Almagro refused to accept the sphinx relief as archaic, believing instead that it was archaistic and not necessarily from a temple.[61]

Temple of Serapis. Early excavations at Emporiae were concentrated in the mainland area known as Neapolis (fig. 5), where were found remains of the fifth- and fourth-century city with later Hellenistic and Roman addi-

61. Almagro 1943, p. 44.

tions.[62] Stratigraphic sondages taken in the sector reveal a continuous occupation since the sixth century B.C.[63] In the southern region, remains of temples have been unearthed. The most impressive and complete and the best understood is that of Serapis in the eastern part (pl. 1).

That there was a temple sacred to Serapis was revealed by the discovery of a fragmentary Greek-Latin bilingual inscription that contains a reference to Serapis.[64] A second inscription, first cited by E. Hübner and most fully studied by F. Fita,[65]

PI AEDEM
A PORTICUS
MENI F
IVS

has been reconstructed to read "[Sera]pi" for the first line. Fita's interpretation was also followed by Almagro.[66] The inscription must refer to either the initial building of the sanctuary or a reconstruction.[67] According to Almagro's reading, the sanctuary had benches ([sedili]a) of some type and a portico (porticus). There are other testimonia to the spread of the cult of Serapis around the Iberian Peninsula, but the temple at Emporiae remains the most extensive architectural manifestation for the cult yet found.[68]

Already in the nineteenth century with the discovery of marble column shafts, bases, and cornices, it had been suggested that this sector in the southeast could be associated with the Temple of Serapis.[69] In 1911 J. Puig i Cadafalch reported that the southern sector of the Greek city contained several distinct sanctuaries. In the area to the west, the excavators had unearthed in one of the Roman cisterns a statue of Asklepius that formed an element in a sanctuary dedicated to the god that took shape in the fourth century B.C. over the remains of an even earlier religious spot, perhaps dedicated to Artemis of Ephesus.[70]

The cult of Serapis probably entered Spain during the first century B.C., carried to the peninsula by merchants who plied the trade between south-

62. For the history of the city walls see Sanmartí i Grego, Castanyer i Masoliver, and Tremoleda i Trilla 1992, pp. 102–112; *HA*, p. 250.

63. Almagro 1945, pp. 64–69.

64. Almagro 1952, p. 18, no. 2. More recently, G. Fabre, M. Mayer, and I. Roda, *Inscriptions romaines de Catalogne*, vol. 3 (Barcelona, 1991), pp. 26–27; H. G. Vidman, *Sylloge inscriptionum religionis Isiacae et Serapicae* (Berlin, 1969), pp. 767–768.

65. *CIL* II, 6185; Fita 1883, pp. 127. 66. Almagro 1952, p. 89, no. 2.

67. Puig i Cadafalch 1911–1912, p. 314.

68. García y Bellido 1967, pp. 135–136.

69. See Botet y Sisó 1879, plan opposite p. 29.

70. For the statue find see Bosch Gimpera and Serrá Rafols 1929, p. 14. For the history of the area see Sanmartí i Grego, Castanyer i Masoliver, and Tremoleda i Trilla 1990, pp. 137–138.

ern Spanish ports and southern Italy, Sicily, and Africa. Greeks who came with the Roman army also may have fostered the spread of the cult, since the earliest epigraphic evidence for Serapis on the peninsula is an altar from Castra Caecilin (Norba Caesarina [?] Cáceres) dating to 80 or 79.[71] There are Greek names on some inscriptions from elsewhere on the peninsula.[72] At Valencia the precinct of Serapis may have been shared with the sanctuary of Isis.[73]

The Structure. The ruins of the sanctuary lie over the remains of the fortification wall, which would indicate that the sanctuary dates from after the arrival of the Consul Cato in 195 B.C., when the fortifications for the lower city were replaced by a massive Roman fortress overlooking the city.[74] There is archaeological evidence that this southeastern corner of the lower city may have already been separated off by walls and porticoes as early as the fourth century B.C., though the temple does not date to that early a period.[75] Puig i Cadafalch, who excavated the site, never identified it specifically with a cult of Serapis, though he did eventually decide that the sanctuary was associated with Isis.[76] He maintained that the inscription commemorated a rebuilding of the sanctuary perhaps similar to the rebuilding of the Sanctuary of Isis at Pompeii after the earthquake of A.D. 62. He too reconstructed (sedili)a and noted the importance of benches in the sanctuary furnishings for the Alexandrian cult. Puig i Cadafalch argued that the temple and associated sanctuary should have opened to the east, toward the sea, as Isis was protectress of sailors.[77]

The sanctuary consists of a single building raised on a platform situated on the west end of a large porticoed plaza 23.5 m × 50 m (fig. 6), a length equal to almost twice the width, which appears to maintain the older, presanctuary design for the space.[78] The portico columns were undecorated, with Tuscan capitals.[79] The temple proper (12.5 m × 10 m; see fig. 7) in-

71. García y Bellido 1967, pp. 135–136; idem 1956, p. 296.

72. For Callinicus from Valencia see García y Bellido 1956, p. 297; idem 1967, p. 129. E. Hubner (*CIL* II, 6185) identified the name Climene on the inscription from Emporiae as Greek; see also Almagro 1952, p. 89, no. 2.

73. García y Bellido 1967, p. 129.

74. Sanmartí i Grego 1988, p. 100; García y Bellido 1956, p. 325; Puig i Cadafalch, Falguera, and Goday 1934, p. 83.

75. Sanmartí i Grego, Castanyer i Masoliver, and Tremoleda i Trilla 1990, pp. 120–121.

76. Puig i Cadafalch 1913–1914, pt. 2, plan between pp. 830–839, labeled "temple V"; idem 1911–1912, p. 305.

77. Puig i Cadafalch 1911–1912, p. 314–316; see also García y Bellido 1956, p. 303.

78. Sanmartí i Grego, Castanyer i Masoliver, and Tremoleda i Trilla 1990, p. 123; García y Bellido 1956, pp. 313–321.

79. Puig i Cadafalch, Falguera, and Goday 1934, p. 88. García y Bellido (1956, p. 318) identified the capitals as Doric.

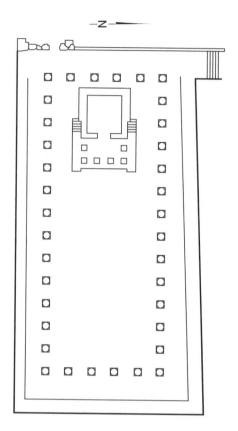

Figure 6. Hypothetical restoration of the Temple of Serapis precinct (based on Puig i Cadafalch 1913–1914, pla)

corporates two parts: a cella (7.5 m × 6.7 m), and the rectangular pronaos (5 m × 10 m) that fronts it, which is wider than the front of the cella, creating a T-shaped plan, with the pronaos being 40 percent and the cella 60 percent of the total area.[80] The width of the cella, 6.75 m, if divided by 27, the number that Vitruvius argues should be employed for a Doric tetrastyle (4.3.3), yields a module of 0.25 m. The walls of the cella are 0.50 m, equal to two modules, as are the column bases.[81] The pronaos is approached from the rear via two flanking staircases on the podium, which enter through the back side of the extension arms of the T. The facade is not interrupted by a front staircase and presents the aspect of a wall or a speaker's podium. Four columns of unknown type stood atop Attic bases, and the porch was finished with two columns that wrapped around to either side of the pronaos and thereby created a deeper space. The area of

80. Sanmartí i Grego, Castanyer i Masoliver, and Tremoleda i Trilla 1990, p. 130.
81. Ibid.

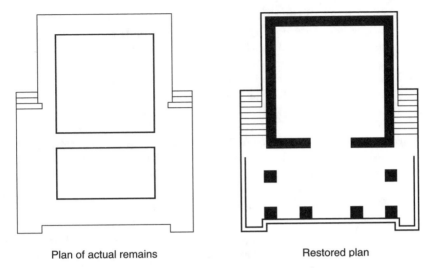

Plan of actual remains Restored plan

Figure 7. Plan of the Temple of Serapis (after Puig i Cadafalch 1911–1912, figs. 38 and 39)

the porch is somewhat less than that of the cella. The intercolumniation is wider between the center pair.[82]

To bed the foundation of the podium, the builders dug through to bedrock. At the foundation level, they employed two different types of fill. For the area to hold the cella, the fill is earth. The area supporting the pronaos has thicker retaining walls and a fill of mortared stone.[83] The outer wall of the podium proper is constructed of large, drafted blocks carefully arranged in a header-stretcher fashion and possibly clamped together.[84] The exterior wall of the podium encloses a series of small units defined by smaller partition walls within the podium structure.[85] Inside the cella were found two layers of pavement, a finer one covered by a rougher one.[86] The stone is sandstone that has been roughened to receive a coat of stucco, some of which still adheres. One of the corners of the podium is constructed with a cement core covered with a stone facing that was also stuccoed, a kind of *opus caementicium* with *opus incertum* finish. A similar form of construction may have been used for the cella walls.[87]

82. García y Bellido 1956, p. 316.
83. Sanmartí i Grego, Castanyer i Masoliver, and Tremoleda i Trilla 1990, p. 127.
84. García y Bellido 1956, fig. 3. For general construction see Puig i Cadafalch, Falguera, and Goday 1934, p. 89.
85. Sanmartí i Grego 1992, p. 153.
86. Puig i Cadafalch, Falguera, and Goday 1934, p. 90.
87. García y Bellido 1956, p. 318.

Enough remains of the podium's base molding to identify it as a simple *cyma reversa*, which gained popularity in Italy during the course of the third and second centuries B.C.[88] Puig i Cadafalch paralleled the base molding with a *cyma reversa* crown molding. E. Sanmartí i Grego has argued that the lateral stairways had an odd number of risers, each 0.20 m high, thus following the Vitruvian rule that one should start and end an ascent to a sanctuary on the same foot (3.4.4), and yielding a height of 1.80 m for the restored podium.[89] Though the order for the pronaos colonnade is unknown, A. García y Bellido proposed Ionic because of the Attic bases.[90] Using Vitruvius as a guide, Sanmartí i Grego has calculated the height for the facade: The column bases were 0.50 m (two modules), with a radius of 0.25 m (one module). The total height for the columns, including capitals, would have been 3.50 m, 14 times the module. The total height for the facade would have been twice the height of the colonnade, 7 m. The front of the temple would have described a rectangle, 7 m by 10 m. The cella itself, measured from its interior rear wall, was 7 m. Thus the interior length of the cella and height of the facade are identical.[91]

A water channel runs around three sides of the portico and passes under the cella. Puig i Cadafalch proposed that this indicated that the construction of the temple postdated that of the portico.[92] This view has been upheld by R. Wild, who in the study of the use of water in the cults of Serapis and Isis could find no clear evidence to link the channel to cultic or ritual uses and concluded that it served only to drain the colonnade.[93]

Almagro, in his study of the epigraphic finds from Emporiae, dated the inscription to the first century A.D.[94] If Puig i Cadafalch is correct in concluding that it refers to a restoration rather than an initial building campaign, then the sanctuary existed by the mid–first century A.D. Nothing in the excavations revealed major structural changes, so the alterations may have been minimal, and the present plan of the precinct may reflect the original form.

García y Bellido argued that the construction technique was Hellenistic,[95] though he offered no specific date for the building. However, *opus caementicium* with *opus incertum* was employed for the cella walls for the

88. Ibid.; Sanmartí i Grego, Castanyer i Masoliver, and Tremoleda i Trilla 1990, p. 131, using L. Shoe, *Etruscan and Republican Roman Mouldings,* Mélanges of the American Academy in Rome, no. 28 (Rome, 1965).

89. Puig i Cadafalch 1911–1912, p. 317; Sanmartí i Grego, Castanyer i Masoliver, and Tremoleda i Trilla 1990, p. 131.

90. García y Bellido 1956, p. 316.

91. Sanmartí i Grego, Castanyer i Masoliver, and Tremoleda i Trilla 1990, pp. 132–133.

92. Puig i Cadafalch 1911–1912, p. 313.

93. Wild 1981, p. 187.

94. Almagro 1952, pp. 89–90, no. 2. 95. García y Bellido 1956, p. 317.

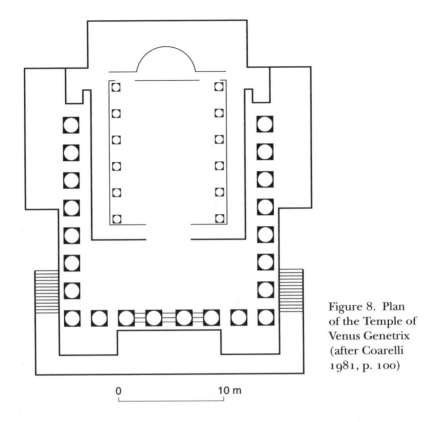

Figure 8. Plan
of the Temple of
Venus Genetrix
(after Coarelli
1981, p. 100)

0 10 m

Temple of Jupiter at Anxur in the early first century B.C.[96] Moreover, con-
crete construction has been found at Ostia that can be dated to the mid–
second century B.C., and a type of construction material akin to concrete was
used in Pompeii slightly earlier.[97] *Opus incertum* construction in Rome itself
is dated to the first decades of the second century B.C.[98] Concrete with lime
mortar and volcanic sand probably began to be used in the second century
on the Italian peninsula, and the surface covering of *opus quasi-reticulatum*
dates perhaps to the period of Sulla.[99]

The plan for the Temple of Serapis is the most unusual feature in the
sanctuary. It can be paralleled by the Temple of Venus Genetrix in the fo-
rum of Caesar (fig. 8), begun in 48 B.C. In the Roman example the temple
and complex were larger and the cella has an apsidal end, but the general
principle is the same—a temple raised on a podium with a flush facade and

96. Boethius 1978, p. 174. 97. Ibid., pp. 128–130.
98. Coarelli 1981, p. 369.
99. Carrington 1933, pp. 131–132. See also Mau 1899, p. 38.

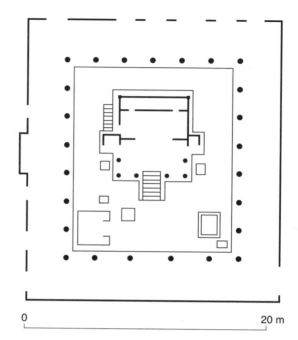

Figure 9. Plan
of the Temple
of Isis in Pompeii
(after Richardson
1988, p. 281)

0 20 m

two rear lateral staircases giving access to a platform that forms the base for the pronaos. However, the T shape of the Temple of Venus is nowhere near as pronounced, and the lower flush facade may have been designed to accommodate a rather impressive *rostrum,* or speaker's platform.[100]

A closer comparison can be made with the Temple of Isis at Pompeii (fig. 9). Both Puig i Cadafalch and García y Bellido noted specific points of similarity. The Iseum has a modified T plan with a staircase on its south side as well as a frontal flight of stairs. The columns of the pronaos extend across the front and include the sides. The later Temple of Vespasian (fig. 10), also at Pompeii, has a plan similar to that of the Iseum, though in the former the T is more prominent. It has two lateral stairways like the Temple of Serapis.[101] The walls for the construction of the Iseum are of tufa covered with stucco— not that different from sandstone covered with stucco.[102]

In plan, all four sanctuaries are remarkably alike. The focus of interest is the temple surrounded by a plaza space defined by a colonnaded peribolos.

100. R. Ulrich, "Imperial Oratory and the Roman *Templum-Rostratum,*" *AJA* 91 (1987), pp. 283–284; Coarelli 1981, pp. 103–104; Fiorani 1968, pp. 91–103.

101. García y Bellido 1956, pp. 315–317.

102. Vos and Vos 1988, p. 73; Richardson 1988, p. 282 n. 17.

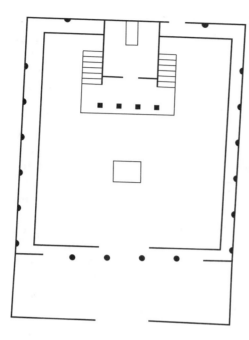

Figure 10. Plan of the Temple of Vespasian at Pompeii (after Puig i Cadafalch 1911–1912, fig. 41)

The longitudinal axis is stressed by the lateral colonnades and denied by the unaccented fronts of the podia that, for the Temples of Serapis (pl. 2), Venus Genetrix, and Vespasian (pl. 3), appear like a speaker's platform. The Temples of Isis and Vespasian sit in more squared precincts, whereas the Temples of Serapis and Venus Genetrix occupy rectangular spaces. The Temples of Isis and Serapis sit away from the back wall of the sanctuary and occupy more of a middle position, though all the sanctuaries were probably designed to be entered opposite the temple. At the sanctuary of Serapis this is not clear, since the east end of the sanctuary no longer exists.

Differences cannot be ignored, however. The Temple of Venus does not have stressed wings to the T plan. The Temple of Isis is in reality a rectangular structure with two distinct side projections that connect with the pronaos from which they are entered, but they interrupt the straight lines of the lateral walls and describe more a transept than a T. The Temples of Vespasian and Serapis display a different design concept. The pronaos of each is a rectangle grafted onto a square naos. The longer side of the rectangle forms the facade of the temple. In this design the two side projections are integral parts of the composition and do not really represent separate pavilions.

The temples had stairways that led up from the rear to the top of the podium. The function of the single staircase of the Iseum is quite different

from that of the other two temples. The staircase terminates in the rear wall of the south-side pavilion; there is no direct access from the stairs to the pavilion or to the pronaos. Instead, the entrance is to the left at the top of the stairs, into the cella proper. Since the Temple of Isis is also equipped with a large front staircase, the rear stairs should be regarded as serving as a secondary means of access or perhaps egress.

The Temples of Vespasian and Serapis, on the other hand, have only rear access, by means of two lateral stairways. Neither temple preserves evidence of front stairs, though the intercolumniation of the Temple of Serapis is slightly wider at the central pairing. The stairways lead directly into side projections of the pronaos at both temples and do not supply immediate entry into the cella. There are seven risers for the stairways at the Temple of Serapis and eight for the Temple of Vespasian.

The plans of the Temples of Serapis (fig. 7) and Vespasian (fig. 10) reveal important differences. The pronaos of the Pompeiian temple is raised on its podium to head height, and there were only four front columns, of which no traces remain, and no columns to the sides.[103] The Temple of Serapis does not sit atop so high a podium, and had two lateral columns as well as the four in the front.

Decorative details also serve to separate the four temples. The Temple of Venus was partially built of marble and included rich sculptural displays.[104] The great fountain also served to add a sense of grandeur to the structure. The Temple of Vespasian was revetted in marble,[105] whereas the Iseum was richly painted.[106] Of all the temples, the Iseum must have been the most decorated.[107] There is no evidence for such advanced decorative work on the Temple of Serapis.

Relationship. García y Bellido dated the Temple of Serapis to the late Republican or early Augustan period.[108] This view is strengthened by Sanmartí i Grego's observation that the *cyma reversa* molding on the base of the podium is similar to that on the Republican temple on the upper forum (infra). Moreover, the technique of *opus quasi certum* used for some sectors of the temenos wall is dated at Emporiae to the start of the Augustan period.[109] Puig i Cadafalch argued for an earlier date based on the pottery finds at the sanctuary, Campanian ceramic fragments that provide a late-third- or second-century B.C. date for use of the site, but the discussions of

103. Richardson 1988, p. 193. 104. Coarelli 1981, p. 103.
105. Vos and Vos 1988, pp. 41–42. Blake (1959, p. 153) did not note the marble.
106. Blake 1959, p. 155. 107. Lyttelton 1974, pp. 198–199.
108. García y Bellido 1956, p. 318. 109. Sanmartí i Grego 1992, p. 153.

the pottery finds do not actually place the fragments in clear association with specific features of the sanctuary.[110]

The Sanctuaries of Isis and Vespasian at Pompeii, of Venus Genetrix in Rome, and of Serapis present a common urban sanctuary design of the first century B.C., an axially aligned temple surrounded by a longitudinally arranged, colonnaded enclosure. The form is known from the forum at Emporiae (infra) and from the early Imperial fora in the capital. The siting of the Temples of Serapis and Isis some distance from the back wall perhaps softens the strong axial march, and may be a less common design feature, but the Sanctuary of Demeter at Pergamon (fig. 16), a Hellenistic construction, with its four stoas surrounding a central temple, shows a similar pattern.[111] In contrast to the commonality of the general design of the sanctuaries, the temples themselves represent a style that is distinct, and they can be related only to one another.

The present remains of the Temple of Isis date to after the A.D. 62 earthquake.[112] The rebuilt temple may retain the placement of the earlier structure, but provides no idea of the original plan. There is no evidence for an earlier temple on the site of the first-century A.D. Temple of Vespasian, though earlier buildings did occupy the site.[113] The Temple of Vespasian was a new construction, sharing certain construction features with the rebuilt Building of Eumachia next door,[114] and was unfinished at the time of the eruption. If the two Pompeiian temples postdate the earthquake of A.D. 62, then they cannot have influenced the design for the Temple of Serapis. Moreover, although the Temples of Isis and Serapis could share common features because of a cultic relationship,[115] the lack of evidence for cultic water facilities at Emporiae[116]—evidence that exists at Pompeii— suggests that there are no compelling cultic reasons for similarities in the plans of the temples. A date in the middle of the first century B.C. may be more precise for the Temple of Serapis.[117] Perhaps it was built as an element in the remodeled lower city, which arose when Caesar made Emporiae a veterans' colony in 45 B.C. The Temple of Serapis is stylistically similar to

110. Puig i Cadafalch 1911–1912, p. 319. There is reference to only one piece of later pottery, a fragment of first-century A.D. Gallic sigillate.

111. Coulton 1976, p. 273.

112. For rebuilding and inscription see Vos and Vos 1988, p. 73. For the earlier Temple of Isis at Pompeii see Tran Tam Tinh 1964, pp. 31–32.

113. Blake 1959, p. 153. 114. Ibid.

115. The Temple of Isis at Sabratha sits in a similar enclosure, but the temple is a traditional Italic type; see Brouquier-Reddé 1992, pp. 58–63.

116. Wild 1981, p. 19.

117. Sanmartí i Grego, Castanyer i Masoliver, and Tremoleda i Trilla 1990, p. 125; HA, p. 250.

Caesar's Temple of Venus Genetrix in Rome. The two plans share in partic-
ular the T-shaped rear access, and flush front podium. It might have been
politically as well as culturally farsighted to commission a temple design that
quoted the plan of the temple dedicated to the family goddess of the con-
queror of the Gauls. The Temple of Serapis was probably the last major
building project in the lower city as the Roman emphasis shifted to a newly
laid-out upper city.

The Temple of Serapis may be seen as the architectural jewel of Neapolis,
built as an element in a major beautification of the city that began in the
second century B.C.[118] The unusual T plan of the temple with lateral rear
stairs reflects the freer architectural expression of late Hellenistic building
as it emerged in Roman contexts. At Emporiae, the second century saw the
formal delineation of the agora area defined by an L-shaped colonnade on
the south and west sides and a two-storied stoa on the north side with inte-
rior colonnade.[119] The Temple of Serapis itself probably was conceived to
be part of a larger complex of sanctuaries dominated by the earlier Sanctu-
ary of Asklepius—a complex that defined the southeastern region of the
city. The ensemble may well have been highly decorated, to judge from the
statue of the healing god and the fragments of a statue of a seated Serapis
that have survived.[120] The sanctuaries were separate, enclosed by temenos
walls, but still related by location and by cults. Neapolis must have assumed
an aspect akin to the much richer Hellenistic cities of Asia Minor, where
one finds interconnected sanctuaries, formally defined agora spaces, and
two-storied stoas.

The completion of the Sanctuary of Serapis toward the middle of the first
century B.C. could also have coincided with another major change that took
place in midcentury in Neapolis. The Roman city began to take shape on a
rise above and west of Neapolis. Here about 195 B.C. a praesidium had been
constructed overlooking the Greek town. By the end of the second century
it no longer was of use and was replaced by an orthogonally planned Ro-
man civic center with forum and associated structures (fig. 4). This new
center came to be the focus of the new Roman city of Emporiae, and it was
surrounded by a wall. Thus there were two separate, walled communities.
Sometime during the mid–first century, the walls isolating Neapolis and
the developing Roman town were taken down, and the two entities were
merged.[121] This fusion may have occurred at the same time that Caesar

118. Mierse 1994, pp. 801–805.

119. Mar and Ruiz de Arbulo 1988, pp. 39–60.

120. For the Asklepius statue see Ripoll Perelló 1981, p. 111 (where it is dated third cen-
tury B.C., in the tradition of Phidias); idem 1982, p. 26. For the Serapis statue see Sanmartí i
Grego 1992, pp. 145–147.

121. Aquilué, Mar, and Ruiz de Arbulo 1983, p. 133.

settled the veterans' colony at the site, which also could have been when the city was granted the rank of a municipium, a status change perhaps reflected on the coinage.[122] The expansion of the religious sector of the city could well have been in response to these other changes.

The Roman Forum. The first major Roman construction in Emporiae was on the hill overlooking Neapolis, a praesidium later abandoned.[123] The hilltop was redesigned with an orthogonal grid plan at the end of the second century B.C.[124] The initial area for the upper city was enclosed by a wall of polygonal limestone masonry 700 m north by south, 300 m east by west.[125]

The forum was part of the original plan for the upper city (fig. 11). The exact size of the Republican forum cannot be determined, since the east and west limits have not been recovered. Tabernae lined the south side. Each was on average 7.40 m × 4.65 m, with walls 0.50 m thick. The doors were in some cases 3 m wide and opened directly onto the central public space.[126] The north end of the complex was dominated by a great temple surrounded by a cryptoportico. The forum was to remain permanently in its Republican location.

Much of the forum temple was robbed out after the third century A.D.[127] What remains are fragments of the foundation and exterior walls of the temple, which were constructed of *opus incertum* with portions of *opus caementicium*.[128] Visible sections of the podium are of cut and fitted sandstone blocks ca. 1.10 m × 0.60 m, probably coated with stucco. *Opus incertum* technique was used for the compartment walls within the podium. The front staircase rested on top of a mass of concrete. A bit of a *cyma reversa* lower molding from a corner section of the podium survives, as well as fragments of Corinthian capitals that correspond to the pilasters carved in the

122. Ibid., p. 137. Caesar installed a colony of veterans at the site sometime between 49 and 45 B.C. (Livy 34.9.3: "Tertium genus Romani coloni ab divo Caesare post devictos Pompei liberos adiecti. Nunc in corpus unum confusi omnes Hispanis prius, posteremo et Graecis in civitatem Romanam adscitis"); Ripoll i Perelló 1982, p. 12. For change in the coinage see Guadán 1980, p. 10, no. 39.

123. Aquilué Abadías et al. 1984, p. 47.

124. Ibid., p. 76; Sanmartí i Grego 1978, p. 311. M. Almagro earlier argued that the change to an orthogonal plan in the upper city occurred when Caesar refounded the city, an event Almagro thought had been commemorated on a coin issue; see Ripoll i Perelló 1982, p. 12. For independent coin studies see Guadán 1969, p. 52; Grant 1946, p. 155; Hill 1931, p. 35. Recently Sanmartí i Grego (1978, p. 616) has disputed the historical and numismatic evidence, arguing that the change in status actually happened much earlier, about 90 B.C., and was granted to several cities along the Catalan coast.

125. Aquilué Abadías et al. 1984, p. 76.

126. Ibid., p. 74. 127. Ibid., p. 252.

128. Ibid., pp. 50–51.

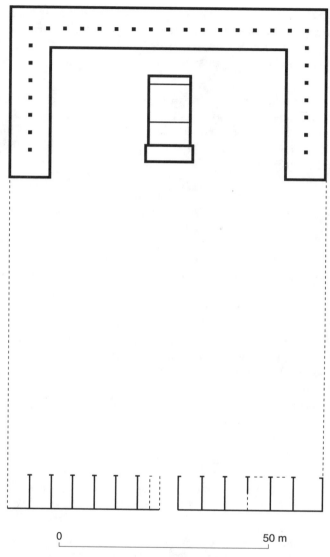

Figure 11. Plan of the Republican forum at Emporiae (after
Aquilué Abadías et al. 1984, plate 4)

walls; a single block that has remains of pilasters on the front and sides; and three blocks with pilasters carved only on the front.[129] There are some black and white tesserae, probably from a paving of *opus signinum*.[130]

The temple was placed on the natural rock, and the podium was raised to a height of 1.75 m.[131] The plan is a T (fig. 12) with the crossbar forming the front end, which opened to the south and was cut through by the staircase (fig. 13). The dimensions are 12.8 m in front, 10.4 m in the rear, with a length of 20 m. The walls average a thickness of 1.60 m.

There are no remains of the reconstructed colonnade of the temple. The temple itself seems too narrow to have been octastyle, and even a hexastyle plan would have meant crowding the columns. The finds of the pilasters and capitals suggest a pseudo-peripteral plan. An intercolumniation of 2.75 m has been proposed based on an assumed thickness of 1.10 m for the exterior walls of the podium—1.60 m minus 0.50 m for the molding. This thickness corresponds with the first of the lateral walls in the podium proper. The interaxial distance between this wall and that of the front of the temple is 8.25 m. This is the distance from the corner of the front of the cella to the angle column; divided by 3, it yields the interaxial spacing for the side two columns and the corner pilaster, and this can be carried around to the front.[132]

The few remaining blocks with pilasters provide a width of 0.80 m for the cella walls. Following the rhythm of the columns along the front, there should be five pilasters per side, along with two columns—a total of six intercolumniations. The cella may have been paved with *opus signinum*.[133]

The possible small chamber defined by a lateral wall in the podium at the rear of the cella is problematic. It could have served as an adytum, though the excavators have pointed out that it was more common for these to have been subterranean, and there is no trace of a staircase into this space. A second possibility, though also quite unusual, would be that the wall marked off the area for the niches of three gods of a capitoline triad such as have been found in later contexts in North Africa.[134]

In front of the temple was an altar placed on the same north-south axis as the temple. It is almost square, 1.65 m × 1.95 m, and constructed of mortared sandstone blocks. It sits 5 m from the front of the temple's access stairs, on the same level as the pavement.[135]

The podium fill contained fragments of common ceramic types from the

129. Ibid., p. 56, figs. 27 and (fragments of a pilaster with flutes) 28.

130. Ibid., pp. 58–59. 131. Ibid., p. 51.

132. Ibid., pp. 56–58. 133. Ibid., p. 58.

134. Ibid., p. 59; for North African comparisons see Barton 1981, pp. 261, 286–287, 308–309.

135. Aquilué Abadías et al. 1984, p. 62.

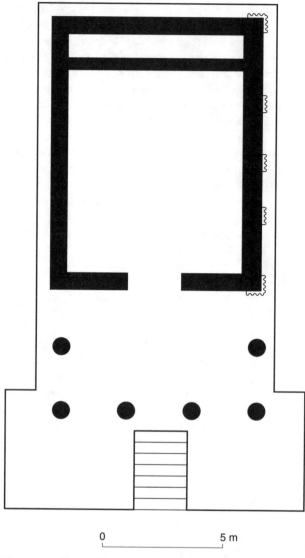

0 5 m

Figure 12. Restored plan of the Republican temple from
the forum at Emporiae (after Aquilué Abadías et al.
1984, plate 8)

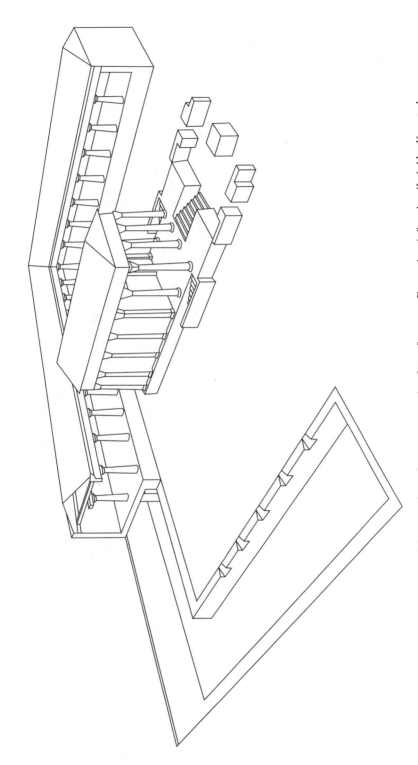

Figure 13. Reconstruction drawing of the temple and temenos portico from forum at Emporiae (after Aquilué Abadías et al. 1984, plate 14)

late second and early first centuries B.C. The temple was built as an integral part of the forum plan and not added later. The altar likewise was a contemporaneous construction.[136]

The temple precinct opened to the south onto the forum plaza. The other three sides surrounding the temple formed a "pi"-shaped portico that stood two columns deep. It was raised on a substructure cryptoportico. Nothing of the portico remains, and only fragments of the cryptoportico. Like the portico above, the cryptoportico was two aisles deep. The pillars placed on the central axis were constructed of drums either as complete cylinders or as two half cylinders. They have a diameter of 0.80 m, a height of 0.40 m, and an intercolumniation of 2.80 m. In the northeast and northwest corners, the rhythm was broken by the angle pillars. The drums were stuccoed, and the pillars were set directly on the natural rock.[137]

The walls of the cryptoportico are not of a uniform construction, though *opus incertum* is most common. The outer walls of the east and west branches block out the two main kardines that border the forum. The north wall, which is as long as two insulae and occupies the total space between the two kardines, is actually addorsed by exterior structures. Ventilation and lighting were provided for the interior by means of light wells and air vents that opened from the podium of the portico on the three sides facing into the temple precinct.[138]

Nothing stands of the upper portico, but some architectural features have been found: four Doric capitals with diameters of 0.47 m. These may have formed the exterior colonnade and were probably stuccoed over with lime plaster. There are eight fluted drums for columns with heights of from 0.36 m to 0.87 m and diameters ranging from 0.52 m to 0.60 m. There are also some plain column fragments and a base with a double *cyma reversa* molding. These may have been elements in the interior colonnade.[139] If the assumed placement is correct, then the interior colonnade was unfluted and the exterior colonnade was fluted.

Emporiae's orthogonal plan with forum is the earliest known example on the Iberian Peninsula. The discovery of such a fully articulated plan for forum and neighborhood sharply puts in question J. B. Ward-Perkins's assumption that Roman planning entered the West only with the arrival of Augustus, and then almost exclusively in Cisalpine Gaul.[140] The forum design at Emporiae must be as early as the earliest examples from southern France and predates by half a century the best-studied Republican forum in the southern French region, that at Saint-Bertrand-de-Comminges.[141] Even

136. Ibid., pp. 55, 62. 137. Ibid., p. 64.
138. Ibid., p. 65. 139. Ibid., p. 72.
140. Ward-Perkins 1970, pp. 1–19.
141. For the traditional treatment of the forum at Saint-Betrand-de-Comminges see Grimal 1983, pp. 43–45; and Woloch's descriptive catalog therein, s.v. Saint-Bertrand-de-

the forum at Colonia Narbo Martius (Narbonne) dates from the end of the first century B.C.[142]

The last decade of the second century B.C. and the early years of the first century B.C. were the time when the formula for the forum seems to have become fully defined. At Pompeii the forum, with its dominant temple of Jupiter on the axis, took shape sometime about 80 B.C.[143] The earlier forum at the third-century colony at Cosa never developed strong axial sensibility defined by a main temple and with the civic, administrative, and sacred units placed along the longitudinal movement.[144]

The forum at Emporiae appears highly structured, with the parts clearly marked off, though in its first phase there is no evidence for a basilica. It may not follow the 2:3 proportions suggested by Vitruvius (5.1.1–3)[145] in its original plan, but with the addition of the basilica during the Augustan phase it assumed those proportions. However, even in its earliest phase there do seem to have been proportion considerations. The temple precinct is one-third the length of the entire forum complex.[146]

The temple plan must predate that of the Temple of Serapis in Neapolis. The forum temple has the same T shape, but without a pronounced facade since it is cut by stairs. The wings in this case become secondary elements, not unlike the side projections of the lower platform of the Temple of Jupiter at Pompeii (fig. 14). However, there is no denying that the plan, which is such a striking feature of the later Temple of Serapis, is already present in an incipient form in the forum temple, and it may be reasonable to assume that a kind of architectural dialogue was set up between the two parts of the city. Certainly the Temple of Serapis with its surrounding precinct had the same marked axiality as the forum, an axiality that is often identified as a Roman design conception.

Comminges, which dates the forum complex to the reign of Augustus. New investigations have cast doubts on this traditional dating and on the idea of a fully formed forum with temple plan at Saint-Bertrand; Guyon et al. 1991, pp. 89–122.

142. Solier, Janon, and Sabrie 1986, pp. 41–46; Solier 1973, pp. 315–324; Perret 1956, pp. 1–22.

143. This date is based on Richardson's date for the Temple of Jupiter on the forum at Pompeii; Richardson 1988, p. 138. Richardson down-dates Maiuri's earlier date of 150–120 for the temple (Maiuri 1973, pp. 101–124). Richardson (1988, p. 99) also has down-dated to 120 Maiuri's date of 150 for the initial construction of the forum (Maiuri 1973, pp. 212–223). If Maiuri's dates are correct, then Pompeii can be regarded as the possible model for the developments at Emporiae. However, if Richardson's later dating is correct, then the forum at Emporiae was taking shape alongside that at Pompeii.

144. Brown 1980, pp. 56–69, fig. 73.

145. "Latitudo autem ita finiatur uti, longitudo in tres partes cum divisa fuerit, ex his duae partes ei dentur; ita enim erit oblonga eius formatio et ad spectaculorum rationem utilis dispositio."

146. Jiménez Salvador 1987, pp. 173–177; idem n.d., pp. 97–100.

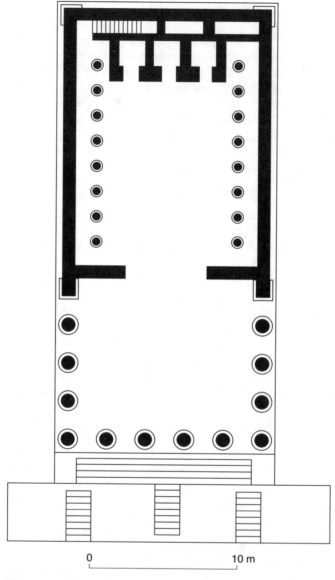

Figure 14. Plan of the Temple of Jupiter at Pompeii (after
Richardson 1988, p. 139, fig. 19)

Not only is the forum design at Emporiae the oldest on the peninsula, but it must be considered the oldest outside the Italian peninsula. Certainly, if Sanmartí i Grego is correct and the status change reflected on the Emporiae coinage really occurred about 90 B.C. rather than 45 B.C., then the colony would have been the logical source of inspiration for a Romanizing idea. It has no clear predecessors, and interestingly, as built in its Republican form, it is already a fully articulated example of one type of forum with the delineated sacred, administrative, and public sectors, though it must be admitted that the administrative building, the basilica, did not appear until the Augustan reforms.

A comparison between the forum at Emporiae and that at Glanum near Marseille reveals just how different the Iberian and Gallic conceptions could be. The Glanum forum, in its first form dating to between 30 and 20 B.C. (fig. 15),[147] was, unlike that at Emporiae, integrated into the older fabric of the city and probably replaced older structures, including perhaps temples. As it appears in its later shape (Augustan or Flavian? see fig. 36), which also may reflect the earlier design, it is really a square colonnaded space anchored on the north side by a basilican structure and on the south side by an apsidal wall. The forum is integrated physically into the old urban plan rather than used as the organizing element for a new plan, but it is effectively sealed off from the outside world. There is no formal temple as part of this plan. Outside the space stand a pair of small temples, which are surrounded by a peribolos on three sides, an area separate and apart from the forum proper. This sacred area dates to the period between 40 and 20 B.C.[148] The first forum at Emporiae is linked to the upper city because the Kardo Maximus emptied into the southern rank of tabernae. The sacred precinct was set off from the rest of the forum by means of a decumanus that cut through the complex,[149] but it was not treated as an architecturally distinct unit as at Glanum. The experiments at Emporiae and Glanum represent two opposing responses to the formation of formal public spaces.

The cryptoportico that served to raise up the portico that surrounded the temple at Emporiae is, like the entire forum complex, the earliest ex-

147. For the chronology of building at Glanum see Rolland 1946, pp. 34–39; Charles-Picard 1963, p. 112. For the destruction of 125 B.C. see Rolland 1946, p. 84. Gros and Varene (1984, p. 31) offer a date of 30 to 20 B.C. for the first forum at Glanum based on the evidence of the acanthus decoration and the second-style wall painting in the "maison aux alcoves" buried beneath the forum. In a more recent study, Roth Congès (1987, pp. 196–197) proffered a date of 20 B.C. based on the evidence of the arentine ware found in a sondage of 1984.

148. Roth Congès 1992, p. 51, fig. 9.

149. One of the Augustan changes to the forum was to enclose it and move to isolate it from integration into the urban plan; Jiménez Salvador 1987, p. 174.

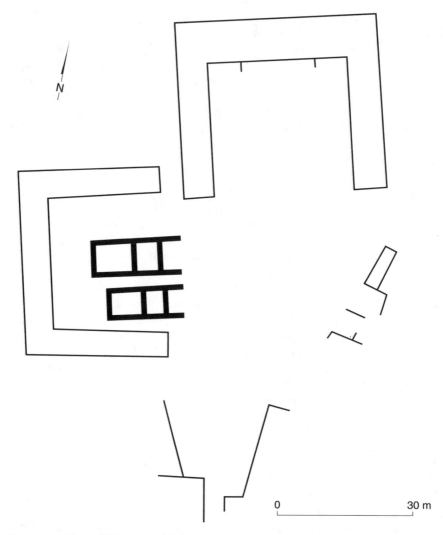

Figure 15. Plan of Glanum, with forum marked (after Roth-Congès 1992, fig. 9)

ample of this type of architectural feature so far found in the western provinces.[150] The cryptoportico at Emporiae must be compared with the earliest examples in Italy, which developed during the late second century B.C. These first experiments include the substructures for the terraces of the great scenographic sanctuaries at Palastrina, Terracina, and Tivoli as well as substructures for terraced villas.[151] It is only the cryptoportico of the Piazza di Tani in Tivoli that shares the double-nave plan. The date here will not help, however, since the Tivoli example is also from the first century B.C.[152] The major construction campaigns on the great sanctuaries of Latium probably overlap the building program of the Republican forum at Emporiae.[153] However, the use of the "pi"-shaped portico to frame the temple is clearly a design conceit developed by the architects in Latium and well understood by the builder of the Emporiae forum. The Emporiae designer realized the potential of the cryptoportico as a way of gaining height for the portico itself, effectively separating the temple and temenos from the landscape.[154]

The Emporiae cryptoportico diverges from the Italian examples in the use of materials. Vaulting with *opus caementicium* is common in many of the early Italian cryptoporticoes. The cryptoporticoes were among the first structures to be built with Roman concrete.[155] Though concrete was used for some aspects of the construction in the forum at Emporiae, concrete was not employed for the cryptoportico. Nor is there evidence that the cryptoportico was vaulted. The walls for the cryptoportico were built of stone masonry, much of it *opus incertum*.[156]

Though the plan and function of the cryptoportico at Emporiae can be argued to partake of contemporary design ideas emerging from Latium, in construction technique it has a strong affinity to Greek building practices. The cryptoportico is a trabeated structure and looks more like the Hellenistic experiments in multistory stoas such as building 5 on the agora at Cyrene, the south-side stoa at the Sanctuary of Demeter at Pergamon (fig. 16), or the south stoas on the agora at Assos.[157] These Hellenistic structures were of stone masonry with traditional trabeated construction.[158] The use of post-and-lintel technique requires the placement of intermediary supports, and the Hellenistic examples share with the Emporiae crypto-

150. The other cryptoporticoes known in the West date to the end of the first century B.C. or later. For an overview of the western provincial examples, see Will 1973, pp. 325–342.

151. Giuliani 1973, pp. 79–113. 152. Ibid., pp. 86–88.
153. Coarelli 1987. 154. Ward-Perkins 1973, pp. 51–56.
155. Giuliani 1973, pp. 137–142.
156. Aquilué Abadías et al. 1984, pp. 65–66.
157. Martin 1973, pp. 23–44. For the Sanctuary of Demeter at Pergamon see Radt 1988, p. 210. For Assos see Akurgal 1985, p. 65.
158. Martin 1973, p. 31.

Figure 16. Elevation of the south stoa and plan of the Sanctuary of Demeter at Pergamon (after Martin 1973, fig. 5)

portico the double-aisle design defined by the regular and rhythmic pattern of central pillar supports. It is the variation in this pattern using arches and a barrel vault that was employed about 70 B.C. by the architect for the cryptoportico at Suessa in Campania, which is the closest in its internal structuring to the Emporiae cryptoportico.[159]

As with the developments in the lower city of Neapolis, the changes to the upper city are best understood as responses, at least in part, to influences entering from Hellenistic Greek areas, both from the old Greek East and from Campania.[160] The alterations at Emporiae can be associated with, but are not paralleled by, the late Republican colonial projects in southern France. This was the period of active empire building. The changes at Emporiae show the responses of an old Greek settlement to the new realities of Roman control. Other sites present a native reaction to Romanization.

159. Johannowsky 1973, pp. 144–145.
160. For the changes in Neapolis see Mierse 1994, pp. 795–805.

THE NATIVE RESPONSE TO THE ROMANS' ARRIVAL

Saguntum

There is no evidence that Saguntum was particularly favored for Italian settlement following the Second Punic War. It was a pre-Roman settlement. During the second century B.C. the heights of the Cerro de Castillo, where the ancient settlement was located and which had been walled since the fourth century, were expanded toward the east (the Plaza de Armas) and a large capitolium-type temple built (fig. 17) in a region not previously occupied.[161]

The excavations have revealed the western part of the foundations (fig. 18) for the pronaos and two of the three cellas, built of local stone worked in blocks and laid dry.[162] Reconstructed, the temple has a width of 11.90 m. The foundation was built as a series of chambers formed by cross walls, not unlike the system used for the podia of the temples at Emporiae (supra). Each cella was supported by foundation walls that formed a rectangular space, and the pronaos sat atop its own rectangle. The distance from the back edge of the structure to the front of the pronaos, but excluding the stairs, was also 11.90 m. The uneven level of the bedrock forced the builder to adapt the constructions, which permitted the height differences to be bridged by the foundation.

The techniques used for the construction of the temple seem more native than Roman. The structure is of dry stonework, with neither clamps nor mortar nor anathyrosis. The blocks were laid in horizontal courses directly atop the bedrock. There are no foundation trenches. The individual stones were squared on their outer faces. The outer walls have thicknesses that range from 1.20 to 1.70 m.

C. Aranegui Gascó's analysis of the plan of the temple[163] shows a structure based on proportional ratios. A modular unit of 1.19 m controls the entire plan. If a circle is inscribed in the square area defined by the cellas and pronaos, it has a diameter of 11.90 m (ten times the unit). The distance from the end of the pronaos to the end of the flight of stairs is 2.38 m (two times the unit). The length-to-width ratio for the complete temple is 6:5.

Aranegui Gascó has determined that the three cellas likewise bear a proportional relationship to one another of 3:4:3, based on a width of ca. 2.50 m (2.55) to ca. 3.50 m (3.40) to ca. 2.50 m (2.55). For the cellas, the modular unit in operation is 0.85 m, which governs the construction

161. Aranegui Gascó 1992a, p. 57; Aranegui 1990, pp. 241–245; Aranegui 1986, pp. 155–162 (construction details pp. 155–157); *HA*, pp. 255–256.

162. Aranegui Gascó 1992a, p. 57. 163. Aranegui 1986, pp. 157–159.

Figure 17. Sketch plan of the forum and theater at Saguntum (after Hernández Hervás 1988, fig. 10)

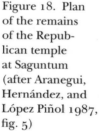

Figure 18. Plan of the remains of the Republican temple at Saguntum (after Aranegui, Hernández, and López Piñol 1987, fig. 5)

details. The perimeter walls were 1.70 m thick, or twice 0.85. Fourteen times 0.85 m yields 11.90 m, which links this second module to the larger modular unit used for the basic plan. The width of 11.90 m can be divided into forty units of 0.2975 m, and forty-eight of these new units equals the length of 14.28 m. This all leads Aranegui Gascó to conclude that the builders used a Roman foot of ca. 0.2975 m for the construction.

Aranegui Gascó has reconstructed the superstructure, for which only scant remains have been found, as a tetrastyle Italic temple with high po-

dium.[164] The columns may have been aligned along the axes of the longitudinal walls forming the cellas. The intercolumniation would have been 3.30 m. She has further pointed out that the use of proportional ratios based on squares as the means of designing the construction can be found in the capitolium temples of Florence, Terracina, Minturno, Cosa, Orvieto, and Luni. Like some of the Italian capitolia and like some Hellenistic sanctuaries, the Saguntum temple was accompanied by a cistern 3.75 m × 6 m × 4 m in depth.

Bendala Galán has pointed out that Saguntum's legal right to a capitolium temple during the first half of the second century B.C. was no stronger than that of Italica. This was a native town with no evidence of a resident Roman or Italian community.[165] Nothing other than the plan supports the identification. However, it is perhaps worth remembering that Saguntum had a special relationship with Rome, as is made clear in the ambassador's speech before the Roman Senate (Livy 28.39, 1–29). The official reason given for Rome's involvement in the Second Punic War was to aid and avenge Saguntum. Moreover, Publius and Gnaeus Scipio went to great pains to reestablish the city once they had recovered it from Hannibal, even seeking out former residents who had been sold into slavery after the city's fall in 219 B.C. (Livy 24.42, 4–9; 28.39, 1–29). Such special associations may have ultimately made a capitolium temple type not appear quite so out of place, especially if the new temple did not displace an older structure of importance and significance. The temple, erected in a new sector, could well have been a physical manifestation of the relationship between Saguntum and Rome.

Azaila

The site of Azaila (Cabezo de Alcalá de Azaila; see fig. 19)[166] sits on a bluff 83 m above the Río Aguas, a tributary of the Ebro River.[167] The bluff is saddle shaped. Excavations have isolated the settlement on the north hill and the necropolis on the southern rise.[168] The structures within the city were arranged along two sides of a central north-south axial street and along subsidiary east-west streets.

164. Ibid., p. 159, fig. 5. 165. Bendala Galán 1989–1990, p. 29.

166. For the precise location see Cabré 1929, pp. 1–38. For Republican-period settlement in the Ebro Valley see Martín-Bueno 1993, pp. 108–127; Beltrán Lloris 1990, pp. 179–206.

167. Beltrán 1986, pp. 101–109; Beltrán Lloris 1979, pp. 141–232; Villaronga 1977; Beltrán Lloris 1976; Pellicer 1969, pp. 63–88; Beltrán 1966, pp. 308–309; Beltrán 1964, pp. 79–86; Beltrán 1961, pp. 65–79; Beltrán 1945; Cabré 1945; Cabré 1943, p. 43; Cabré 1940–1941, pp. 232–235; Cabré 1929, pp. 1–38; Cabré 1926, pp. 211–221; Cabré 1925, pp. 297–315.

168. Cabré 1929, pp. 7–10.

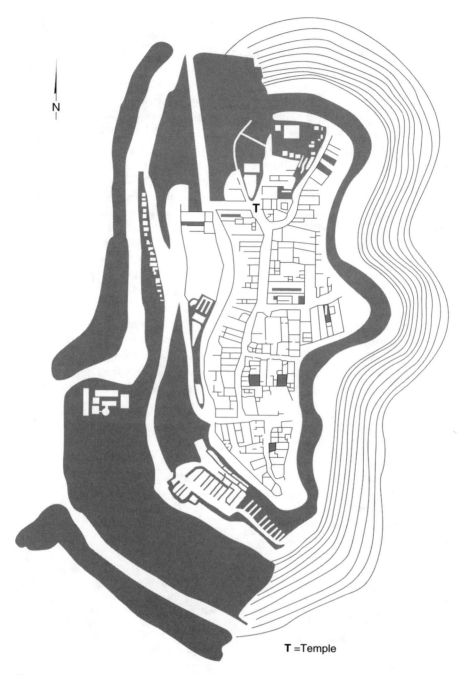

N

T

T = Temple

Figure 19. Plan of Azaila (after Cabré 1943, p. 52)

The Roman or classical temple sits at the head of the northern entrance to the citadel at the juncture with the major north-south street. Though it is not on the highest position in the town, it does command its site and looks out over an open area (pl. 4). It consists of three distinct spaces confined to two chambers (pl. 5). The small first room or pronaos is 1.20 m deep by 3.56 m wide. This area is separated from the main chamber or cella by two *anta* projections from the wall. The cella is 6.50 m deep by 4.10 m wide and consists of a large paved frontal area behind which is a platform raised up 0.81 m. The platform extends over the remaining rear portion of the chamber.

The structure does not stand alone; rather, it is incorporated into a group of buildings with which it shares common walls (pl. 6). The perimeter walls are of mortared rubble work up to a height of 1.23 m above the pavement of the cella.[169] The superstructure atop the rubble work was probably of mud brick.[170] The *antae,* which serve to distinguish the two spaces, are of mud brick. All the wall surfaces were stuccoed, and the stucco was decorated to resemble isodomic masonry. A portion of the plaster has survived in the inner chamber.[171] The interior platform was constructed of sandstone blocks for the top and front, which covered over a fill of smaller, unequally sized sandstone rubble pieces. The upper edge has a simple molding. The pavement in front of the platform, now largely lost, was a composition of lozenges against a background of swastikas executed in black and white tesserae. A second mosaic covered the pronaos floor with an imbricated scale pattern. The finding of a large piece of carbon in the doorway between the two rooms may indicate that the doorjambs were of wood.

In front of the pronaos stood two columns *in antis.* The sandstone bases of the two tori are still in place. Cabré suggested that the columns might have been of wood. Some fragments were found of triglyphs and metopes along with moldings for a gable and cornices—all worked in gypsum. The order could have been modified Doric or, more likely, Tuscan. The structure was raised up from the street level and had a single step of three sandstone blocks leading up to the first room.

To Cabré, the appearance and plan of the remains suggested a prostyle temple. The findings inside the building tend to support the identification. Still in situ was a sandstone altar, though without inscription. Most important were the fragmentary remains of three bronze statues: one of a man, one of a woman, and the third of a horse. The man's feet were found in

169. The walls have been rebuilt since the destruction of the civil war; Cabré 1940–1941, pp. 232–235.

170. Cabré (1940–1941) was not clear about the evidence for this.

171. Cabré 1925, fig. 14.

place on the podium of the inner chamber on axis with the structure. To the figure's left had stood a horse with its left foot raised. The woman's head had fallen onto the lower floor of the chamber, and its original position and form could not be determined. A stain on the platform to the right of the male statue's feet may indicate where the female statue once stood.[172]

There is general agreement that Azaila passed through three stages: an initial Hallstatt period,[173] an Iberian sequence,[174] and a final Romanizing epoch. What is not clear are the time spans for the specific periods and the end date for the final occupation. The temple dates from the period of Romanization and was probably destroyed either during the Sertorian campaigns[175] or during the civil war—perhaps in 49 B.C., at the time of the Battle of Ilerda.

The bronze fragments from the interior of the Roman temple have been studied in several papers. Cabré proposed that the male head was a portrait of Augustus, but Nony doubts the identification. Nony has noted that the female head resembles in the treatment of the hair a bronze Nike found at the nearby site of Fuentes del Ebro.[176] This particular hair treatment is not normally considered Augustan.[177] He has also noted that the two Azaila heads possess an Etruscan quality comparable to the head of the Arringatore in the use of incision for details and the compact rendering of the forms.[178] The male head could be a portrait type in the Hellenistic tradition of the late Republic. The two statues must have formed some type of heroic memorial, perhaps to an important local Roman leader accompanied by his horse and a figure of Nike.[179]

Just as the sculpture can be related to Republican Roman types, so too the temple structure is best understood in comparison with Italic forms. There is a cella approached through a pronaos that is clearly differentiated by the two *antae*. The pronaos had two frontal columns, making it technically a prostyle temple, and the columns may have been of wood, as were the earlier Etruscan temple superstructures. Such temples are known from Italy

172. Ibid., p. 312. The bronzes are now in the collection of the Museo Nacional de Arqueología in Madrid; see *Los bronces*, nos. 45–47.

173. Identified from finds in the necroplis at the site rather than the town proper; Beltrán 1964, p. 64.

174. The change from Hallstatt to Iberian in the Ebro Valley was first proposed by P. Bosch Gimpera during the early part of the twentieth century; Bosch Gimpera 1932; idem 1929. See also Beltrán 1986, p. 101; idem 1974.

175. Beltrán (1986, p. 102) favors the Sertorian campaigns. Beltrán (1984, p. 125) has argued for a major destruction of the native settlements in the Ebro region during the Sertorian rebellion, in either 76 B.C. or 72 B.C.

176. Beltrán 1957, p. 87. The identification of the figure as a Nike rather than a portrait of an unknown woman was made by Nony (1969, p. 23, no. 1).

177. García y Bellido 1948, pp. 446–449.

178. Nony 1969, p. 24. 179. Ibid., pp. 24–25.

and from the Greek world, but prior to the arrival of the Romans, and prior to the Azaila temple, they are not found on the Iberian Peninsula. Just as the heads are best understood as local creations with strong foreign influence, so too the temple at Azaila must be seen as a local response to outside stimuli.

Prostyle, distyle *in antis,* small-chamber temples developed in the Etruscan heartland and were later imported into Rome itself. The origin for the temple type on Italian soil is to be sought in Etruria and not Rome.[180] It is not the Etruscan form nor its Roman version that has been found at Azaila. There is no great pronaos preceding the cella. The temple commands its position, but it does not occupy a large plaza site. Rather, it is integrated into a block of buildings. There is a small podium, atop which sits the temple structure. Yet it has a rise of only one step. The columns are not to either side in place of the *antae* or prostyle but rather are placed in toward the center of the porch. They are not on axis with any other feature of the temple. In these important respects, the Azaila temple does not resemble its sources but instead reflects local modifications to the design.

Azaila was not a Roman town. It was a native settlement with a long history. Probably before the start of the first century B.C. it began to either Romanize itself or be Romanized. The finds of Campanian B ware certainly indicate that it was part of the expanding trade and commercial network that was under the control of Italian businessmen.[181] The particular hybrid quality of the temple and the sculptures suggests not that they are merely native copyings, but rather that something stronger was inspiring the choice of models. That both temple type and sculptural forms can be related to Etruscan prototypes points to a north Italic element at Azaila. This is distinct from the Greek or Hellenistic influence that must have flowed out of Emporiae into this region. The fact that the temple housed a type of sculptural ensemble without historical tradition in the region could suggest that it was built for a resident foreign population rather than to suit native needs. Moreover, that the temple occupied the prime position at the entrance into the town may well indicate that this population was of some significance.

The influences were subjected to native modifications. The sanctuary was forced into a preconceived urban pattern, not given its own space. The sanctuary was kept small and was not architecturally distinct from that which surrounded it. The Azaila temple was spatially arranged as a standard Greco-Etruscan temple with pronaos and cella. It possessed a columned front and a cult statue (?) base—all features absent from Iberian sacred architecture.

180. Vitruvius mentions the Temple of the Three Fortunes near the Colline Gate as being an example of a distyle *in antis* temple in Rome (3.2.2–3). D. S. Robertson, *Greek and Roman Architecture* (Cambridge, 1977), pp. 199–200; Boethius 1978, pp. 38–40.

181. Beltrán Lloris 1979, pp. 141–232.

But these were placed within a structure that blended comfortably into the urban fabric of the native town.

Botorrita

The temple at Azaila may represent the native attempt to respond to the growing cultural pressure of an outside force. The same may be true for the possible sanctuary at Botorrita in upper Aragon, but here the distance from the emerging centers of Roman power permitted the local forces to dominate.

Botorrita sits 20 km west of Zaragoza on the Río Huerva, a tributary of the Ebro. The existence of a native town known as Contrebia Belaisca has been acknowledged for some time because of coinage that was minted at the site. The identification of Botorrita with Contrebia Belaisca was first proposed by J. J. Pamplona in 1957.[182] The site had strategic merit in the pacification of the upper Ebro region. Ptolomy knew the region as the Celtiberian heartland, and the coinage finds in the Ebro Valley confirm such an identification.[183]

The remains occupy a hill site, Cabezo de las Minas, which has been excavated at two levels. The lower level contains a house and agricultural production center of Republican date.[184] The acropolis has been under investigation since 1980.[185] From the lower area has come an important example of Celtiberian epigraphy, a bronze plaque found in the patio.[186] Though the text cannot be fully interpreted, it may well be a sacred or judicial text of some type.[187] From the area of the major structure (fig. 20) on the top of the hill may have come a second inscription, this one in Latin, which identifies the site as Contrebia Belaisca. The inscription was found by clandestine digging somewhere in a fold on the east side of the hill.[188] The excavations have confirmed that the site was occupied from the third century B.C. until its destruction in 49 B.C. with the battle of Ilerda, though it may have continued to be occupied through the early Imperial period.[189]

There is evidence on the acropolis for a large stone structure existing during the late third or second century B.C., the remains of which are under the later adobe structure and form part of the substructure support for the later building.[190] The remains of the adobe construction survive to a height

182. Pamplona 1957, pp. 147–150.

183. Guadán 1980, pp. 138–151, 180–203.

184. Beltrán Martínez 1982, pp. 319–339.

185. Beltrán 1986, pp. 102–109; Beltrán Martínez 1985–1986, pp. 265–274; idem 1983, pp. 222–225; idem 1982, pp. 6–18; idem 1982c, pp. 95–108; *HA*, p. 260.

186. Beltrán Martínez and Tovar 1982. 187. Beltrán Martínez 1982a, p. 326.

188. Ibid., p. 339.

189. Beltrán 1986, p. 104; Beltrán Martínez 1985–1986, p. 265.

190. Beltrán 1986, p. 106. A fragment of Iberian black ware helps to date this first building phase; Beltrán Martínez 1982c, p. 97.

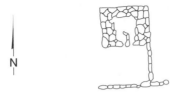

N

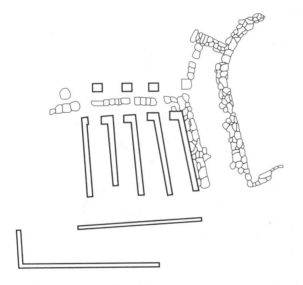

Figure 20. Plan
of the remains at
Botorrita (after
Beltrán Lloris
1990, fig. 59; and
Beltrán Martínez
1983, p. 223)

of 5 m at some points. The walls stand atop socles of roughly worked stone.
What has been unearthed is less a single edifice than a building complex
arranged around a central courtyard. The main structure[191] has five walls,
which stand atop socles of roughly worked stones, and form five corridors,
each with a single access that opens onto the central plaza. The width of the
corridors averages 2.30 m. The corridors have a preserved height of ca. 3 m.
The walls turn at right angles at the point at which they enter the courtyard,
thereby forming a frame for the doorway. The doorways have an approxi-
mate height of 1.90 m with widths varying from 1.20 to 1.55 m. Some car-
bonized wood has been found and could testify to the existence of wooden

191. Beltrán Martínez 1982b, p. 12.

jambs for the doors. The walls were stuccoed with mud. There is a possible back wall.[192]

Small holes about 3 m up on the corridor walls may have supported beams for a second story. Some of these holes are round, and some are triangular.[193] The evidence of fragments of fallen pavement further testifies to a second story.[194]

The lower floor comprised five narrow chambers with a uniform height of over 3 m. Each had a single means of access and of light that opened onto a kind of vestibule space defined by the three gypsum columns. The columns stood in front of the entrances to three of the chambers, but without any specific relationship to the chambers, the opening, the wall, or one another. The column drums stood atop stone plinths, and at both ends pilasters provided a visual closure to the lower facade, which had an irregular intercolumniation varying from 2 to 2.3 m. Two gypsum capitals may belong to the columns, but they lack intervening drums. They have diameters of only 0.50 m. If they do belong with the columns, then the diminution from lowest drum to capital was rapid or the columns were quite tall.[195]

In front of the colonnade opened a plaza in which stood a single-roomed rectangular structure. Its preservation is not as complete as the main adobe structure, nor is its relationship to this structure clear, though it is roughly on the north-south axis of the complex. There are remains of lines of stones that must have supported walls. A portion of the floor was paved with stone, which may have supported a built structure atop it.[196]

The plaza itself yielded several more fragments of architectural members: column shafts, capitals, bases, finely worked blocks of sandstone. Several of these fragments are marked with letters from Iberian script. These architectural elements are of sandstone. The columns are much finer in their treatment than the gypsum columns in front of the adobe structure's lower story. The bases are composed of a torus with wide flange that stands atop a square plinth. The shafts are set off from the capital by a necking treatment. The capitals are of two tori. One of the capitals has traces of red paint.[197] These architectural elements, especially the capitals, cannot be paralleled by any specific models. However, A. Beltrán Martínez has suggested that they have a general Greek quality, though they must be considered a freely adapted native version.[198]

The original position of these fragments can only be guessed at. Initially the excavator proposed a second-story colonnade for the adobe structure,

192. Beltrán Martínez 1983, p. 223.
193. Beltrán Martínez 1982b, p. 12; idem 1982, p. 96.
194. Beltrán 1986, p. 107. 195. Beltrán Martínez 1982b, p. 13.
196. Beltrán 1986, p. 107.
197. Beltrán Martínez 1982, pp. 98–100.
198. Ibid., p. 101.

octastyle perhaps over the lower portico.[199] More recently it has been suggested that they were part of a general colonnade for the plaza itself.[200] The elements must have been removed from their original position, identified with letters to help with the reconstruction, and then left and forgotten. This removal may have occurred after the destruction of the Sertorian period, when the building changed in function and the secondary walls divided up the vestibule.[201] There may have been plans to reconstruct the building that were never realized.

At its height during the late second century B.C., the complex formed a grand center on the acropolis of Cabezo de las Minas. The adobe structure was two-storied, perhaps with a second-story colonnade. Roughly on axis with it was a second, smaller structure with a built monument inside. G. Fatas Cabeza has proposed that the adobe structure was a public archive.[202] One of the items on display would have been the bronze plaque inscribed in Latin and recording the judgment of the senate of Contrebia in relation to a dispute about the water rights of other local native peoples. The Roman commander of the region, C. Valerius Flaccus, acknowledged and approved the decision.[203] Beltrán Martínez has suggested that it was the senate meeting house—the curia—and not just an archive. The lower story may have served as a kind of storeroom or adytum space, especially since the grander and finer colonnade may have been on the second story.[204] The complex may have had a religious structure opposite the curia. The small rectangular building is more or less on axis, and the possible structure built inside could have been an altar.[205]

The problem presented by the complex at Botorrita is one of source. How much of it is a native creation, how much a response, like the Azaila temple, to outside pressures of Romanization? The two-story curia proposed in Beltrán Martínez's reconstruction is unique. There is nothing like it on the Iberian Peninsula. The only structure that can possibly be related to it—the two-story building sometimes identified as the Curia of Julius Caesar, and represented on a coin type by Augustus (pl. 7)—postdates it.[206] Although two-story designs are not known for temples in the Classical world, they do have a history as a funerary building type from the fourth century B.C. on in the eastern Mediterranean and North Africa. Indeed, if they are the sources, then the builder went quite far afield to seek them out.

On the other hand, it may be easier to explain Botorrita as a completely

199. Ibid., p. 100. 200. Beltrán 1986, p. 106.

201. Beltrán Martínez 1985–1986, pp. 272–273.

202. Fatas Cabeza 1982, p. 10.

203. Beltrán Martínez and Tovar 1982, p. 23. For a treatment in English see J. S. Richardson, "The *Tabula contrebiensis,*" *JRS* 73 (1983), pp. 33–41.

204. Beltrán Martínez 1982, p. 100. 205. Beltrán 1986, p. 107.

206. Price and Trell 1977, pp. 71–74.

native structure that resembles Greek forms only by accident. Although the actual elevation cannot be paralleled by any building on the Iberian Peninsula, the plan is not so unusual. The arrangement of several long, narrow rooms alongside one another, each with its own entrance but all sharing a common rear wall, is not unlike the arrangement of houses in urban plans in some native towns or *oppida*. A number of the houses at Azaila display this same organization.[207] The same distribution marks the pattern in the native sites in lower Aragon.[208]

ANALYSIS

The Roman conquest of the Iberian Peninsula did not bring with it an immediate change in the architectural forms employed in temple building. The Republic lacked any strongly defined architectural sensibility that could be easily transported to a newly conquered region.

The process of Romanization was certainly faster in the south, where a strong Roman presence must have become established early in the lower Baetis (Guadalquivir) Valley. Latin steadily replaced the native tongue in the area. There was a school of Latin poets reciting in Corduba (Córdoba) by the mid–first century B.C. One of Caesar's more important friends was the wealthy Balbus, son of a native family of Gades.

The progress was slower moving up the Ebro Valley—with the first major Roman center, not established until the mid–first century, at Celsa. Nonetheless, the finds of Campanian ware throughout the region provide evidence of commercial penetration, and the entire area was militarily pacified during the Celtiberian Wars of the mid–second century.

Perhaps the depth of Republican Romanization over most of the south and east of the peninsula was best explained by García y Bellido, who noted that after the pacification of the Celtiberian regions in 133 B.C. there were no more native revolts on the Iberian Peninsula. For the next century the wars that erupted were all local responses to the larger social and civil unrest that rocked the late Republic. Those living on the peninsula took sides in these matters and paid for their choices, but they did not attempt to break with Rome. Even the Sertorian revolts were less manifestations of native unrest than attempts at Roman reform.[209]

One of the forces at work that helped transform parochial sensibilities into larger Roman concerns may have been the institution and promotion

207. Cabré 1929, plan II.
208. P. Bosch Gimpera, "Les investigacions de la cultura ibèrica al Baix Aragó," *AIEC* 7 (1921–1926), pp. 72–80.
209. A. García y Bellido, "Los auxiliares hispanos en los ejércitos romanos de ocupación (200–30 a. d. J. C.)," *Emerita* 31 (1963), pp. 213–226.

of Roman concepts of civic administration in native towns. Certainly this process is better evidenced in the Imperial period, but it may be safe to assume that it was to some degree in operation during the Republic, as shown by the bronze plaque with its Latin inscription at the native town of Contrebia Belaisca. Here the decree of the native senate is upheld by the local Roman official.[210] Beltrán Martínez has noted that the solution to the water problem follows native tradition rather than the Roman legal approach.[211]

The architecture reveals a similar mosaic pattern of Roman and native elements. At Italica, which represents the first phase of building following the conquest, a Punic presence may still be operating within a newly established Roman center. Emporiae may evidence the struggle of the older Hellenic population to retain its own identity even as the site also witnessed the birth of a new Roman architectural concept. Saguntum, Azaila, and Botorrita evince the varying degrees of native willingness to emulate and imitate a foreign cultural model. Several factors—including trade and settlement patterns—may have influenced the particular way in which the new Roman order was manifested architecturally.

Trade. The east coast of the peninsula was part of an extensive trade network that included the south coast of France, the west coast of Italy, and Sicily. Here the Greek communities had traditionally controlled trade until the advent of strong Roman power. Marseille, although the major Greek city in the north, may have ceased to produce objects for trade by the third century and perhaps instead sold her engineering skills. C. Goudineau has observed the paucity of goods that can be traced back to Marseille in the archaeological record of southern France. However, the similarities in the defensive systems used by both Greek and native communities throughout the region may testify to a single design source, which may have emerged at Marseille.[212]

Emporiae probably replaced Marseille as the major Greek producer of export items, at least if the ubiquitous gray ceramic ware found along the coast was manufactured in Emporiae.[213] However, the major new arrival was Italian wine transported along the coasts of France and Spain in dressel amphorae.[214] The shift in the importance of the players in this trade network and the replacement of Greek products with Italian drew Emporiae automatically into connection with Italy. The wine trade may well have been

210. For the decree see n. 203 supra. For civic administration see Curchin 1990.

211. Beltrán Martínez 1985–1986, p. 273.

212. Goudineau 1983, pp. 76–86.

213. H. Gallet de Santerre, *Ensérune: Les silos de la terrassa est,* in *Gallia* 39 suppl. (1980), pp. 97–102.

214. Tchernia 1983, pp. 87–104; Keay 1990, pp. 120–150.

under the control of Cosa, and we may see some evidence of this impact in the spread of the capitolium type of temple, which was well developed at Cosa and emulated at Saguntum.[215] The case of Emporiae presents a more complicated picture, for although the wine trade drew the city into connection with Cosa, it was also connected with the Campanian region. Perhaps the stronger Hellenic sense of the southern Italian region drew the Greeks of Emporiae. The evidence of the connections is clearly manifested in the finds of Campanian wares at Emporiae and in the exchange of architectural forms.[216]

Emporiae was founded from the start to serve as a location for the commercial penetration of the native interior,[217] and out of Emporiae the Campanian pottery and perhaps the Hellenistic architectural ideas flowed. The former can be followed; the latter seem to have ceased to have any impact in the region except at Emporiae itself. Prior to the Roman arrival in the coastal region, the presence of Greek influence can be seen in architectural developments in the native settlements such as Ullastret. When Emporiae ceased to control the access to trade, it also may have ceased to function as the distributor of recognizably Hellenic cultural influence.

It has been noted that during the second century B.C. the coastal native communities of Catalonia, those most immediately receptive to influence from Emporiae, began to abandon their defended *oppida* sites and relocate along the coast itself. These new communities such as that at Baetulo (Badalona) show evidence of adopting the urban plan of Roman Emporiae with its forum. Although Emporiae may have served as the model, it was as a Romanized city, not a Greek prototype, that it functioned. These new foundations were trying to capitalize on the coastal wine trade in which the Iberian Peninsula was becoming a participant.[218] The finds of Italian luxury goods testify to their connections with the coastal trade network.[219] Although Emporiae itself may have tried to neutralize the cultural impact of the Romanizing process happening in the upper city by its civic building program in the old Greek city, it had no effect. The Roman economic network succeeded in depriving the last gasp of Hellenizing on the peninsula

215. For Saguntum's role in the wine trade of the imperial period see Aranegui Gascó 1992a, pp. 35–43. The study of the harbor finds from Cosa has not revealed any linkage with southern Iberia, but there is evidence of trade connections with the Emporión region. Amphora handles stamped with the name of the Sestii family have been found. The Sestii were the major industrial and shipping family of Cosa during the second and first centuries B.C. Much of their interest concerned the shipping of cheap table wine from Cosa west into Gaul and Iberia; E. Will, "Roman Amphoras," in A. M. McCann, *The Roman Port and Fishery of Cosa: A Center of Ancient Trade* (Princeton, 1987), pp. 171–220, fig. IX-1, no. 4.

216. Mierse 1994, pp. 801–803.
217. Ruiz de Arbulo Bayona 1984, pp. 115–140.
218. Tchernia 1983, p. 103. 219. Keay 1990, pp. 134–150.

of any significant impact on the peninsula itself. Ironically, the forces that were to create the Roman forum complex may have been developed in the Campanian region and the Hellenistic East and first been brought together in an old Greek colonial outpost, but the Roman forum quickly lost all associations with Greek architecture.

The temple at Saguntum and the Temple of Serapis at Emporiae present an interesting example of the complicated forces at work in creating the architectural vocabulary of Roman Hispania. They are sophisticated buildings in terms of both the visible aspects of the structures and the modular systems used to design them. Sanmartí i Grego has suggested that the use of these complex systems of modules to unite the various parts of sacred structures, to create true *symmetria,* can be found developing on the Italian peninsula during the second century B.C. in architectural workshops, *officinae.*[220] Perhaps by the end of the second century one such *officina* was in operation on the east coast of the Iberian Peninsula, in the old Greek region that would have been most receptive to this more abstract type of thinking and designing.

Settlement Patterns. The Romans had little doubt that the Iberian territory that they conquered did have cities; certainly Phoenician foundations at Malaka, Sexi, Ibiza, and Gadir, as well as Greek Emporiae, must have constituted such to them. Strabo refers to them as *poleis.* The native settlements were perhaps a bit more problematic; Strabo most commonly calls them *komai.*[221] They did not necessarily possess the normal features that Romans associated with city life.

Studies of native settlement patterns in the Ebro River system,[222] the area around Jaén,[223] and the Guadalquivir Basin[224] through the Romanization of the Republican period reveal a system of primary, secondary, and even tertiary sites. These were arranged in a hierarchical format. Primary sites developed because of their strategic and geographical locations, which permitted them to effectively command the nearby territory. Secondary and tertiary sites developed in some type of association with the primary sites and were both visually under the watch of the primary site and near enough for easy physical communication. The control may also have been in some ways political and economic.

The development of new trade networks along the northeast coast

220. Sanmartí i Grego, Castanyer i Masoliver, and Tremoleda i Trilla 1990, p. 135.

221. Rouillard 1986, pp. 35–41; Jacob 1985, pp. 293–305.

222. Dupré 1985, pp. 281–291; Royo Guillén 1984, pp. 65–95; Ruiz Zapatero and Fernández Martínez 1984, pp. 43–63.

223. Crespo García and López Rozas 1984, pp. 207–222.

224. Ruiz Rodríguez and Molinos Molinos 1984, pp. 187–206.

spawned the formation of new Ibero-Roman towns in the region around Emporiae. At the same time, south of Barcelona the evidence is different. Here the Iberian coastal communities that had formed in the fourth and third centuries were pushed out of existence during the first century B.C. by the strength of the emerging Roman system of villa agriculture, which also must have been a feature of the trade network.[225]

The establishment of Roman or Romanized settlements along the coast, in the lower Baetis (Guadalquivir) River valley, and the lower Ebro River system must have permitted the spread of Romanization, and with it new architectural ideas, out into the native hinterland still only nominally under Roman control. The temple at Azaila may represent part of that spread. It is difficult to see the temple as a natural development of native traditions, since nothing in the architectural record for the region suggests that there existed any type of formal religious architecture. The temple must be seen as new construction, a hybrid, perhaps satisfying the needs of a local resident foreign population. A similar situation may have influenced the development of possible temples at Pollentia (Mallorca) and Valencia; however, these buildings are not architecturally well understood.[226]

It seems reasonable to assume that architectural developments in main settlements such as Azaila would have passed down into the small satellite communities in due time, and that by this process villages may have come to assume a more Roman appearance in the space of some years. Increased excavation of smaller, secondary sites may yet show evidence of the spread of new architectural forms and the creation of Romanized towns. However, the civil wars that so devastated much of the peninsula area during the first century B.C. interrupted the process, and under Augustus, the Romanization process and the formation of architecture on the peninsula become quite different.

Administration. The curia-temple complex at Contrebia Belaisca might well be seen as an example of the spread of architectural forms out from some central place, perhaps one of the new Ibero-Roman foundations along the coast. However, there is another force involved here that must be considered as well: the role of administration. If the identification of the complex as a curia-temple arrangement is correct, then the ensemble is best considered as a native response to the emerging forum complexes along the coast. Indeed, the Latin inscription suggests that the town was operating as one of the local centers. Here the native senate met, and it would seem that

225. Miret, Sanmartí, and Santacana 1986, pp. 79–88; idem 1984, pp. 173–186.

226. Bendala Galán 1989–1990, pp. 29–30. There seems to me too little surviving to work with for these possible temple structures. See also A. García y Bellido, "¿Un templo romano arcáico en Valencia?" *AEspA* 20 (1947), pp. 149–151.

there was a decision to frame that native administrative apparatus in something resembling the emerging formal architectural framework of Roman administration. It can only be assumed that the resulting structures were the product of native builders who freely adapted their classical models. Yet the forum complex is emulated, with the administrative building balancing the temple roughly along the longitudinal axis of the space. If the column fragments found deposited in the plaza and marked to facilitate a reconstruction belonged to a surrounding colonnade rather than to a second story for the adobe structure, then the complex resembles even more a forum with its defined spatial integrity.

CONCLUSION

The surviving remains of temples from the Republican period can be no more than a small sampling of what must have been standing at the end of the first century B.C. Caesar's references to fora in various towns may well indicate that the physical appearance of Republican Iberian settlements was quite similar to that of Republican settlements found in provincial Italy. However, the temples also testify to a variety of local responses to the activities of Romanization. With no official architectural policy to dictate and govern building programs, local builders—native and Italian—were free to adapt forms to suit specific needs. The Iberian Peninsula during the Republic produced centers for architectural and artistic experimentation along the east coast, in the Ebro Valley, and in the southern region.[227] The process of exploration began almost as soon as the annexation, with the building of the temple at Italica. It continued throughout the next two hundred years despite revolts, civil wars, economic exploitation, and political instability and reached its apogee with the great building campaigns at Emporiae, which parallel what was happening in the Greek area of Italy.[228] The next period witnessed the end of such tolerance of architectural diversity.

227. Ward-Perkins 1979, pp. 197–204; idem 1970, pp. 1–19; E. Gabba, "Considerazioni politiche ed economiche sullo sviluppo urbano in Italia nei secoli II e I a. C.," in *Hellenismus in Mittelitalien*, vol. 2, pp. 315–326; H. Galsterer, "Urbanisation und Municipalisation Italiens im 2. und 1. Jh. n. Chr.," in *Hellenismus in Mittelitalien*, vol. 2, pp. 327–340.

228. F. Zevi, "Monumenti e aspetti culturali di Ostia repubblicana," in *Hellenismus in Mittelitalien*, vol. 1, pp. 52–83; M. Torelli, "La situazione in Etruria," in *Hellenismus in Mittelitalien*, vol. 1, pp. 97–115; M. Verzar, "Archäologische Zeugnisse aus Umbrien," in *Hellenismus in Mittelitalien*, vol. 1, pp. 116–142; W. Johannowsky, "La situazione in Campania," in *Hellenismus in Mittelitalien*, vol. 1, pp. 267–299.

Augustan Homogenization

The Emperor Augustus altered the political and administrative courses of the Empire and recorded the changes in the *Res Gestae*. On the Iberian Peninsula the new order resulted in a unity ending the division between acculturated and unacculturated regions. Augustus created three provinces: Lusitania, Baetica, and Tarraconensis (Strabo 3.4.20; Pliny 3.6; Pomponius Mela 2.87). The most sophisticated area of Baetica he turned over to the senate for governing and concentrated his attentions on the largely native regions: he pacified the Cantabrian coast and established a strong Roman presence in the Ebro Valley at Caesaraugusta (Zaragoza) and in the west in Lusitania at Augusta Emerita (Mérida).

Where previously the Iberian region had been open for pure exploitation, Augustus ushered in a new era in which provinces came to be treated as functioning members of the Empire. Augustus himself spent time on the peninsula while directing the Cantabrian campaigns, and lived for two years (26–24 B.C.) at the east-coast port city of Tarraco (Tàrraco, Tarragona), which was to eclipse Carthago Nova (Cartagena) as the major coastal city.[1] His presence tied the peninsula into the larger political sphere of Rome's Mediterranean empire. While resident in the city, he received a delegation of leading citizens from the eastern Greek city of Mytilene.[2]

There seems little reason to doubt that under Augustus a policy was promulgated that stressed homogenization of the western provinces—both the

1. Tarraco and not Carthago Nova may have been the capital of Republican Citerior; for the most recent discussion see Ruiz de Arbulo 1992, pp. 115–130.

2. *IGR* 4.33; Bowersock 1965, p. 36 n. 3.

older Iberian territory and the newly acquired Gallic regions.[3] Just as Paul Zanker[4] has argued that Augustus sought to promote a revived sense of Roman pride among Romans and Italians through the careful manipulation of visual forms, a similar process was undertaken in the western provinces, initially sponsored by Agrippa, whose name appears in association with several monuments in Spain and France.[5]

The imposed visual unity promoted under Augustus integrated several features on the Iberian Peninsula. The standard Roman urban grid plan, developed during the late Republic, was employed for new foundations, cities built ex nihilo, and rebuilt older cities. The forum, perhaps first really used on the peninsula at Emporiae, became the organizing device for new cities and, as an imposed element, was inset into existing older urban units. Care was taken with the choice of temple plans and the selection of architectural decorative features.

MODIFIED PLANS

Emporiae

The Roman city of Emporiae (Emporión, Ampurias) had taken shape during the last century of Republican rule, but archaeological evidence shows clearly that the Republican forum and temple areas were modified during the Augustan period. Their function changed as the ideological framework of the Empire was redefined.

Architectural reforms began during the last decade of the first century B.C. The area of the civic forum to the south of the temple precinct was redesigned (fig. 21). The decumanus was no longer prominently allowed to enter the rectangle of the forum and divide the two sectors. The forum rectangle was effectively sealed off. As if to increase the distinction, a great gateway was constructed on the south side, providing a formal entranceway into the civic region.[6]

The function of the nonreligious area of the forum was further altered from its Republican stress on the commercial as indicated by the tabernae to a new formal concern with local civic administration. The doors of the tabernae of the south and west wings were walled up so that the portico in

3. The administration of these new and large divisions was aided by the creation of administrative centers, either by establishing a town ex nihilo or by promoting a particularly strategically placed native or Republican town. These then provided the nuclei for the formation of satellite communities through the region; see Audin 1985, pp. 61–82.

4. Zanker 1990.

5. Mierse 1990, pp. 308–333; Mar and Ruiz de Arbulo 1990, pp. 145–154.

6. Jiménez Salvador 1987a, p. 174.

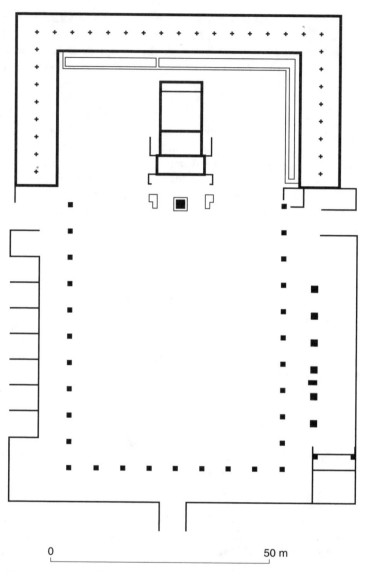

0 50 m

Figure 21. Plan of the restored Augustan forum at Emporiae
(after Aquilué Abadías et al. 1984, plate 5)

these areas did not provide access to anything behind the screen of columns (pl. 8). Instead, the doors to the tabernae opened out onto the street, and the commercial aspect of the forum was shifted away from the central plaza. A new area of tabernae was added behind the cryptoportico atop the remains of the old praesidium.[7] Pottery finds provide a date in the late first century B.C. for this change.[8]

There are some architectural fragments from this portico that permit its reconstruction. The columns stood atop foundations of *opus caementicium* and had an intercolumniation of 4.30 m. There was a slight widening of the intercolumniation to 4.90 m on the south-side portico.

The bases of the columns, of which seven fragments are preserved, consist of a squared plinth 1.15 m per side and 0.12 m in height. Atop this are the base and first drum of the column. A fillet with a *cyma reversa* profile serves to mark off the base from the column. The column shafts are plain and decrease from a diameter of 0.75 m at the bottom to 0.60 m at the top. There is some variation in the heights of the individual drums. The final drum is crowned with a sculpted astragal of pearls. A simple concave curve forms the fillet that joins the capital to the shaft.

The capitals are Ionic with four faces, the volutes placed on the diagonals. The entire piece is encircled by an Ionic cyma composed of a band of egg and dart separated from the volutes by a second plain band. The abacus is thick and composed of two parts separated by a central dividing line. The columns and capitals are of a local sandstone.[9]

The back walls of the portico were constructed of *opus certum*. Placed on line with the columns of the portico were pilasters. Both the pilasters and the walls were stuccoed with lime. No details of the moldings have survived, which may indicate that such details were done in stucco. The portico has a width of 5.50 m.

The central area of the forum was paved with large blocks of sandstone 0.80 m × 0.40 m × 0.40 m. The portico stood above the level of the paving about 0.75 m, and three steps gave access.

The most important alteration to the forum plaza was on the east side. Here the interior space of the portico and tabernae was expanded 5 m to the east (fig. 22), taking a portion of the adjoining kardo. The new arrangement for the back wall of the tabernae on the west and south sides was not followed on the east side. Instead, a second row of columns was added and a large, two-aisle space created that had no front wall but rather stood open onto the forum for most of its length. The back wall was the one that blocked out the street. It was of *opus incertum* (*quasi-reticulate*) construction for the base

7. *HA*, plate 111.
8. Aquilué Abadías et al. 1984, pp. 200, 204–205, 208–209.
9. Ibid., pp. 80–86.

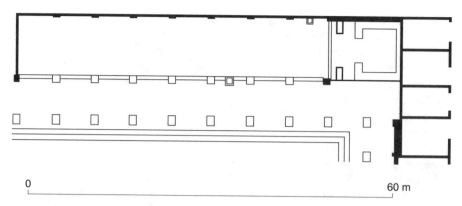

Figure 22. Plan of the basilica on the forum at Emporiae (after Aquilué Abadías et al. 1984, fig. 52)

and *opus certum* above. The interior colonnade continued the same rhythm of column spacing as the portico, and pilasters lined the back wall.

At the south end of the interior aisle was a chamber only as wide as the second aisle, suggesting that the front of the colonnade was intended to continue the line established by the portico, while the real chamber in this new construction begins at the second colonnade. This new interior space has a width of ca. 10 m. It is limited at the north end by a wall that separates it from the new east-west cross street. Its length is 60 m. The small room on the south is preceded by a vestibule, and is marked off with a rise of three steps. The walls are of *opus certum*, probably with a superstructure of tapis or adobe.

The interior of the great room has preserved some traces of wall paintings. Fine statue bases have also been found. The stratigraphic record from under the new extension to the east has revealed that the adaptation was made along with the other Augustan alterations to the forum.[10] The excavators have suggested that the same column and capital types used in the forum porticoes were employed here too.[11]

This was probably a new basilica added to the forum complex. It was placed in an unusual position—off to the side rather than opposite the temple. The presence of statue bases supports this identification. The small room to the south could have been the tribunal, a normal feature of a basilican hall, or the curia. The size of the *ordo decurionum* for Emporiae is unknown. *Ordines* on the Iberian Peninsula varied with memberships, running from fifty to upward of one hundred. If this room did house the curia, then the *ordo* was small.[12]

10. Ibid., pp. 87–88.
12. Curchin 1990, p. 23.

11. Ibid., pp. 97–98.

Temple Area. The temple precinct too was altered during this period. Along the north and east sides of the temenos an L-shaped channel, perhaps part of a nymphaeum, was placed directly against the walls of the crypto-portico. The walls of the channel are of small stones mortared together and faced on the interior with *opus signinum*.[13]

The temple itself was given two new lateral entrance stairways (fig. 23). In front of the podium were added two L-shaped wings that served to enclose a space directly in front of the podium. Placed before this new temple facade were two statue bases that flanked the older altar. For all this construction except the staircases and bases, the technique was in *opus caementicium* with large stones.

There is also evidence that on the west end of the temenos a wall was intended to enclose the south side of the precinct. Had the wall been completed, it would have sealed the sacred sector off from the main forum. The new lateral stairs for the temple and the bases placed in front are in *opus incertum* and probably date to just prior to the Augustan modifications, when *opus certum* became the favored technique.[14] Perhaps the new stairs would have provided access to the top of the temple podium once the old entrance had been rendered unusable by the wall placed across the south end of the precinct. The wall was not finished, and the unity of the two sectors of the forum was retained, but the front of the temple was altered substantially enough to warrant another means of entrance to the cella.

Saguntum

During the same decades that Emporiae was undergoing a modification to its forum, the native settlement at Saguntum witnessed an expansion of the region that surrounded the Republican temple of capitolium type. Strong terracing walls were constructed of mortared blocks of local dolomite limestone, some more than a meter thick, to the north and west of the temple area. The walls varied in height between 2 m and 17 m, and thick buttresses of roughly worked pillow stones supported the walls at vulnerable spots. The temple itself was set apart on a platform space.[15]

The Republican temple may have formed an element in a larger architectural ensemble, since there is evidence for other Republican-period structures in the area, underlying the later Augustan buildings.[16] However, the nature of this early complex is not apparent, though it does seem to have included a cistern to the southwest of the temple proper.[17] In the plan

13. Aquilué Abadías et al. 1984, pp. 98–99.
14. Ibid., p. 99.
15. Aranegui, Hernández, and López Piñol 1987, p. 73.
16. Aranegui Gascó 1992b, pp. 57–59, fig. 4.
17. Aranegui, Hernández, and López Piñol 1987, see plan fig. 7.

Figure 23. Partial reconstruction of temple and temenos portico of the forum at Emporiae during the Augustan period (after Aquilué Abadías et al. 1984, plate 15)

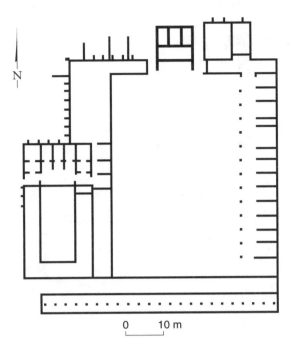

Figure 24. Restored plan of the Augustan forum at Saguntum (after Aranegui, Hernández, and López Piñol 1987, fig. 7)

N

0 10 m

for the Augustan forum, the Republican capitolium still plays a fundamental role (fig. 24). It anchors the north point of the longitudinal axis for the forum. The actual remains of the temple podium appear to be lower than the paving level of the forum plaza proper[18] and may indicate that the temple had ceased to have a ritual function.

To the east of the temple was a new structure (fig. 25) consisting of two unequal parallel rooms—the westerly 6.85 m × 9.85 m, the easterly 4.58 m × 8.50 m. The two rooms shared a common back wall that also served as part of the north terrace wall. Three large buttresses flank the exterior of the rear wall of the two-room building. Both chambers opened to the south and gave access to a raised porch three steps above the level of the forum plaza. There are traces of five columns along the porch, fragments of which show evidence of having been plastered. These columns sat atop Attic bases without plinths.[19]

The two-chambered building, constructed of small mortared blocks of dolomite limestone, was built over a substructure fill that formed the terrace

18. Ibid., p. 75.
19. Ibid., pp. 77–83; Bonneville 1985, p. 275.

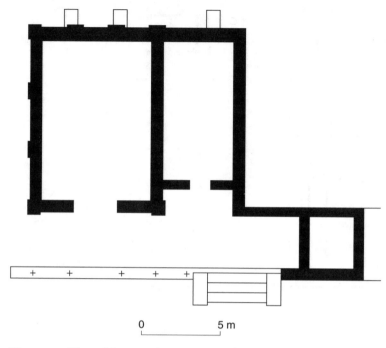

Figure 25. Plan of the new Augustan temple at Saguntum (after Pérez Igualada in Bonneville 1985, fig. 6A)

and contained, along with small and large stones, ceramic fragments of arentine ware that can be dated to a twenty-year span from 10 B.C. to A.D. 10.[20]

Clearly the building was important. Although not on the main longitudinal axis for the forum, it does sit just to one side, and should be seen as a major structure in a prime position. J.-N. Bonneville, using the epigraphic evidence from the building, has argued that it was a sacred structure dedicated to Apollo and Diana, whose worship can be documented at Saguntum with other epigraphic and literary testimonia.[21]

The building itself was probably slightly larger than the capitolium temple next to which it stood. Unlike the temple, it was structurally bonded to the tabernae that formed the east flank of the forum. The colonnade in front

20. Aranegui, Hernández, and López Piñol 1987, p. 77.

21. Bonneville 1985, pp. 255–275; for the long-standing association of Diana/Artemis with Saguntum see chap. 1 supra. Augustus made use of both gods in his official iconography. At the dedication of the Temple to Apollo on the Palatine in 28 B.C. a quadriga carried both Apollo and Diana to the ceremony; Zanker 1990, p. 85.

of the row of tabernae joined with the columns of the portico or porch of the building. Its design is unorthodox—without parallels elsewhere. It could have served as the city's curia. A sculpted head of Caligula found nearby might support such an attribution.[22] The raised porch that overlooked the forum proper would have provided a suitable speaker's platform.

The east and west sides of the forum were lined with colonnades, the substructure supporting system for which has been found in places. The west side had the more heavily buttressed terrace wall. The actual arrangement of tabernae on the west side is not quite clear, and the tabernae did not occupy the entire side but were limited in the northern half by a large hall. A row of tabernae behind the colonnade formed the east side. These units were ca. 7 m in length by ca. 4.20 m in width. Two openings in the exterior wall on the east side, each ca. 3.20 m, may have offered access to the forum through the row of tabernae. The portico columns had a diameter of ca. 0.475 m, with an intercolumniation of ca. 4.20 m. A recovered Tuscan capital may indicate the order of the colonnade.[23]

Though modern structures cover much of the south side of the forum, it has been possible to determine something of the original construction. Here stood a two-storied structure, the lower story of which served as a cistern fed by a drain from the west side of the forum. The cistern was 67.40 m long and, from exterior to exterior, ca. 7.60 m wide. A central row of piers of pillow blocks divided the interior into two vaulted aisles. The walls were covered in *opus signinum*. The roof of the cistern served as the floor for a second-story structure that closed off the south side of the forum and was raised slightly higher than the level of the tabernae. It was fronted by a colonnade that continued the pattern of the side colonnades.[24]

Behind the portico on the west side was a grand hall arranged on the longitudinal axis parallel to the longitudinal axis of the forum proper. It stood 40 m × 20 m. The hall rose atop a terrace platform strengthened with buttresses along the north and west sides. An earth fill formed the southern two-thirds of the platform, but at the north end there were several small cells, probably storage rooms, arranged around a central unit with two columns that supported two of the columns of the north row of the center peristyle in the hall above. There may have been connections between this area and the substructure of the west portico to the north, and there seems to have been access from the outside to these rooms via an opening in the west terrace wall.[25]

22. Aranegui, Hernández, and López Piñol 1987, p. 83 n. 26.
23. Ibid., pp. 83–86. 24. Ibid., pp. 86–90.
25. Ibid., pp. 90–92.

The hall above, which was the largest structure on the forum, must have been the basilica. It consisted of a central nave 10 m wide surrounded by an ambulatory 5 m in width. Four column bases, each with double tori but without plinth, have survived. The proposed reconstruction shows an interior peripteros with ten columns on the east and west sides and four on the north and south, an interaxial spacing of 3.30 m, and an estimated height for the central nave portion of 7 m. The ceramic evidence from the fill provides a late Augustan date for this building.[26]

The plaza of the forum is ca. 60 m × ca. 36.40 m, measuring from the edges of the porticoes. However, if the platforms at the north and south ends on which the porticoes stand are discounted, then the longitudinal distance is 54 m, which gives a proportional ratio of ca. 3:2.

An inscription laid into the plaza floor indicates that the forum was paid for by a member of the wealthy and important local Baebii clan, Cnaeus Baebius Geminus,[27] who is known from a second inscription on a statue base from the forum to have been a civic pontifex during the reign of Augustus.[28]

NEW FOUNDATIONS: GRID PLANS, FORA, AND TEMPLES

Augusta Emerita

Dio Cassius (53.26.1) supplies the reference for the foundation of the colony of Augusta Emerita (modern Mérida) in the newly formed province of Lusitania by veterans of the V Alandae and X Gemina legions. The date for the foundation is not certain, though 25 B.C. is generally accepted.[29] However, the final battles in the Cantabrian War were not fought until 19 B.C., and so a later date is also possible.

Augusta Emerita (fig. 26) was a medium-sized western city situated on the banks of the Río Guadiana (Anas). It was walled from its earliest phases, as is recorded on the early coin issues from the city, and as is clear from the discovery of the remains of a gate.[30] Since the city was conceived as a provincial capital, it must have grown to equal Tarraco. In the fourth century

26. Ibid., p. 92. 27. Alföldy 1977, pp. 12–13, 27.
28. Aranegui, Hernández, and López Piñol 1987, p. 96.
29. Sáenz de Buruaga 1976, p. 19; Almagro Basch 1976, pp. 189–190; idem 1965, p. 9; Beltrán Martínez 1976, p. 224. Canto (1990, pp. 289–298) has recently challenged this accepted view, arguing for an earlier initial foundation under Caesar.
30. Guadán 1980, nos. 975–976. Guadán dates these to the earliest issues, which he places between 25 and 23 B.C. Burnett, Amandry, and Ripollès (1992, no. 10) identify the gate as a camp gateway, not the city gate.

1. Amphitheater and theater complex
2. Probable municipal forum (Marble Forum)
3. Probable provincial forum with temple
4. So-called Temple of Diana
5. So-called Arch of Trajan
6. City gate

Figure 26. Schematic plan of Augusta Emerita

A.D., Ausonius referred to Emerita or Hispalis as the eleventh most important city in the world (the text is corrupt at this point).[31]

The Augustan City. The orthogonal plan for the new foundation of Augusta Emerita can be reconstructed partly from the location of cloacas.[32] The area enclosed by the earliest walls and the placement of the forum are

31. *Ordo urbium nobilium,* 11–14. 1–5:

> Cara mihi post has memorabere, nomen Hiberum,
> [Hispalis/Emerita], aequoreus quam praeterlabitur amnis,
> submittit cui tota suos Hispania fasces.
> Corduba non, non arce potens tibi Tarraco certat
> quaeque sinu pelagi iactat se Bracara dives.

The Hispalis or Emerita poses a problem. The *Codex Leideasis Vosianus* lat. 111 from the ninth century reads *Hispalis* whereas the fourteenth-century *Codex Parisinus* 8500 reads *Emerita.* For a full discussion see Sáenz de Buruaga 1976, p. 27.

32. Almagro Basch 1976, pp. 196–198. For the overall review of Augusta Emerita see Alvarez Martínez 1993, pp. 131–152.

debated subjects.[33] J. R. Mélida and J. A. Sáenz de Buruaga suggested that the original city was quite small, contained within the rectangle formed by the so-called Arch of Trajan on the west and the so-called Temple of Diana on the east.[34] Almagro has argued that the Arch of Trajan is in reality an Augustan construction, and that it probably never could have served as a gate since a cloaca passes beneath it.[35]

The Temple of Diana and the associated precinct sit at the crossing of the Kardo Maximus (modern Calle Calderón de la Barca and Calle Calvario) and the Decumanus Maximus (Calle Santa Eulalia). The Calle Santa Eulalia maintains the line established by the Roman bridge over the Río Guadiana. The streets defining the Kardo Maximus pass under the Arch of Trajan. By the tradition of Roman planning, the forum should be here at the crossing of the two, where there is a high point of land and where stand the remains of a temple.

The Kardo Maximus continued west toward the modern Plaza de Santiago and the Parador Nacional. Over the centuries several fragments of high-quality architectural decoration have been found in this area, several preserved today in the Parador Nacional. In the nineteenth century Laborde drew the remains for a large ruined building in the area. The remains of a substantial podium to a large structure, perhaps a temple, have been discovered. Almagro has proposed that here was the city's major forum, but not its only forum.[36] As a provincial capital, Augusta Emerita could have had two fora quite early, and possibly three at its height.[37]

The probability that the early city had two fora is strengthened by the distinctive character of the two regions. The main provincial forum would have held the city's most important temple. The forum would have been planned under Augustus and built during his tenure. Architectural members now in the Parador Nacional must come from the temple on this forum. It was in this same region of the city, the Calvario, that Laborde claimed to have seen the remains of the great building. In his publication *Voyage pittoresque et historique* (Paris, 1806), he reproduced his plans and reconstruction of the ruins, which he argued were those of a pseudo-dipteral temple to Jupiter.[38] The plan (fig. 27) shows a large structure set within a walled precinct and raised atop a podium with a single, frontal flight of

33. Alvarez Martínez 1985, pp. 39–40.

34. Sáenz de Buruaga 1976, p. 20; Mélida 1929, p. 6.

35. Almagro Basch 1976, p. 198; Macías Liáñez 1913, p. 49.

36. The excavations of the podium have not yet been published. Dr. Alvarez Martínez kindly allowed me to visit the ruins.

37. Alvarez Martínez 1985, pp. 40–42. For the discussion of three fora see Trillmich 1995, pp. 271–272.

38. Vol. 1, pt. 2, p. 111; in the 1813 version, p. 110, plate CXLV. Hauschild 1975, fig. 1.

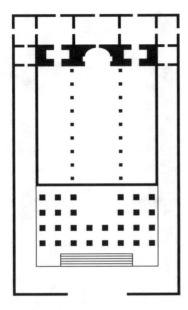

Figure 27.
Laborde's struc-
ture from Augusta
Emerita (after
Alvarez Martínez
1982, fig. 6)

stairs. The superstructure consists of a main room some 18 m by 21 m pre-
ceded by a deep, octastyle pronaos. The interior space is divided into three
naves by two rows of nine columns. The back wall contains a central apse
and to either side smaller, cruciform chambers. Both the side chambers and
the apse are joined with narrow passageways and further communicate via
other passages with a series of rooms that appear on the plan to be distinct
from the main structure, since they wrap around the exterior and seem to
open onto a lower precinct.

Laborde's drawings are all that exist of the purported building. Both J. M.
Alvarez Martínez and T. Hauschild disagree with Laborde's identification.
The apsidal rear wall and the tripartite division of the interior space are
troublesome features for a temple. Alvarez Martínez has argued that the
plan shows an imperial basilica. Hauschild has observed how much like an
early Christian basilica the plan appears,[39] a view shared by Bendala Galán.[40]
However, Laborde also supplied a drawing of a Corinthian capital that may
have come from the building and that can be stylistically dated to no later
than the second century A.D.,[41] too early for a Christian basilica.

39. Hauschild 1975, p. 110.
40. Bendala Galán 1989–1990, p. 21.
41. Hauschild 1975, p. 110; Barrera Antón 1984, no. 45.

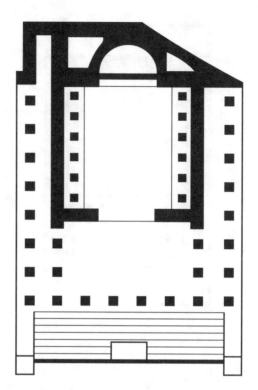

Figure 28. Plan
of the restored
Temple of Mars
Ultor in Rome
(after Coarelli
1981, p. 99)

While expressing doubts about the temple identification, Hauschild and
Alvarez Martínez have commented also on the similarities of the Laborde
design to that of the Temple of Mars Ultor (fig. 28). Augustus's temple to
Mars is also octastyle. The interior width and length are almost equal, as in
the Laborde structure. The pronaos is deep, and there are two freestanding
interior colonnades. These interior colonnades do not really divide the in-
terior space into naves, but they do form a major feature of the interior ar-
chitecture. The Temple to Mars and the Temple of Venus Genetrix (fig. 8),
finished by Augustus, have apsidal chambers.[42] Laborde could have drawn
the remains of a large temple with strong design associations with metro-
politan prototypes.

The forum in this west end of the ancient city, as Alvarez Martínez would
reconstruct it, consisted of a large basilican hall in the west end and a ma-

42. See Coarelli 1981, pp. 100–106; Wade Mead 1980, pp. 69–72; Nash 1961, pp. 401–
406.

jor temple, perhaps eventually dedicated to Concordia Augusti.[43] It was a provincial forum used for the cultic needs of all of Lusitania.[44] This forum space, as Bendala Galán makes perfectly clear, was some distance from the actual crossing of the Kardo Maximus and Decumanus Maximus, the expected position for a forum.[45]

In the eastern sector of the city, the opposite end from the provincial forum, are the remains of the so-called Temple of Diana and its associated precinct. It occupied the crossing of the Decumanus Maximus and Kardo Maximus. The temple opens to the east onto the modern Calle Sagasta, away from the Decumanus Maximus.[46]

Over the centuries, the Calle Sagasta and the nearby Calle Romero Leal have yielded architectural and sculptural materials: the remains of a nondescript building on the Calle Sagasta, a piece of *opus caementicium*, a bit of a Corinthian cornice, a bull's-head protome, and fragments of several togati statues, all from the workshop of one Gaius Ateius Aulus. The area also produced part of a statue and inscribed base dedicated to Agrippa.[47]

Sculptural finds made in 1980 in the area included architectural decoration of *clipei* with the heads of Jupiter Ammon and Medusa as well as caryatids modeled on the maidens of the Erechtheum. These were not the first fragments of this sculpted type to be found. Thirty-nine pieces had been recovered in 1934 at Pancaliente, a location a little north of the city on the Guadiana River.[48] The finding of similar items near the temple would seem to confirm that the whole assemblage must at one time have been used to decorate this area. These sculptural elements are in marble, and the limestone paving stones located near the temple and in a house on the Calle Romero Leal are of high quality, almost like marble. The marble of the architectural ornaments and the limestone flagstones must have provided a rich setting for the temple in this second forum precinct.[49] Alvarez Martínez

43. An inscription dated to the first century A.D., today in the base of the of the monument to Santa Eulalia, is dedicated to *concordia Augusti;* Alvarez Martínez 1982, p. 63. There is a coin reverse with the image of the altar with the legend PER(missu) and AVG(usti) in the field to the sides of the altar and PROVIDEN(tia) below. Other than the coin image, there is no other evidence for the altar; Gil Farrés 1946, pp. 209–248; Beltrán Martínez 1980, p. 138. See also Burnett, Amandry, and Ripollès 1992, no. 28. Fishwick (1987, pp. 180–183) has questioned the existence of the altar.

44. Alvarez Martínez 1982, p. 65.

45. Bendala Galán 1989–1990, p. 21.

46. Alvarez Martínez 1976, p. 48.

47. Ibid., p. 46; Almagro Basch 1965, p. 95; Alvarez Martínez 1982, pp. 55–56. Trillmich (1995, pp. 283–284) has argued that this base held a statue of the Republican hero Agrippa Menenius Lanatus, consul in 503 B.C., or the legendary king Agrippas of Alba Longa.

48. Floriani Squarciapino 1976, pp. 55–62.

49. Alvarez Martínez 1982, p. 57; idem 1976, p. 46. Trillmich (1995) has formally named this the Marble Forum.

has proposed a forum with a temple, a basilica decorated with the *clipei* and caryatids, and a bath building—standard features of an Imperial-period forum. This second forum was smaller and was probably built to suit the municipal needs of the city.

The hypothesis that Augusta Emerita had two fora gains support from other western provincial sites. It has been proposed that Caesaraugusta (Zaragoza) might have had a second forum, one that stood on the banks of the Río Ebro. Based on the evidence of some fragments of an inscription, A. Blanco Freijeiro has posited a shrine to Heracles at this forum, which might indicate that it served as a commercial forum.[50] Commercial fora are also known from several of the later Roman foundations in modern Switzerland.[51] These secondary fora probably did not follow any rules of format. They served commercial needs that would have dictated the arrangement and types of buildings. Interestingly, however, the secondary forum at Boutae, which is also the smaller forum, was placed on the crossing of the Kardo Maximus and Decumanus Maximus.

These other western sites provide parallel evidence for the double-forum plans, but the secondary fora are different. There is no evidence that either of the two fora at Augusta Emerita was a commercial rather than a ritual space. Indeed, if the present suggestions are correct, both fora were equipped with a temple, a basilica, and perhaps other formal structures. The inspiration for the design at Augusta Emerita is to be found in Rome, where Caesar and Augustus had begun to use multiple fora as elements in the remaking of the city.

The name "Temple of Diana" was first applied to the ruins in the second forum in the seventeenth century, without any justification.[52] The ruins have also been identified as a temple to Jupiter.[53] The superstructure remains stand atop a podium and describe a hexastyle, peripteral plan with eleven columns on the long sides (fig. 37). There are remains for eighteen of the original thirty columns. On the south short side there is evidence for a change in intercolumniation. The central intercolumniation is wider than the spaces to either side. There is also evidence for two interior columns on line with the second and fifth columns of the front colonnade and the second columns of the longitudinal colonnades. Some architectural fragments of possible platforms on either side of the front stairs have been found near the temple. These platforms would have widened the main facade by two or

50. Blanco Freijeiro 1976, pp. 99–104. For the cult of Hercules see García y Bellido 1963, pp. 70–81.

51. Broise 1976, pp. 602–629. A similar design pattern may have developed in the cities of the eastern Roman world during the first century A.D.; see S. Friesen, "Ephesus: Key to a Vision in Revelation," *BAR* 19:3 (May–June 1993), pp. 24–37.

52. Moreno de Vargas 1633. 53. Macías Liáñez 1913, p. 50.

three meters. This design conceit can be seen in the Temples of Divine Julius and Venus Genetrix in Rome and the Republican temple on the forum at Emporiae.[54] Little remains of the cella. Half columns may have decorated the exterior walls placed parallel with the sixth, eighth, and tenth columns of the peripteros. The construction techniques employed are conservative. The structure was built of local granite, plastered over. The columns are composed of drums rather than monolithic shafts. The Corinthian capitals are also composed of drums.[55]

In the nineteenth century E. Hübner proposed that the temple was dedicated to the Imperial Cult, based on the evidence of a silver plaque, an *anaglyphum*. This plaque shows a tetrastyle temple facade. Across the architrave is inscribed DIVO ANTONIO PIO AVG. Hübner associated the temple image with the Temple of Diana.[56] There is some specific archaeological evidence that links the remains of the Temple of Diana to the Imperial Cult. A second-century A.D. bronze statue of a bearded and togate older man found in the excavations could represent the *Genius Senatus*.[57] The head of a youth capped with a mass of curls, which was discovered in 1910, has been identified as the *Genius Augusti*.[58] The torso of a seated male figure, found in 1886 south of the temple proper at Calle Romero Leal no. 22, is now considered to be an image of the deified Emperor Augustus or Claudius.[59]

Though none of the finds definitively identifies the Temple of Diana as a temple to the Imperial Cult, R. Étienne had no doubts that the temple indeed had such a dedication. If it served as the officially sanctioned temple to the cult, then the dedication, if not the actual temple, could not date before the reign of Tiberius, when the cult was first promoted in the two Imperial provinces of Hispania.[60] And it must be in recognition of that official dedication that a coin image was created with a tetrastyle temple.[61] There is no overwhelming reason for assuming that the Temple of Diana was built to

54. Trillmich 1990b, pp. 307–308.

55. Alvarez Martínez 1976, pp. 49–50; Barrera Antón 1984, no. 1.

56. For the evidence of the Imperial Cult see *CIL* II, 471. One Publius Atennius Afer is also known to have been a *flamen Augusti;* Fita 1884, p. 104, no. 63. For the *anaglyphum* formerly in the Collection Gayangos and now in the Academia Real de la Historia in Madrid see Blanco Freijeiro 1982, pp. 28–30. For the practice of turning established temples into Imperial Cult temples during the reign of Antoninus Pius see Hanfmann and Mierse 1983, p. 120.

57. Alvarez Martínez 1975, pp. 141–151; idem 1971, pp. 257–261; Nogales Basarrate 1990, p. 107, catalog no. 79

58. Alvarez Martínez 1976, p. 51.

59. The fragment is in the Museo Arqueológico Provincial, Sevilla. Trillmich (1990b, p. 306) thinks that the statue is related to the seated Augustus from the Claudian group in the Old Forum at Leptis Magna. For Claudius see García y Bellido 1949, no. 206.

60. Étienne 1958, p. 203, n. 2.

61. Burnett, Amandry, and Ripollès 1992, no. 29.

serve that purpose. Indeed, the temple pictured on the coin, pictured on the *anaglyphum*, or associated with the cult referenced in the two inscriptions could just as likely be the other temple on the main forum in an abbreviated form.[62] However, W. Trillmich has suggested that the design feature of two platforms flanking the entrance staircase is found on early temples associated with the incipient Imperial Cult, and that it continues as a feature of these temples through the reign of the Emperor Trajan.[63] The Temple of Diana and its surrounding space could have been designed and even built early in the city's history, since they occupy the traditional location for a forum and temple, but the evidence from the site itself would indicate that the temple was serving as a second place for the Imperial Cult, perhaps a municipal cult by about the middle of the first century A.D.

The marble sculptural fragments found in Pancaliente and more recently on Calle Sagasta near the Temple of Diana clearly formed an ensemble that decorated the forum space of the Temple of Diana. The fragments of caryatids (pl. 9) reveal forms based loosely on the caryatids of the Erechtheum. They are not freestanding but are carved in high relief. The now headless maidens[64] wear a peplos with a wide *apoptygma*. The heads may have been veiled with a mantle that descended behind the shoulders. The dress is Greek style, and was not known this far west. There are also *clipei* in high relief that carry in the center of the disks the heads of either a bearded Jupiter Ammon (pl. 10) or a Medusa (pl. 11). Surrounding the Jupiter heads is a twisted rope followed by a tongue-and-dart pattern ending in fillet. The Medusa heads are surrounded by an egg-and-dart pattern that leads into the tongue-and-dart outer ring, and the whole is enclosed by a wreath of laurel or oak.[65]

The purely architectural fragments consist of parts of Corinthian pilaster capitals. There are also panel relief fragments decorated with bucrania and festoons with spiraling acanthus and rosette frame decorations. One panel has bucrania with a heavily laden fruit garland. An isolated relief is ornamented with a laurel tree.[66] The capitals probably belong with the *clipei* and the maidens in a single decorative program. Alvarez Martínez has suggested that they decorated a major civic-administrative structure at the south end of the forum or a portico.[67]

62. Alvarez Martínez 1985, p. 42.

63. Trillmich 1990b, p. 308, citing the Temple of Roma and Augustus on the Old Forum at Leptis Magna, Vespasian's temple at Pompeii, and the Temple of Victoria Parthica on the forum at Timgad.

64. Trillmich (1990b, p. 312) has identified a fragmentary head as belonging to the caryatids, and has offered a reconstruction.

65. Floriani Squarciapino 1976, pp. 56–58; García y Bellido 1949, nos. 417–418, 420–423, plates 297–300.

66. Floriani Squarciapino 1976, plates 23, 28, 29.

67. For a proposed restoration see drawing by R. Mesa in Trillmich 1995, fig. 2.

The remains come from no datable context. M. Floriani Squarciapino, considering the classicizing style of the work and the theme, has proposed a date of either the Julio-Claudian or Hadrianic, though she favors the former. The treatment of the peploi of the caryatids displays a certain dryness and rigidness often associated with neo-Attic work of the first century A.D.[68]

The prototype must be the decorative program of the Forum of Augustus in Rome.[69] There appears to have been the same division of caryatids, the pairing of the maidens into symmetrical reverses to frame the *clipei* as in the attic of the Forum of Augustus. The costumes betray the same horizontal divisions, with the thorax and legs separated by a wide inverted U-tuck of decorative pleats. At least two of the caryatids carry the older Erechtheum convention of falling parallel folds used to heighten the statuesque quality of the weight-bearing leg.[70]

On the other hand, there are important differences. The attic of the Forum of Augustus was decorated with alternating heads of Jupiter Ammon and barbarian princes, not Jupiter Ammon and Medusa.[71] The Augusta Emerita caryatids are in high relief rather than sculpted in the round. Their mantles form the background out of which the figures emerge. The pattern of folds displays a different concept of how to use the drapery, which falls from each figure distinctly, thus individualizing each caryatid. In a similar manner, the heads on the tondi are set off from the framing device by means of an interior decorative band rather than the imbricated leaf pattern of the Roman prototypes.

The pilaster capitals are typologically similar to one another but with subtle differences in the form of the leaves, the caulicus, and the bell itself. The capitals are cut in rich detail, with a strong quality of chiaroscuro that provides a sense of naturalism in the plasticity of the leaves. The distinctions among the capitals are probably no more than the evidence of different hands. The overall sameness outweighs the differences. Floriani Squarciapino considers the capitals to be closest to a group from Ostia that date from the mid–first century A.D. In both, the craftsmen made similar use of the drill to achieve the effects of chiaroscuro.[72]

The archaeological evidence suggests that by the middle of the first century A.D. the city of Augusta Emerita possessed a forum at the crossing of the Kardo Maximus and Decumanus Maximus that was dominated by a granite, hexastyle, peripteral temple and was decorated with a marble sculptural

68. Floriani Squarciapino 1982, p. 40–43; idem 1976, pp. 56 and 62. Trillmich (1995, p. 288; 1990, p. 309) has further supported the Claudian date.
69. Mierse 1990, p. 324; Floriani Squarciapino 1982, p. 40.
70. Floriani Squarciapino 1976, plate 24.
71. Vezàr 1977, pp. 34–35.
72. Barrera Antón 1984, nos. 10–18; Floriani Squarciapino 1976, p. 56.

program that had been freely adapted from that which decorated the Forum of Augustus at Rome.

When was the double-forum plan adopted at Augusta Emerita, and to what date should the temples be ascribed? In his initial discussion of the Temple of Diana, Alvarez Martínez stressed the difficulty of dating the structure on purely stylistic features of construction. The masons worked in the conservative technique of *opus quadratum.* It was also used for Augustus's own temple to Mars Ultor.[73] The local granite employed for the temple was employed for the first version of the theater, which we know was dedicated by Agrippa. The inscription over the entrance reads M. AGRIPPA L. F. COS III. TRIB. POT. III, honoring Agrippa in his third Tribuncia Potestas, and providing a date of 16 to 15 B.C. The theater columns also stand on Attic bases, like the columns on the temple. These shared features might allow for a date for the temple in the decade 20 to 10 B.C., placing it in the first period of construction for the city,[74] which would make the construction of the Temple of Diana contemporaneous with that of the temple at Saint-Bertrand.[75]

The iconography of the caryatids and *clipei* is Augustan. Not only are the sculptures reminiscent of those in the Forum of Augustus, but they contain specific references to the early Imperial iconography.[76] The Medusa-head panels are surrounded by laurel garlands, and there is the single relief of a laurel tree, a symbol of Apollo that recalled the emperor's association with the god at Actium.[77] In a similar way, the Apollonian associations were made at Saguntum. Moreover, they are elements in the iconographic programs found at several cities in the Roman West during the first century A.D. *Clipei* with the horned head of Jupiter Ammon also decorated a temple at Tarraco. Heads of Jupiter Ammon and Medusa ornamented a building on the forum at Aquilia and have also been found at Iader (Zora), Tergeste (Trieste), and

73. Ward-Perkins 1981, pp. 32–33, 43.

74. Trillmich 1990b, p. 304.

75. Older studies of the development of fora in the western provinces, using Sapéne 1966, and Sapéne's excavation reports issued from 1929 to 1938 by the Commission des Fouilles, always cite the forum-temple at Saint-Bertrand-de-Comminges as an example of early western civic forum building; see Grimal 1983, pp. 43–45, fig. 10B. However, the most recent published results of excavations undertaken since 1985 at the site reveal that the temple area and the so-called forum space to the west cannot be treated archaeologically as a single unit. There is evidence for a major fire in the decades A.D. 60–80 in the western sector that is not evidenced in the temple and the temenos region. Yet in plan it remains clear that the two units did form a forumlike area, which, if the temple were turned around, would resemble that at Emporiae; Guyon et al. 1991, p. 97.

76. There is material similar to that from Mérida that has been found in Flavian and Trajanic contexts at Ostia. F. Matz has argued that the Mérida material should also be considered later, perhaps Hadrianic in date; see Blázquez 1982, pp. 93–94.

77. Zanker 1990, p. 92; E. Strong, *Roman Sculpture* (London, 1907), p. 38, plate 7.

Pola. The dates for the pieces are uncertain, but work at Pola was ongoing during the reign of Augustus.[78] They also appear on the podium of the temple at the Gallic site of Aventicum, the old capital of the Biturigos.[79]

Augusta Emerita had other sculpture that in subject matter ties to works from the capital that formed part of the official propaganda of Augustus. The earliest version of the theater was decorated with marble relief panels. All the known fragments are decorated with arms: shields, helmets, swords. They probably ornamented some part of the peristyle outside the theater, perhaps a library.[80] One fragment contains bucrania with garlands, a theme also found on one of the Pancaliente reliefs. Sculptors for both may have been inspired to resurrect the Hellenistic subject matter because of the prototype of the Ara Pacis, though it may have had a more general function in Augustus's iconographic program and may have been associated with notions of renewed piety.[81] F. Salcedo Garcés has argued that Jupiter Ammon may have been invoked on one panel, a fragment of which contains a horn. Other panels with sea motifs—tritons and dolphins—could be references to the Battle of Actium.

The iconographic program for the theater reliefs cannot be determined with certainty. The style of execution provides a late Julio-Claudian date for the pieces, which makes them coeval with the production of caryatids and tondi around the Temple of Diana. The entire sculptural ensemble for both the theater and the Temple of Diana region, along with a recently published historical relief panel featuring Agrippa performing a sacrifice, which also stylistically dates to the mid–first century,[82] were perhaps installed as a group. The series of Julio-Claudian portraits that decorated a room in the peristyle of the theater[83] might likewise have been part of this program, which served to stress the Augustan associations with the city almost seventy-five years after its foundation. The Augustan iconographic program for the forum was actually put in place two generations after the Temple of Diana was built, during a period when the Augustan achievements along with Julio-Claudian successes were being praised in public.[84]

The Temple of Diana and the area in which it stood were designed and built in the late first century B.C. or early first century A.D. The area was redecorated in the middle of the first century A.D. along with the theater. The situation for the large, main forum region is different. The building that

78. Roberti 1985, pp. 40–49, esp. 42; Bertacchi 1980, p. 141; Ward-Perkins 1981, p. 178.
79. Vezàr 1977, p. 14, no. 22; pp. 24–31, figs. 7–8.
80. These have been studied as a group by Salcedo Garcés (1983, pp. 243–283).
81. Zanker 1990, p. 117. 82. Trillmich 1986, pp. 279–304.
83. There were heads of Augustus, Tiberius, Drusus, and Agrippina; *Museo Nacional de Arte Romano: Mérida* (Madrid, 1988), p. 13; Almagro Basch 1965, p. 92. Also see Floriani Squarciapino 1982, pp. 37–38; Strong 1982, p. 118.
84. Smith 1990, pp. 89–100; idem 1988, pp. 50–77; idem 1987, pp. 88–138.

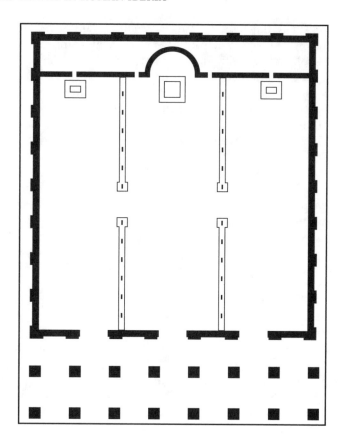

Figure 29. Restored plan of the capitolium temple at Narbonne (after Perret 1956, fig. 8)

Laborde drew was an element in the east provincial forum. The pronaos in the Laborde plan is a deep one, with four columns that end where the walls of the cella proper begin. In design, the Laborde structure appears midway between the temple at Vienne, a pseudo-peripteral *sine postico* with longitudinal colonnades that continue beyond the beginning of the cella but become pilasters against the solid wall at the last two intercolumniations, and the capitolium temple at Pompeii, which has almost the same exterior arrangement as the Laborde structure except that it is hexastyle rather than octastyle. Both these temples belong to late-Republican building campaigns.[85] At the city of Narbo (Narbonne) in southern Gaul a large octastyle temple, probably the capitolium, was built during the first century A.D. It too is pseudo-peripteral (fig. 29).[86] The Laborde structure would have been

85. Ward-Perkins 1981, pp. 158, 226–227.
86. Perret 1950, pp. 1–22; Solier, Janon, and Sabrié 1986, pp. 41–46.

perhaps about half the size of the Narbo temple and quite similar, with its octastyle facade that became pseudo-dipteral along the sides. Though nothing remains of the building Laborde drew, the plan could describe a temple very much in the tradition of late-Republican large temples that were built in Italy and the West at the end of the Republic and the start of the Empire. Moreover, if they are at all reflective of the reality of what he saw, the specific features in the Laborde drawing—the apsidal termination of the axis and the interior colonnades—seem to be paralleled by structural elements in the two temples dedicated by the Emperor Augustus in the capital, the Temple of Venus Genetrix and the Temple of Mars Ultor. The similarities between Laborde's basic structure and contemporaneous temples from the West and Italy suggest that Laborde did see the ruins of the main temple at Augusta Emerita and that it must have been a temple built early in the city's history.

The double-forum plan at Augusta Emerita must date from the city's inception or from soon thereafter. Emerita was an orthogonal plan from the beginning; there is no evidence for a change in the plan of the city. From the start the city was clearly designed with one major building complex: the theater and amphitheater. This sector was already under construction by 16 B.C. It seems only reasonable that the two forum complexes, being equally significant features, would have been elements in the original design. The standard gridiron plan was a conservative device already in use on the peninsula at Emporiae during the first century B.C., and was in contemporary use at Caesaraugusta[87] and in Gaul at Lugdunum (Lyon).

The so-called Arch of Trajan would seem to have also been an original feature, set up to mark the transition from one sector of the city to another. The arch has no association with Trajan. Its position on the Kardo Maximus allows it to function as a physical accent to the change in spaces, not unlike later arches in North African cities.[88] It is an austere monument, an extreme version of Augustus's arch at Susa, and though there is no evidence to supply a date, there is nothing that precludes an early date for its erection. I. A. Richmond long ago stressed that it could not have served as a city gate as Mélida had suggested.[89]

In many respects, the legacy left by Augustus to his Lusitanian capital is quite startling and certainly important for our understanding of the development of urban planning and sacred spaces in the West. The standard orthogonal plan was modified to allow for a double-forum pattern, one provincial, with a grand octastyle temple modeled on prototypes in the city of Rome, the other at the crossing of Kardo Maximus and Decumanus Maximus and serving municipal needs. Here a conservative, peristyle temple was

87. Beltrán Lloris 1990, pp. 196–202.
88. Alvarez Martínez 1982, p. 65. 89. Mélida 1929, no. 701.

built. Later the space was decorated with a sculptural program whose sub-
ject, theme, and style were borrowed from the capital. Augusta Emerita
shows better than any other site in the West the degree to which Imperial
policy during the reign of Augustus was to stress visual homogeneity through-
out the territories. However, the striking architectural element in the com-
position is the peripteral plan of the Temple of Diana, and before we can
consider its significance it is necessary to examine the other contemporary
building projects.

Barcino

In its earliest form, Barcino (Barcelona) was a modest city, a stop on the
Augustan coastal road.[90] There were Iberian habitation sites in the general
area, though the finds are rare within the confines of the present-day city.
As is usual elsewhere, the remains are most common on hilltops. Within the
city proper, the main hill of Montjuich, near the harbor on the southwest
boundary of the city, has yielded some Iberian remains: storage pits in the
zone nearest the harbor and also around the stadium.[91]

It is also Montjuich that has held the only evidence for a Roman Repub-
lican settlement: an exedra of four blocks.[92] This community may have
resided on the slopes, though it is not clear whether it was a Romanized na-
tive population or a resident foreign population. F. Pallarés has suggested
a late-Republican date, and A. Balil has argued for a date early in the first
century A.D.[93]

Under Augustus the coastal road was shifted. The Republican route from
the Pyrenees to Tarraco passed inland rather than coming through the city.[94]
The later *Antonine Itinerary* indicates that the road diverged to go along the
left bank of the Rubricatres at Praetorium and continued thus to Barcino.
This change was probably made during the Augustan redividing of the pen-
insula. The shifting of the road to include Barcino must have been made at
the time of the official foundation of the colony and may also mark the mo-
ment in time when the hillside community was abandoned in favor of the
flatlands better situated to exploit commercial land and sea traffic. During

90. This view is opposed by Granados (1987, pp. 61–68), who has argued that Barcino was
initially a military foundation. See also Pfanner (1990, pp. 69–71), who places the foundation
during the late Republic. Guitart Duran (1993, p. 68) is certain that the city was not estab-
lished until the last two decades of the first century B.C.

91. Balil 1964, p. 30, fig. 3.

92. A. Balil 1964, pp. 45–46; idem, "La exedra romana de Montjuich (Barcelona)," *Am-
purias* 27–28 (1955–1956), p. 273.

93. Pallarés 1970, pp. 45–46; Balil 1964, p. 72.

94. It entered the region at Aquae Voconiae (Caldas de Malavella), then continued to
Seterrae (Hostalrich), Praetorium (Llinas), and Arrago (Sabadell), and passed over the Rubi-
catres at Matorell, where the bridge still stands.

Augustus's reign several native settlements, or *oppida*, and hilltop towns moved from their defensive localities to nearby flatlands,[95] perhaps with official encouragement. There in a more vulnerable position some were permitted to enclose themselves with walls, which may have served as a statement of the new Roman order being developed under Augustus.[96]

Plan of the City. In the third century A.D. the citizens of Barcino raised walls to protect their city. They made use of cut stone from older structures and incorporated parts of an older curtain wall. The standing walls evidence two distinct building phases,[97] and a few remains have been identified as coming from the first phase,[98] the Augustan foundation period. The proposed first city would have been a rectangular area oriented parallel to the seaport. Vestiges of the older Roman city might still be found in the plazas of the cathedral and of Ramon Berenguer el Grande, and the streets of Subteniente Navarro and Tasineria. A double-arched gate, like the portal of Augustus at Nîmes, stood until 1862, when it was demolished, and may have been the early Augustan entrance gate in the south wall.[99]

A new Roman foundation without any older settlement on the site, Barcino should show a Roman grid plan (fig. 30). The crossing of the Kardo Maximus and Decumanus Maximus can be reconstructed by means of the gateways in the later walls. The Decumanus Maximus began at what is today the Plaça Nova, near the cathedral. This is the only late-Roman gate still standing. The Decumanus Maximus followed the present-day Carrer de Obispo Irurita, crossed the Plaça de Sant Jaume, and continued down the Carrer de la Ciutat to exit at the now demolished Gate of Regomis.[100]

The crossing of the Decumanus Maximus and Kardo Maximus served to divide the city into four distinct regions, which were further subdivided into insulae by means of lesser kardines and decumani. The four regions were not of equal size, since there was a shift in the trace of the Kardo Maximus

95. Drinkwater 1983, pp. 11–12, 131; DeWitt 1940, pp. 29–30. The older view that Saint-Bertrand-de-Comminges began as a hilltop settlement founded by Pompey as stated by Grimal (1983, pp. 244–246) has been challenged more recently; see Guyon et al. 1991, p. 92. Older Roman settlements were clearly replaced by new Augustan settlements, as when Celsa was surpassed by Caesaraugusta; see Beltrán Lloris 1985.

96. For the practice of enclosing Augustan cities with great walls see Mierse 1990b, pp. 358–360.

97. A. Durán y Santpere, "Vestigios de la Barcelona romana en la Plaza del Rey," *Ampurias* 5 (1943), p. 53.

98. Balil 1961, pp. 61–63; Pallarés 1970, p. 8.

99. Pallarés 1970, p. 85, fig. 15; Balil 1961, p. 86, fig. 60. For additional views of the gate see Victor Balaguer, *Las calles de Barcelona* (Barcelona, 1866). For the portal of Augustus at Nîmes see Varene 1981, pp. 22–35, esp. 30–31.

100. Pallarés 1970, pp. 85–86.

Figure 30. Outline of ancient Barcino against the alignment of modern streets of "Barrio Gótico" in Barcelona (after Balil 1964, fig. 70)

toward the west. The basic form of the insulae can be obtained from the exploration of the northern sector of the city, where one of the decumani, now the Calle de los Condes de Barcelona, crossed the Kardo Maximus as defined by the Carrer de la Llibreteria and the secondary kardo of the Carrer de la Pietat. The *intervallum* is defined by the broad alley, ca. 7.30 m wide, that separates the city walls from the actual constructions and perhaps marked the *pomerium*. The streets had a width of 3.5 m, and the regions, which measured ca. 50 m × 40 m, had an area of ca. 2000 m². The insulae were defined by six kardines and five decumani and were arranged in a pattern of seven by six. This held true for the two northern regions of the Roman city. In the two southern regions two of the insulae may have been divided in half by a small alleyway.[101] Pallarés's reconstruction of the Augustan city roughly approximates the later area of the late antique city (fig. 31). However, the city is rectangular and at several places would include territory outside the present trace of the third-century walls.

In a more recent study, J. Gimeno Pascual has argued that the Augustan city was larger than the city encompassed by the later walls (fig. 32). It was rectangular, measuring 405 m × 280 m. Gimeno Pascual agrees with the placements of the Kardo Maximus and the Decumanus Maximus, but he believes that the original line of the Kardo Maximus was straight and did not make the shift now made by the Carrer de Call. Two insulae in the southern regions show evidence of having been split in half by a small kardo that may have subdivided the entire row of insulae. Although such a change in plan would have destroyed the rhythm of the regular insulae that is the norm for an orthogonal plan, Gimeno Pascual points out that such deviations can be found in the first-century A.D. plans for the western cities of Nemausus (Nîmes), Arelate (Arles), and Forum Iulia (Frejus).[102]

The original Augustan foundation was made ex nihilo. The orthogonal plan was imposed and even shows evidence of having followed the same subtle distinctions of the first-century A.D. Gallic urban design, which suggests that it was preconceived and not adjusted for the site. Like the southern French plans, it must reflect an Augustan conception.

Forum. The crossing of the Kardo Maximus and the Decumanus Maximus would have occurred in the modern Plaça de Sant Jaume, a product of the nineteenth-century restructuring of the old Gothic quarter.[103] This section has also yielded epigraphic material of Roman date, mostly dedicatory

101. Gimeno Pascual 1983, p. 17.

102. Ibid., pp. 18–20.

103. For late-nineteenth-century changes to the Gothic quarter, see Guitart 1986, pp. 111–114.

Figure 31. Augustan Barcino according to Pallarés (after Pallarés 1970,
pianta de Barcellona roma)

Figure 32. Gimeno Pascual's reconstruction of Augustan Barcino (after Gimeno Pascual 1983, fig. 9)

inscriptions found on the west side of the plaza.[104] A headless statue of generic female type, probably of second-century manufacture, was found in 1875 on what would have been the northeast corner of the forum, the present-day vicinity of the Carrer del Paradís.[105]

The Carrer del Paradís also contains the remains of a peripteral temple that, like the one at Augusta Emerita, survived by being immured into a later structure.[106] Balil has argued that this was the forum temple, and that it stood in a space somewhat smaller than the present-day outline of the Plaça de Sant Jaume.[107]

Pallarés has proposed an interesting modification of the standard plan. She agrees that the modern plaza stands atop the old forum, but argues that the temple, rather than occupying the central position on the longitudinal axis, was in reality one of a pair of temples. A second sacred building stood parallel to the temple in the southeastern quadrant of the forum, perhaps where the Gothic church of Saints Justo and Pastor now stands. A column shaft, perhaps from the temple, was found here, and the church bears the same relationship to the city wall on the south side that the temple does on the north side. Considering that the church is dedicated to the city's two oldest saints, it might reflect the fact that one of the oldest churches in the city traditionally occupied the site, and in early Christian times, such churches often replaced pagan temples. The Kardo Maximus would have passed between the two temples. Pallarés has proposed a large forum area, equal to eight insulae. There may have been a basilica at the west end, where according to city archives an ancient structure was demolished in 1848.[108]

The date for the forum at Barcino, like that for the forum of the Temple of Diana at Augusta Emerita, depends on what date is assigned to the temple. There is no evidence for the cult of the temple at Barcino, but it is generally assumed to have housed the Imperial Cult.[109] As such, the cult could not have been established prior to Tiberius. There is good reason to assume that the layout of the orthogonal plan must date to Augustus, when the city was founded. There is no reason to assume that Barcino was conceived without a standard forum space, which would have included a temple. The forum and temple must date to the initial building program of the new

104. For a list of unfinished items left by L. Caecilius Optatus (*CIL* II, 4514) see Balil 1964, p. 74; for a dedication to L. Licinius Secundus by the authorities of nearby Ausa (*CIL* II, 4537) and other references to Licinius Secundus (*CIL* II, 4542–4547) see pp. 75 and 80; for Nummius Aemilianus Dexter, later proconsul of Asia (*CIL* II, 4512), see p. 83.

105. Balil 1964, pp. 138–139, no. 9, fig. 43.
106. Today the Centro de Excursionista de Catalunya.
107. Balil 1964, pp. 93–94. 108. Pallarés 1970, p. 95, no. 5.
109. Balil 1964, pp. 93–95.

city of Colonia Iulia Augusta Paterna Faventia Barcino.[110] The temple may indeed have been rededicated to the Divine Augustus later in the first century A.D., at the same time that the Temple of Diana may have received the same dedication.

Conimbriga

The city of Conimbriga (Condeixa-a-Velha), about 14 km from the modern city of Coimbra on the Portuguese coast, was one of the most westerly cities in the Roman world. Though a native Lusitanian settlement existed at the site throughout the years of Republican control, there is no evidence that there was any foreign, Roman impact on the architectural development. A truly Roman city did not appear until the time of Augustus.

The geology of Conimbriga is limestone, and the forum was placed on a large flat surface that is somewhat irregular. Though the forum was heavily remodeled under the Flavians, the location did not shift. The Augustan forum (fig. 33) was oriented north-south, ca. 50 m × 50 m. The temple at the north end extends beyond the rear perimeter and has no backing wall behind the cella's rear wall. The great temple precinct occupied the entire north side, and the primary entrance was from the south. At Augustan Conimbriga the new city did not totally displace the old. Behind the north side of the forum the old Iron Age native settlement continued to flourish. The forum was joined directly to the older community via the design element of the cryptoportico, which also served as the temple platform.[111]

The north side of the forum was dominated by the sacred structures. Along the west side ran tabernae with slight variations in dimensions, which opened directly onto the plaza.[112] A portico ca. 3.5 m wide fronted the tabernae. The walls in this area were composed of a lower foundation of large blocks. The wall proper was of smaller stones of diverse dimensions and irregular joins held in place with iron clamps.[113] The builders of the forum completely cleared the west side of all previous constructions and set the tabernae directly on the bedrock.

The east side of the forum is a single enclosed structure. There is no evidence of a portico in front of it. The building is composed of two chambers. The southern one is the largest, 33 m × 13.65 m, a ratio of 2.5:1 with an area of 45 m². The west wall is totally encompassed within a later building.

110. In the 1934 work on Catalan Roman architecture, the authors suggested a late Republican or early Imperial date for the temple on the basis of the treatment of the capitals; Puig i Cadafalch, Figuera, and Goday 1934, p. 99.

111. Alarcão and Étienne 1977, p. 28; *HA*, pp. 369–370.

112. Alarcão and Étienne 1977, p. 34.

113. Ibid.

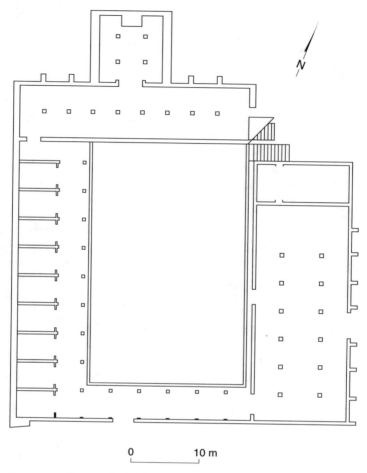

0 ————— 10 m

Figure 33. Restored plan of the Augustan forum at Conimbriga according to Alarcão and Étienne (after Alarcão 1993, p. 214)

It is impossible to speak with any certainty about the structure's forum facade. The east wall, the back wall, has evidence of eight buttresses on the exterior disposed equally on either side of the central door. These buttresses rest on the natural rock.

At the north end there is evidence for a wall that may have served to divide the large chamber and separate off a smaller space, 3.87 m deep. The large central space was divided into three naves by means of two colonnades each with six columns. The columns no longer exist, but the substructure of

one of the colonnades was incorporated into a later building phase. There are massive stone foundations 2 m × 2 m. This structure was a basilica of three naves. It had access from its lateral sides, with a tribunal at its north end. The presence of the massive stone foundations for the colonnades and the wall buttresses along the east wall suggests that the building was tall, probably two side aisles flanking a central nave with clerestory.[114]

The curia existed as a second chamber to the north. This room, 5.44 m × 13.65 m, shared a common wall with the basilica, but there is no evidence for direct communication between the two spaces. The entrance ought to have been off the forum, though it has not been found. The walls are of the same type of construction as the basilica: a socle of mortared stone above which rises a wall of smaller stones with large joints. The size of the chamber, 74.25 m², makes the Conimbriga curia among the smallest known.[115]

Cryptoportico and Temple Areas. The forum was dominated by its temple, of which only some portions of the substructure remain. The ground level on the north side of the forum falls away. In order for the temple to be the dominant structure, it had to be raised artificially by being placed atop a terrace.[116] This terrace then served as a cryptoportico. Interestingly, the cryptoportico provided the access from the higher level of the forum to the remaining portions of the Iron Age settlement. Two parts make up the cryptoportico and are arranged to form a T shape (fig. 34). The major wing, which forms the crossbar of the T, runs east-west and is 34.30 m × 7.80 m (internal dimensions). The smaller section—a crypt that underlies the temple itself—is 10.50 m long by 8.80 m wide and is oriented north-south.[117]

The cryptoportico was situated below the level of the forum and was entered on its western end by means of a staircase of seven steps that led down from the level of the north end of the tabernae. Enough of the west wall of the cryptoportico remains to determine construction methods. It was built of two lower rows of stones selected for similarity of shape but only roughly worked and bedded in concrete. The wall proper was raised atop this foundation. The subfoundation was of local stone. The placement of the walls atop concrete made with the local stone appears elsewhere at the site, and marks the Augustan building phase. Much of the Augustan cryptoportico was enclosed in the later Flavian building program. The north wall of the Augustan cryptoportico shows evidence of four exterior buttresses.

114. Ibid., pp. 35–36.
116. Alarcão and Étienne 1973, p. 373.
117. Ibid., p. 374.

115. Dalty 1977, pp. 343–344.

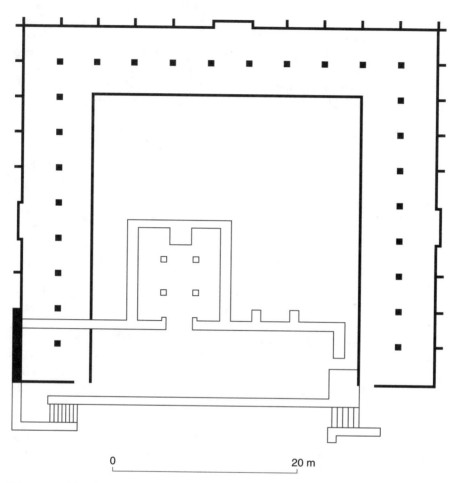

Figure 34. Drawing showing the superimposition of the cryptoporticoes at Conim-
briga (after Alarcão and Étienne 1973, p. 394, fig. 1)

The long chamber was divided in half lengthwise by a colonnade of quad-
rilateral piers, 0.80 m per side, made of local stone. They stand 3.50 m from
either the north or south walls. There were eight piers regularly placed to
create nine individual spaces. At the eastern end of the cryptoportico was a
door that gave direct access to the Iron Age settlement, which continued to
exist throughout the Augustan period.[118]

118. Alarcão and Étienne 1977, pp. 29–30; idem 1973, p. 375.

The north wall contained an opening at its center that led into a smaller space, a crypt, divided into three compartments by means of two rows of three piers each. The southernmost pair of piers was attached directly to the entranceway. The doorway and main passage were 2.75 m wide, and the two sides were each 2.25 m wide. There is some variation in the thickness of the walls. The east and west walls are 1.50 m thick, while the northern wall is thinner, 0.75–0.80 m. The construction technique used in the crypt differs from that employed for the main chamber. The large blocks are of local stone, but they are dressed on the long sides. They vary in dimensions and are held by mortar.[119] A masonry construction against the north wall (1.75 m × 2.50 m) may have served to support the statue base for a colossal cult statue in the temple proper. A colossal head of Augustus was found in the destruction level of the Flavian cryptoportico.[120]

The later Flavian rebuilding of the forum and temple has served to hide most of the Augustan temple remains. Étienne and J. de Alarcão have proposed a colonnade along the temple's south facade that would have stood atop the central piers of the cryptoportico. A single socle for a column base has been discovered. It is a beveled square, 1.05 m × 1.05 m. The central circle of the column base had a diameter of 1 m. The total height of the socle is 0.53 m, of which 0.04 m is the circle of the column base itself.[121] A Tuscan base with two tori measuring 0.23 m and a portion of shaft 0.37 m found among the later Flavian buildings might also belong to the Augustan temple.[122] A single fragment of a fluted column shaft with twenty-two flutes tops the base.[123]

The excavators have argued that the pronaos of the temple proper was set off from the colonnade by a pier on either side of the two columns. These two piers were slightly taller than the colonnade, which had a height of ca. 6.40 m. The temple itself has been restored with an elevation of 11.20 m (7.95 m for the base, column, and capital; 1.74 m for the architrave, frieze, and cornice; 1.51 m for the gable).[124] As reconstructed, the temple projects beyond the line of the colonnade with another four columns. The side and back walls are decorated with Corinthian pilasters, though it must be noted that none of the capitals for the Augustan temple have survived.

The temple sat atop a terrace constructed over the cryptoportico. It was a pseudo-peripteral, tetrastyle temple with two side wings that formed porticoes to either side of the pronaos. The normal design of the pronaos has

119. Alarcão and Étienne 1977, p. 30.
120. Ibid., pp. 237–238, plates xxxv, xxxvi, xxxviii.
121. Ibid., p. 32 n. 16, plate lxx, 2, 3.
122. Ibid., p. 33, plate xvi, 3. 123. Ibid., plate lxx, 1.
124. Ibid., p. 33. This is slightly smaller than the 13 m proposed in 1972; idem 1973, p. 380.

been slightly modified to allow for a breaking of the rhythm of the colonnade at the point where the wings and pronaos meet. At this juncture, the pier is substituted for the column, and the height of the colonnade is raised. The temple proper is further distinguished by the placement of a second row of four columns in front, which are not flanked by the columns of the side wings.

The pronaos was also set off from the two porticoes by the difference in the details in the columns. A small column base 0.95 m × 0.95 m with a central diameter of 0.90 m and a single torus with a total height of 0.33 m could have been used for the portico colonnades. The portico columns were probably smaller and shorter than those that formed the temple's facade. The temple columns may have been distinguished by their double tori.[125]

The total height of the portico should not have exceeded 9.50 m.[126] If a single fragment of molding does come from the entablature of the portico, as has been suggested, then the exterior decoration was a simple *cyma reversa* (piece 66 G IX 9).

Access to the temple platform was provided by a staircase to the east. This staircase, placed north of the curia, offered the only means of climbing to the terrace. The stairway began to the east, turned back to the west, and moved up to the platform. This major set of stairs is balanced on the west side by a staircase that descends from the forum proper into the cryptoportico.

Though it is difficult to separate the few Augustan fragments of the forum from the later Flavian structures, the excavators remain of the opinion that the initial construction phase for the forum and the first temple date to late in the reign of Augustus. Datable finds consist of Italian sigillate of Augustan and Tiberian periods.[127] The north side of the forum with its cryptoportico is particularly problematic to read because of the Flavian overbuilding. A. Roth-Congès has challenged the excavators' interpretation, arguing that the Augustan forum did not have a temple set atop a cryptoportico on its north side.[128] She has instead suggested that the north side was dominated by a basilican hall of two-nave type that was built atop the cryptoportico and that included a small secondary chamber. This secondary chamber was placed on the axis of the long sides and formed a small sanctuary within the basilica itself, an *aedes Augusti*. The two sides of the forum were lined with tabernae, and there was no basilica on the east side.

Roth-Congès's reconstruction would offer a far less impressive complex than that proposed by the excavators. Interestingly, it would have resembled somewhat the Augustan forum at Glanum (fig. 36), but would be markedly

125. Alarcão and Étienne 1977, p. 33 n. 20, plate xiii, 3.
126. Alarcão and Étienne 1973, p. 350.
127. Alarcão and Étienne 1977, p. 183.
128. Roth-Congès 1987b, pp. 711–751.

different from anything yet found on the peninsula. It would actually compare more to the later fora that developed across the Strait of Gibraltar in Tingitane, which may themselves have origins in military architectural design.[129] Thought provoking as the Roth-Congès hypothesis is, it seems hard to accept that a settlement like Conimbriga, in which a new complex was clearly imposed over the existing native settlement, would have witnessed the development of a forum model quite so different from that being used throughout the remainder of the peninsula. The Glanum model is a distinct feature of a town that has almost a century of developmental history, and seems to belong specifically to it. The fora without temple, which do indeed appear in the West, belong to a later period, and there is little reason to believe that the first experiment with this design feature occurred in this far western outpost.

ANALYSIS

For the moment, it seems useless to try to argue for the emergence of a specifically provincial Iberian style of architectural treatment during the Augustan period. It is more profitable to consider how the influences of (1) urban planning, (2) stylistic options, (3) elite patronage, and (4) Imperial iconography compromised the larger Augustan concern of creating visual homogeneity.

Urban Planning

Though orthogonal plans can be posited for all the Augustan foundations and probably most of the Republican settlements on the peninsula, only that for Barcino has been studied sufficiently to allow for some general observations about the nature of early Roman Imperial urban planning on the peninsula. There are several hypotheses about the layout of the ancient city, all of which agree that the later walls in some way maintain aspects of the Augustan perimeter[130] and that the forum occupied the central position and was surrounded by roughly equal-sized insulae that extended farthest to the south, toward the harbor area.[131] Only Gimeno Pascual has argued for a distinct shift in the pattern to smaller insulae in the southern region. The most recent excavations of the forum area have revealed that the paving stones were in place during the Augustan period.[132]

129. Euzennat and Hallier 1986, pp. 73–103.

130. For discussion of the later walls see Richmond 1931, pp. 86–100.

131. Durán i Sanpere (1957) argued that the forum was nearer to the Gothic cathedral rather than under the Plaça de Sant Jaume.

132. Granados 1987, fig. 4.

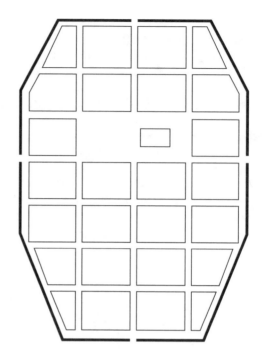

Figure 35.
Augustan Bar-
cino according to
Granados (after
Granados 1987,
p. 67, fig. 4)

Easy application of the orthogonal plan allowed it to spread rapidly throughout the peninsula during the later first century B.C. There is no evidence on the peninsula of any Roman accommodation to native religious sensibilities such as C. Walthew has argued took place in northern Gaul under Augustus with the promotion of rural sanctuaries.[133] The decision to promote Romanization in these areas may have been spurred on, as it has been argued was the case elsewhere in Gaul, by a desire to dramatically devalue the pre-Roman culture. Such gestures were even more forceful when a foundation was made ex nihilo as at Augusta Emerita or Barcino.[134]

The insulae at Barcino were large and roughly square, measuring on average 50 to 60 m per side. The forum itself was composed of modular units of insulae, two in J. O. Granados's plan (fig. 35), eight in Pallarés's, and four in Gimeno Pascual's. A similar pattern has been projected for the upper city at Emporiae, on admittedly limited archaeological evidence. Here the grid plan is Republican and must be dated to the same period as the initial forum itself. The insulae were probably again square and large, averaging

133. Walthew 1982, pp. 228–230.
134. Bedon 1985, p. 87.

60 to 70 m per side, and the forum space occupies one and one-half insulae units. Whereas the orthogonal plan itself was derived from Greek models and was employed in Greek town sites in southern Italy as early as the fourth century B.C., though not at the Greek sites on the Iberian coast, the Greek insulae tend to be long and narrow. It was the long, narrow insulae that Roman planners first adopted during the mid-Republic. The large, square insulae were first employed in the first century B.C. for the Roman colonies in northern Italy and may have accompanied a change in centuriation.[135] It is out of this late-Republican development that the insulae plans for Emporiae and Barcino came. The plan used at Emporiae may have been contemporary with those for the north Italian settlements. The other Republican plans as well as the Augustan plans on the peninsula must have continued to employ this same type of large, square insulae.[136]

There are German and Gallic sites with insulae patterns that are comparable in date to the peninsular towns: Augusta Raurica (Augst) and Augusta Treverorum (Trier); and Auraso (Orange) and Arlete (Arles).[137] These sites reveal patterns similar to those at Barcino and Emporiae. If it is correct to associate the walls and the plan together at Orange, then a date of 10 B.C. for the orthogonal arrangement can be proposed, somewhat later than the dating for Augusta Emerita or Barcino. The foundation for Arles is dated to 46 B.C., when a veterans' colony was established, but the date for the town's design is usually given as Augustan.[138] At present there is nothing known in southern France that can be considered contemporaneous with the development of Emporiae, though it has been suggested that the grid networks, which become clearer in the archaeological record for the later first century B.C. because they survive from the traces of stone structures built along them, indeed may have been present already early in the reign of Augustus but with wooden structures.[139] Certainly the large, square insula plan may have entered Gaul via Italy during the Augustan and Julio-Claudian period, but it is equally reasonable to assume that it entered from the Iberian Peninsula, where Emporiae may have provided the model for the peninsular and even Gallic and German developments.

Granados has suggested that the actual agents responsible for implanting the Roman style in the West included Romanized natives, long-resident Roman families who might have supported an architectural workshop such

135. Boersma 1982, pp. 38–39.

136. Beltrán's plan "Zaragoza romana" (1976a, opposite p. 49) shows a restored scheme for the insulae at Caesaraugusta, based on selective excavations within the confines of the modern city of Zaragoza, that has units with an average width of 50 m. However, he does not adhere to a strictly repeated pattern of squares.

137. Boersma 1982, pp. 43–45; Walthew 1982, p. 231; Magdinier and Thollard 1987, p. 89, fig. 15; Rouquette 1987, p. 98, fig. 1.

138. Rouquette 1987, p. 102. 139. Mertens 1985, p. 262.

as may have built the Republican temples at Emporiae and Saguntum,[140] and military engineers, who were the builders of roads, bridges, and aqueducts in areas only recently come under Roman control.[141] Workmen in some cases seem to have come from Italy, specifically Campania in the case of Caesaraugusta.[142] For Gaul, P. Pinon has proposed that there was a programmatic set of five orthogonal urban-plan schemes, which had been developed in Italy, available to would-be planners.[143] Such seems a reasonable enough explanation of the homogeneity of Augustan and early Imperial urbanization in the West, though the sources for the schemes may indeed have included the early experiments on the Iberian Peninsula as well as in Italy. The use of a standardized set of variations would also account for the appearance of certain features somewhat irregularly and at distant intervals, such as the two-forum plan that was in use at Augusta Emerita, perhaps at Caesaraugusta, and for several of the towns along Lake Geneva. This may represent a standard, albeit rarely employed plan type, called for at sites that combined administrative and commercial activities.

It needs to be noted that the Iberian Peninsula, like Gaul, actually witnessed two distinct forces that influenced urbanization. Along the south and east coasts the economic concerns, coupled with a long tradition of urban settlement, afforded a perfect environment for the spread of specifically Roman cities. Emporiae and Saguntum perhaps represent the norm, which may eventually be further evidenced with excavations along the coasts. Older cities stimulated by Augustus's administrative and economic reforms may have witnessed new private investment in public munificence, which took the form of fora, temples, baths, theaters, amphitheaters, and basilican halls. It would seem appropriate that the spread of the concept of the *cursus honorum* among the elite of both native and Italian stock throughout the peninsula should have resulted in the building of appropriate settings.[144] On the other hand, Augusta Emerita and Conimbriga offer examples of urbanization with military concerns. The towns could house veterans or legions, or could at least be part of the pacification program for an area. These settlements might best be seen as model cities, offering examples of the new lifestyle being introduced by the Roman presence. The walls of cities like Augusta Emerita with their grand and imposing gates may well have served both to protect the new foundations and to highlight the physical difference between the old and the new orders.[145]

140. See chap. 1 supra.

141. Granados 1987, pp. 61–72. For the question of Roman military engineers involved in establishing cities see MacMullen 1959, pp. 214–217.

142. Richmond 1931, pp. 86–100.

143. Pinon 1985, p. 191. 144. Curchin 1990, pp. 6–8.

145. Mierse 1990b, pp. 358–360.

Fora. Under Caesar and Augustus, *oppida* began to relocate from high defensive positions onto flatlands, usually with better access to road systems or river courses or coastal facilities.[146] For these new towns the forum unit offered a ready-made element to be employed, around which the sectors of the city could be laid out. The Catalan coastal communities could well have started the process, taking as their model the newly built forum at Emporiae but now using it as the heart of the town. These communities would have offered the southern Gallic towns that emerged the formal pattern for the new urban life, or at least caused them to assume a more substantial appearance in the wake of Caesar's conquest.[147] Emporiae and the other Catalan towns provided clear examples of how these new building types and new civic spaces were to be employed.

Saguntum was not a new foundation but an old, important Iberian town. The new Augustan-period forum was built in the upper town, the region of the old Iberian settlement, and incorporated the Republican-period temple. It is certainly possible that with the economic changes brought about under Augustus the town began to experience new prosperity but chose not to relocate. The forum at Saguntum resembles that at Emporiae, but not the Republican design so much as the Augustan remodeled forum. Like the later forum at Emporiae, the Saguntum design includes a basilican hall as a fundamental part. But the Saguntum pattern is different: a second, smaller sanctuary is integrated into the forum portico by the use of a continuous colonnade linking the porch of the sanctuary with the side colonnade.

In reality, there are two separate forum designs that begin to emerge on the Iberian Peninsula during the Augustan period. They share in common key elements: a temple, basilican hall, and large open court space. The Augustan forum at Emporiae represents one type, which probably was paralleled by the fora at Augusta Emerita, Barcino, and Ebora (Évora) as well as the fora in the Catalan coastal towns. In each case the temple is a free-standing element probably surrounded by a colonnade. Those at Emporiae and Ebora have been found. This was the prototype for the so-called double-forum or compound-forum pattern that was to become the standard for Gaul, where it may also have been influenced by traditional rural sanctuary designs.[148]

The forum at Saguntum and that at Conimbriga demonstrate the second approach, one in which the temple element, at Saguntum the secondary sanctuary and at Conimbriga the main temple, is physically joined into the bigger design and loses its autonomy to become just a feature in the larger

146. Mierse 1990a, p. 310; Drinkwater 1983, p. 131; DeWitt 1940, pp. 19–20; Keay 1990, pp. 120–150.

147. Genty et al. 1979, pp. 111–131.

148. Walthew 1982, pp. 229–230.

composition. The source for this treatment may be traced back to Hellenistic design practices, particularly in Asia Minor, such as seen at the sanctuary at Megalopolis.[149] It may have again been via Emporiae that an eastern Hellenistic design conceit could have entered the peninsula. The mid-first-century B.C. Sanctuary of Serapis in the lower city, though not physically integrating all the parts like the forum at Saguntum, does exhibit a certain east Greek Hellenistic sensibility in the arrangement of the parts. The temple opens onto a long, narrow precinct, in a pattern reminiscent of the Sanctuary of Demeter at Pergamon.[150] A more immediate inspiration for both the Serapis and the Saguntum designs—one that included the integrated sanctuary and the long, narrow precinct—was the Forum of Caesar, which P. von Blanckenhagen has shown was itself strongly influenced by Hellenistic designs.[151]

At Saguntum, the secondary temple incorporated into the forum is not architecturally significant, though it may well have had major cultic and political importance. However, the contemporary design for the forum at Conimbriga, as reconstructed by Étienne and Alarcão, clearly shows the integration of the prime cultic building into a larger pattern, and moreover demonstrates how a metropolitan model with its Hellenistic underpinnings could be scaled down and accommodated to suit the needs of a small provincial and insignificant town. The Conimbriga forum resembles that at Saguntum—it was planned with a temple on axis and a basilican hall to the side—but the construction favors the main and only temple, which was raised atop a cryptoportico and was brought into the design by interlocking the temple's porch colonnade with the plaza's peristyle colonnade. Thus, unlike at Saguntum, where only the secondary temple is joined to the whole composition, at Conimbriga the main temple becomes but an element in the larger design. Both Saguntum and Conimbriga represent a distinctly different concept of a forum space from that of the Emporiae type. At Saguntum and Conimbriga there is a sense of some direct response to either Hellenistic or metropolitan models.

It may be worth considering that the two designs represent in some manner local responses rather than imposed designs. The forum design—as seen at Emporiae—provided the necessary space for the conducting of a Roman style of life, and easily could be laid out, especially since it worked within the modular units of the insula system. Saguntum and Conimbriga provide a glimpse of a different response. These two fora operated in exactly the same way and provided the same features, but they exhibit a dif-

149. Russell 1968, p. 322. 150. Radt 1988, pp. 206–214.
151. Von Blanckenhagen 1954, p. 24. See also Gjerstad 1944, pp. 40–72.
For the newest investigation of the Forum of Caesar see Ulrich 1993, pp. 49–80.

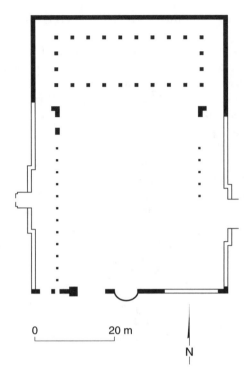

Figure 36.
Augustan forum
at Glanum (after
Todd 1985,
fig. 44)

0 20 m

N

ferent stylistic concept. At Saguntum, an old and established town, the de-
sign choice may reflect the local desire to break with the physical pattern
emerging elsewhere along the coast. Conimbriga is more difficult to assess.
There was an older native town, but not one of any importance. Yet it is per-
haps worth noting that the forum does provide access from the plaza to the
older section of the town, which may indicate that some local force was ac-
tive in directing the process of Romanization.

Although there may well have been two different design paths being fol-
lowed for fora on the Iberian Peninsula, there is at least one feature that ap-
pears to join these early fora together: the placement of the basilica to one
side rather than opposite the temple. In this design aspect, the Iberian fora
break with the pattern that emerges elsewhere in the West, where the temple
is most commonly balanced along the axis by the basilica. The importance
of the basilica within the forum design in the West, outside of the Iberian
Peninsula, is already perhaps evidenced at Glanum, where the temple is to-
tally displaced by the basilica (fig. 36). This stress on the basilica may reflect
the impact of design ideas entering Gaul from northern Italy. At both Alba

Fucens and Brixia (Brescia) the forum plans, which date to the first century B.C., stress the basilica as a balance to the temple.[152]

As understood at present—and it must be stressed that the full arrangements at Augusta Emerita and Barcino have not yet been determined[153]—the designers of the Iberian fora placed emphasis on the temple as the primary structure (accepting the Étienne and Alarcão version of Conimbriga). The entire focus of the Iberian fora designs, represented by both the Emporiae and the Saguntum types, places primacy on the cultic aspect of the space over civic or governmental uses.

The investigation of western fora designs during the late Republican and Augustan periods reveals that, although there was a general similarity that relates all the fora to one another, there were also individual design aspects that permitted each forum to possess some integrity—aspects that are not dissimilar to the variations allowed in the orthogonal plans.[154] That regional building traditions and preferences had already become apparent to Roman planners of Augustus's day is well illustrated in the first chapter of book 6 of Vitruvius's *De rerum architecturum*, where he provides practical advice for responding to climatic variation and reveals an awareness of different building techniques employed throughout the Empire. The details in Vitruvius suggest that western building traditions may have survived the initial process of Romanization and still had some power to influence the new conceptions of Imperial architecture.

Stylistic Options

Peripteral Temples. Of the remains of temples built during the Augustan period, the superstructures for those of Barcino and Augusta Emerita remain intact enough to allow for a stylistic analysis. Their peripteral plans are the most striking aspect of the temples. The peripteros stands atop a high podium, and the access is from a frontal staircase. Peripteral temples are rare in Roman contexts, but parallels can be drawn with the rebuilt Temple of Minerva on the Aventine (known from the Severan Marble Plan) and the Temple of the Dioscuroi on the Roman Forum, both reconstructed under Augustus.[155]

The temples at Augusta Emerita[156] and Barcino[157] are only partially preserved, but enough remains or was found in earlier excavations to permit a

152. Russell 1968, pp. 324, 327, figs. 12, 15.

153. The basilica remains that have been identified at Barcelona are of Claudian date; Granados 1987, pp. 71–72.

154. Bedon 1985, pp. 87–88. 155. Gros 1976, plate XVI.

156. Alvarez Martínez 1976, pp. 43–53; idem 1977, pp. 91–95; *HA*, pp. 276–279.

157. The collected material on the Barcelona temple, including the text of Celles's excavation report from the 1830s, is found in Bassegoda Nonell 1974; *HA*, p. 334.

basic reconstruction of the plans. The intercolumniation of the short sides for the Augusta Emerita temple (fig. 37) [158] is a simple A-B-A rhythm interrupted in the front by a slight widening of the middle intercolumniation. The nineteenth-century excavations of the Barcino temple never revealed the front, and so it is not possible to say whether it too had such a break in the rhythm. However, the rear and side intercolumniations (fig. 38) reveal the same regular A-B-A rhythm as at Augusta Emerita. Both temples are pycnostyle, with six columns by eleven columns. They are roughly the same size, the Augusta Emerita temple at ca. 21.90 m × 40.75 m being about 5 m wider than the Barcino temple at ca. 16 m × 41 m.[159] The widening of the central column pair used on the front on Augusta Emerita's temple can also be found in the remains of the tetrastyle temple at Augustobriga (Talavera la Vieja) (fig. 39),[160] near Augusta Emerita. The Augustobriga temple (pl. 12) is partially preserved in the front elevation and podium.[161] The Augustobriga temple has no firm dating evidence, but there are structural features, to be discussed, that permit it to be considered a contemporaneous work with its neighbor at Augusta Emerita.

None of the three temples has much surviving evidence for the cellas. However, in Portugal at Ebora Liberalitas Iulia (Évora) (fig. 40), also near Augusta Emerita and in the ancient province of Lusitania, are the remains of a third peripteral temple built of granite (fig. 41), which retains structural remains of the cella.[162] The Ebora temple has marble column capitals and bases. Marble was not employed in Lusitania during the reign of Augustus.[163] The earliest use of marble appears to date from the reign of Claudius. The evidence from the recent excavations on the temple site at Ebora indicates that the podium of the temple and the floor of the plaza were covered with marble slabs, and dating finds confirm a Claudian date for these features as well.[164] The capitals display stylistic qualities usually as-

158. All published plans for this temple show it to be more of a parallelogram than a true rectangle. This feature has been exaggerated in my drawing.

159. All measurements used have been determined from the published plans and elevations of the temples unless otherwise indicated. The specific measurements for the Augusta Emerita and Barcino temples have been taken from those published in Hauschild 1982, pp. 145–156.

160. The published plan for the hypothetical restoration of the temple at Augustobriga by García y Bellido (1962, plate CLXIV) is highly suspect since it is the same drawing that he later used for the reconstructed plan of the temple at Corduba; García y Bellido 1964, p. 157.

161. *HA*, p. 304. The temple is recorded by Mélida (1925, no. 262, plate 20) with photographs showing its incorporation into a later building. It was freed and moved when the town was to be flooded by a dam, and now sits reconstructed on the shore of the artificial lake; García y Bellido 1956–1961, pp. 235–237.

162. Hauschild 1988, pp. 208–220. 163. Barrera Antón 1984, p. 20.

164. Hauschild 1994, p. 324 (evidence of coin finds and ceramic fragments); idem 1988, pp. 208–220; *HA*, pp. 305–306.

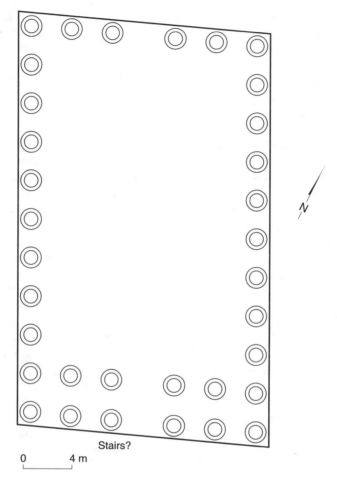

Stairs?

0 4 m

Figure 37. Reconstructed plan of the so-called
Temple of Diana (after Menéndez-Pidal 1976,
fig. 7; and *HA*, p. 277, fig. 121)

sociated with later-first-century architectural decoration.[165] Yet the Ebora
temple shares with the Barcino and Augusta Emerita temples the peripteral
plan, and the three temples along with that at Augustobriga were built of
local stone, which required a plaster coating initially. Moreover, the position
of the Ebora temple on the high point in the ancient city would argue for
its primacy as the town's main religious structure, and for its being, there-

165. Hauschild 1982, pp. 152–153. The temple has been dated as late as the early third
century A.D.; see Mesquita de Figueiredo 1913, p. 365.

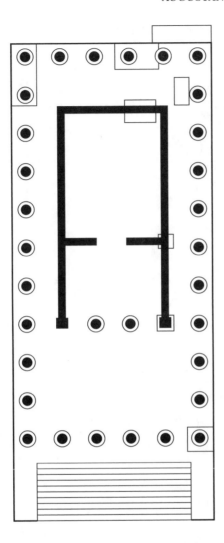

Figure 38. Hypothetical restoration of the plan of the temple in the forum at Barcino based on Celles and Puig i Cadafalch (after Bassegoda Nonell 1974, nos. 2 and 4)

fore, comparable to the temples at Augusta Emerita and Barcino. It was surrounded by a "pi"-shaped cryptoportico that held up a portico in a manner akin to the Republican forum temple at Emporiae.[166] García y Bellido noted that the name Ebora is Celtic, related to the native name for York (Eburacum) and to the name of a Celtic group in Gallia Belgica (Eburones). The Latin appellation, Liberalitas Iulia, would suggest a change in status that must have occurred before 27 B.C., when Octavian was proclaimed Augus-

166. Hauschild 1994, pp. 324–329.

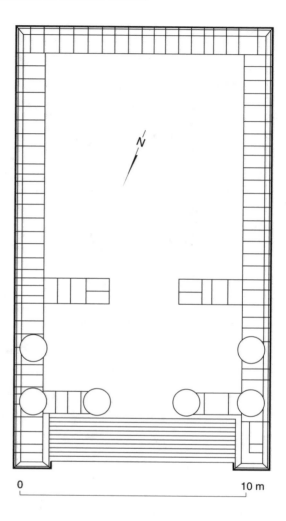

Figure 39. Hypothetical restoration of the plan of the temple at Augustobriga (after García y Bellido 1962, plate CLXIV)

0 10 m

tus. The establishment of a Romanized Ebora Liberalitas Iulia in Lusitania belongs to the same period as the foundation of Augusta Emerita. Considering the temple's prime position, it is difficult to believe that it does not belong, at least in plan, to the initial layout of the Roman town.[167]

The Ebora temple is smaller than the Augusta Emerita and Barcino

167. García y Bellido 1971, pp. 2–3. García y Bellido did not believe that the town assumed a position as a municipium until the time of Vespasian, which would be when he would probably place the building of the temple—though he does not actually make such a statement; Alarcão 1993, p. 218. For a more general overview of Portuguese developments during

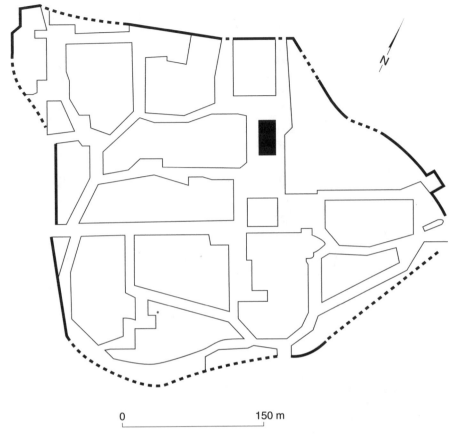

Figure 40. Plan of modern Évora with wall and temple of Roman Ebora marked (after García y Bellido 1971, fig. 3)

temples, ca. 14.50 m × 28 m, about two-thirds of the length of the other two. The difference may in part be explained by the inconsequence of the town. Its shorter length also means that it has fewer side columns, 6 × 9 rather than 6 × 11. But it shares with the Augusta Emerita and Barcino temples the pycnostyle intercolumniation and the simple A-B-A rhythm. Not enough of the front colonnade survives to determine if the rhythm is interrupted by a widening of the central pairing. Only the Augustobriga temple breaks the pycnostyle plan by being systyle.

the early Empire see Alarcão 1990, pp. 43–57. Pfanner (1990, p. 70) argues for a foundation of the city under Caesar.

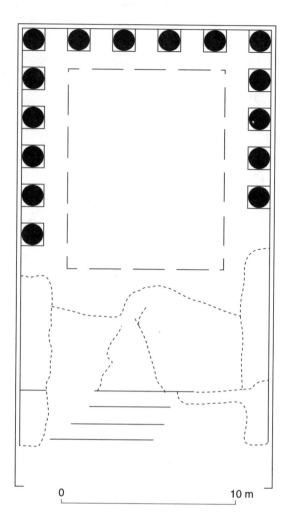

Figure 41. Plan
of remains of the
temple at Ebora
(after Hauschild
1982, fig. 6)

0 10 m

The rhythm of the intercolumniation changes on the long sides from
that on the short sides for the temples of Augusta Emerita and Ebora. The
spacing between columns narrows, and the side rhythm is A-C-A, with
C having a modular relationship to both A and B. At Barcino the opposite
occurs. Here the spacing on the long sides widens, creating a systyle pattern,
though the rhythm, as at Augusta Emerita and Ebora, is technically A-C-A,
with C retaining a modular relationship to A and B. At Augustobriga the
front systyle spacing is continued to the long sides.

Vitruvius discusses the modified peripteral plan alongside the pseudo-

dipteral type (3.2.5–6; 4.4.1–2). He knew only one example in Rome, the temple of Jupiter Stator by Hermodorus. The type is rare in Rome, and to Vitruvius's example can be added two temples on the forum holitorium, one a small Doric peripteral temple and the other an Ionic peripteral perhaps dating to ca. 90 B.C.,[168] Republican temple A on the Largo Argentina, and the Temples of Minerva on the Aventine and the Dioscuroi on the forum, both already cited. The Temple of Neptune in Circo may have been peripteral if P. Gros is correct in his identification of the remains of the temple on the Via San Salvatore.[169]

Gros has shown that the modified Italic peripteral temple plan developed out of Pytheos's design for the Temple of Athena Polias at Priene,[170] and R. Carpenter long ago stressed the role that Pytheos's influence had on Vitruvius's form for the Ionic order.[171] The Italic peripteral plan has either a shallow opisthodomus or none at all.[172] The remains of the temple on the Via San Salvatore in Campo are the most Greek in plan, with a stereobate, a stylobate, and no marked exterior axiality. The temple on the forum holitorium and temple A on the Largo Argentina showed the standard Italic qualities of a raised podium and frontal axiality, and it is this tradition that informs the design of the three peripteral temples on the Iberian Peninsula as well as the two Augustan rebuildings in Rome. The Iberian examples could well be seen as continuing the Republican pattern. They share in common the 6 × 11 peripteros (except for Ebora), which was part of Pytheos's plan for the Athena Temple at Priene,[173] and the pycnostyle intercolumniation that was common in Hellenistic temples.[174]

Although limited, the archaeological evidence at Barcino and Ebora has permitted the reconstruction of the placement of the cellas within the peristyles.[175] The two temples share a deep porch. The antae of the cellas are

168. Coarelli 1981, pp. 318–319.

169. Gros 1976, pp. 110–111, fig. 15.3.

170. Gros 1976, p. 111.

171. Carpenter 1926, pp. 259–264. The very notion of the manipulation of the grid into which the colonnade is placed is probably a reflection of the influence of Pytheos; see J. J. Pollitt, *Art in the Hellenistic Age* (Cambridge, 1988) p. 243.

172. It must be noted that this might also be the influence of Hermogenes, whose Temple of Dionysus at Teos has a very small opisthodomus; see Akurgal 1985, pp. 140–141, fig. 48; W. B. Dinsmoor, *The Architecture of Ancient Greece* (London, 1975), p. 274, fig. 99.

173. This is also the arrangement for Hermogenes' Temple of Dionysus at Teos.

174. Carpenter 1926, p. 267.

175. The restoration of the two columns *in antis* on Celles's plan for the Barcino temple seems based on the excavator's reading of Vitruvius rather than on any archaeological evidence; Puig i Cadafalch, Figuera, and Goday 1934, p. 97. Hauschild (1982, p. 148) believes that there is archaeological evidence to support the reconstruction.

aligned with the fourth columns of the long sides at Barcino and probably also at Ebora (figs. 41, 42).[176] This creates an almost pseudo-dipteral space for the fronts of the temples. Such deep spaces may have been intended to compensate for the lack of a true pronaos before the cult chamber. Interestingly, this same trait is also found in the rebuilt Augustan peristyle temples in Rome as well as the small temple on the forum holitorium and Temple A on the Largo Argentina. The Temple of Augustus at Ankara shows a similar treatment.[177]

These large, deep porches formed from the peripteros itself are a feature of the temples from the great Republican sanctuaries of Jupiter Anxur and Hercules Victor in Latium with their *sine postico* temple types.[178] The two major new temples commissioned or dedicated by Augustus, the Temples of Venus Genetrix and Mars Ultor, were built using the *sine postico* plan and display the same treatment of the front.[179]

The peripterally planned temples on the Iberian Peninsula make use of a Republican Italian design conceit that consisted of a Hellenistic Asian model modified by grafting onto it an Italian podium, pronounced axiality, and frontal access emphasized by a deep porch. Neither the temple at Barcino nor that at Augusta Emerita can be earlier than the Augustan period. So whereas they clearly come from a design pattern developed during the Republic, they actually belong to the revival or continuation of the design under the Emperor, for it was Augustus's architects who restored the Temples of the Dioscuroi and Minerva on the Aventine using the plan, and ultimately it must be with these metropolitan models that the Iberian temples resonate.[180]

Although a smaller temple, the Ebora structure (in either the García y Bellido [fig. 42] or the Hauschild [fig. 41] versions) must also come from this period. It demonstrates the same design conceits in the treatment of the cella and peripteros as the Italian prototypes and the Barcino temple. Hauschild's slightly smaller porch for his reconstruction of the plan of the Ebora temple may be explained as a local modification of the metropolitan

176. Two versions have been proposed for the alignment at Ebora. In García y Bellido's older study (1971, figs. 1, 2), the reconstruction of the plan for the Ebora temple shows the cella antae aligned with the fourth columns on the long sides. More recently, Hauschild (1982, pp. 152–154, fig. 6) has proposed a change and has shortened the porch area, aligning the antae with the third columns.

177. H. Schede, *Ankara und Augustus* (Berlin, 1937), fig. 5. Recent investigations of the temple at Ankara have thrown into question whether the peristyle for the temple dates as early as the reign of Augustus; Toni Cross, "Ankara's Imperiled Temple," *Archaeology* 41:4 (July–August 1988), p. 74.

178. Coarelli 1987b, pp. 85–140; idem 1984, pp. 77–85, 328–332.

179. Coarelli 1981, pp. 103–104, 107; Gros 1976a, pp. 92–95.

180. Gros 1976a, pp. 15–52; Coarelli 1981, pp. 69–70, Temple of the Dioscuroi.

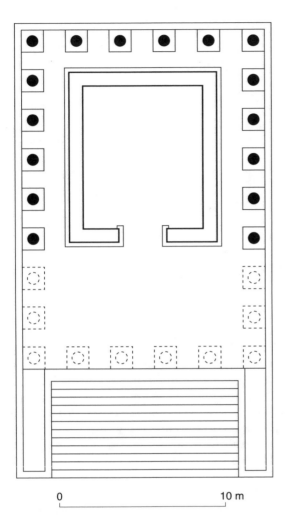

Figure 42. Re-
stored plan of
the temple at
Ebora according
to García y Bellido
(after García y
Bellido 1971,
fig. 1)

0 10 m

plan to meet the needs of a smaller structure.[181] It is constructed of granite,
as is the temple at Augusta Emerita. In terms of plan and concept, it seems
perverse to try to push the Ebora temple out of association with the Augusta
Emerita and Barcino temples and the Augustan structures with which there
are shared traits.

The podia for the temples at Augusta Emerita (pl. 13), Barcino (pl. 14),
and Ebora (pl. 15) are all preserved to some extent, though that at Barcino

181. Hauschild 1988, pp. 210–211.

shows evidence of heavy reconstruction. Each is distinct in molding profiles, with Barcino's being the most elaborate and Ebora's the simplest. At Augusta Emerita and Ebora a top cornice consists of a *cyma reversa* molding. Interestingly enough, this is also the top molding found in the Augustan levels for the forum at Conimbriga.[182] A *cyma recta* molding forms the cornice at Barcino. The lower moldings are each distinct. The podia for Barcino and Ebora are raised atop leveling courses from which a *cyma recta* molding masks the join between podium wall and leveling course. This lower *cyma recta* balances the *cyma recta* top molding on Barcino's podium or contrasts with the *cyma reversa* at Ebora. The molding for the leveling course at Barcino consists of a convex fillet and a flat fillet. A. Jiménez has noted that the profile for this lower molding at Barcino is similar to that of the Republican-period Hellenistic shrine of Asklepius at Emporiae.[183] The lower moldings for the Ebora and Augusta Emerita[184] podia are simpler, though that at Augusta Emerita possesses one unusual feature, a series of flat stones that project from the very base of the podium, forming a type of splash guard around the entire structure. A convex fillet serves to mask the join where the wall and splash guard meet. The only comparable example is that found in the Republican-period Round Temple at Tivoli, which shares this same feature.[185]

The column bases for the temples at Barcino (pl. 16), Augusta Emerita (pl. 17), and Augustobriga (pl. 18) sit directly atop the podium without plinths. Double tori of almost equal size make up the actual bases. The Barcino bases have rather wide and flat tori, in contrast to the more compact style at Augusta Emerita and Augustobriga. Bases of equal- or almost equal-sized tori are a Republican type known at Glanum (pl. 19), the early Imperial Temple of Augustus, and Livia at Vienne (pl. 20) the theater at Lugdunum.[186] The bases at Ebora (pl. 21) are markedly different. The upper torus is smaller, and the profile of the base is a modified Attic-Ionic type. The bases sit atop plinths and are worked in marble.

Though the bases at Augusta Emerita have no plinth, they do not rest directly on the cornice of the podium. There is a kind of stylobate course on which they sit. This is unique to Augusta Emerita. The lack of plinths, however, for the bases of Barcino, Augusta Emerita, and Augustobriga is inter-

182. Alarção and Étienne 1977, plate 16.

183. Jiménez 1975, pp. 282–283; for the archaeological and architectural study of the shrine see Puig i Cadafalch 1911–1912, pp. 307–312.

184. In his 1976 reconstruction drawing of the temple at Augusta Emerita, Menéndez-Pidal (1976, fig. 6) shows the podium with a simple euthynteria course topped with a *cyma reversa* molding that balances a *cyma reversa* molding on the cornice. The actual physical evidence as published and as seen by the author does not seem to support this reconstruction detail.

185. R. Delbruech, *Hellenistische Bauten in Latium*, vol. 2 (Strassburg, 1912), plate 17.

186. Those from the theater at Lugdunum are quite close to the Barcino bases; A. Audin, "Datation de theater de Lugdunum," *Latomus* 16 (1957), pp. 225–231.

esting. In his discussion of the Ionic order, Vitruvius describes the plinth, the thickness of which must be considered in determining the proportional arrangement of the order (3.5.2). Yet in reality, plinthless column bases had been a common feature of Greek building since the fifth century. Jiménez has suggested that the plinthless style may have entered the Roman building vocabulary after the Macedonian wars.[187] The style spread during the Republican period, with plinthless buildings being erected in the highest concentration in the western part of the Empire during the late first century B.C. and the early first century A.D. Even the Temple to Augustus and Livia at Vienne in southern France was built using columns without plinths.[188] The style of building seems to have been particularly popular on the Iberian Peninsula, where in addition to the three temples discussed, there is evidence for contemporary plinthless constructions at Numancia, Osuna, Carteia, and Carmona.[189]

The columns of the temples at Augusta Emerita (pl. 22), Ebora (pl. 23), Barcino (pl. 24), and Augustobriga (pl. 25) are composed of drums with wide fluting and thick intervals. The coarseness of the local stone must have dictated such a perfunctory treatment, which was probably refined by means of a coating of plaster that still adheres in parts to the columns at Augustobriga.[190] On the other hand, the large, deep channels with wide interstices also served to refract the strong summer light of the peninsula, creating intense shadowing that is still visible on the standing columns. This intensity may have combined with the entasis, particularly noticeable on the columns at Barcino and Ebora, to give the peristyles a dramatic massiveness and lend to the building an air of increased significance.

The Corinthian capitals for the four temples reveal two different stylistic affiliations. The Augusta Emerita capitals (pl. 26) consist of three separate blocks,[191] an old-fashioned Republican building practice also used at Ebora (pl. 27)[192] and Barcino (pl. 28), where two blocks rather than three form the capitals. It is also the technique used for the odd Augustan-period capitals at Carteia.[193] The capitals at Augustobriga (pl. 29) are single blocks, which was the common Augustan-period practice as seen in the capitals for the Temple of Mars Ultor in Rome and the Maison Carrée at Nemausus

187. Jiménez 1975, p. 291. 188. Ibid., p. 288.

189. Ibid., pp. 283–285.

190. It is possible that at Ebora the contrast between the white of the marble and the dark gray of the granite was exploited by the builders to create a polychrome effect, in which case the columns would not have been stuccoed. Hauschild (1988, pp. 211, 215) has argued for a similar intentional interplay of dark and light stone for the aedicula at Munigua in Baetica (infra, chap. 5).

191. Barrera Antón 1984, no. 1.

192. Hauschild 1988, p. 214, plates 28 a–c.

193. Woods 1969, plate IX.

(Nîmes). The capitals at Ebora and Barcino were fully sculpted, whereas those at Augusta Emerita and Augustobriga were only blocked out in stone and were finished in plaster.

The Barcino capitals (pl. 30) are flat, with a markedly linear approach that renders the surface almost lacelike and denies the sculptural or plastic potential of the order. The same treatment can be seen in some of the capitals of the Temple of Augustus and Livia at Vienne (pl. 31),[194] usually considered to be a work from the late first century B.C. It is also seen in the Corinthian capitals for the theater at Arles,[195] where the leaves are rendered flat against the capital, and in the capitals of the "Fourches de Roland," also at Arles, which W. D. Heilmeyer dates to the period of the Second Triumvirate.[196] The Barcino capitals therefore continue a line of style best known from late-Republican and early-Augustan construction in neighboring Gallia Narbonensis.

The capitals at Augustobriga and Augusta Emerita are, of course, difficult to define, since the details were in plaster, which has been lost. The profile of the stone cores at Augusta Emerita (pl. 32) to which the plaster was attached are much more sculpted, suggesting that the final capitals would have appeared much more plastic than the Barcino capitals. Three rows of acanthus leaves are plainly visible in the stone drums. The leaves curl out, and each leaf is rendered as a separate entity. The Augustobriga cores reveal no such plasticity, and there the plaster refinements may have emulated the flat treatment of Barcino. The sculpted quality of the Augusta Emerita capitals relates them to a second sculptural trend, also best known in Gallia Narbonensis, seen in the capitals of the Maison Carrée. The strongly plastic quality in all these capitals resembles that which is such a pronounced feature of the capitals of the Temple of Mars Ultor.

The capitals at Augusta Emerita, when completed in plaster, must have possessed a strongly accented chiaroscuro like those of the Temple of Mars Ultor. This same quality has been noted for other capitals found on the peninsula and identified as Augustan—at Clunia,[197] at Tarraco in the theater capitals, and at Carteia. The importance of the model of the Temple of Mars Ultor and the Forum of Augustus for the stylistic details at Augusta Emerita is further evidenced in the capitals from Pancaliente. These capitals formed part of the decorative program for the forum space in which the temple stood, and have been dated, along with all the Pancaliente material,

194. P. MacKendrick, *Roman France* (New York, 1972), p. 83.

195. The theater is dated Augustan; Clebert 1970, p. 162.

196. Heilmeyer 1970, p. 112, plate 7: 1–3.

197. Trapote 1965, p. 5, no. 2. The identification of the capital as Augustan rests on the stylistic evidence.

to the mid–first century A.D., after the completion of the temple, but the capitals possess elongated and twisting stems from which the acanthus leaves emerge, which can be paralleled to the treatment of the Corinthian capitals in the north exedra of the Forum of Augustus.[198]

The profiles for the Augusta Emerita and Ebora capitals, which share the same plastic qualities and chiaroscuro effects, can be identified with Heilmeyer's "Korinthische Normalkapitelle," and as has already been shown, they can be paralleled by contemporary capitals from southern Gaul and Rome. The Barcino capital type, which may have been employed in a modified form in plaster at Augustobriga, has been designated by Ma. A. Gutiérrez Behemerid as belonging to the class of Italic-Corinthian, and in addition to the cited parallels there are several other late-Republican prototypes from Italy, southern France, and North Africa from which the style could be derived. Besides the Barcino examples, the style has been noted for isolated capitals that form a coastal band extending south to Tarraco, and all are assumed to be of Augustan date.[199]

The recent work by Roth-Congès, in which the author has described a diagnostic designation for the acanthus decoration of late-Republican and early-Imperial monuments in southern France,[200] is useful for understanding the patterns of stylistic linkage and development on the Iberian Peninsula. Like the French examples, the Iberian capitals can be broken down into one group that favors symmetrical leaf patterns and another that tends toward asymmetrical leaf patterns. To the former group, which Roth-Congès has shown is ultimately of late-Republican origin, belong the capitals from the temple at Barcino, which can be further placed into Roth-Congès's category of acanthus "*à flèches*," a grouping that includes the capitals from the Temple of Augustus and Livia at Vienne. The capitals from the first-century A.D. theater at Italica in Baetica also can be described as symmetrical, though perhaps belonging to a different subcategory, Roth-Congès's "*à gouttes.*" The presence of this ultimately Republican style deep in the heart of southern Iberia may indicate that the older pre-Augustan treatment had already spread extensively on the peninsula and was quite capable of surviving the impact of newer metropolitan styles. This may be of some significance if indeed the plaster treatment of the Augustobriga capitals partook of this older style.

The asymmetrical treatment, which according to Roth-Congès developed in the eastern Empire and progressively displaced the symmetrical

198. For Augusta Emerita see Barrera Antón 1984, nos. 16–17; for the Forum of Augustus, Heilmeyer 1970, plate 2:2.

199. Gutiérrez Behemerid 1982, pp. 26–29.

200. Roth-Congès 1983, pp. 103–134.

style during the early Principate, can be clearly identified in the capitals of the Temple of Mars Ultor. It is this style that can still be seen in the one surviving plastered capital from Augusta Emerita, which, though probably dating from a late-first-century A.D. restoration of the temple, still possesses this older, Augustan form.[201] It is this same treatment that the capitals of Ebora display. These too may be the result of late-first-century A.D. work on the temple, but in style they resemble the Augustan-period asymmetrical treatment also known at the Maison Carrée.[202] The surviving plastered capital at Augusta Emerita and the marble capitals and bases at Ebora may represent an archaistic stylistic phase in Lusitania already noted for the Pancaliente sculpture and sacrificial relief.[203]

At least two different styles for the Corinthian order can be seen in the four Iberian temples, and possibly three if the plaster forms at Augustobriga and at Augusta Emerita are considered a separate style. These are not distinctly Iberian developments but can be linked to stylistic developments initiating in Italy and spreading—probably simultaneously—north and west to southern Gaul and Iberia. The Italic-Corinthian tradition is a late-Republican style, clearly distinct from the Corinthian *Normalkapitelle*, a contemporary Republican development that seems to have found favor in the official building programs of Augustus, where it is seen not only in the Temple of Mars Ultor but also in the Temples of Divine Julius and Apollo on the Palatine.[204] Except for the rather odd and seemingly retrograde multiblock treatment of the capitals at Augusta Emerita, Ebora, and Barcino, there is nothing in the capitals to suggest a particularly conservative strain. The architectural sculptors were obviously aware of the two prevailing styles. The limited archaeological evidence might suggest that the Italic-Corinthian was preferred in that region closest to southern France, though it has also been suggested that it had spread to Baetica and even to Lusitania. Perhaps there was an easy sharing of sculptors, or at least pattern books, particularly in the coastal area.

Only the temple at Barcino retains any fragments of the entablature. These were discovered in the excavations of 1931, and Puig i Cadafalch offered a reconstruction of the frieze and cornice. The soffit-block coffers have an alternating rhythm of rosettes and a generic floral pattern, separated by acanthus consoles. Punctuating the cornice at regular intervals are lion-

201. Barrera Antón 1984, no. 20.

202. Hauschild (1988, pp. 214–216) has also noted the similarity of the Ebora capitals to Augustan treatments including those of the Temple of Fortuna at Pompeii, the Augustan Gate at Nîmes, the theater at Orange, and the theater at Augusta Emerita.

203. Pancaliente: Squarciapino 1976, p. 62; relief: Trillmich 1986, pp. 298–299.

204. Heilmeyer 1970, p. 112.

head sima spouts.[205] The lion spouts continue a long tradition of architectural decoration that can be taken back to archaic Greek building. Decorative simas were used in Pytheos's Athena Temple at Priene.[206] A comparison of the Hellenistic lion head from Priene with the first-century B.C. lion heads from the Maison Carrée and the Temples Gemines from Glanum[207] and the temple at Barcino reveals only a similarity of motif. The heads from Priene and the Maison Carrée share a plasticity in the rendering of the forms, with rich articulation of the muzzle and the eyes. The Barcino and Glanum heads are more schematic. The eyes are outlined rather than modeled. The muzzles are not so carefully sculpted, and the manes are treated as linear patterns. Lacking more heads from Western contexts, it is difficult to determine exactly the nature of the two influences. The closeness in similarity between the heads of the Maison Carrée and the Hellenistic prototype from Asia Minor may lend credence to Gros's argument for a separate Hellenistic connection in southern Gaul that sidestepped the Italian region,[208] but this is clearly not the case at Barcino or at the other Gallic site of Glanum, where the different style may betray an older, Republican Roman style akin to that which seems to inform the capital designs at Barcino. The closest parallel to the Barcino heads is from the market basilica at Ephesus—an Augustan-period construction, not a Hellenistic monument.[209] Here too the heads have a more schematic treatment, suggesting that the style employed is not that of the traditional Hellenistic East but perhaps a Western force, the same influencing the work at Glanum and Barcino.

There is a little more material on which to build a comparison of the soffit blocks. From Gaul there are remains from the theater at Arles, from the Temples Germines at Glanum, and from the Maison Carrée. Moreover, there are fragments of cornice soffit blocks from Augustan-period structures at Miletus and Ephesus. A striking feature of the Puig i Cadafalch restoration of the Barcino entablature is the inconsistent treatment of the acanthus scrolls on the consoles. There are two distinct renderings, one with two stems forming the frame for the plant and the other with a single, central spine. A similar alternation in design of the acanthus scroll can be found in the console blocks for the skene of the theater at Arles and in the console blocks for the Temples Gemines at Glanum, though in both cases the specific differences are not the same.[210] Interestingly, the treatment of the acanthus leaf for the Barcino, Arles, and Glanum consoles is the same insofar as the lobes of the leaf are positioned symmetrically rather than asymmetrically.

205. Puig i Cadafalch 1927–1931, pp. 87–97.
206. M. Schede, *Antiken traufleisten Ornament* (Strassburg, 1909), no. 42.
207. Roth-Congès 1983, fig. 12. 208. Gros 1973, pp. 167–180.
209. Alzinger 1974, plates 18–22. 210. Roth-Congès 1983, fig. 23.

The alternation of pattern is carried into the coffers at Barcino. A design of a four-petal flower resembling a star or a Greek cross is contrasted with a more standard eight-petal rosette. A similar pattern can be found in the soffit blocks of the cornice for the skene of the theater at Arles, where two floral motifs are juxtaposed one with the other. It was also used in the Augustan-period Tabernakel building at Miletus, where rosettes alternate with an eight-petal flower,[211] not too dissimilar from the starlike four-petal flower at Barcino.

This variation in specifics of the decorative pattern in the architectural sculpture that can be found in three provincial areas—Iberia, Gaul, and Asia Minor—is not found in metropolitan work. Obviously, no one region established the prototype, but the commonality of the detail may suggest some exchange of architectural ideas and concepts at a very specific level. It is perhaps worth recalling the entablature with the bull's-head protome from Carteia, because its closest parallel may be the Hellenistic bull's-head capitals from Asia Minor such as have been found on the agora at Magnesia.[212]

There is nothing that survives for any of the Iberian temples above the entablature level. In his reconstruction for the temple at Augusta Emerita, J. Menéndez-Pidal Alvarez included an arch resting on the entablature and placed above the opening of the central columns on the front short side (fig. 43).[213] The function for such an arch is not clear, and at Augusta Emerita, the architectural evidence for the restitution is largely absent. The Antonine-period *anaglyphum* or silver plaque from Augusta Emerita, in the collection of the Real Academia de Historia in Madrid,[214] shows the form of a hexastyle temple, usually interpreted to be the Temple of Diana, with an arch. Based on this piece of evidence, Menéndez-Pidal included the arch. The temple at nearby Augustobriga does still retain the arch, which might further argue for its existence at Augusta Emerita.

The reconstructions of the total elevations for the three peristyle temples must remain highly dubious, considering the lack of superstructure remains above the level of the entablature. However, reconstruction attempts have been made. Menéndez-Pidal's elevation for the temple of Augusta Emerita would indicate a total height of about 22 m for the temple. The podium is ca. 4 m high, the combined column and entablature, 14 m. At Ebora, the podium is ca. 3.5 m high, and the columns with bases and capitals are ca. 7.5 m. The surviving fragments of entablature rise an additional 1.5 m,

211. R. Köster, "Römische Bauornamentik in Milet," in W. Müller-Wiener, ed., *Milet 1899–1980: Ergebnisse, Probleme, und Perspektiven einer Ausgrabung, Kolloquium, Frankfurt am Main, 1980*. Istanbuler Beiheft no. 31 (Tübingen, 1986), pp. 157–164, plates 1–2.

212. Alzinger 1974, p. 123.

213. Menéndez-Pidal 1976, pp. 213–214, fig. 6.

214. Blanco Freijeiro 1982, pp. 28–30.

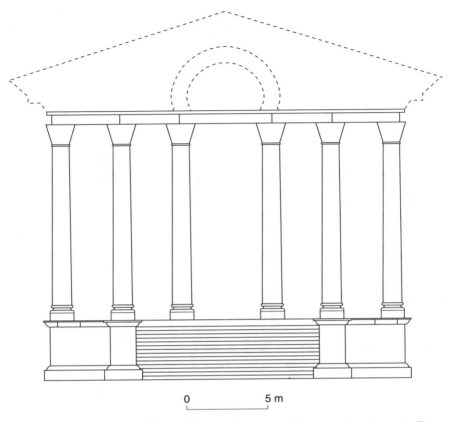

Figure 43. Restored facade of the Temple of Diana at Augusta Emerita according to Menéndez-Pidal Alvarez (after Menéndez-Pidal Alvarez 1976, fig. 6)

giving a combined height of 12.5 m. Menéndez-Pidal offered rather elaborate cornice moldings for Augusta Emerita, which increased the height of his reconstruction. Hauschild, who has provided the restored elevation for Ebora (fig. 44), rejects such elaborateness, and his total restored height for Ebora is only 16 m. The Menéndez-Pidal restoration for Augusta Emerita would indicate roughly a 3:1 ratio between the lower structures of the temple and its cornice and pediment. Hauschild's Ebora elevation also has a 3:1 ratio.

The podium of the temple at Barcino is ca. 2 m high, and the columns have a height of ca. 9 m.[215] The surviving cornice fragments add about 2 m

215. Étienne (1958, p. 221) claims a height of 11.25 m for the Barcino columns, though it is not clear what the measurement is based upon.

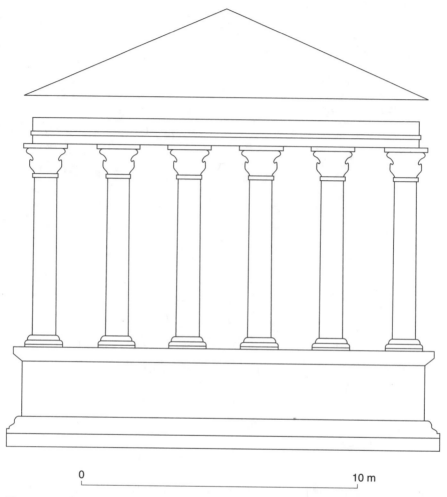

Figure 44. Restored facade for the temple at Ebora according to Hauschild (after Hauschild 1982, fig. 7)

more, yielding a height for the lower cornice of the gable of ca. 13 m. The ratio between the solid podium and the colonnade and entablature above is about 1:5 at Barcino, about 1:3 at Ebora, and about 1:3 at Augusta Emerita. Barcino's temple must have seemed attenuated in comparison with the other two (fig. 45).

Puig i Cadafalch noted that the arrangement of podium and colonnade at Barcino resembled that of the late-Republican Temples of Fortuna Virilis

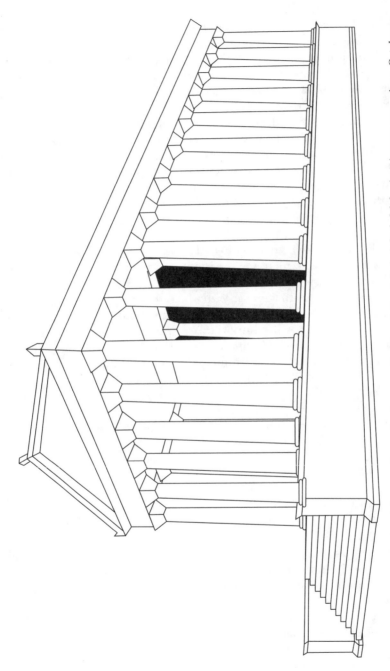

Figure 45. Restored view of the temple on the forum at Barcino (after J. Puig i Cadafalch, *Arquitectura romanica a Catalunya* [Barcelona, 1909], p. 44)

at Rome and Vesta at Tivoli.[216] At Barcino the columns themselves are about four times the height of the podium, which is similar to the relationship of columns and podium at the Temple of Augustus and Livia at Vienne. The columns of the Maison Carrée are roughly three times the height of the podium, closer to the correspondence of columns to podium at Ebora and Augusta Emerita. As has already been discussed for the capitals, the temple at Barcino, in terms of its decorative treatment, seems to come out of a late-Republican tradition that either entered Iberia via southern Gaul or entered southern Gaul via Iberia. The Augusta Emerita and Ebora temples, on the other hand, belong to fully articulated Augustan style, and are part of the same architectural force that informed the Maison Carrée.

The three Iberian peripteral temples pose some interesting problems for the study of early Imperial Roman architecture in the western provinces. Certainly non-peripteral temples were built, as is shown by the temple at Conimbriga, probably by that at Augustobriga, and by the modified forum temple at Emporiae. Which was the more common type cannot be determined from the existing evidence. The survival rate of the peripteral temples may have more to do with the ease with which they could be accommodated into the fabric of specific later structures than to any numerical quantity. The lack of evidence for the important temples, either of late-Republican or early-Augustan date, at Corduba (Córdoba), Tarraco (Tarragona), and Caesaraugusta (Zaragoza) undermines any attempt to make generalizations about temple building on the peninsula during these decades. The analysis of the decorative aspects of the temples does allow us to see the presence of two distinct styles operating on the peninsula, and these two styles were not isolated but rather were either offshoots of the two stylistic forces in southern Gaul or themselves the parents of the Gallic versions. The lack of firm dates for any of the buildings under consideration undercuts all attempts to establish the priority of Gaul or Iberia in the development of the style.

The particular similarities that join the Barcino temple to the Temple of Augustus and Livia at Vienne and to selected monuments at Glanum and Arles might well support the notion of a traveling workshop of architectural sculptors active in southern Gaul and eastern Iberia. Their style, ultimately derived from late-Republican prototypes, may well have been influential elsewhere on the Iberian Peninsula, though the workshop members may not have been themselves active much beyond Barcino.

What does seem to appear in the peripteral Iberian temples are signs of local responses. Therefore, although it is reasonable to argue that the Augusta Emerita temple partakes of metropolitan models, the temple has a strange archaistic quality in the use of coarse-grained, local stone for the

216. Puig i Cadafalch, Figuera, and Goday 1934, p. 97.

building and the employment of multi-drummed capitals instead of the more current single-drum units. It is this same local transformation of forms that has already been noted for the forum at Conimbriga.

The temple at Ebora is by far the more troublesome. Its bases and capitals of marble must be later than the granite capitals and bases at Augusta Emerita. Yet they do retain in profile and sculptural quality a close resemblance to those of the Maison Carrée. The peripteral plan at Ebora must be seen as belonging to the same phase as the temples at Barcino and Augusta Emerita. Peripteral temples were never popular in the West,[217] and it is hardly likely that a small and insignificant town would have adopted such a plan long after it had ceased to have any meaning. It seems far more reasonable to assume that the temple at Augusta Emerita, the capital for the province in which Ebora sat, supplied the prototype, and the building of that temple provided the impetus for Ebora to build her own smaller version. The marble capitals and bases may well reflect the late date for the completion of the temple or evidence a remodeling of the temple sometime in the later first century A.D., when the temple at Augusta Emerita itself may have been remodeled, to judge from the surviving plaster from one capital and the fragment of a bronze acanthus scroll, which may have decorated the entablature.[218] It was probably during this same period that the great sculptural program in the forum was carried out.

Builders. What is perhaps most intriguing about the Iberian temples is the way in which they cannot be placed into any clear line of development. The temple at Augusta Emerita seems to have nothing to associate it with the temple at Vienne, except that at both temples the column bases have no plinths but are raised on a stylobate, a feature totally lacking at Barcino and Ebora. In all aspects—designs of the fora, planning of the temples, execution of the buildings, sculpting of the decoration—the question remains: Who was responsible? One source must have been civilian workshops, the *officinae* that may have become established on the peninsula during the Republican period and perhaps built temples like the Temple of Serapis in Emporiae and the capitolium at Saguntum. Gros has suggested that the best way to understand the Maison Carrée is to see it as the product of an architect from Gallia Narbonensis, a man trained perhaps in Rome, aware of developments in middle-Augustan architecture, and capable of translating these grand schemes into smaller provincial forms, but who was also still in touch with the strong, late-Hellenistic trends of his native southern Gaul.[219] Heilmeyer's observations about the local quality of southern French capi-

217. Hauschild (1988, p. 211) lists as parallels seven other temples in the West.
218. Barrera Antón 1984, no. 20; bronze acanthus scroll: *Los bronces,* p. 107, no. 4.
219. Gros 1981, p. 42.

tals also can be applied to the Iberian examples, suggesting that the workmen could have been local.[220]

The Iberian Peninsula had areas that were highly civilized, and old centers like Emporiae, Gades, Carthago Nova, or Corduba may well have had architects or at least builders and workmen who were aware of building styles other than those emanating from Rome. Hellenistic influences had been entering the peninsula from the time of the Republic through Emporiae via the trade with Campania that also brought Hellenistic influences to southern France,[221] and perhaps earlier through the Punic south. It is well documented that Greek ideas were penetrating the Carthaginian world of North Africa,[222] and these may have also entered the peninsula, especially at the last Carthaginian foundation at Carthago Nova.

On the other hand, new foundations in areas with no real tradition for city building must have been created by the military engineers who traveled with the army.[223] Army engineers could have been responsible for the layout of places like Caesaraugusta and Augusta Emerita, since both were strategic strongholds in recently pacified areas, and foreign—Italian—workmen probably built some of the first structures such as the temples.[224] Small foundations like Conimbriga and Ebora, which were located near new cities constructed as military sites, might themselves have been initially planned by resident army engineers. Where the engineers were the source of the design, a certain uniformity may be expected—the result of some type of official guidelines that may be reflected in the styles chosen, such as the *Normalkapitelle* capitals with their metropolitan, Augustan affiliations.

Yet even within the unity, there was room for variation. The individual buildings and complexes display local traits of their own, and even foundations that may have been planned and initially directed by engineers could well have received some influences from civilian workshops in due time. It is often the specific details that link together various Augustan buildings rather than repeated grand plans and ensembles, and these more modest linkages may be the result of the passing of architectural ideas throughout the West by means of the so-called *Skizzenbücher*[225] that provided provincial builders with ideas that could then be manipulated to suit local needs or wants. Lacking any real evidence for their existence, it is difficult to know

220. Heilmeyer 1970, p. 112.

221. Gros 1976b, p. 315.

222. Rakob 1980, pp. 119–172; Lezine 1961.

223. For the general idea of the importance of the army as supplier of provincial builders see MacMullen 1959, pp. 214–217.

224. At Augusta Emerita there is no evidence for determining the identity of the workmen employed in the early building programs, but at Caesaraugusta an inscription records the presence of Campanian workmen involved in the early construction there; Richmond 1931, p. 94.

225. Gros 1973, pp. 169, 173.

the sources for the *Skizzenbücher*. It would seem most likely that they emerged from Rome itself. Perhaps we do well to see Vitruvius's work as a kind of grander version of just such guides. Vitruvius's material would also suggest that these sources must be seen not as officially sanctioned designs so much as collections of architectural ideas circulating in and around the capital.

Elite Patronage

None of the peninsular temples discussed in this section has a dedication, and so none has a known cult. Attempts have been made to assign an Imperial Cult dedication to the temples at Barcino, Ebora, and Augusta Emerita. Certainly the Imperial Cult in a fully authorized form did flourish on the Iberian Peninsula after Tiberius permitted it, but if the temples under consideration were built prior to the reign of Tiberius, as has been suggested here, it is not possible that they were intended as such cult buildings, since the worship was not officially sanctioned under Augustus in the West. More likely, their initial dedication must have been to another state cult, and only later, if at all, were they converted. However, even in the more neutral form, these temples, along with others on the peninsula, may have played a role in the larger propaganda campaign of Augustus.

Augustus spent time on the Iberian Peninsula during the early years of his reign. It is not known how much of the peninsula he actually saw, though he well may have traveled much of the east and north from his residence in Tarraco to the northern fields of the Cantabrian campaigns. What he did not see may have been seen by Agrippa. Certainly the major building programs undertaken on the peninsula during Augustus's lifetime, both those that resulted from Imperial initiative like Augusta Emerita and those that reflect local desires like Saguntum, must have suited the Emperor's plans for bringing the entire Roman world under sound management.

Like Gaul, the Iberian Peninsula cannot be treated as a uniform region during the early Empire. In the south, the high degree of cultural sophistication, the long-standing urban tradition, and the existence of a native elite—probably landed—who had already adopted a Roman lifestyle during the Republic helped to influence the direction that Romanization under the Emperor assumed in the region. The authority and importance of the local elites is best manifested at Saguntum, where an inscription records that the new forum was a gift to the city by a member of the Babii, a local aristocratic family of indigenous lineage. The family is also known from a series of statue bases that testify to their general importance to the town.[226]

It is impossible to determine exactly how the patron may have influenced the design without more specific documentation, but it may be safe to as-

226. Alföldy 1977, pp. 7–13, 24.

sume that the unusual inclusion of the secondary shrine sacred to Apollo and Diana reflected the patron's wishes. Could the Babii have desired to establish some type of physical linkage between themselves, the city of Saguntum, and the Imperial household? There is no evidence for how the Babii fared under Augustus, but it does seem that the family was prospering among the Roman elite in the capital by the end of the first century A.D.[227] The presence of a shrine to Apollo or Diana need not have carried associations with the Emperor. After all, Saguntum was one of the settlements with a shrine to Artemis of Ephesus. However, the pairing of Apollo and Diana in such a specific manner and in the central area of the Roman city during the reign of Augustus seems much more than accidental. B. Kellum has shown how important Apollo was to the iconography of peace that Augustus stressed in the capital, and it was Apollo accompanied by his sister and their mother, Leto, that formed the sculptural ensemble in the interior of the Temple of Apollo on the Palatine.[228] Neither were the allusions to the Emperor to be found only at Saguntum, nor only in sacred structures.

Saguntum is the only town where there is some hint of the role played by the local elite in determining the manner of Romanization. It is near enough to Tarraco that the Emperor's presence could well have stimulated the building program. D. Fishwick has stressed that Augustus was less strong handed in directing the promotion of Imperial ideology in civilized regions—in which Saguntum must be counted—than in the newly conquered territories.[229] The local elites who saw their own prosperity as in some way linked to the new order and the peace brought by Augustus may have been quite happy to carry out the Imperial program for the Emperor.

It may be these same local forces that initiated the changes to the forum and its temple at Emporiae. The city must have continued to prosper during the late first century B.C. and early first century A.D. The changes to the forum, especially the inclusion of the basilica, seem to testify to the recognition of the local elite as the accepted sanctioned agents of government for the town. It is pushing too hard perhaps to see in the simultaneous changes to the front of the temple an attempt on the part of elite patrons to reference a monument in Rome itself, especially since the lower city at Emporiae provided a perfectly acceptable model for the new facade for the forum temple. However, as has already been suggested, the Temple of Serapis in the lower city well may borrow from the temples of Divine Julius and Venus Genetrix for its unusual rostrum front, and the designer of the new facade for the temple on the forum may have been quoting from two sources in the remodeling.

227. Ibid., pp. 15–23. 228. Kellum 1986, pp. 169–176.
229. Fishwick 1978, pp. 1204–1209.

Imperial Iconography

The importance accorded the basilican structures at Saguntum, Emporiae, and Conimbriga testifies to the growing acceptance by the local elite of the role that they were expected to play within the society that the Emperor was creating. The forum, the temple, and the basilica provided the stage setting for the *cursus honorum* that dominated the public life of the local provincial elite. The value of establishing good relations between the local elites and the newly created government of the Emperor must have been manifested when the embassy from Mytilene arrived at Tarraco to beg favors from the Emperor for that city, among which was the right to honor the Emperor as a god.[230] Nor was Mytilene the only eastern city to send such delegations of important citizens to the Emperor while he was resident on the peninsula.[231] Such ties benefited a town, and the public acknowledgment of the linkage must have done much to bolster local pride. Augustus refused to officially sanction his worship in the West, but placing his favorite deity on the forum was certainly a way of honoring the Emperor. There may have been more physical manifestations of associations between cities on the peninsula and the Emperor if indeed some of the images on the coins from the old Punic cities of southern Iberia with images of buildings on their reverses refer to structures that somehow were associated with the Emperor.[232]

Perhaps one of the most significant differences between the Imperial process of Romanization on the peninsula and that which happened simultaneously in southern France is the lack of martial imagery in the former. The decoration of the arches of southern France is full of images of victory and defeat,[233] types of decoration totally absent on the peninsula, even though Augustus waged war on the northern coast. As early as the trophy at Saint-Bertrand-de-Comminges,[234] there was an official personification of Hispania as a young defenseless woman, a personification also on the breastplate of the Prima Porta Augustus and perhaps in the grand program celebrating the Roman army and Imperial conquest that decorated the Sebasteion at Aphrodisias,[235] but again, this is not a type known on the peninsula itself. In choosing iconography appropriate for the peninsula, the Emperor and his agents decided not to stress conquest, not to use a strong-arm ap-

230. Price 1984, pp. 55–57.

231. For Tralles's embassy see MacMullen 1959, p. 208.

232. Mierse 1993b, pp. 38–40.

233. Silberberg-Peirce 1986, pp. 306–323.

234. Charles-Picard 1957; MacKendrick 1972, p. 95, fig. 4.3.

235. The image on the Sebasteion has been identified as representing the Callaeci, a northern tribe; Smith 1990, p. 92.

proach to reminding the residents of the realities of Roman rule. Instead, a more subtle approach was taken. In the relief decoration of the theater at Augusta Emerita there are martial references, but they are buried in a larger program and allude not to the conquests on the peninsula, but rather to Augustus's victory at Actium.[236] Similarly, the heads of Jupiter Ammon put up in midcentury around the Temple of Diana in Augusta Emerita must still have carried some association with conquest. Alexander the Great had first placed such shields of gold on the Parthenon to celebrate his victory at Granicus, and later Marius put shields up in the Forum of Rome to announce his victory over the Cimbres (Cicero, *de Oratore* 2.266). Augustus's sculptor for the Forum of Augustus had made permanent in stone what had been a temporary decoration. Moreover, Jupiter Ammon was a patron god of the army.[237] The significance of the head of Jupiter Ammon in the decorative program at Augusta Emerita would not have been lost on the veterans, who formed the core of the founding population.

The forum at Saguntum was built on a high cliff and was not laid out on the flat land nearby. Though there is no archaeological evidence for pre-Roman native settlement at the spot of the forum, the earlier Iberian walls are in the general vicinity, and native tradition had been to build atop high, easily defended locations. The area was probably not totally virgin. The initial Romanization of the spot occurred during the Republic, when the temple, probably the capitolium, was built, and this was in turn incorporated into the Augustan forum, forming the axis along which the space was arranged. Thus in two stages a possibly native area was made Roman. At the same time, the prestige of the city's traditional patroness, Artemis of Ephesus, was co-opted for Imperial propaganda when the secondary shrine on the forum joined Diana with her brother Apollo. Thus what might have stood as a symbol of pre-Roman identity was effectively neutralized and, moreover, merged with a symbol of Imperial power.

At Saguntum, the physical manifestation of the Romanization process was a restructuring of space, probably done by the local elite but tacitly approved by the powers in nearby Tarraco, the provincial capital. Similar events must have taken place during these same decades throughout the Iberian Peninsula. The old native sacred area of Glanum in southern Gaul was subjected to radical redefining during these years. The new Imperial space was manifested in the old native region rather than in the actual forum itself.[238] The old city of Tarraco, possibly the newly designated capital

236. Salcedo Garcés 1983, pp. 243–283.

237. Vezàr 1977, p. 35; Zanker 1969; D. Kienast, "Augustus und Alexander," *Gymnasium* 76 (1969), p. 435.

238. Clavel-Lévéque and Lévéque 1982, pp. 675–682.

of Tarraconensis, honored Augustus in a more direct manner by erecting an altar to the Emperor. The altar does not survive, but it is recorded in a passage from Quintilian.[239] The source makes clear that Augustus was alive and knew about the altar. Étienne has dated its building to 26–25 B.C. and has suggested that the source of inspiration may well have been the embassy from Mytilene in 27 B.C.[240] Mytilene celebrated its new relationship with the Emperor by publishing a formal announcement, a copy of which was sent to Tarraco.[241] The action of Mytilene devolved from an older Hellenistic tradition of rivalry among Greek cities for the favors of the Hellenistic rulers. The notification of the action could have spurred on such a rivalry among some of the western cities, especially after the establishment at Lugdunum (Lyon) of an officially sanctioned cult centered to some degree on the person of the Emperor and practiced around an altar.[242]

The altar at Tarraco is known only from an image on a series of coins struck under Tiberius.[243] The image in no way resembles the later and more elaborate altar at Lugdunum (pl. 33), nor was the cult really the same. The cult at Lugdunum was established and propagated as part of the official Imperial policy and was used to help Romanize the northern Celtic tribes by inclusion of their tribal elites into a religious and political celebration that honored the Emperor in a manner not totally devoid of native significance.[244] Fishwick has rightly argued that the altar and associated cult at Tarraco were born out of a local response to an outside, Hellenistic Greek stimulus. It was a spontaneous, local event that could be used by the Emperor.[245] It is hard to know if the request of the embassy from Mytilene struck a chord within the native elite of the city, reminding them of an older, pre-Roman tradition of honoring by deification worthy leaders, as Étienne[246] has implied, or if Tarraco simply wanted to enter into competition with the older cities of the East. The issue of competition, however, must be what caused Augusta Emerita to erect its own altar to the Emperor sometime after Tarraco. This altar is known only from coin images struck under Tiberius.[247]

239. *Inst. Orat.* 6.3.77: Et Augustus nuntiantibus Tarraconensibus palmam in ara eius enatam, "apparet," inquit, "quam saepe accendatis."

240. Étienne 1958, pp. 365–370.

241. Others were sent to Pergamon, Actium, Brindisium, Syrian Antioch, and Massalia.

242. Fishwick 1972, p. 46.

243. Guadán 1980, no. 410.

244. Fishwick 1978, p. 1204.

245. Ibid., p. 1209.

246. Étienne 1958, pp. 67–118.

247. Guadán 1980, nos. 1001–1003; Burnett, Amandry, and Ripollès 1992, no. 28. For the opposing view on the altar see Fishwick 1987, vol. 1, pp. 180–183.

CONCLUSION

It is difficult to assess the overt role that Augustan official policy played in the development of sacred architecture on the Iberian Peninsula. There is little doubt that new cities such as Augusta Emerita were to some degree planned as model cities and as such were to reflect some preconceived notion of Roman urban life. Those who planned them and even those who executed the designs were probably foreigners in many cases. Other new cities such as Conimbriga, Ebora, and Barcino may have also to some degree been influenced by events at more prestigious sites, but there was a local need that also seems to have affected building forms. Certainly at cities like Emporiae and Saguntum—old, established centers with their own traditions— the local interests must have dictated the form of Augustan Romanization. Therefore it is difficult to argue for any single influence that will explain why there should be three peripteral temples on the peninsula. The distinctive stylistic features exhibited by the three temples permit us to see that whatever underlying thread links the plans together, the execution of the structures of the temples points to two different but coeval stylistic forces.

If it is not possible to argue for an official design policy that would explain the appearance of these three temples, then perhaps it is best to suggest the power of local taste even in newly Romanized areas like Lusitania. We can cite a preference for older forms, which might explain the conservative nature of the actual building techniques combined with the references to older Republican sanctuary designs. The peripteral plans seem to link best with the Greek Hellenistic tradition—which can be explained for Barcino, which was within the orbit of the old Greek sphere, but which is difficult to explain for Augusta Emerita and Ebora.

It is worth noting that although many specific aspects of the temples and fora can be paralleled by architecture being built elsewhere in Gaul and Italy, the Iberian temples always seem to retain a Spartan quality, at least to judge from the fragmentary remains. A comparison of the entablature of the Barcino temple with the entablature of the late-Augustan Temple of Concord[248] in the Roman Forum reveals just how simple even decorated surfaces were kept on the peninsula. Was this merely the result of a provincial inability to create such richly articulated decorative surfaces? Hardly, when we consider what the architect and the sculptor of the Maison Carrée were producing during the same period, and the fact that the Maison Carrée was physically within the same artistic sphere of operation as the workshop that seems to have been responsible for buildings at Barcino, Arles, and Vienne. Moreover,

248. See Zanker's discussion of the iconography of architectural decoration (1990, p. 258).

the architect of the Maison Carrée may well have been a native of southern Gaul if Gros is correct. Provincial inability seems to beg rather than answer the question, and would really be valid only for those areas in the far west or north where the process of Romanizing was truly new. The evidence at Saguntum and Emporiae bears witness to up-to-date knowledge of many patrons, whereas the novelty of the Conimbriga forum design seems to put the lie to the notion of mere provincial brutish copying.

The findings from the Iberian Peninsula might well require that we change our conception of Romanization under Augustus. Though it must still be seen as a period when the emphases were on urbanization and general homogeneity of forms, there was much room for local variation and perhaps tacit encouragement of just such explorations. Augustus's toleration of the Tarraco cult may well indicate that the Emperor understood that the way to link the Empire together and to assure peace within its boundaries was to tolerate and even foster each unique provincial view of how to accommodate Romanization in light of local comprehensions and needs.

CHAPTER THREE

New Choices under Tiberius

The reign of the Emperor Tiberius (A.D. 14–37) saw the continuation and probable completion of projects started under Augustus. Local architects and builders on the Iberian Peninsula began to look for their models outside of the neighboring provinces or Italy and instead turned their attention to Asia Minor and the building programs in the Greek East. They were motivated to find different sources of inspiration, in part to respond to the need for architecture for the newly born Imperial Cult, which was to dominate the public religious life of the provincial cities during the first century A.D.

IMPERIAL CULT

Years ago Étienne offered the hypothesis that the concept of an Imperial Cult that centered around the deified person of the Emperor may have had a separate development on the Iberian Peninsula. Though the cult, as officially sponsored by Rome from the first through the third centuries A.D., was born from the earlier eastern Hellenistic ruler cults, in the West the Iberian Peninsula may have provided particularly fertile ground for the spread of a foreign cult that tapped an indigenous belief system. Étienne argued that two distinct pre-Roman versions of the cult had existed on the peninsula. One was formed among the Iberian peoples and had its roots in the monarchical system that had taken shape during the Tartessian period, perhaps under the influence of Near Eastern merchants. The other version was to be found among the Celts and probably the Celtiberian peoples, where there was a practice of according great importance to the warrior chief to whom all other warriors gave their lives if necessary.[1] Foreign leaders, both

1. Étienne 1958, pp. 49–80.

Carthaginian and Roman, who created followings on the peninsula prior to the final conquest under Augustus may have made use of this cult of personality to promote their own programs.[2] The great tomb markers such as the fifth-century tower at Pozo Moro in the Iberian territory, and the architectural sculpture that seems to have been a mainstay of sculptural workshops of the Iberian region from the fifth through the first century B.C., may be best understood as artistic products responding to this earlier cult of "pseudo-divine" leaders.[3] Even the small Republican temple at Azaila can be considered a type of heroon to a local, powerful Roman leader (Sertorius?) to whom the Celtiberian population accorded personal devotion—what Étienne called the "devotio iberica."[4]

The Altar at Tarraco (Tàrraco, Tarragona). If indeed an incipient form of personal cult that later merged with the official Imperial Cult did exist on the peninsula at the time that Augustus took control, it seems hard to believe that he would have totally ignored its potential political value. Under the Emperor Augustus at least four altars were erected in the West that in some way honored the Emperor: an altar on the Elbe (Tac. *Ann.* 1.39.1, 57.3; Dio 55.10a2), the Altar of the Three Gauls at Lugdunum (Lyon) (pl. 33) (Strabo 4.3.2; Livy, *Per.* 139), the Ara Ubiorum at Cologne, and the altar at Tarraco (Quint. *Inst.* 6.3.77).[5]

The altar at Tarraco is known from a reverse on a Tiberian coin struck by the city's mint (pl. 34),[6] and fragments of sculpted reliefs found in the region of the upper city, near the cathedral, have long been associated with the altar.[7] These represent aspects of the provincial priesthood: the *apex* and *aspergillum* along with an oak swag between bucrania. G. Alföldy suggested that they may have decorated the altar, though Étienne argued against such a view since the shield is absent and is clearly an important feature of the coin image.[8]

2. Ibid., pp. 81–115.

3. For the Porcuna group see González 1987. For Osuna see García y Bellido 1943.

4. Étienne 1958, p. 75.

5. Mierse 1990, p. 323. For the Altar of the Three Gauls see Brogan 1973, p. 204; Audin 1964; Audin and Quoniam 1962, pp. 103–116. See also Fishwick 1978, pp. 1201–1253.

6. Burnett, Amandry, and Ripollès 1992, nos. 218, 221, 225, 231.

7. For the fragments of relief sculpture see Albertini 1911–1912, no. 121, figs. 136–138. Albertini's description of the evidence for the original find spot suggests that the fragments may not have actually come from the cathedral area, according to a mid-nineteenth-century source, who quotes an earlier source, according to which the fragments "fueron hallados, no en los cimientos de la capilla nueva de Santa Tecla, como comunmente se cree, sino en la calle llamada del Horno de San Bernardo, detrás de la plazuela dicha del Oli, distante de la catedral como un tiro de fusil." Albertini did not accept the notion that these reliefs belonged to the altar.

8. Alföldy 1978, col. 600; Étienne 1958, p. 369.

The coin image shows the front face of the altar, which is framed at each side by a pilaster holding up a cornice. The face is decorated with a swag, probably of oak, suspended from bucrania. In the loop of the swag is a shield. These elements can be related to the general Augustan iconographic program wherein the oak swag represented the *corona civica* bestowed on those who saved the life of a fellow citizen; the swag was cited by Augustus himself as one of his emblems (*Res Gestae* 34).[9] The bucrania appear in Rome as part of Augustus's revival of older religious forms.[10] The shield could refer to the gold shield (*clipeus virtutis*) voted Augustus by the Senate to acknowledge his *virtus, clementia, iustitia,* and *pietas* (*Res Gestae* 34) and placed on display in the Curia Iulia. The image of the shield is known from Arles, where an inscribed marble shield was displayed.[11] In his study of the coins, G. F. Hill argued that the shield obscured a spear behind it. He read the two elements as symbolic of the victories of the Cantabrian wars—a more immediate iconography, and one that specifically linked Augustus to the peninsula and to Tarraco. The Emperor had lived in the city while finishing the campaigns.[12] The only element missing from the description of honors paid Augustus as recorded in the *Res Gestae* is the pair of laurel trees, but Fishwick has proposed that they decorated the opposite side of the altar.[13]

Étienne suggested that the altar had stood in the upper city, near the later medieval cathedral.[14] The recent excavations by Hauschild in the upper city have shown that the region saw no major building until late in the reign of Tiberius, and since the altar and its precinct clearly were already in place during Augustus's reign, they could not have been set up in the upper city near the site of the later Gothic cathedral.[15] If the reliefs did come from the altar, then they must have been moved from elsewhere to the upper city where they were found. Fishwick has proposed that the altar was located in the lower city, perhaps in the forum, which had been built during the Republican era.[16] Such a placement can be paralleled at Narbo (Narbonne), the provincial capital of Gallia Narbonensis.[17]

9. Zanker 1990, pp. 92–94. 10. Ibid., pp. 117–118.

11. Ibid., pp. 95–96.

12. Hill 1931, p. 47; see also Étienne 1958, p. 377. Fishwick (1982, p. 226) argues against the spear.

13. Fishwick 1982, p. 226. He follows Beltrán's earlier denial of Hill's assertion; Beltrán 1953, p. 63.

14. Étienne 1958, p. 369. This was also the opinion of Capdevila (n.d., pp. 55–57, with pictures of the reliefs).

15. Hauschild 1972–1973, pp. 3–44.

16. Mar and Ruiz de Arbulo 1987, p. 44; Koppel 1985b, pp. 45–48. For the initial archaeological investigations see Serra Vilaró 1932; Hernández Sanahuja 1884.

17. Fishwick 1982, pp. 224–225 (*CIL* XII, 4333 = *ILS* 112). Fishwick's citing of Étienne's study of the placement of temples on fora (1982, p. 224, n. 20) seems weak since in each case

The altar at Tarraco was the local manifestation of the cult of Augustus and Roma. It was the earliest physical evidence of the cult in the West, and its creation must have been spurred by the embassy from Mytilene. In the Greek East the cult was a continuation, albeit with some significant changes, of the earlier Hellenistic ruler cult, and the decree from Mytilene shows that the concepts of the divine so basic to the cult were already well established by the last quarter of the first century B.C.[18] The Tarraco altar displayed the interweaving of the Emperor's personal iconography—the oak swag, the palms—with the official state iconography of revived piety and possibly the attributes of priesthood, if the reliefs are part of the altar. Even if the reliefs did not decorate the altar, they may have been part of the decorative program for the altar temenos.

Other Iberian Altars. The altar at Tarraco is the only one known from the Iberian Peninsula for which there is evidence of more than a coin image. A second altar is often posited for Augusta Emerita based solely on the evidence of a coin reverse type (pl. 35).

The issue of coins is agreed to be Tiberian, probably one of the last struck by the colonial mint, which first issued coinage sometime around 25 B.C.[19] All the coins, except for the initial issues, were of bronze, and the altar series were struck as an *as* and its division, a *semis*.[20] The flan size for the depiction of the altar is somewhat smaller than the flan of the sesterce used for the depiction of the altar at Tarraco. This difference in size may have affected the degree of detail permitted the die cutter, whose cut images would always bear a one-to-one relationship with the struck coin.

The altar consists of a central block framed by a top cornice molding and a stepped platform. The central block is divided into vertical units of closely set vertical lines separated by large blank spaces. Though there is some variation due to different dies and to careless striking, it would appear that the sides of the block are to be read as highlighted by the grouping of vertical lines and that another grouping is to be read as occupying the midpoint. On some of the strikings, horizontal lines, also in a tight group, divide the upper half of the other two blank areas on the front block, and beneath each of these horizontal groups there appears to be a circle. Beltrán Martínez has interpreted the image as representing an altar with two doors set between

there is no clear indication that the preserved temples were those dedicated to the Imperial Cult; the argument becomes circular.

18. Price 1984, pp. 54–55.

19. Beltrán 1976b, pp. 93–105; Gil Farrés 1946, pp. 209–248.

20. Gil Farrés 1946, nos. 149–155; Burnett, Amandry, and Ripollès 1992, nos. 28, 34, 35, 36, 46.

framing pilasters, and separated by a pilaster. From the top of the flat cornice there are small arcs, three on each side, which Beltrán Martínez has read as palms.[21] The reverse also carries the legend in exergue PROVIDENT. PERMI AVG. or variants.

The obverse for this series is the radiate crowned head of Augustus with variations of the legend DIVVS AVG. PATER C.A.E.[22] Beltrán has dated the coin issue as Tiberian. He has argued that it was one in a series of coins struck by the mint at Augusta Emerita with reverses that featured monuments or aspects of the city: the city gate, a tetrastyle temple, and the legionary eagle (referring to the veterans' foundation).[23] It would seem reasonable to assume that the altar represented on the reverse reproduces in some manner an actual altar in Augusta Emerita dedicated to Augustan *providentia*. It might be assumed that the earlier altar at Tarraco spawned an imitation at this other provincial capital. However, it might also be argued that this altar dates to after the official recognition of the cult to the Divine Augustus in the West by Tiberius in A.D. 15.

TEMPLES, IMPERIAL CULT, AND STYLISTIC INFLUENCES

Tarraco

By the beginning of Tiberius's reign Tarraco and perhaps Augusta Emerita had well-established municipal cults dedicated to the Emperor Augustus with a ritual centered around an altar. In A.D. 15 an embassy of citizens from Tarraco appeared before Tiberius requesting permission to erect a temple to the Divine Augustus following the pattern that had been established in the Greek East during the Emperor's lifetime. Tiberius's decision to allow the formal sanctioning of the Imperial Cult in the West must have had some political motivation, for Tacitus clearly records that the temple—and probably the cult practice—was to serve as a model for all the other provinces ("in omnes provincias exemplum"). Tarraco was to be the first western city so privileged.

Tiberius initiated in Rome the official cult of the *divus Augustus*, to be served by a *flamen*, and the first temple for it stood on the Palatine. There was a feast day approved and a college of *sodales Augustales* established whose members came from the *gens Iulia*.[24] The approval of the temple and cult at Tarraco carried the cult out of Rome into the provinces.

21. Beltrán Martínez 1980, p. 138; Beltrán 1953, p. 55.

22. Guadán 1980, nos. 997, 1001, 1002, 1003. For 1003, Guadán has argued that the features of Augustus seem to resemble those of the young Tiberius.

23. Beltrán 1976b, p. 97.

24. Tacitus, *Ann.* 1.54: "Idem annus novas caerimonias accepit addito sodalium Augustalium sacerdotio. . . ." Idem, *His.* 2.95. Fishwick 1978, p. 1211.

Though its earliest form as a state-sponsored cult in Tarraco is not known from the archaeological or epigraphic record, the epigraphic evidence testifies that by the mid–second century the priesthood in Tarraco was the most diverse in the Iberian provinces. Étienne has shown that several priestly titles existed—in certain cases, more than a single title for the same priesthood.[25] From quite early on the cult must have come to play a role in the *cursus honorum* of Tarraco's and Tarraconesis's elites, which might well explain the complexity of the priesthood. For the elite of the provincial capital there were two cults that must have been interwoven, a municipal and a provincial. Quite immaterial of the newly sanctioned cult's role in the larger state-sponsored propaganda, it had an important local aspect. The priesthoods of the Imperial Cult offered the final stage in the development of a local career for a member of an elite family. A priesthood usually capped a civic career.[26] The priesthoods may have had particular significance since so few of the Iberian elite elected to pursue their fortunes in Rome but chose to remain on the peninsula.[27] The priesthoods, and particularly those associated with the Imperial Cult, served to bind together the active agents of the local society and tied them into a larger system that eventually included the entire Roman world and ultimately led back to Rome itself. For the deserving freedmen, who were so essential to the economic well-being of the city, was reserved the priesthood of the *sevirate*, and though they were denied the chance of wielding local power through the magistrates or senate positions, there was some recognition of social status for successful freedmen. The higher priesthoods were usually held by former magistrates; thus their service and rank were publicly acknowledged.

The potential significance on a local level of an Imperial Cult was understood by the ambassadors from Mytilene who petitioned Augustus at Tarraco. They were high-ranking men of local importance.[28] Augustus himself must have appreciated how the cult might function when he encouraged and fostered the formation of the ritual around the Altar of Roma and Augustus at Lugdunum, for the ceremonies were held by the Celtic chieftains, and the altar itself was inaugurated by Drusus (Cassius Dio, 54.32.1). The spontaneous Iberian cult that developed around the altars may have been a Romanized version of an older native practice of worshiping or honoring through deification superior warriors and leaders.[29]

The temple built at Tarraco after A.D. 15 was, therefore, significant to the city as a statement of local prestige and recognition by Rome of the city's importance, as a physical manifestation of the goal aspired to by members of

25. Étienne 1958, p. 163. 26. Curchin 1990, pp. 43–45.
27. Ibid., p. 49.
28. Among the group was the poet Criagoras; Bowersock 1965, p. 36.
29. Étienne 1958, pp. 75–118.

the local elite, and as an architectural statement—a display of the city's resources. There is no evidence of specific patronage, though there is an inscription from the second century A.D. that records a curator—here probably a caretaker, not a commissioner:

C(AIO) CALPURNIO

P(ubli) f(ilio) Quir(ina tribu) Flacco
flam(ini) p(rovinciae) H(ispaniae) c(iterioris),
curatori templi,
praef(ecto) murorum,
col(onia) Tarr(aconensium) ex d(ecreto) d(ecurionum).
C(aius) Calpurnius Flaccus
honorem accepit,
impensam remisit.[30]

The role of the *cursus honorum* was in part to encourage the local elite to spend their resources for the benefit of their cities, and that is reflected even in the charter for Colonia Genetiva Iulia (Osuna), the ancient Urso refounded as a Roman colony by Caesar.[31] From all appearances the temple and cult were not imposed on Tarraco, and therefore it would seem likely that Tiberius required that the city itself pay for the monument.

As a provincial capital, Tarraco must have had within its elite stratum a fair number of resident foreigners who served in the governor's entourage and who may or may not have interacted with the local aristocracy. Tarraco, once a native settlement (Kese), had continued to gain importance during the Republic and early Empire; its upper echelon must have been composed of a complicated mixture of native aristocracy, successful Italian immigrants, and officials in the governor's court, though how these strands were interwoven is not clear. It has been suggested not only that the indigenous elite continued to be important into the Principate but that it may have been from this group that the western provincial senators were recruited for the Senate in Rome rather than from the discharged soldiers or impoverished civilians who formed the ranks of the colonists.[32] However, the presence of such a heterogeneous population forming the elite element must have provided the city with a much more cosmopolitan flavor than might have been found at Saguntum or a new foundation like Augusta Emerita. Moreover, the city's role as a major east-coast port for the peninsula, a role it had begun to assume during the Republic, automatically joined Tarraco

30. *CIL* II, 4202; Alföldy 1975, no. 264.

31. Curchin 1990, pp. 106–108. At Urso magistrates had to pay for games and theatrical performances (*Lex coloniae Genetivae Iuliae sive Ursonensis* [*ILS* 6087]).

32. This idea has been promoted by Syme; R. Syme, *Tituli* 5 (1982), pp. 518–519. Curchin (1990, pp. 48–49) has expressed some doubt.

into a network of coastal trading cities in the Empire, which included some of the most sophisticated and wealthy cities of the ancient world.

Three questions revolve around the temple at Tarraco: (1) What did it look like? (2) Where was it built? and (3) When was it built?

Appearance. No foundations for the temple have yet been found. At best, there survive some possible architectural fragments that have been discovered throughout various sectors of the old city over the last two centuries, and these have been attributed to the superstructure of the temple. However, two series of coins struck by the city's mint during the reign of Tiberius appear to portray the temple. The two series are slightly different. One is a small issue of dupondii (pl. 36). The reverse shows an octastyle temple raised on a high podium approached by a single flight of stairs. This image is paired with a single obverse type: a seated figure wearing a radiate crown and holding a scepter.[33] That the seated figure is the Divine Augustus is assured by the legend DEO AVGVSTO on the obverse. This may represent the cult statue placed within the temple, which according to the reverse legend, CVTT AETERNITATIS AVGVSTAE, must be the temple approved by Tiberius. The series was short-lived to judge from the small number of surviving examples of the coin and from the fact that the series contained only the single obverse and reverse types.

A second series of large coins, sesterces, was also struck (pl. 37). This series included a reverse type of an octastyle temple, but the temple stands on a low stepped platform, similar to the stepped krepidoma of a Greek peristyle temple. The large flan of the sesterce permitted the die cutter a larger field in which to place the image, and the temple appears broader than the podium counterpart. The temple type is not the only reverse image in the series, which includes two other types: an altar with the legend CVTT (Colonia Vrbs Triumphalis Tarraco) and a crown or wreath encircling the letters CVTT. There are four obverse types that can be paired with any of the three reverse types: a profile head of Tiberius wearing a laurel crown encircled by the legend TI CAESAR DIVI F. AVGVSTVS, a profile head of Augustus with radiate crown with the legend DIVVS AVGVSTVS PATER, an Augustus seated on a curule chair with a Nike resting on his outstretched right hand, and, a variant of the latter, an Augustus seated on a throne with right hand outstretched to support a Nike, the latter two carrying the legend DEO AVGVSTO.

The altar reverse image is that already discussed and must reference the famous altar in the city. The octastyle temple reverse carries the legend AETERNITATIS AVGVSTAE CVTT and therefore must also represent the

33. Burnett, Amandry, and Ripollès 1992, no. 224.

temple dedicated by the city to Divine Augustus. The wreath that encircles the CVTT could be of either laurel or oak, both attributes associated with Augustus,[34] and the CVTT might be a reference to Augustus's act of raising the city's status. All the obverse and reverse types play on Augustus and his association with the city; even Tiberius wears the same laurel crown. The interchangeable nature of the obverse and reverse types would indicate that the entire series needs to be treated as an entity. The temple image cannot be separated from the series, as has been the tendency.

All studies of the Tarraco temple rest on the coin representations and the Tacitus citation. There is general recognition that the two temple images are not the same, though generally the significance of the difference has been ignored.[35] Puig i Cadafalch merely noted the points shared between the two images—octastyle format, high pediment decorated with a circle probably intended to represent a *clipeus*, acroteria that he thought were palmettes, and flared capitals on the columns indicating that they were Corinthian.[36] Interestingly, when he illustrated his discussion of the temple with a reconstruction drawing, he favored the podium image with its frontal staircase even though he did illustrate both coin temple types.[37] In his 1953 study of architectural images on Roman Iberian coinage, Beltrán Martínez described the differences between the two temple portrayals. He decided in favor of the high podium temple, which was the more common type of Roman temple, and argued that the other image must have represented a simplification on the die cutter's part.[38] He questioned the notion that the order was Corinthian, instead favoring the Composite order, with the columns seated on Attic bases. His views remained the same in his 1980 study.[39] F. de Asís Escudero y Escudero discussed the two representations, mentioning that the high-podium type, though reproducing the normal Italic-Roman temple form, was more likely a variant of the peristyle version since in terms of coin images the podium-temple format could be paralleled by only one other image on an Iberian coin, a variant of a temple image from the mint at Augusta Emerita (pl. 38). The normal temple format for the Iberian coinage, as seen on examples from Caesaraugusta (pl. 39), was a low platform onto which the temple was placed. Moreover, he expressed his doubts about the specificity of Beltrán Martínez's attribution of the Composite order.[40]

34. Laurel was a symbol of Apollo, and before Augustus's home on the Palatine the Senate had ordered laurel trees planted (*Res Gestae*, 34); Zanker 1990, p.92.
35. The one exception is Woods (1975, pp. 345–354).
36. Puig i Cadafalch, Figuera, and Goday 1934, p. 103.
37. Ibid., figs. 101, 102. 38. Beltrán 1953, pp. 61–62.
39. Beltrán Martínez 1980, p. 137.
40. Asís Escudero y Escudero 1981, p. 180.

The two Tarraco coin images cannot be regarded as variants of one another. There is a fundamental conceptual difference between a temple on a high podium with a central staircase and one set on a low platform without specific means of entrance. Asís Escudero y Escudero's point about the novelty of the podium representation among Iberian coin types is significant. Woods caught the importance of the distinctions in his 1975 investigation of the temple. He was the first to see the existence of a real series with a possible internal chronology that could be reconstructed. He contended that the coins were struck over the period of time during which the temple was planned and executed, and argued that the first three strikings portrayed the peristyle or low-platform temple. This image reflects the planned temple. The final striking showed the podium temple and was a portrait of the temple as finally built.[41] Certainly Roman mint masters were not averse to striking images of conjectural buildings,[42] and indeed several of the temple representations from the coinage of southern Spain are best understood as depictions of planned structures rather than portraits of standing buildings.[43]

Woods offers the best explanation for the difference between the two images. Obviously, arguing that the two images are somehow just variations made by different die cutters will not work. The differences are too great to be explained as the result of different interpretations of the same prototype. If a temple that these images represented stood in Tarraco, then it is difficult to believe that two die cutters would see so totally different and actually quite opposed visions of an existing building. Certainly the mint master, if not the die cutters, would have known whether or not the temple stood on a high podium. Woods's idea that one image reflects reality and the other an unbuilt structure merits further consideration.

What Woods did not investigate was the relative importance of the two series; in fact, he considered both images part of the same series. Size alone, however, indicates that such cannot be the case. The podium-temple type is paired with only one reverse type, the seated Augustus. The coin is a dupondius, and the average weight of these coins is 16 g. The low-platform or peristyle type is one of three reverse types that can be paired with any one of four obverse types. These coins are sesterces with an average weight of 23 g. Moreover, coins in the peristyle-temple series are more commonly found in coin collections than is the podium issue, suggesting that the former was the larger and perhaps more significant series.

Asís Escudero y Escudero is correct in stressing the unusual aspect of the podium portrait; variation among images is minimal and focuses mainly on

41. Woods 1975, pp. 349–352.

42. Prayon 1982, pp. 319–330.

43. Mierse 1993b, pp. 37–57.

the placement of the legend surrounding the temple. It must also be noted that the peristyle-temple treatment is equally as detailed. There are differences in specific renderings of the peristyle image that can be attributed to different die cutters, but again these differences are found in the exact placement of the letters of the encircling legend, the rendering of the pedimental ornament, and the specificity of the entablature decoration. The identifying elements of the temple itself—the octastyle format, the three-stepped podium with the lowest step being the largest, and the flare of the column capitals—never vary. There is no evidence for shorthand or sloppy rendering of these features.

But the two temple images do not function in the same manner. The podium temple stands alone. The peristyle image belongs to a larger series that celebrates Tarraco and its position within the new Augustan order. The city's title, CVTT, is proudly emblazoned on the reverse field with the emblems of the city's association with Augustus: the altar, the temple, the laurel or oak wreath. The city celebrates its historical ties with the Princips: site of the first municipal cult to the Emperor in the West, site of the first provincial cult and temple to the Emperor in the West. The series honors Emperor, Empire, and city. The series is too politically important to have included an image of the never-built temple. This series is a numismatic program, as carefully thought out as any propagandistic sculptural program. The reason for the striking could only have been to place the final element, the temple itself, into a context. Certainly Tarraco could have had two temples to the Imperial Cult, one a podium type, the other a peristyle form, and with the inclusion of the altar, which must have still been standing, there would have been three areas devoted to the worship of the Divine Emperor. This sounds like too much so early in the development of the cult. Woods is right: one of the temple images is not valid. But it is the podium type, not the peristyle form, that belongs to the category of planned designs.

The two images raise an additional, and more perplexing, problem. It is possible to argue that the podium design was dismissed in favor of the peristyle, which was built, but the coins supply no rationale for the rejection. The portrait of the podium facade captures the essence of an Italic-Hellenistic temple of the first century A.D. and could easily be the representation of the temple of Augusta Emerita, of Barcino, or of Ebora, were any of these octastyle. The image in no way indicates how the side and rear colonnades stand atop the podium. It is worth noting that the three existing peristyle temples have been adjudged to have been dedicated to the Imperial Cult, and considering their physical importance within their respective cities, the attributions are probably justified, though as it was argued in the previous chapter, the dedications must have occurred at a later date since the temples are best seen as Augustan in origin. Indeed, if Tiberius did intend that Tarraco's temple would spark a spate of such cultic spaces in the Impe-

rial provinces of the West, then it would have been perfectly sensible to permit or even encourage less affluent towns, like Ebora, Barcino, and probably Augusta Emerita, to rededicate existing temples to the new cult, especially since the cult needed privileged space within the city if it was to function properly for the local elite. In small cities the amount of important space was limited, as well as the resources needed to build on a monumental scale. The tetrastyle temple image on the smaller Augusta Emerita coin,[44] which has already been mentioned in connection with Asís Escudero y Escudero's analysis, is rendered in both the treatments in a most abbreviated form and could reflect the attempt to symbolically indicate the change in status of the existing temple (the Temple of Diana?).

It is also quite possible that a temple similar to those at Augusta Emerita, Barcino, and Ebora also stood in Tarraco on the forum of the city, which was remodeled under Augustus.[45] Though no traces of such a temple have been found, it is unlikely that the major city forum would have stood without a temple, especially considering the standard pattern on the Iberian Peninsula during the Augustan period (supra). The podium issue would reflect the first decision on the part of the city's elite to rededicate the forum temple to the new Imperial Cult.

Augusta Emerita may have moved faster than Tarraco and, following Tiberius's intent, quickly rededicated its temple, an event symbolically honored with a coin that records the new dedication but not the specific nature of the temple. If Asís Escudero y Escudero is correct in dating the podium issue at Tarraco to no earlier than A.D. 22,[46] then a lag of seven years occurred between the time of Tiberius's approval and the first manifestation of the new cult at Tarraco. Asís Escudero y Escudero has cited as a model for the seated Augustus in the curule chair on the obverses of both the podium and peristyle series a similar treatment of Tiberius on a coin issued out of the mint at Rome that can be dated to A.D. 22.[47] The observation is sound, but if the coins are broken into two series it becomes apparent that the Augustus on the curule chair is one of several obverse types on the peristyle series.

The seated Augustus in the curule chair from the peristyle series (pl. 40) tends to be a cleaner image than that from the podium issues. This treatment of Augustus is remarkably close to that of a seated Tiberius from the reverse of a special striking of sesterces from the mint of Rome to celebrate

44. The coin is an *as*, smaller than either of the Tarraco coins. For the common low-podium image see Guadán 1980, no. 1011. For the variant with higher podium and frontal stairs see the discussion in Asís Escudero y Escudero 1981, pp. 180–182.

45. Hauschild 1976b, p. 214. For excavations and work on the lower forum see Serra Vilaró 1932; for a synopsis of excavations see Koppel 1985b, pp. 45–48.

46. Asís Escudero y Escudero 1981, p. 178.

47. Ibid., p. 178 n. 3.

the Emperor's aid for the rebuilding of the cities of Asia Minor after the earthquake of A.D. 17 (Tacitus, *Anal.* 2.42; see pl. 41). Tiberius is portrayed with his left arm raised, the hand grasping a staff, and his right arm extended with the hand holding a *patera*, and the encircling legend reads: CIVITATIBUS ASIAE RESTITVTIS. This image can be dated from the obverse legend, which reads: TI CAESAR DIVI AVG F AVGVST PM TR POT XXIIII. Tiberius celebrated his twenty-fourth *Tribunicia Potestas* in A.D. 22–23. C. H. V. Sutherland[48] has maintained that all the coins carrying the legend TR POT XXIIII must have been struck in that year, whereas M. Grant[49] contends that coins with that legend were issued as late as A.D. 29. The seated Tiberius comes from the Civitatibus Asiae series, and probably dates to A.D. 22–23.[50] So both the podium and peristyle issues were not struck before A.D. 22.

The profile head of Augustus from the peristyle series (pl. 42) can also be related to issues from the mint of Rome that carry the Tiberian legend TR POT XXIIII known as the DIVVS AVGVSTVS (Divus Augustus) type (pl. 43).[51] The Divus Augustus type is long-lived. One of the issues pairs a profile Augustus head with an altar reverse. Though the altar does not at all resemble the altar from the peristyle issue, the head does bear similarities with the profile Augustus and Tiberius heads from the peristyle issue. The diagonal line terminating the bust extends below the line defining the throat. The necks are elongated, and the facial features are modeled so as to soften the visages. The eyes are deeply set. The hair falls in comma-shaped curls above the nape of the neck and is brushed away from the brows. This particular profile head from the Divus Augustus group is acknowledged to be a later image,[52] and the SC on the reverse indicates that it could not have been struck at Rome before A.D. 22–23.[53]

The peristyle series is stylistically tied to the Tiberius issues from the mint of Rome. The associations further testify to the importance of the peristyle issue. If time is allowed for the dispersal of the types from the mint at Rome to the provinces, then it may be possible to posit a date of ca. A.D. 24 for the peristyle issue. The podium issue was slightly earlier, perhaps A.D. 23.

The suggestion that the low-platform peristyle-temple image actually represents what was built in this western provincial capital and that in this in-

48. Sutherland and Carson 1984, p. 88.

49. Grant 1946, pp. 447–448.

50. Sydenham and Mattingly 1923, p. 105, no. 19; Robertson 1962, p. 67, no. 15; Sutherland and Carson 1984, p. 97, no. 48.

51. Laffranchi 1910, pp. 1–11; Sydenham 1917, pp. 258–278; Sutherland 1941, pp. 97–116; Sydenham and Mattingly 1923, pp. 93–97.

52. Sydenham 1917, p. 267; Sutherland 1941, p. 106.

53. Grant 1946, pp. 447–448.

stance the low podium is intended to portray a peripteral temple is startling. It suggests that the city fathers rejected an Italic temple type in favor of a more Greek peripteral form. The delay in construction of up to seven years after Tiberius had approved the temple may have permitted other Iberian cities to rob Tarraco of her glory. The city fathers may have decided to make their statement architecturally. An octastyle peripteral temple would have been a most distinctive structure.

Vitruvius (3.2.7) points out that dipteral temples are usually octastyle. Puig i Cadafalch revived the Vitruvian point and suggested that the Tarraco octastyle temple may well have been dipteral.[54] If Puig i Cadafalch is correct, then the design for the Tarraco temple would ultimately be tied to Hellenistic designs from Asia Minor, where the dipteral temple was most at home. In choosing a Hellenistic type with known Asian roots, the city fathers of Tarraco may have been intentionally following the stylistic pattern used by those cities of Asia Minor that had been granted permission almost half a century earlier to honor the Emperor with such massive displays. The temple that Pergamon built was, to judge from the coin image, a peripteral temple of standard Hellenistic type raised on a high krepidoma.[55] It may well have been this temple that the embassy from Baetica cited as the example they wished to follow in honoring Tiberius (Tacitus, *Anal.* 4.37).

The elite of Tarraco knew about the sanctioning of the cult in the East; a copy of the Mytilene decree had been set up in Tarraco and must have been on public display. Moreover, the embassy from Mytilene had come to have their audience with Augustus in Tarraco.[56] The choice of the seated-Tiberius type from the Civitatibus Asiae series could have reflected a conscious desire to join with an iconographic program that centered on the old Hellenistic Greek world of Asia Minor. The force dictating this interest was competition. As residents of a recently elevated capital city with a resident governor and his court, a city that was also a wealthy port, Tarraco's elite may have wished to make an architectural statement that befitted their new rank.

Placement. There is no doubt that a temple was built. The *SHA:Hadrian* records that it was restored by the Emperor Hadrian when he wintered in Tarraco.[57] The curator for the temple under Hadrian, Caius Calpurnius Flaccus, is recorded in an inscription from the site.[58] When he was praetor,

54. Puig i Cadafalch, Figuera, and Goday 1934, p. 101, fig. 102; p. 103. Asís Escudero y Escudero (1981) notes that the coin image is not adequately detailed to support such a reconstruction.

55. Fuchs 1969, fig. 77.

56. Puig i Cadafalch, Figuera, and Goday (1934, p. 102 n. 2 [citing Hübner 1888, p. 248]) refer to an inscription at Mytilene that records the temple at Tarraco.

57. *SHA: Hadrian* 12.4. 58. Alföldy 1975, no. 264.

Septimus Severus also repaired the temple.[59] The epigraphic evidence for the Imperial Cult at the site is also abundant.[60]

The location of the temple has been debated since the seventeenth century, when the local antiquarian L. Pons de Icart placed it in a position between the high city of the Gothic cathedral and the port. Later, he changed his mind and considered that such a major temple must have stood where the cathedral now stands on the highest ground.[61] This question of location has continued to plague investigators.[62] Throughout the eighteenth and nineteenth centuries impromptu excavations revealed fragments from large Roman structures, several of Italian marble, and these have come to be associated with either the Altar of Augustus,[63] the Temple to Divine Augustus, or the Temple of Jupiter, the other large temple at Tarraco. B. Hernández Sanahuja noted that all the architectural fragments had come from the vicinity of the cathedral, and concluded that the city's most important temple, that of Augustus, must have stood at this point.[64] In his 1929 guide to the ruins of the city, J. M. de Navascués, then director of the archaeological museum, argued that the marble fragments found near the cathedral, which included a composite capital and parts of sculpted reliefs of *clipei* with the heads of Jupiter Ammon in a medallion form, were more probably from a temple to Jupiter, the remains of which had to be under the cathedral.[65] He suggested that the Temple of Augustus may have stood nearby in the area of the Plazuela del Oli, where fragments of marble-relief acanthus scrolls had been found.[66] A. Schulten took this hypothesis much further, producing a plan for the city that showed the general layout of the upper town (fig. 46). The Temple of Jupiter he placed on the highest point, establishing the axis for the city; this is the location still occupied by the Gothic cathedral. The Temple of Augustus was slightly east, though still on a high spot.[67] The two temples shared the upper terrace of the city.

The existence of a Temple of Jupiter is recorded in Suetonius (*Galba* 17)[68] and Florus (*Vergilius orator an poeta*). Florus was a friend of Hadrian and resided in Tarraco.[69] There are also two questionable inscriptions, one

59. Hernández Sanahuja 1944, p. 28.
60. *CIL* II, 4225, 4226, 4262, 4279, 4287, 4288, 4289, 4292, 4294, 4300, 4303, 4536.
61. Pons de Icart 1572, pp. 224–225.
62. For a review of the early literature see Hernández Sanahuja 1944, pp. 30–31.
63. Albertini 1911–1912, nos. 120–121.
64. Hernández Sanahuja 1944, p. 33.
65. Navascués 1929, pp. 17–19. For the fragments see Albertini 1911–1912, no. 122. For the composite capital see Strong 1960, pp. 119–128.
66. Albertini 1911–1912, no. 119.
67. Schulten 1948, p. 43.
68. *Galba*, 12: "quodque oblatam a Tarraconensibus e vetere templo Iovis coronam auream librarum quindecim conflasset ac tres uncias. . . ."
69. *OCD*, s.v. Florus.

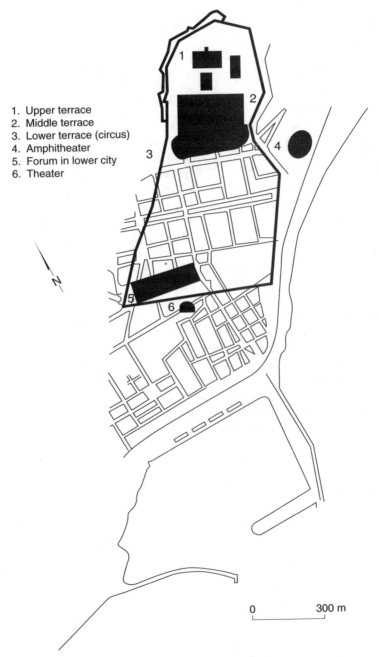

1. Upper terrace
2. Middle terrace
3. Lower terrace (circus)
4. Amphitheater
5. Forum in lower city
6. Theater

0 300 m

Figure 46. Plan of modern Tarragona, with ancient
monuments marked according to Schulten (after
Pujol in Schulten 1948, plan 1)

of which may reference a "porticus Jovis."[70] The Suetonius reference indicates that the temple was of some age by the end of the first century A.D. The Florus source is perhaps the most interesting. According to the author, Jupiter brought Europa to Tarraco, and a cult to the African god Jupiter Ammon was established. Puig i Cadafalch thought that the cult may have spread as far south as Valencia.[71] Puig i Cadafalch, following Navascués and Schulten, argued that the Temple of Jupiter lay under the cathedral and the Temple of Augustus elsewhere on the upper terrace. He attributed the sculpted friezes of garlands with implements of sacrifice and the *clipei* with heads of Jupiter Ammon to the Temple of Augustus.[72]

Woods reviewed all the theories proposed through 1975, considered the find spots of all the casual finds, and concluded that a temple stood in the area bounded by the streets San Lorenzo, Santes Creus, Merced, Granada, and Talavera, in which most of the fragments had been discovered. This is the area south of the cathedral, and in it must have stood the Temple of Augustus.[73]

The breakthrough in the investigation came with the publication of Alföldy's major study of the inscriptions from Tarraco.[74] Alföldy was able to discern a clear pattern in the distribution of types of inscriptions in the upper city. Schulten had been the first to realize that the upper city, the old city, had in fact been composed of three great terraces (fig. 46). He wanted to place the two temples on the top terrace. The second terrace, the larger, he reconstructed with a forum and praetorium, while the lowest level had the circus. The basic arrangement can still be discerned in the modern layout, and excavations in the 1960s and 1970s revealed much more detail about the terrace pattern.[75] Alföldy's analysis showed that the upper terrace contained inscriptions that belong to the provincial Imperial Cult. Here the Emperor had been honored by all of Tarraconensis. The second terrace contained the municipal honorific inscriptions. The city celebrated the Divine Emperor, continuing the cult begun in the late first century B.C. at the altar. Therefore, the only temple that should dominate the upper terrace, and the entire composition, must be that of the Imperial Cult.

However, although Hauschild was willing to assume that the great terrace composition dated to the same period as the establishment of the cult itself,[76] the evidence from the excavations of the 1980s[77] in the upper terrace

70. *CIL* II, 3729; Schulten 1948, p. 41 n. 2.
71. Puig i Cadafalch, Figuera, and Goday 1934, p. 106.
72. Ibid., pp. 104–105. 73. Woods 1975, pp. 346–351.
74. Alföldy 1975.
75. Hauschild 1972–1973, pp. 3–44; Recasens 1966.
76. Hauschild 1976b, p. 217.
77. TED'A 1989, pp. 141–191; Dupré i Raventós 1987, pp. 25–30; Aquilué 1987, pp. 165–186. Also see discussion in chap. 5 infra.

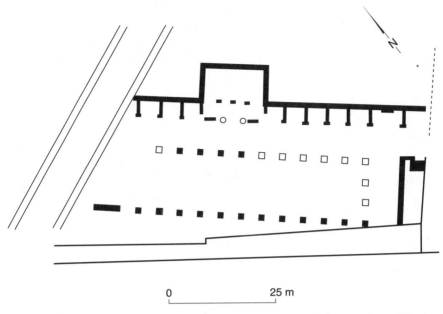

0 25 m

Figure 47. Plan of the lower forum at Tarraco by Serra Vilaró (after Serra Vilaró 1932, figs. 1 and 24)

region suggests that actual building did not take place until the second half of the first century A.D. Yet there is another option. The city possessed a forum in the lower city (fig. 47). The date for its construction is not certain. J. Serra Vilaró, who excavated the area, revealed structural remains that he interpreted as a forum and a curia.[78] He unearthed a rectangular space with an interior colonnade that defined a central spatial unit 14 m × 60 m. The ratio is ca. 1:4, which Puig i Cadafalch found unusual for a forum.[79] He suggested that instead these were the remains of a single building rather than a forum, and probably those of a macellum. Recently R. Cortés, as well as R. Mar and J. Ruiz de Arbulo, has reconsidered Serra Vilaró's findings and has offered a different reading—that these are the remains of a basilica (fig. 48), not of the total forum.[80] If this newest understanding of the area is correct, then the forum itself may have spread out from the basilica. The forum space proposed by Serra Vilaró does seem too small for a city as important as Tarraco. What is not yet known is the position of this possible

78. Serra Vilaró 1932.
79. Puig i Cadafalch, Figuera, and Goday 1934, pp. 237–238.
80. Mar and Ruiz de Arbulo 1987, p. 40.

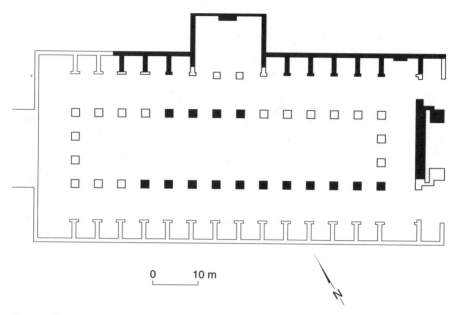

Figure 48. Remains of the lower forum at Tarraco reinterpreted as a basilica (after Cortés 1987, fig. 5)

basilica on the forum itself. Did it sit on one of the two longer sides in a manner similar to the Augustan designs, or did it dominate one of the two small sides, forming one of the boundaries?

Cortés, Mar, and Ruiz have taken their interpretations a bit further. They have argued that the larger rectangular space that juts out of the north wall, which Serra Vilaró thought to be the curia, was rather the space intended for an *aedes Augusti*. As such, it could have held the famed Altar to Augustus, though at present there is no archaeological evidence to support such a view. In this newest interpretation, the forum did not possess a temple; the annex to the basilica provided the cultic focus, in an arrangement similar to the one that Roth-Congès proposes for the original design of the forum at Conimbriga.[81]

A date for the design of this lower forum has not yet been determined. E. M. Koppel has suggested that a group of sculptures—probably on view in the courtyard to the east of the basilica, which was possibly the formal entrance to one of the short sides—formed a series of Imperial portraits of

81. Roth-Congès 1987b, pp. 711–751. See also discussion in chap. 2 supra (n. 128).

the Julio-Claudian line[82] and could provide a Claudian date for the complex. Based on stylistic criteria, Recasens i Carreros also has given a mid-first-century A.D. date to the two Corinthian capitals that were found in the ruins (pl. 54).[83]

Although a mid-first-century date may suit the actual remains so far unearthed, it does not seem appropriate for a forum for a major city such as Tarraco. It seems difficult to accept that the city had to wait until the Claudian period before it could boast a standard feature of Roman urban design. Moreover, if the annex did enclose the Altar to Augustus, then it must have been constructed around an already existing structure, since the altar can be dated to the reign of the Emperor. Excavations in the lower city have revealed finds of Iberian ceramics that can be associated with the late-Republican occupation. The area, which later held the possible basilica, was in use during the first century B.C.[84] Alföldy has argued that there was a forum present in the lower city by the beginning of the Imperial period that replaced an earlier open area. He has identified two early inscriptions as coming from this forum.[85]

An early Augustan date seems perfectly plausible. The change in the city's status would have demanded such a feature, if one did not already exist. If the Claudian basilica occupies the space of an earlier Augustan basilica, for which no evidence exists, then the rest of the forum must stretch either east or west. If it occupies one of the short sides—the more traditional position for Claudian-period basilicas on the peninsula[86]—then the forum is either north or south of the remains. It is certainly possible that the annex to the basilica created a new formal setting for the Altar of Augustus, which had stood perhaps in a more open setting in the earlier forum.[87] But does that mean that the forum lacked a temple? There are examples of fora without temples in the West, but they are not the norm, and if the Tarraco forum dates to the Augustan era, then the models, both Republican and Augustan on the peninsula, would seem to have included temples. Moreover, it is hard to imagine that the new capital of the province of Tarraconensis would not have built a temple on its forum to rival that which was being built during these same decades on the forum at Narbo (Narbonne), the capital of Gallia Narbonensis.[88] Possibly the octastyle temple on a high podium that deco-

82. Koppel 1985a, pp. 841–856.

83. Museo Nacional de Arqueología de Tarragona, inv. 34.245, 34.246; Recasens i Carreros 1984, pp. 324–325.

84. Aquilué i Abadías and Dupré i Raventós 1986, p. 11.

85. Alföldy 1975, nos. 1, 2.

86. For a discussion of Belo see chap. 4 infra.

87. Fishwick 1982, pp. 223–233.

88. Solier, Janon, and Sabrié 1986, pp. 41–46.

rates the reverse of the Tiberian dupondius from Tarraco represents this temple. Its image appears strikingly like that of the temples at Augusta Emerita, Barcino, and Ebora, and could indicate that, like them, it too is of Augustan date. The original plan may have been to rededicate this temple to the new provincial cult, and both provincial and municipal cults would have been served by spaces on the main forum of the city. It was only when Augusta Emerita made just such a rededication and began the process of creating a formal Imperial Cult space around the Temple of Diana [89] that the elite of Tarraco changed their minds, opting to seek an alternative position for the temple and a different structural type for the building.

The place most likely to be chosen once the forum had been deemed unsuitable would be a high point overlooking the city. In such a position the temple would announce the importance of the cult. The Gothic cathedral occupies just such a spot. The excavations by Sánchez Real in the cloister of the cathedral revealed that by the Claudian era there was noticeable activity in this area, which was seemingly ignored during the Republican and Augustan periods. The lack of evidence of Augustan use rules out the possibility that the altar stood at this point.[90] In level H, Sánchez Real found some possible material of Tiberian date, albeit questionable, and in level G there was a Tiberian coin. This was not enough to convince Sánchez Real that work initially began in this region of the upper city during the later first quarter of the first century A.D.,[91] but in his analysis of the lamps found in level H, C. Rüger thinks that there is enough evidence to posit that something was happening at the spot as early as the Tiberian period.[92] The evidence of Tiberian activity is admittedly minimal—a few fragments of a variety of ceramic types and one coin from the level above—and, moreover, mixed in with the possible Tiberian items are Claudian pieces. The results of these excavations in the cathedral would suggest that work began in earnest only in the Claudian period. More recently, excavations in the upper city have confirmed Sánchez Real's findings, and the excavators have stressed that real building activity on this high point did not get under way until the Flavian period.[93]

On the heights have also been found some sculptural fragments of three *clipei*, two with heads of Jupiter Ammon framed by a serpentine-and-tongue pattern. The third *clipeus* held the head of Medusa. The fragments were not found in their original position.[94] There is no evidence that such imagery

89. Alvarez Martínez 1984, p. 49. 90. Sánchez Real 1969, p. 281.

91. Sánchez Real 1989, nos. 264, 265, 269, 271.

92. Rüger 1968, pp. 237–258.

93. Aquilué 1987, p. 173; Aquilué i Abadías and Dupré i Raventós 1986, pp. 16–17; TED'A 1989, pp. 158–159.

94. Hernández Sanahuja and Morera Llauradó 1894, p. 18; Hernández Sanahuja 1885, p. 231.

must belong to a Temple of Augustus, and there have been those who have argued that they come from a Temple of Jupiter.[95] However, on the Iberian Peninsula at Augusta Emerita, and elsewhere in the West, the imagery of Jupiter Ammon and Medusa are well known as elements in the Imperial iconography of Augustus,[96] and it is not unjustified to see these tondi as decoration somehow associated with the Temple of Augustus. Koppel has made the most recent stylistic analysis of these remains and has argued that they represent work done in two different periods. One of the heads of Jupiter Ammon is Claudian or late Tiberian, the other Flavian.[97] Her findings bridge the gap between those who would see the reliefs as being completely Julio-Claudian or Flavian.[98] A date in the Claudian period suggests that something akin to the decoration of the forum area around the Temple of Diana in Augusta Emerita was taking place in Tarraco in the same years.

What would seem clear is that the temple actually built to honor Augustus was that which is represented by the low-podium- or peristyle-type temple on the issue of sesterces. This temple was built after an earlier type was considered and rejected. The earlier temple may have been the temple already standing in the lower forum of the city.[99] If such was the case, then the new temple most likely was not constructed in the same area, but was rather located in a new spot atop a high point overlooking the city. Work may have started there at some point during the reign of Tiberius, but was interrupted quite early, perhaps because of the financial crisis of A.D. 33,[100] and work did not really resume again until the Claudian period. The early Tiberian and Claudian phases were concerned exclusively with the temple. The great terrace composition that is the dominant element in the urban plan of Tarraco was not developed until the Flavian period, when the temple was made a feature in a much larger composition.

Bilbilis

The northeast of the peninsula was difficult for the Romans to pacify. This was the territory of the native Celtiberian peoples who had strongly resisted Roman conquest during the second century B.C., leading to the famous siege of Numantia.[101] During the first century B.C. the Roman presence was

95. Albertini 1911–1912, no. 122.

96. Supra, chap. 2; Zanker 1969; Vezàr 1977, 6.34, fig. 7.8; Budischovsky 1973, p. 201. In Spain see Salcedo Garcés 1983, pp. 243–283.

97. Koppel 1990, pp. 338–339.

98. García y Bellido 1949, pp. 425, 515, no. 417; F. Poulsen, *Sculptures antiques de musées de province espagnol* (Copenhagen, 1933), p. 56.

99. The newest guide to Tarragona places the Temple to Augustus on the lower forum; see Aquilué et al. 1991, p. 24.

100. Thornton and Thornton 1990, pp. 655–662.

101. Schulten 1914–1931.

established at Lepida or Celsa, along the Ebro River,[102] while further north older Celtiberian settlements such as Numantia and Tiermes[103] were Romanized during the reign of Augustus.

The site of Bilbilis, 5 km from modern Calatayud, sits on a natural, rocky outcropping overlooking the alluvial valley of the Jalón River, a tributary of the Ebro system, and during the Roman period was at the crossing of the roads from Tarraco to Complutum (Alcalá de Henares) and from Saguntum to Numancia.[104] The pre-Roman city is still not well understood. It does seem that the rocky area was inhabited during the second and first centuries B.C.[105] Archaeological finds and autonomous coinage struck by the city using models of other Celtiberian coin types confirm the presence of a pre-Augustan native population.[106]

The first settlement may have been on the highest point on the outcropping, known as Bámbola or San Paterno, which can be described as an acropolis (fig. 49),[107] but the later development of a sanctuary on a spit of land overlooking the valley, which continued as a sacred spot well into the medieval period (the Ermita of Santa Bárbara),[108] may indicate that even in the pre-Roman town, this area was of religious significance.[109] The Roman city extended down the slopes of the acropolis and onto the somewhat rugged terrain to the east and south. The northern edge was walled straight across from the acropolis to the second height at the northeast limit of the city. Excavations have disclosed bath and forum areas.[110] It is the temple and its platform and nearby theater ensemble that is the most interesting architectural feature of the site.

The terrain of Bilbilis precludes easy access to the site. To the north and west the landscape continues to climb, and to the east and south it drops away sharply to the valley floor. The south side is heavily eroded, but it is here that sometime during the Roman period the natural crevasse of the rock was exploited to hold the cavea of a theater, while the natural spur of jutting rock was extended to form a platform (pl. 44). The middle portion

102. Beltrán Lloris 1985. 103. Ortego 1980.

104. Magallón Botaya 1982, pp. 77–83; Martín-Bueno 1972, p. 112; Rubio 1954, p. 141.

105. Martín-Bueno 1982b, pp. 96–105.

106. Guadán 1980, nos. 532–541.

107. Martín-Bueno 1972, p. 106.

108. Rubio 1954, p. 142, fig. 3. The Hermitage (Ermita) was still standing into this century.

109. For the development of the site see Martín-Bueno 1993, pp. 123–124; idem 1990, pp. 219–239; Martín-Bueno, Cancela Ramírez de Arellano, and Jiménez Salvador 1985a, pp. 255–270; idem 1983a, n.p.; Martín-Bueno and Jiménez 1983b, pp. 63–78; Martín-Bueno 1981a, pp. 29–37.

110. For excavation reports see Martín-Bueno 1982b, pp. 96–105; idem 1975; idem 1973, pp. 591–602. For earlier works see Dolç 1954b, 1954a, 1953; López Landa 1946; Sentenach y Cabanas 1918.

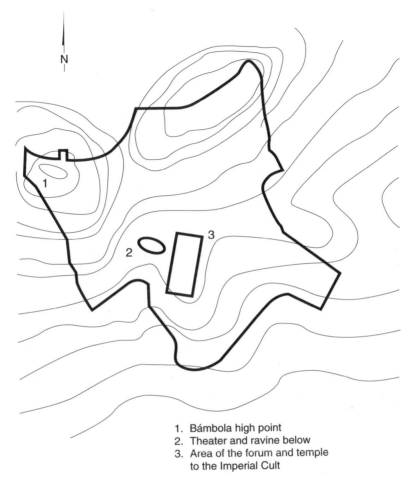

1. Bámbola high point
2. Theater and ravine below
3. Area of the forum and temple
 to the Imperial Cult

Figure 49. Sketch plan of the site of Bilbilis (after Martín-Bueno 1972, p. 121)

of the cavea of the theater is bedded into the natural curve of the landscape. The upper cavea was amplified with concrete construction, and concrete was used to mold the entrances, which provided access to the seating blocks.[111] The orchestra was, however, built atop a fill of concrete and stone 6 m deep that served as the foundation. This impressive mass was used to support the *scaena frons*. From the orchestra fill have come the finds that provide a beginning date for the construction—the late first century B.C. It was at this

111. Martín-Bueno 1982c, p. 84.

point that the city was probably granted the status of a municipium by Augustus, when similar large-scale urbanization programs were being undertaken elsewhere on the peninsula.[112]

It has not been possible to determine the exact completion date for the work. The excavator M. Martín-Bueno has argued from the stylistic evidence of the decorative pieces from the *scaena frons* for a mid-Julio-Claudian date.[113] By A.D. 28 the temple and its platform must have been finished, for an inscription records the dedication to the Emperor Tiberius in his twenty-ninth *Tribunicia potestas*.[114]

Though it is more common for Roman theaters to be built with little concern for the natural condition of the landscape, there are other examples in the West at Clunia, Segóbriga, and Lugdunum (Lyon) of theaters that were designed to exploit the terrain.[115] However, the theater at Saguntum offers the closest parallel to that at Bilbilis. Just as they were redesigning their forum, the city fathers of Saguntum were also seeing to the construction of a theater at the old city. The theater was built in a natural hollow that was partially filled. The finds from the fill offer a late-Augustan, early-Tiberian date for the construction,[116] making it contemporaneous with that at Bilbilis. Like the Bilbilis theater, the structure is partly in concrete (*opus caementicium*). The Saguntum theater was designed to form an element in the urban plan centered on the forum, and was physically joined to it.[117] In this regard it is different from the Bilbilis theater, which was instead an element in a different type of ensemble.

The temple,[118] which overlooks the theater and its associated sanctuary, is the most interesting feature of this architectural complex on the south side of Bilbilis. The sanctuary platform is aligned north-south, parallel to the theater. The elevated spot was further strengthened by means of buttress walls and fill. In this manner, a broad, expansive flat area was formed flanking the east side of the theater but sitting at a higher level than the cavea (pl. 45).

The small cult building, possibly a short, hexastyle Corinthian temple in its first form, though more likely tetrastyle,[119] sat on a raised podium or

112. For the fill see Martín-Bueno 1982c, p. 84. For the status change to municipium see Martín-Bueno 1987, p. 99; idem 1981b, pp. 250–251.

113. Martín-Bueno 1982c, p. 84.

114. Martín-Bueno 1987, p. 109; idem 1981b, p. 252.

115. For Segóbriga see Almagro Basch 1986, pp. 53–63. For Clunia see Palol 1982, pp. 33–34. For Lyon see Wuilleumier 1953, p. 63.

116. Hernández Hervas 1988, pp. 131–132.

117. Ibid., p. 134.

118. For the information on the platform and temple see Martín-Bueno 1987, pp. 103–109; idem 1981b, pp. 248–249.

119. The temple was remodeled during the second century. Initial analysis led to the conclusion that the temple was originally tetrastyle (Martín-Bueno 1981b, fig. 2), but more recently

stereobate, partly cut out of the bedrock, which in turn was enlarged with lockers defined by support walls and fill (pl. 46). The temple may have been peripteral in its initial design. The rear of the temple rested on a solid support wall, a *posticum*, but the side colonnades may have been individually supported, and only later, perhaps in the second-century remodeling, were these column supports joined together into a wall.[120] The present remains of the foundation show two rectangles, a smaller embedded in a larger. These must define the second-century temple. The smaller rectangle is that which defines the cella; the larger, the peristyle. The temple was raised high atop this podium and was approached by means of a large frontal staircase 9.49 m × 7.70 m.[121] This podium did not occupy the total width of the platform, and passageways are to both the east and west sides. A ramp runs to the east to connect the sanctuary with the city proper. The platform itself, which extends out from the temple front, was also carved from the living rock and was, perhaps, the forum for Bilbilis. The way in which the temple was positioned on its high platform with a grand staircase offering entrance and facing a large, open plaza seems to hark back to late-Republican design conceits such as the Temple and Sanctuary of Hercules at Tivoli.[122]

The surviving cuttings show that this forum plaza was fully enclosed on three sides by colonnades. The paved, open space thus defined was almost square, 48.64 m × 44.88 m. The enclosed nature of this area (fig. 50) with its temple at one end and possible basilica on the northwest side[123] is not unlike that at Conimbriga. The resemblance is even closer if the proposed reconstruction of the temple atop an open cryptoportico is correct.[124]

The surrounding porticoes were constructed on top of terraces. On the east side there may have been tabernae that opened onto the forum and that were supported atop a cryptoportico that in turn was supported by a terrace wall.[125] The lower story may well have opened up with views of the landscape below (fig. 51). The southern portion of the platform was extended by a barrel vaulted substructure of concrete which in turn is buttressed with a fill

it has been decided that the temple might have begun as a hexastyle temple (Martín-Bueno, Cancela Ramírez de Arellano, and Jiménez Salvador 1985a, p. 259), though the evidence is not clear on this point (Martín-Bueno 1987, p. 103). See chap. 6 infra for a discussion of the possible changes during the second century.

120. Martín-Bueno 1987, p. 103; Martín-Bueno, Cancela Ramírez de Arellano, and Jimémez Salvador 1985a, p. 259.

121. Martín-Bueno 1987, p. 103.

122. Interestingly, Pfanner (1990, fig. 22) sets this comparison up visually but never addresses it within the text.

123. Martín-Bueno 1987, p. 108.

124. Martín-Bueno 1987, fig. 2, from the west looking east; Martín-Bueno, Cancela Ramírez de Arellano, and Jiménez Salvador 1983a, figure entitled "Reconstrucción hipotética del conjunto religioso de Bilbilis," view from the east looking west.

125. Martín-Bueno 1987, p. 105.

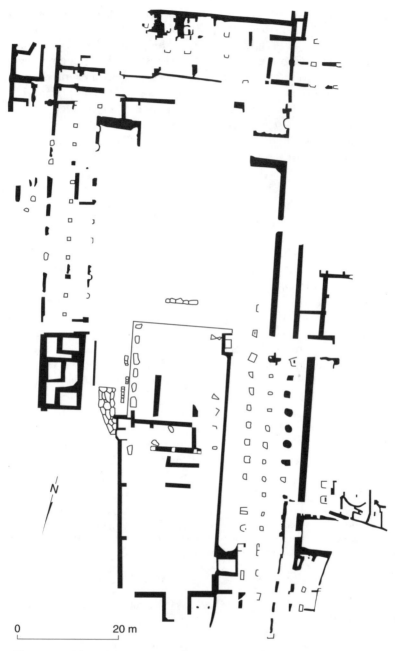

N

0 20 m

Figure 50. Plan of the remains of the sanctuary area at Bilbilis (after Martín-Bueno 1990, plate 60)

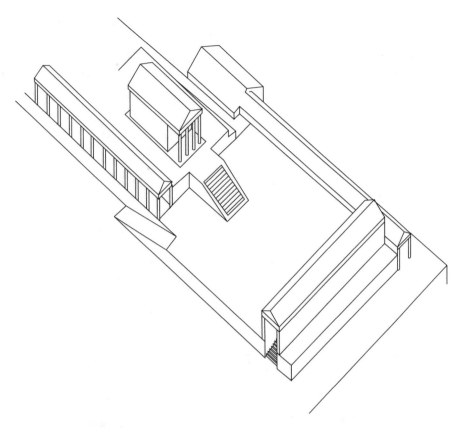

Figure 51. Hypothetical reconstruction of the area of the Temple of the Imperial Cult at Bilbilis as seen from the southwest (after Martín-Bueno 1981b, fig. 2)

(pl. 47). Exactly what it supported is not known, though it seems that the lower portico of the east side continued here on the south side as well. This southern area may have been a cistern for the forum,[126] and it must have supported a portico to close off the south side of the plaza. The west side probably held a structure. Large blocks of stone were used for the fill on the west-side terrace, and the supporting wall was built of large, irregularly shaped blocks.[127] Also on the west side was a passage running north and cut into the living rock below the level of the structure. The passage was partially built of small ashlar blocks and was covered, and could have had a colonnade

126. Martín-Bueno, Cancela Ramírez de Arellano, and Jiménez Salvador 1985a, p. 260.
127. Ibid., p. 259.

on the western side. It led to an apsidal space that may have been a nymphaeum. At this point, the lower passage seems to have joined to a portico one stage higher. It too was partially cut from the living rock.[128] It was obviously of some importance that the temple and its sacred space dominate the east side of the theater. The platform was extended to the south by means of a concrete and stone vault that created a profile visible from the valley below. The reason could have been to offer a dramatic setting for the temple. The west side, which overlooked the theater, may have had a roofed terrace that created a covered portico terminated on its north end by a fountain.

The entire ensemble was an impressive feature crowning a cliff face overlooking the river valley. The theater and sanctuary were conceived of as a single unit. The east side of the sanctuary provided an open portico with views down into the orchestra. A staircase served to connect the lower cavea with the entrance to the sanctuary north of the temple proper. The south side may have provided the main access from the valley below up to the city on the cliffs. Ascent would have been up the ravine and to the west side of the theater, along the western cliff face.[129]

Bilbilis was not a significant city. It was perhaps 24 ha, a medium-sized city for the peninsula. It produced one famous son, the first-century poet Martial. There is nothing in the city's political history or geographical location to explain the unusual arrangement of theater and sanctuary on the south side. There is enough casual evidence to support the theory that there was a pre-Augustan town on the site. The grant of the rank of municipium must indicate that a fair population was already present. The rank acknowledged the overwhelmingly native element of the population but extended to that population *ius Latii* (Latin citizenship) while permitting the town to continue its autonomous existence.[130] Within the region, the dominant cultural and political center was Colonia Caesaraugusta, which was the conventus capital. The old native centers at Numantia and Tiermes, although in the process of rebuilding and Romanizing, were nowhere near as significant as Bilbilis in terms of political rank or architectural expansion.[131] Yet what is striking is that neither native influences nor Roman design principles as developed at Caesaraugusta seem to have dominated the design choices made at Bilbilis.

Martín-Bueno has argued that two forces governed the urbanization of Bilbilis: the natural terrain, which informed all design decisions, and the

128. Ibid., pp. 259–260. 129. Martín-Bueno 1972, p. 112.
130. For a general discussion see Curchin 1991, p. 66.
131. Numantia was not accorded more than peregrine status; T. Ortego y Frías, *Guía de Numancia* (Madrid, n.d.), pp. 24–27.

preconceived notions of the "Imperial Roman city" as they had developed
so far in the Roman West.[132] The site itself did dictate choices. There is no
evidence for an orthogonal arrangement at Bilbilis, and in fact the residen-
tial quarters appear to have climbed the hill to the north or descended the
slopes near the theater.[133] The features of the south side are adapted to the
setting, but moreover, the theater, temple, and forum are all specifically Ro-
man features that belong to the Imperial design programs of the West. The-
aters, temples, and fora were among the first items built at new foundations
or recently Romanized native settlements. What is novel at Bilbilis is their
arrangement, for here the difficulties of the terrain have been exploited to
create a truly dramatic siting for these elements.

It may be safe to assume, with Martín-Bueno, that the start on the great
complex occurred with the city's change in rank[134]—sometime during the
reign of Augustus. The evidence from the fill of the theater would suggest a
starting date early in the first century A.D., and certainly the work of con-
struction would take several years on an ensemble of this size. A date for
construction during the Tiberian period is not out of line. The inscription
from the sanctuary is perhaps dedicated to Tiberius, which might suggest
that the temple was to the Imperial Cult, one of the first to be built speci-
fically for the cult after the approval of the Tarraco temple.[135] Moreover, the
city may have wanted to establish some type of association with the Em-
peror, for the city struck coins with the image of Tiberius and a reference to
Sejanus.[136]

It is valuable to reconsider the essential features of the Bilbilis complex
since it is so unusual. There is a theater that is partly cut directly into the liv-
ing rock. The theater sits within a natural ravine, and its west side is bounded
by the main access into the city. The east side holds a sanctuary that is lo-
cated on a rocky spur that has been artificially enlarged and stabilized with
terraces. To the north of both theater and sanctuary is an open area.[137]

Aspects of the design at Bilbilis can be related to other peninsula sites.
The enclosed treatment of the plaza, which was perhaps a forum space, with
the raised temple seems to echo the Augustan plan at Conimbriga. So too the

132. Martín-Bueno 1972, p. 105; Martín-Bueno and Jiménez 1983b, pp. 69–78.

133. Martín-Bueno 1972, p. 114.

134. Martín-Bueno 1981b, pp. 250–251.

135. Ibid., p. 252.

136. Burnett, Amandry, and Ripollès 1992, no. 398; Guadán 1980, no. 551.

137. In the earlier analyses of the site, this area was designated the forum and there is pos-
sible evidence for tabernae; Martín-Bueno, Cancela Ramírez de Arellano, and Jiménez Salvador
1983a, plan of Bilbilis, n. 10. More recently, the enclosed area in front of the temple has been
identified as the forum; Martín-Bueno 1987, pp. 99–111; Martín-Bueno, Cancela Ramírez de
Arellano, and Jiménez Salvador 1985a, pp. 258–261.

lateral placement of the basilica on the plaza can be paralleled by the pattern adopted at Conimbriga, Emporiae, and Saguntum during the Augustan phases. But in terms of the larger complex, only the theater at Saguntum is comparable. This may not be accidental, since the two sites were native towns. Saguntum may actually have provided some design impetus for Bilbilis. The sites share the same type of rocky, raised setting. At both, the commanding heights of the older town were kept and then adapted to suit the new Roman model. If indeed a space that lies behind the theater and to the north of the temple and that may have been approached via a street running next to the theater was the main forum, then the theater and forum arrangement was not unlike that at Saguntum. This combination of forum space with theatrical space perhaps was a development out of a Republican design concept first given form at Cosa, where the *comitium* of the curia building opens like a theater, with the steps providing the cavea seating, and acts as a transitional region between the open area of the forum and the enclosed space of the curia.[138] However, the datable material from both Saguntum and Bilbilis seems to point more to contemporary developments than to prototype and emulation. It seems reasonable to suggest that architects at both sites were influenced initially by another source more than by each other. Yet there is no reason to assume that once work began there was not communication between the two towns, since they were engaged in building similar grand complexes.

The association of sanctuary with theater is not unknown in earlier Roman architecture. It was well established with the theater of Pompey in Rome.[139] Even earlier staged spectacles had been performed near temples on the Italian peninsula. The Sanctuary of Fortuna at Praeneste with its great cavea-staircase was designed to facilitate some type of theatrical event.[140] Even the major sanctuaries at Gabii and Tivoli have orchestralike spaces in front of the temple proper.[141] There was, therefore, Roman Republican precedent for the combination of a sanctuary and a theater into a single architectural feature, and Republican design conceits clearly informed architectural choices on the Iberian Peninsula through the reign of the Emperor Augustus.[142]

The level of the sanctuary was above the cavea of the theater. It is difficult, given the present state of the remains, to know if one could view the activities in the orchestra of the theater from the plaza terrace and portico on the west side. The formal nature of the west side with its fountain and platform space might well suggest that a view down into the theater was

138. Richardson 1957, pp. 49–55. This architectural pattern may have had parallels at Paestum and Rome; Hanson 1959, pp. 37–39.

139. Hanson 1959, pp. 43–55. 140. Ibid., pp. 34–36.

141. Ibid., pp. 30–32.

142. See the discussion of the peripteral-temple plans in chap. 2 supra.

something that was considered by the designer. In Rome, theaterlike ritual performances were staged in front of the Temple of the Mater Magna until quite late, according to Arnobius.[143]

What separates the Bilbilis plan from the Saguntum design is the importance accorded the sanctuary on the east side of the theater. There is no evidence for such a feature at Saguntum, where the sanctuaries were on the forum. The temple at Bilbilis may have been dedicated to the Imperial Cult. Such a dedication would be suitable for a temple tied to a theater. In the *Georgics* (3.20–30) Virgil places his allegorical Temple of Augustus near a stage building.[144] The text of an inscription from Magliano and dated A.D. 19 implies a connection between the Temple of the Deified Augustus and a theater. The inscription is part of a decree honoring Germanicus. It states that the curule chair of Germanicus Caesar is to be kept in the Temple of the Deified Augustus once it is completed, and that the chair is to be brought from the temple and placed among the chairs for the *ludi Augustales*.[145]

Both Roman ritual practice and architectural development show that the theater and temple at Bilbilis probably were conceived of as a single unit. Though not paralleled by any other construction yet known from the western provinces, the concept invoked at Bilbilis had good solid Roman cultic and architectural pedigrees, though it does seem reasonable to suggest that the combination of theater with Temple to the Imperial Cult (if such is correct) places the Bilbilis ensemble on the cutting edge of architecture designed for cultic practice.

There is much more than mere accident or accommodation of the landscape involved at Bilbilis. Though artificial terracing was used to support the orchestra and the *scaena frons* of the theater, the basic plan is Greek. The placements of the theater and the sanctuary take advantage of the natural setting. There are some Roman modifications, but the shape and general form are determined by the natural features. The effect this has on the entire ensemble is to rob it of any sense of axiality. The landscape has been allowed to assert itself and to dominate the design to an unusual degree for a Roman construction. In the major "landscape" sanctuaries of the

143. *Adv. Nat.* 7.33: "Tranquillior, lenior Mater Magna efficitur, si Attidis conspexerit priscam refricari ab histrionibus fabulam."

144. *Georgics* 3.13–39:

> . . . iam nunc sollemnis ducere pompas
> ad delubra iuvat caesosque videre iuvencos,
> vel scaena ut versis discedat frontibus utque
> purpurea intexti tollant aulaea Britanni.

145. Hanson 1959, pp. 84–85 n. 28. Gros (1990, pp. 381–390) has argued for an association of theaters with the incipient Imperial Cult in Gaul.

Republic—Praeneste, Terracina, and Tivoli—the concern with strict axiality and symmetry takes precedence over any real desire to use the landscape. At Bilbilis, the dramatic situation has been heightened. The temenos platform was extended by shoring up the southern edge with a vaulted chamber that was intended to support a structure above it. From below, the full impact of the extended platform and its surrounding galleries must have been impressive. The southern point pushing out into space may not have been unlike the commanding presence of the platform for the Republican sanctuary at Terracina. Since the theater sits at a lower level than the sanctuary, even when the full *scaena* was in place, it would not have blocked the view up to the sanctuary.

Though the earlier Republican Italian sanctuaries provide legitimate comparisons to the Bilbilis concept, they do not provide actual design parallels. It is the great theater-temple complex at Pergamon that supplies the probable prototype for the plan at Bilbilis and perhaps also for Saguntum. Three specific design traits link Bilbilis to Pergamon: (1) casual placement of the individual elements of the composition, which permits the landscape itself, rather than rules of axiality or symmetry, to determine how and where structures are placed; (2) the arrangement of the sanctuary above the theater; (3) the use of a long projecting tongue of land to move the architecture out into the void.

On Pergamon's west side (pl. 48), the Athena sanctuary crowns a cliff top that then develops into a great theater cascading down a slope and stopping at a terrace that juts out into space above the plain below. The steep slope of the west side is exploited both as the bed for the theater and as the height from which the Athena Temple can overlook the landscape below. The location of the individual elements is determined by the lay of the land, nowhere more visible than in the vertiginous quality of the theater cavea, which moves down the cliffside at a steep grade. The terraces must have been placed according to the rock of the cliff face, since they are partially constructed of the living stone itself.[146] The theater serves to link the Athena sanctuary above with the terraces and the two small temples below. The composition was developed over a period of time. Originally the Athena Temple stood alone, dominating its high position.[147] The temenos of the temple was enclosed on two sides and the theater built under the reign of Eumenes II (197–159 B.C.).[148] Though it is not clear that the complex was conceived of as a unit, the west side of the temple temenos, which overlooks the theater, was left free of major building and would have permitted movement between the two parts.

146. Bohn 1896.
148. Radt 1988, pp. 180, 286.

147. Lehmann 1954, p. 15.

It cannot be said for certain that the design of Pergamon was intended to link sanctuary with theater, but at Aegae,[149] a site near Pergamon and during the third and second centuries B.C. much under the cultural influence of Pergamon, the same type of arrangement occurs. The city is also perched on a high point, and on the west side the theater flows down the slope of the cliff. Above it there is a temple, the temenos of which is enclosed by an L-shaped structure on the east and south sides. On the west side, which overlooks and connects with the theater, there is no building to impede communication. Here the design does seem purposeful, with the goal of creating a single complex of temple, theater, and lower terrace.

The parts in both of these Hellenistic cases, like the parts at Bilbilis, work independently of each other, but seem to be elements in a larger composition that work the strongest visually when they are treated as a single, grandiose statement.[150] What dictates placement in each of these examples is the natural landscape rather than a concern with symmetry or balance, the latter strong aspects of Roman Republican sanctuary designs. Out of the restrictions imposed by the site, the architect has created massive architectural ensembles. The limitations of the sites have been capitalized upon, exploited to create a grand composition that works most compellingly as the sum of its parts.

This is not to say that there is no human modification of the site. The terraces at Pergamon are built with great supporting walls punctuated with buttresses.[151] A similar type of construction dominates the design at Bilbilis. The potential of the site is realized with the aid of buttress walls, fill, and concrete. The great terraces at both Pergamon and Bilbilis jut out into the surrounding space, sculpting the void and throwing the architecture away from the land.

It is not just the design aspects that demonstrate a relationship between the Hellenistic East and this new center on the peninsula. There are some specific construction aspects worth considering as well. If Martín-Bueno is correct about the first construction phase for the temple, then the use of isolated supports for each column can be paralleled by the similar treatment of the columns of the peristyle of the newly discovered Wadi B temple at Sardis,[152] the contemporary Temple of Augustus at Pessinus (Ballihisar),[153] and the slightly earlier Temple of Augustus at Ankara.[154] T. Howe has shown that this was a standard way of building in the Hellenistic East. Of course,

149. Bohn 1889, plan 36. It is interesting to note that Pfanner (1990, pp. 75–76, fig. 17) visually sets up this comparison but never discusses the linkage in any depth.

150. Lehmann 1954, p. 18. 151. Bohn 1896, pp. 21–34.

152. Ratté, Howe, and Foss 1986, pp. 50–63.

153. Waelkens 1986, p. 41.

154. Krencker and Schede 1936, pp. 23–30, plate 2.6, fig. 27.

the possible peristyle form for the first temple at Bilbilis further testifies to a Hellenistic connection, though in this case the earlier peristyle temples at Barcino, Augusta Emerita, Ebora, and probably Tarraco would have provided more immediate models.

The construction of large artificial platforms to support the podium on which the temple stands can be likewise paralleled by contemporary Roman building in Asia Minor at Pessinus and Ankara,[155] though these are not Hellenistic features. The great height at which the temple stands above the plaza finds a counterpart in the temple at Pessinus.

The terrace-portico arrangement at Bilbilis is one of the more interesting aspects of the composition. The mixture of built structure and construction from the living rock, so prominent a feature of the east- and west-side terraces at Bilbilis, is not that different from the construction of the halls that lined the lower terrace at Pergamon, where there is evidence for the same type of mixing of construction techniques.[156] The use of the terrace-porticoes to enclose the space and define a precinct has many precedents, already discussed, on the Iberian Peninsula, and could certainly be considered a solely Roman aspect of the design. However, it is worth noting that Hellenistic Pergamon also offers a viable prototype for the sanctuary space in the sanctuary of Demeter, located on the south slope of the site.[157] The complicated, multistoried nature of the superstructures of the porticoes at Bilbilis, as restored by Martín-Bueno, M. Luisa Cancela Ramírez de Arellano, and J. Luis Jiménez Salvador, seem somewhat reminiscent of the great multistoried Hellenistic market buildings at Aegae and Alinda.[158] At both the Hellenistic sites and at Bilbilis, post-and-lintel construction was used for these tall, imposing buildings. It is the evidence for the lower supporting posts that can still be seen at Bilbilis.[159] Certainly the fine cut-stone ashlar masonry of the Hellenistic period is not found in large amounts at Bilbilis, though there is some evidence for small-scale ashlar work in one of the passageways.[160]

In her discussion of the compositional elements of Hellenistic ensembles, P. Williams Lehmann stressed the importance of the vista.[161] The great complexes were designed to be seen from afar. They were built, like musical compositions, in a crescendo manner to be resolved in a final structure. Lehmann's study centered on Pergamon, but what she says is equally applicable to Bilbilis. The ensemble moves up the south slope, spreading from the orchestra of the theater up through the cavea to the level of the ter-

155. Waelkens 1986, p. 42 n. 20; Devreker and Waelkens 1984, p. 52.
156. Bohn 1896, pp. 21–35. 157. Radt 1988, pp. 206–214.
158. Bohn 1889, p. 21, fig. 24; p. 29, fig. 28.
159. Martín-Bueno, Cancela Ramírez de Arellano, and Jiménez Salvador 1985a, p. 260.
160. Ibid., p. 259. 161. Lehmann 1954, p. 18.

races, where the composition is at its largest, and then resolving in the raised temple, the roof of which must have peaked just above the surrounding porticoes.

There seems little reason to doubt that the architect for Bilbilis conceived of the composition in Hellenistic terms. The view up to the site was significant, but so too were the views out. If the excavators are correct in reading the existence of an open portico on the lower terrace of the sanctuary, then the design incorporated the landscape. This too was a Hellenistic device, since clearly the views from the theaters at Pergamon and Aegae were unobstructed, and no doubt the terraces themselves, though they were lined with halls, probably had areas open to the view. The designer of Bilbilis may have carried this much further, however, and included the view as a formal element in the composition.

The site of Pessinus, in central Asia Minor in Galatia, was designed on a grand scale during the Tiberian period. A peripteral temple, probably Corinthian, and dedicated to Augustus, was built at the top of a theatrical complex.[162] The temple was enclosed by colonnades on three sides and opened onto the theater, which spread out in front and below. Temple and theater were placed on the central axis that ran through the plaza at the lowest level. As at Bilbilis, the temple sat on a natural rocky outcropping, enlarged and supported with buttresses. Some of the columns sat atop individual foundations.[163] Extending out from the base of the theater is a large plaza that was surrounded on three sides by Ionic porticoes. The site combines the features known at Bilbilis. The natural setting is exploited for dramatic effect.

ANALYSIS

Tiberius. The Tiberian period in the development of Roman architecture is largely ignored.[164] In comparison with the Augustan period it seems to lack any real direction or force. So many of the monuments either finished or built during the era seem to be the result of ideas that are best seen as taking form during the Augustan period. Moreover, from the standpoint of the provinces, Tiberius appears to have lacked any coherent view, and so it is difficult to argue for some type of master plan that informed provincial building projects. The only building usually considered is the Emperor's villa on Capri, the Villa Jovis.[165]

Although it may be true that Tiberius took less interest than Augustus in

162. Akurgal 1985, pp. 277–278. 163. Waelkens 1986, p. 41.

164. In his general study of Roman architecture, Ward Perkins (1981) devotes only three pages to Tiberius (pp. 45–47).

165. For a recent standard treatment see Sear 1985, p. 89, fig. 46.

directing architectural forces, it is a mistake to see the period as lacking its own dynamic. Some aspects of Tiberius the man are worthy of consideration. Tiberius was not the traveler that Augustus was.[166] And though he spent time during campaigns in the West, there is little reason to believe that he knew the provinces well. But he does seem to have been a philhellene. His fondness for Rhodes, where he spent his years of exile, began early in his life, and he spent his time there engaging in philosophical debates and attending lectures.[167] This fondness for the Greek world manifested itself on Capri, where the Emperor surrounded himself with a Greek atmosphere.[168] And although there is nothing about any of this that suggests that Tiberius in some way promoted the Hellenic forces in the Roman West during his reign, neither would he have had any reason to actively undermine their movement to the West.

Tiberius is not considered to have been particularly generous to the provinces.[169] He was not engaged in major urbanization programs,[170] and except in rare circumstances, the Imperial purse was not opened to fund public architecture. What he did offer was generally reasonable taxation combined with a willingness to bring to justice those officials who sought to exploit the provincial wealth[171]—and, for the Iberian Peninsula, the continuation of peace. The western troubles were confined to the eastern and northern regions of Gaul. There may have been times that threatened the peninsula, but there is no evidence of any serious problems during his reign.[172]

Under such rule, local cities may have taken it upon themselves to engage in large-scale public building. The time was peaceful, and for the most part, trade within the Mediterranean Basin was possible. At Tarraco the marble used for at least some of the architectural sculpture was Italian.[173] At Bilbilis there are traces of imported stones used for some of the construction, fragments of Greek marble from Pentelica and Italian marble from Luni. Colored stones come from Euboea, Teos, and Docimion in the Aegean region, and from Chemtou in North Africa. It is not completely clear how much of

166. Marañón 1956, p. 209.

167. Suetonius, *Tiberius* 11.2. For an analysis see Seager 1972, pp. 29–35. For a psychological interpretation see Marañón 1956, pp. 207–209.

168. Houston 1985, pp. 182–183.

169. Suetonius, *Tiberius* 48; Mitchell 1987, p. 350

170. Seager 1972, p. 173.

171. Seager 1972, pp. 170–171. The prosecution of C. Vibius Serenus, governor of Hispania Ulterior, is the only evidence of a direct Iberian connection, and he was accused of using excessive force (uis publica) against Roman citizens, not of misrule of provincials; Tac. *Ann.* 4.13

172. The Spanish provinces may have been endangered when the Aedui of Gaul rebelled, but there is no real evidence; Seager 1972, p. 166.

173. The composite capitals are identified as being made of Italian marble, and so too the fragments of the architectural frieze of acanthus scrolls are of Italian marble.

this imported material belongs to the first phase of building and how much to the second-century phase, but several of these sources were already in operation by Tiberius's reign.[174] Certainly building supplies could move throughout the Empire.

Patronage. The actual payment for building programs is difficult to reconstruct for the peninsula. At Saguntum there is evidence that a single, powerful, probably old, family—the Babii—underwrote the Augustan transformation of the city. There is no such evidence for any of the Tiberian sites being considered. Yet by the first century A.D. there were individuals with extraordinary wealth living on the peninsula who were willing to expend large amounts of money on public beneficence, as can be seen in an inscription from Castulo, a city on the border between Tarraconensis and Baetica.[175] The role of the private benefactor was becoming, already, a major source for public building in the provinces, as can be seen in Pisidian Antioch, where a wealthy man, T. Baebius T. f. Ser Asiaticus, paid for the paving of what was probably the Tiberia Platea.[176] It seems reasonable to assume that private sources lie behind much of the public building from this period forward on the peninsula.

Private benefactions could come from the generous nature of the benefactor, but there were in place new means to encourage public beneficence. It must have been during the reign of Tiberius that the system of the *summa honoraria* was established that was to dominate the redistribution of private monies into public works throughout the peninsula. For towns that had been granted colonial or municipal status the *summa honoraria*, the payment for office, often must have been the single largest income generator, coming ahead of such items as local taxes on trade, money lending, or rental of public lands.[177] Based on the evidence from North African third-century sources, it is apparent that local elites were expected to pay standard sums to assume their positions within the *cursus honorum*. These sums were substantial; at Thubursicu Numidarum the town councilors and the duoviri paid four thousand sesterces each, and a *flamen* paid six thousand sesterces. R. P. Duncan-Jones has estimated that an average town could earn about thirty-five thousand sesterces by filling the magistracies and priesthoods.[178]

174. Martín-Bueno and Cisneros Cunchillos 1985b, pp. 875–879.

175. Duncan-Jones 1974, pp. 79–85.

176. Levick 1967, p. 82. For the archaeological background on Pisidian Antioch see K. Tüchelt, "Bemerkungen zum Tempelbezirk von Antiochia ad Pisidiam," in R. M. Boehmer and H. Hauptmann, *Beiträge zur Altertumskunde Kleinasiens: Festschrift für Kurt Bittel* (Mainz am Rhein, 1983), pp. 502–504; D. M. Robinson, "Roman Sculptures from Colonia Caesarea (Pisidian Antioch)," *Art Bulletin* 9 (1926–1927), p. 5.

177. Duncan-Jones 1985, pp. 28–33.

178. Ibid., p. 29.

It has been suggested that Barcino may have encouraged outsiders to take up magistracies in the city as a means of raising revenue through the charging of the *summa honoraria*.[179] On the Iberian Peninsula the municipal charters and laws may have demanded that magistrates who promised and had initiated the construction of a public building, or the donation of money toward such a construction, or the payment of the *summa honoraria* for the office, had to fulfill the promise.[180] The pride that the local elites developed during the early Empire in the process of the *cursus honorum,* by which their status was publicly acknowledged and their position reinforced, was also exploited to encourage and compel these same people to part with some of their wealth for the public good.

The local magistracies were limited to the free-born elite, a policy that denied access to freedmen, who could be among the wealthier members of a provincial society. This resulted in a potential source of income that the cities could not directly exploit. Freedmen did donate to public works.[181] Those of the emperor's slaves and freedmen, members of the *Familia Caesaris,* that attained high position within the administrative operations of the Empire were posted to various provinces and might well have seen fit, particularly in their freed state, to make gifts to those cities in which they held their highest and final position.[182] Claudius Etruscus, the son of one of the emperor's freedmen who had attained high administrative rank and private wealth during the second half of the first century A.D., used his father's money to build a public bath complex.[183] The potential wealth to the city to be obtained by capitalizing on the freedman class could not have gone totally unnoticed. One way to draw some of this private wealth into the public sector was to allow free-born sons of freedmen to enter the *cursus honorum*.[184] Their numbers on the Iberian Peninsula may have been quite small, but the names of several have been preserved, and their fathers may have had to pay royally for the privilege of moving their sons into the ranks of the elite.[185]

There were good reasons to encourage the development of financial resources. Building was expensive. North African sources provide some costs. A medium-sized temple ran between sixty and seventy thousand sesterces in the second century, a forum with its porticoes about two hundred thousand,

179. Curchin 1990, p. 100. 180. Ibid., p. 66.

181. Weaver 1972, p. 232, citing the gift of Salvia C. f. Marcellina, the freeborn wife of M. Ulpius Capito Aug. L, to the Collegium Aesculpi et Hygiae.

182. Weaver 1972, pp. 267–281.

183. Statius, *Silvae* i. 5; Weaver 1972, pp. 284–294.

184. Curchin 1990, p. 71.

185. For a general discussion see Curchin 1990, p. 72 (citing G. Fabre in *Actes du colloque 1973 sur l'esclavage* [Paris, 1976], pp. 425–426); Mackie 1983, p. 56.

and a theater up to six hundred thousand.[186] A large, octastyle temple like that built at Tarraco must have stretched the city's resources and required several years of the city's annual income to offset the cost. Such considerations make the enterprise at Bilbilis even more astounding. Here, expensive buildings—theater, forum, temple—were placed on a site that itself must have cost a considerable amount to have prepared. The intrinsic value of the complex was increased by the use of imported building materials for some of its aspects.

Although the epigraphic evidence for Spain does not yet supply direct support for the increasing role of private funding for public works, it seems obvious that it was to private sources that the emerging cities of the first century A.D. had to turn. The Imperial purse simply did not open. Even for projects as deliberately political as the promotion of the Imperial Cult, there is no reason to believe that Tiberius helped defray the costs of building. The institution of the Imperial Cult itself may have helped to garner resources. The local priesthood would have generated money through the *summa honoraria.* At Tarraco the provincial nature of the shrine may have encouraged monies from outside the city itself to flow into its coffers. The possibly more modest form of the temples at Barcino and Augusta Emerita, possibly older temples reconsecrated to the Imperial Cult, may testify to the expenses involved in new building, outlays too great for these new cities.

However, the nature of the embassy from Tarraco to Tiberius, as recorded by Tacitus (*Ann.* 1.78), and of the perhaps slightly later embassy from Baetica (4.37) suggests that competition among the cities of the Iberian Peninsula was beginning to be encouraged. Tiberius refused the request from the Baetican group to permit the erection of a temple to himself, but according to Tacitus, the petition was made on the model of the cities of Asia, suggesting that the worldview of the Iberian residents comprised more than just their nearest neighbor.

Influences from Asia Minor. The influence of architectural forms from Asia Minor, both older Hellenistic and contemporary aspects, is certainly the most interesting feature of the architectural development on the Iberian Peninsula during Tiberius's reign. What is not clear is the means by which the influence entered. The Imperial Cult itself, which during the same period took root in Asia Minor as well as on the peninsula, may have been an element encouraging this movement of ideas. Even if Étienne is correct and the Iberian Imperial Cult devolved as much from local, pre-Roman forces as from any outside influences, it must be acknowledged that the physical, architectural manifestations that it assumed were ultimately of Greek ori-

186. Duncan-Jones 1985, p. 29; idem 1982, pp. 77–78, 90–92, nos. 8, 9, 10a, 11, 42.

gin. The earliest altars were out of the old Ionian tradition, which goes back to the archaic period[187] and certainly blossomed with the Hellenistic altars in both the East and the West. Augustus himself seems to have intentionally promoted the altar as an element in Imperial architectural propaganda.[188] It may simply have been that Asia Minor and the old Hellenistic cities were seen as providing the proper architectural prototypes for the city elites in Tarraco and Baetica to emulate.

It is possible to see in the peripteral temples of the Augustan period or the octastyle peripteral temple at Tarraco western imitation of eastern architectural forms, but that really will not explain Bilbilis. There, the concept is too grand, the emulation too free and individualized, and the expense too great to suggest anything other than a totally new creation built on Hellenistic theory. This would indicate that the forces involved were more complicated than mere imitation and may have had much to do with the situation of architecture in western Asia Minor during the first quarter of the first century A.D.

The one certain time when Tiberius opened the Imperial treasury was when he rebuilt the cities of Asia Minor destroyed or damaged in A.D. 17. This event is recorded in Suetonius (*Tiberius* 48) and Tacitus (*Ann.* 2.47), by the issue of coinage already discussed, and by several inscriptions found in Asia Minor.[189] Nor was this the first time that places in the Greek East had been repaired after earthquake damage. Augustus had assisted Cos in its restoration after an earthquake in 26 B.C.[190] What also seems clear is that the Imperial liberality was matched in some instances by local benefactions intended to help with the recovery.[191]

There is also archaeological evidence for the repair of the cities in Asia Minor. An inscription from Aegae would indicate that the Temple of Apollo Chresterius was restored as a result of the earthquake of A.D. 17.[192] At Pergamon, the Heroon of Diodoros Pasparos—sitting on one of the slopes of the upper city, which was damaged but not destroyed—was remodeled.[193] Ephesus received some type of help after the earthquake,[194] and the first phase of the great Hanghäuser complex, the Hanghaus I on the south front

187. H. Hoffmann, "Foreign Influence and Native Invention in Archaic Greek Altars," *AJA* 57 (1953), pp. 189–195.

188. Fishwick 1978, p. 1205.

189. Mitchell 1987, p. 350 n. 106; MacMullen 1959, p. 210.

190. Mitchell 1987, p. 350 nn. 102–103.

191. On the private restoration of a temple at Sardis, Mitchell (1987, p. 350) cites L. Robert, *BCH* 102 (1978), p. 405.

192. T. R. S. Broughton, "Roman Asia Minor," in Frank 1938, vol. 4, pp. 712–718.

193. Radt 1988, p. 282.

194. T. R. S. Broughton, "Roman Asia Minor," in Frank 1938, vol. 4, p. 712.

of Kureten Street, dates to the rebuilding phase.[195] By far the most exten-
sive rebuilding occurred at Sardis, where Tiberius gave outright 10 million
sesterces and the remission of all contributions to the Imperial and public
treasuries for five years.[196] This was a tremendous amount of money, and
the excavations have produced some glimmers of how the city responded to
the rebuilding process.[197]

The third decade of the first century A.D. was then a time of tremendous
building along the west coast of Asia Minor, much of it in the old Hellenis-
tic centers. It cannot be maintained that specific Hellenistic monuments
such as the theater-temple complexes at Aegae and Pergamon were among
the architectural features being repaired, but it is clear that these cities were
damaged and were in the process of rebuilding. The activity that followed
the earthquake was more an increase than a novelty. There had been work
in the theater at Pergamon during the first century B.C.[198] Ephesus had
witnessed some major building during the Augustan period. In fact, Herod
of Judaea had made bequests of large sums to the cities of the Anatolian
coast.[199] Herod's donations may have served to encourage traditional Hel-
lenistic building, particularly in places like Pergamon, considering his own
fondness for grand, dramatic architectural projects.[200] Throughout the last
decade of the first century B.C. and the first two decades of the first century
A.D. there were major building projects ongoing in the old Hellenistic cen-
ters of Asia Minor. The activity must have increased to a perhaps frenzied
state after the earthquake and in the subsequent reconstruction programs.
The volume of resources that the Emperor released should have encour-
aged just such an occurrence.

It is impossible to prove that the architects responsible for Saguntum's
Augustan design and Bilbilis's Tiberian program were trained on projects in
Asia Minor. However, it is well documented that architecture as a profes-
sion in Rome was often practiced by Greeks. Moreover, until Septimus
Severus established professorships of architecture, those engaged in the pro-

195. Alzinger 1974, p. 58. In a conversation that I had with Anton Bammer during a visit
to Ephesos in the summer of 1989, Dr. Bammer suggested that the substructure terrace for the
great Temple of Domitian might in reality be one of the results of the cleanup after the earth-
quake; for the temple see Akurgal 1985, p. 166.

196. Tacitus, *Ann.* 2.47.

197. Hanfmann and Mierse 1983, pp. 141–142. Discussions that I had with Crawford
Greenewalt, Jr., and Christopher Ratté at Sardis in the summer of 1989 were particularly help-
ful to me.

198. Radt 1988, p. 291. 199. Josephus, *BJ* 1.421–430.

200. See the discussion of Herod's building projects, "Late Second Temple Period and
Period of the Mishna and the Talmud," in *Treasures from the Holy Land* (New York, 1986),
pp. 194–195, fig. 74.

fession learned their craft through apprenticeship.[201] There may have been many projects in Italy and the West on which individuals might have honed their abilities, but considering the impact that Hellenistic theory still had on Vitruvius, it seems reasonable to assume that a good many architects started in the Greek East, either building within the Hellenistic cities or helping to reconstruct them.

The evidence for the penetration of Hellenistic design concepts into the West during this period can be seen outside of the Iberian Peninsula. There is no doubt that the architect for Tiberius's villa on Capri was thinking in terms of vistas, asymmetrical forms, and grandeur of composition. The villa, of course, owes much to the late-Republican tradition of villa design in the region of the Bay of Naples, but it must be remembered that this was probably the most tenaciously Greek part of Imperial Italy[202] and had very likely been responsible for transmitting Hellenistic design conceits north to Emporiae during the first half of the first century B.C. It might also be possible to understand the terraced platform on which the Temple to Augustus was placed—on the east side of Byrsa in the Romanized Carthage and probably begun under Tiberius—as evidence of this Hellenistic force being brought west.[203]

The movement of Greek ideas west is not so unusual. There is epigraphic evidence of Greeks resident on the Iberian Peninsula, and not just in the old Greek areas near Emporiae.[204] Certainly among the vehicles that moved foreigners around the peninsula were the army and the Imperial administration.[205] A Greek or a non-Greek architect, apprenticed in the East on one of the large-scale projects, easily may have been brought to the Iberian Peninsula as an army engineer or perhaps in the service of the governor. Pliny asked the Emperor Trajan to send him an architect to undertake specific projects.[206] Under such circumstances, it is not hard to imagine the elite of Saguntum or Bilbilis tapping just such a person to redesign their cities.

CONCLUSION

There remains the question of the motivating force behind the decision to employ design ideas from Asia Minor. At Bilbilis, it is difficult to think that the patrons were not aware of the novelty of the commission, and if they did

201. Packer 1969, pp. 40–41.

202. Houston 1985, pp. 182–183. See also Coarelli 1983, pp. 191–217, for a discussion of the boldness of Hellenistic-inspired design in the Campanian region.

203. Deneauve 1979, pp. 41–55.

204. For a Greek inscription in Lusitania, see Stanley 1990b.

205. Stanley 1990a, pp. 249–269. 206. *Ep* 10.41.

not recognize it immediately, they must certainly have confronted it when the costs began to mount. Unlike during the Augustan period, when so many design choices, even in the provinces, seem to reflect a larger Imperial purpose, there is little to support the notion of a Tiberian scheme that ultimately informs design options among provincial architects or patrons. It is more reasonable to assume that local desires are somehow reflected in these compositions.

It is an interesting fact that the Iberian Peninsula seems to have harbored a strongly conservative streak, at least in some regions, which shows up in the retention of native names long after the process of Romanization has supposedly been accomplished. This trait is most commonly found in rural settings, and marks both the later Republican and Imperial periods.[207] There was a second dynamic present among the elite population on the peninsula, probably something that can be divided into two streams running parallel throughout the late Republican and earlier Imperial periods: (1) the position of native elites who chose to enter into relations with and prosper from acceptance of Roman control; and (2) the position of the foreign residents and their descendants born on the peninsula, who perhaps formed a separate elite, particularly in colonial settings or commercial towns. Under Caesar, the native aristocracy of Gaul was promoted into the Roman system, and so too some selective individuals of Iberian origin may have been treated.[208] Quite separate might well have been those whose origins were Italian but who had been born on the peninsula.[209] But the two strands of elites may have merged in places like Bilbilis, for though provincial origin— that is, being either of native or of Italian descent—may have carried some degree of disdain in Rome itself, even as late as Martial,[210] the fact remains that within the local governmental system that emerged under Caesar, was expanded under Augustus, and probably encouraged under Tiberius,[211] there was no legal distinction between a Roman who inherited the franchise and the new citizen (except for freedmen). Both groups were equally eligible for the magistracies that formed the *cursus honorum*.[212] Thus the social, cultural, and financial elite of provincial Iberian cities were composed of two forces, and from both of these groups emerged the first literary figures

207. Dyson 1980/1981, pp. 257; Navascués 1968, pp. 214–263.

208. For a discussion of the Titii Hispani and the Balbii of Gades, supporters and friends of Caesar, see Syme 1937, pp. 127–137.

209. Syme 1937, pp. 136–137. Syme concludes that Decidius Saxa was just such a person.

210. Martial seems to distinguish between native-born of the peninsula and born on the peninsula; see preface to Book XII: ". . . ne Roman, si ita decreveris, non Hispaniensem librum mittamus sed Hispanum."

211. Grant 1950, pp. 130–134. 212. Syme 1938a, pp. 9–12.

from the western provinces.[213] It must be assumed that by the time of Tiberius there was an intermingling of the membership. The conservative quality, most apparent in the rural areas, may have been one of the forces that kept the Iberian elites from trying to assume a greater role in Imperial politics in Rome itself.

The conservative quality should not be seen, however, as a refusal to assume a completely Roman style of life, especially in cities. What is striking about the architecture of Tiberian Iberia is the degree to which this region had Romanized. Bilbilis gave birth to Martial, and nearby Calagurris offered the Roman world at least two rhetors,[214] and this was an area somewhat distant from the traditional centers of the coast and the south. The elites of Iberian cities were, already by the time of Tiberius, comfortable in their Romanness, and that is what is sensed in the choice of a design like that at Bilbilis, or in the decisions about which temple to build in Tarraco. These were individuals who could commission a strikingly novel and dramatic architectural complex, perhaps choosing a Hellenistic form that recalls Pergamon specifically because of the association. It is worth remembering that the Athena temple at Pergamon was one of the sites for honoring the Emperor Augustus at the city,[215] and so there may have been some exploitation of iconographical associations when a similar design was created for the Imperial Cult sanctuary at Bilbilis.

It is during the reign of Tiberius that, for a portion of the population of the Iberian Peninsula, being Roman became the identity. The elite were comfortable enough to mold the identity to their view, willing to make their own choices as manifested in architectural selections. It is against this backdrop that the great burst of literary personalities of the first century must be placed and the emergence of the Spanish force in the second century understood.[216]

213. For the native poet from Gallia Narbonensis see Syme 1938b, pp. 39–44. For a discussion of Egnatius, a Celtiberian poet referred to by Catallus (39. 17), see idem 1937. See also Cicero, *Pro Archia Poeta*, 26, for poets of Corduba: "qui praesertim usque eo de suis rebus scribi cuperet, ut etiam Cordubae natis poetis, pingue quiddam sonantibus atque peregrinum, tamen aures suas dederet." This is hardly to be understood as any type of praise for provincial poetry.

214. For Quintilian and Fulvius Sparsus see Gómez-Pantoja 1987, pp. 79–84.

215. Radt 1988, pp. 182–183.

216. Syme 1982–1983, pp. 241–263; idem 1938c, pp. 554–561.

CHAPTER FOUR

Architectural Experiments during the Mid–First Century

It is wrong to think of the Augustan period on the Iberian Peninsula solely as one during which a set plan was imposed from without. Recent scholarship has forced us to reconsider how much we should credit Augustus with actively pursuing policies aimed at creating specific institutions or forcing particular types of physical manifestations of the new Roman order.[1] Yet it remains quite clear that during the last decades of the first century B.C. and the first fifteen years of the first century A.D. there is an unmistakable similarity that is stamped on much of the architecture, which seems to argue at least for some intentional directing.[2] During the reign of Tiberius, the homogeneity of the Augustan period gives way, and there are architectural designs that seem to be the result of local investigations and that appear largely independent of designs on the Italian peninsula or elsewhere in the West. The Imperial government took a less active interest in the political development of the Iberian Peninsula. Tiberius may have intentionally undermined the system of Imperial governmental control in the western provinces, so carefully developed by Augustus, by extending the tenure of provincial officials and by preventing certain appointees from assuming their positions.[3]

During the midcentury, under Claudius, there was renewed Imperial interest in the western provinces. Claudius created new senators from the native aristocracy of Gallia Narbonensis and initiated the incorporation of southern England into the Empire, but seems to have had no specific concern with Iberia. The independent architectural line of development that appears during the twenties was to continue throughout the middle of the first century A.D., perhaps reflective of the largely peaceful and uneventful

1. Ostrow 1990, p. 366.　　　　　　　2. Zanker 1990.
3. Syme 1981a, pp. 189–202.

nature of the relationship between Rome and the far West. It is during these years that the famous literary giants come out of the Iberian Peninsula. The Senecas, Martial, and Quintilian did their early training in Iberian cities that had assumed a Roman shape under Augustus and Tiberius. To pursue their careers, they went to Rome, and though the elder Seneca and Martial returned to their homeland, there is a sense, particularly in the writings of Martial, that the cosmopolitan atmosphere of the capital was missed out in the provinces. By midcentury, the allure of Rome and of the older centers of Roman culture on the Italian peninsula was not that of political conquest but that of cultural heritage. The architectural experiments of the Claudian period testify to the continuing growth of cultural self-confidence of certain populations on the Iberian Peninsula, but such self-confidence must also have spurred a desire to know and to emulate the sources of the culture of which these people were now undeniably a part. It must be against this backdrop of second-generation integration into the Empire that we need to consider the strange case of archaism that appears during this period, best seen at Augusta Emerita.

ARCHAISM

It was under Claudius that Augusta Emerita received its marble forum. In the area around the Temple of Diana a precinct was created and decorated with a sculptural program derived from, though not copied from, the Forum of Augustus in Rome.[4] Here, within a monumental colonnaded space with attic decorations of alternating heads of Jupiter Ammon and Medusa set in units defined by caryatids, were placed the togate portrait statues of important officials and historical and mythological figures associated with Rome's past.[5] A monumental quarter that celebrated the capital was established in this outpost of Rome in the far West. At the same time a gallery of portraits of the Imperial family was placed in a newly designed sector of the theater,[6] and a carved relief celebrating a ritual sacrifice with the figure of Agrippa officiating was also erected in the theater.[7] A similar kind of redefinition may have been taking place in Tarraco, where the relief of a Jupiter Ammon head in a tondo was being used to decorate an important structure.[8] This may have been paired with a Medusa head in a tondo, for which fragments survive, and both appear to date stylistically to the Claudian period.[9] The

4. See chap. 2 supra.
5. Trillmich 1995, pp. 269–291; idem 1993, pp. 49–54; idem 1990, pp. 310–318.
6. *HA*, p. 240, fig. 105; pp. 281–282, plates 49a–c.
7. Trillmich 1986, pp. 279–304.
8. This piece has been known for many years and assigned to a variety of possible temple structures; Albertini 1911–1912, p. 69, no. 122.
9. Koppel 1990, pp. 332–339.

iconography is all Augustan. Either an earlier project was just being completed during the Claudian period or these items are elements in an intentional revival of older forms. If this work at Augusta Emerita is the product of an archaizing movement, then the movement was limited to a few older centers with strong ties to Augustus and is not found in the new developments of the Claudian era.

CLAUDIAN BUILDING PROGRAMS

Clunia

The site of Clunia (Peñalba de Castro) is located on the northern fringe of the Meseta, the central Iberian plateau—a Celtiberian region and home of the Arevecos. The place is known locally as Alto de Castro and is situated south of Burgos, between Peñalba de Castro and Coruña de Conde.[10] The site was never reoccupied after its depopulation at the end of the ancient period, and medieval interest was focused elsewhere with the exception of a hermitage built on the site.[11] There is evidence for occupation in the area during the Iron Age, though it is not clear whether Clunia itself was settled or only nearby areas.[12] The Roman city sat within a network of roads that linked it to most of the major settlements of the northern half of the peninsula.[13]

The northern regions of the Iberian Peninsula did not have the history of pre-Roman monumental architecture and urban development that so marked the south from the seventh century B.C. onward. The Celtic and Celtiberian peoples of this area had formed a culture somewhat different from that in central Europe, since they did not pass through the La Tène phases,[14] but architecturally they shared in common with central European Celts the *oppidum* style of urbanization. Although it is not certain from the archaeological record that Clunia was settled during the pre-Roman period, it was located within the sphere of influence of the important native sites of Numantia and Tiermes.

It was only with Augustus's campaigns along the Cantabrian coast that this region passed under complete Roman control. The area was assigned to the province of Tarraconensis in Augustus's redivision. There are late-

10. Palol 1959, p. 40.

11. Palol 1985a, p. 306; Palol Salellas 1976, pp. 268–269.

12. Palol 1982, pp. 15, 21–22. 13. Ibid., pp. 16–19.

14. In A. Tovar, M. Faust, M. Koch, and F. Fischer, eds., *Actas del II Coloquio sobre lenguas y culturas prerromanas de la Península Ibérica, Tübingen, 17–19 junio 1976* (Salamanca, 1979), see articles by W. Schule (pp. 197–208); P. Kalb (pp. 219–221); M. Koch (pp. 387–419); J. M. Blázquez (pp. 421–434); see also Sangmeister 1969.

Republican references to Clunia and the surrounding territory. The city is mentioned by name as one of the sites of the Sertorian conflicts (Livy, *Per.* 92; Sallust, *Hist.* 2.93). Dio Cassius records that in 56 B.C. Afranius, a legate of Pompey, reduced the native population and imposed a peace on his terms (39.54). Clunia disappears in the literary record until the end of the first century A.D., when Galba hears of the impending civil war while at Clunia (Suetonius, *Galba* 9.2), and from Clunia, Galba marched with a legion composed of Spanish troops, the Legio VII Gemina (Legio Galbiana).[15]

The archaeological investigations at the site have not revealed any evidence for settlement earlier than the first century A.D. There is numismatic evidence of a mint in operation earlier than the establishment of the Imperial town.[16] The earlier native and Republican settlements may have been located somewhat away from the forum area of the later city, which has been the focus of excavations. It was probably under Tiberius that the new city began to take shape as part of the spur toward Romanization that followed the Augustan pacification in this region. It was this promotion of Romanization that continued under Tiberius when the city was established as a municipium, which saw the development of nearby Uxama and Tritium Autrigonum.[17] The great work at Bilbilis must have somewhat influenced developments here. Clunia's theater, located outside the forum region, is also bedded, Greek style, into a cliff face.[18] The city itself is laid out atop a mesa to one side of a crest, which may have been the site of the old town.

It was probably with Claudius that the real stimulus toward a fully articulated Roman shape took place. Clunia does not appear in Pliny's list of Augustan colonial foundations, and there is no archeological evidence for new urban growth during the Augustan period. Under Claudius it may have assumed its role as a conventus capital. This new position could well have served to spark the creation of the forum ensemble.[19]

The city seems to have been planned on an orthogonal system (fig. 52).[20] The full grid plan has not yet been delineated, but the crossing of the Kardo Maximus and the Decumanus Maximus can be determined,[21] and, more important, it appears that there are actually three distinct axes of orienta-

15. Palol 1982, p. 23.

16. Burnett, Amandry, and Ripollès 1992, p. 139; Villaronga 1979, pp. 241–242.

17. Palol 1987, p. 153; idem 1985b, pp. 395–428.

18. Palol 1982, p. 34; Palol Salellas 1976, p. 280.

19. The first appearance of the name as a *colonia* is on an inscription of Hadrianic date (*CIL* II, 2780); Palol 1959, pp. 82–83.

20. The major reports on Clunia are the series of guides to the site authored by Palol (1965,1969,1974,1978,1982); these were regularly updated with new finds and interpretations. See also Palol 1976, pp. 272–285; idem 1985b, pp. 395–428; idem 1987, pp. 153–163; idem 1989–1990, pp. 37–56. Specialized studies are listed in the bibliography of Palol 1982, pp. 159–163. New works include Gurt 1985.

21. Palol 1976, p. 276.

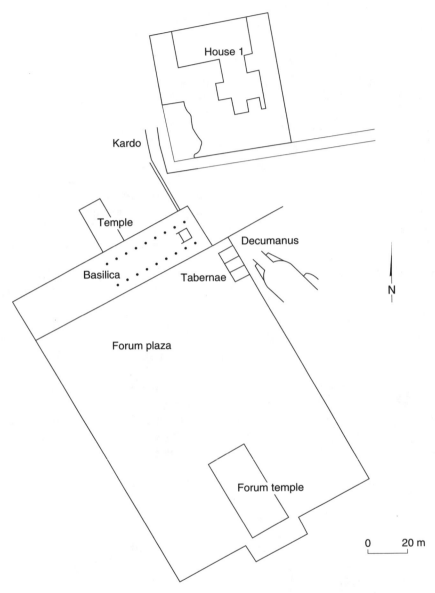

House 1

Kardo

Temple

Decumanus

Basilica

Tabernae

N

Forum plaza

Forum temple

0 20 m

Figure 52. Sketch plan of the forum area of Clunia (after Palol 1978)

tion, which govern different portions of the grid.[22] The forum has an axis aligned from the northwest to the southeast. It is bounded on its east side by a kardine, and the Decumanus Maximus enters via the northeast portal. These streets do not actually cross at a right angle but rather form an oblique angle, and the forum cannot be said to truly sit on the crossing of the Decumanus Maximus and the Kardo Maximus.[23] There may have been an earlier orthogonal plan already in place when the forum was built. Initially there were houses in the forum area represented by the ruins of houses nos. 1 and 3. House no. 3 has yielded fragments of wall paintings that allow it to be dated as Tiberian. The change in purpose of the area from residential to civic and religious seems to have occurred under Claudius, probably as a result of the city's assumption of its new status. A portion of house no. 3 was destroyed, and the older urban plan was altered to accommodate the new alignment of the forum. House no. 1 no longer sat in the grid pattern now established by the forum. Changes were made again during the Flavian period.[24]

The forum plaza is large, ca. 140 m × 100 m, one of the largest so far excavated on the peninsula (fig. 53).[25] The south side is dominated by the remains of a temple located in midposition. Opposite it and occupying the total width of the forum plaza at the north end is the three-aisle basilica. Lining the two long sides are the remains of tabernae. The basilica does not so much close the forum as divide it into two parts. North of the forum is another enclosed space, not too well understood, dominated on its south side by a rectangular structure that abuts the north wall of the basilica.[26]

The main temple[27] sits on the forum's south side. The remains are fragmentary, having been robbed out over the centuries, and consist almost exclusively of the mass of stone and mortar (*opus caementicium*) (pl. 49) preserved to a height of ca. 3.60 m[28] that formed the core of the podium. I. Calvo found remains of columns and stairs, and the later excavations have recovered some traces of the moldings.

The structure stood free on all four sides. The precinct wall behind the temple juts out to form a small niche-like space. A wall appears to have divided this space from the main area of the forum, perhaps to create an enclosed and somewhat hidden room. Although nothing has survived of the

22. Palol 1987, pp. 153–154. 23. Palol 1982, p. 70.
24. Ibid., pp. 72–74. 25. Palol 1987, pp. 155–157.
26. Calvo dug in the forum region, as did Taracena, but the real excavation and publication of the forum have fallen to Palol, who published the seasonal results (1965, p. 24; 1969, p. 34; 1974, p. 34; 1982, p. 70).
27. Unless otherwise cited, the descriptive information for the temple comes from Palol 1982, pp. 76–82.
28. Palol 1989–1990, p. 47.

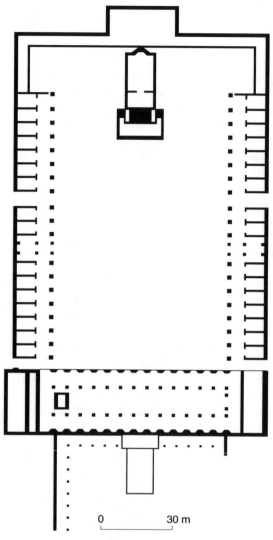

0 30 m

Figure 53. Plan for the restored forum at Clunia
(after Garcí de Jalón in Palol 1989–1990, fig. 3)

superstructure, it is assumed that the temple was Corinthian, pseudo-peripteral, and hexastyle.[29]

The temple plan is not strictly rectangular. There are traces of stairs for mounting to the top of the podium on either of the longitudinal sides, 13.80 m from the front on the east side and 14.10 m from the front on the west side. It is not clear whether the podium could also be ascended from the ground via a frontal staircase as can the forum temple at Emporiae. The present proposed restoration for the temple suggests that the two side stair-cases mounted to a frontal platform that then opened to a frontal facade staircase that made the final ascent to the top of the podium, a treatment similar to the Temple of Venus Genetrix in Rome.[30] The lateral sides are not of equal lengths, the east being ca. 37.35 m and the west ca. 39.90 m. The width of the facade, which includes the projecting stair wings, is ca. 16.60 m. The width of the podium, which rises above the first platform of the lateral stairs, is ca. 13.30 m.[31] The cella proper, of which little is known, terminated with an apsidal space ca. 1.58 m in diameter in the midpoint of the south wall, which is defined by the imprint of the revetment slabs in the mortared fill.[32]

This temple has been identified as dedicated to Jupiter. There is no specific evidence from the remains themselves to support this attribution, but an inscription was found at Clunia that refers to the cult, I.O.M. / L.T.R. / EXP. AVGVRI / NI. . . .[33] Another altar similarly inscribed had been placed in house no. 1 on the fringe of the forum.[34] According to Suetonius (*Galba*, 9.2), the future Emperor Galba heard of his fate from a priest of Jupiter at Clunia who foretold that an emperor would emerge from Hispania.[35] The cult of Jupiter (Jupiter Ammon) was known at the provincial capital of Tarragona. The temple is the only freestanding structure in the forum, and its size is such that it easily holds the south end of the forum. The dedication was obviously important, and the fact that the cult of Jupiter was present in Clunia would suggest that such was the likely choice, especially since the other two options, the Capitoline triad and the Imperial Cult, can be placed elsewhere on the forum.

On the north and south sides of the forum are colonnades fronting the

29. Ibid., p. 48.

30. This is A. García's restoration for Palol 1989–1990, figs. 4–5.

31. These measurements were published in Palol 1989–1990, p. 47.

32. Initially it was unclear as to the shape of the space, apsidal or polygonal; Palol 1982, p. 77. But in the most recent discussion of the building, Palol (1989–1990, p. 48) has identified it as an apsidal space,

33. *CIL* II, 2775. Palol (1959, p. 85) reads this as Iovi Optimo Maximo.

34. IOVI OPTIMO MAXIMO; Palol 1959, p. 85.

35. . . . et confirmabatur cum secundissimis auspiciis et omnibus virginis honestae vaticinatione, tanto magis quod eadem illa carmina sacerdos Iovis Cluniae ex penetrali somnio monitus eruerat ante ducentos annos similiter a fatidica puella pronuntiata.

tabernae. They may also have fronted the basilica. The tabernae end before the east and west sides meet with the south side, and the area surrounding the temple itself is architecturally distinct. The tabernae of the east side are the best understood architecturally. These are not of uniform size and shape. The back wall behind taberna no. 11 (counting from the north) is open and was probably matched by a similar opening in the wall of the west-side taberna. It is through this gap that a decumanus entered the forum. The entranceway was seemingly masked behind the colonnades, and the decumanus effectively ceased to exist within the bounds of the forum itself. Though on the plan it served to divide the forum into almost equal halves, visually it probably did no such thing, since its presence would not have been that noticeable. A secondary entrance at the forum's north end ran along the south facade of the basilica and paralleled the central decumanus and, like it, was probably largely unnoticed when the forum was in operation. The entranceways were no larger than the neighboring tabernae and, in the case of the openings for unit 11, were hidden behind the trabeated arrangement of the interior colonnades. This may also have been true for the northern entrances. In this design the forum at Clunia resembles the more enclosed or self-contained Augustan fora at Emporiae and Conimbriga rather than the open design of the Republican forum at Emporiae, where the decumanus crossed through the forum and physically and visually worked to separate the units of the forum and divide the religious space from the civil space.

The exploration of the tabernae that line the east side has revealed that these are not of uniform size and shape. Tabernae nos. 7, 8, and 9 (counting from the north) form a single complex, clearly distinct from the rest. Units 7 and 9 are rectangular rooms. Unit 8 is twice the size of the others and roughly square. The rooms were discovered in a destroyed state, and little of the superstructure has survived in place. There seems to be no communication between the three rooms, but that all three should be treated together is assured by their shared decorative features, a pavement of *opus signinum*, and walls stuccoed and painted. Slabs covered parts of the lower walls.[36]

Unit 8 (fig. 54) is not only the largest but also the most richly furnished.[37] There was an interior columnar screen of two columns and two pilasters in Corinthian order along the back wall. The excavations indicate two phases of building. The first probably belongs to the Claudian period of the forum.[38] The redecoration, which included statue bases, belongs to the Flavian period. The changes did not dramatically alter the complex.

36. Palol 1982, pp. 82–86.
37. Palol 1989–1990, p. 54 and figs. 6–12.
38. Palol 1974, p. 54.

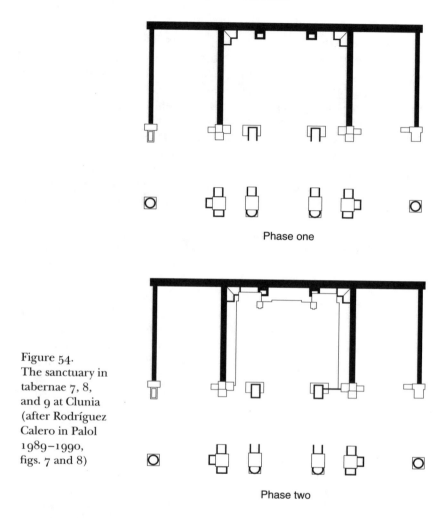

Figure 54.
The sanctuary in
tabernae 7, 8,
and 9 at Clunia
(after Rodríguez
Calero in Palol
1989–1990,
figs. 7 and 8)

The units break the rhythm established by the other tabernae and perhaps by the exterior colonnade. There is evidence that the supports for the colonnade were strengthened here in front of unit 8, perhaps to allow for a more significant exterior feature, a major entrance such as a gable over taberna 8, the central and largest unit. Instead of columns there may have been piers decorated with pilasters.

The structural abnormality of this grouping places it outside the norm for tabernae. Civil architecture on the forum might include a curia in addition to the basilica, but no known curia structures can be paralleled by this

complex. It is easiest to explain it as a cultic structure, particularly consider-
ing the richness of the interior decoration. The joining of three distinct rect-
angular rooms in parallel placement, with the central one being the largest,
brings to mind the traditional triadic form of capitolium temples. The three
rooms formed the cellas, and the colonnade provided the pronaos. There
is no epigraphic evidence for the cult except for a dedication to Minerva
Augusta,[39] which does not in itself indicate the existence of the cult.

Perhaps more telling is the finding of statuary fragments in taberna
no. 10. Here in addition to marble feet, hands, and a bit of a female breast,
there were remains of portraits of two Julio-Claudian princes: a young Au-
gustus, and a Nero.[40] If originally this architectural grouping of tabernae 7,
8, and 9 was intended to honor the Imperial family, then the design is strik-
ing in its novelty. It is arranged so that the shorter axis receives prominence.
This feature is difficult to parallel for sacred architecture. The later temple
in the Templum Pacis of Vespasian is similar in this regard,[41] and could ac-
tually be the model for the design at Clunia, if the provincial cult space
dates to the Flavian reforms rather than to the initial Claudian building of
the forum. If, however, the cultic function of the grouping belongs to the
first building phase, then it stands as an isolated experiment. It may reflect
the influence of Hellenistic-Roman gymnasium and peristyle domestic ar-
chitectural forms as developed in Campania, where the insertion of a taller
gabled porch into the portico had become a design conceit and a means of
highlighting a particular portion of the colonnade without removing the
structure from an integral position within the larger ensemble.[42] Such treat-
ments of domestic peristyles may already have been used on the peninsula;
certainly peristyle houses are known from the southern Iberian contexts,
though the best-studied examples from Italica are of later date.[43] House
no. 3 at Clunia, which is outside the forum proper, was a peristyle house in
its later-third-through-fifth-century forms, and may also have been initially
a peristyle construction that predated the forum proper.[44] To judge from
the later levels of occupation, the house was important, and may have been
so in its initial stages as well.[45] Whether it might have had an interior treat-
ment of the peristyle portico that could have provided the model for this
feature on the forum cannot be ascertained from the present state of the
early remains.

Gymnasia as a distinct architectural type are not known so far on the pen-

39. Palol 1989–1990, p. 39.
40. Ibid., p. 54; idem 1982, fig. 54.
41. Ward-Perkins 1981, p. 67. 42. Ibid., p. 471 n. 5.
43. García y Bellido 1979, pp. 81–102.
44. Palol 1982, p. 72. 45. Ibid., pp. 100–102.

insula, and the early bath complexes did not have large exercise yards attached. It would seem unlikely that the Tiberian bath at Los Arcos in Clunia could have provided a prototype for the embellishment of a part of the portico, and the imperial bath at Los Arcos dates to the Antonine period.[46] For the moment, the unusual grouping, with its exterior treatment that formed some type of cult space on the east side of the forum, must stand alone—without known parallels.

The basilica that closes off the north end of the precinct of the main temple is a large structure. Its longitudinal axis runs the width of the entire plaza and effectively disrupts communication between the south and north halves of the space. The width of the basilica is 26 m. The basilica had three naves: two aisles flanking a wider central space. There is evidence on the east end for a separate room, a curia, though this has not yet been excavated.[47]

North of the basilica and attached to its exterior wall is a mass of stone blocks that formed the platform for a structure aligned on the major axis of the forum established by the main temple on the south side. This structure was also quite large, though the present remains do not provide much detailed information. It seems to have dominated a precinct with some traces of an enclosing wall on the east side. The space would seem to have been an area somewhat smaller in width than that of the southern plaza. The exact function of this space has not yet been determined, though it has been suggested that the stone mass formed the fill for a podium of a temple to Augustus (*aedes Augusti*).[48] There is epigraphic evidence for the existence of the Imperial Cult at Clunia, though the cult may also have been accommodated in the tripartite shrine on the southern plaza.[49]

The forum and its associated structures developed at Clunia in the late Julio-Claudian period and were probably built throughout the third quarter of the first century A.D. They offer some interesting points for consideration. The grand scale of the plan, particularly if it was initiated as two great plazas each with its own temple, harks back to the monumental concepts that first appear in the Tiberian period on the peninsula at sites like Bilbilis, and indeed the idea of a large plaza as the focal point of the design brings forth images of probably similar Tiberian-period constructions at Uxama and Tritium Autrigonum, both of which were in the vicinity.[50] It has already been remarked that Clunia does bear some resemblance to Bilbilis in the

46. Ibid., pp. 50–68. 47. Palol 1987, pp. 154–155.
48. Palol 1989–1990, p. 45; idem 1987, p. 154.
49. *CIL* II, 2778. There is a C. Calvisius Sabinus who was a *magister* and *flamen* of Roma and of Divine Augustus and a [Va]lerius Vegeti [anus] who was a *flamen;* Palol 1989–1990, pp. 39–40.
50. For Uxama see García Merino 1987, idem 1970. For Tritium Autrigonum see Passini 1987.

treatment of the theater and even the construction of the town on a high position rather than in the valley, though there is nothing here as dramatic as the setting for rocky Bilbilis.

The plan for the forum at Clunia breaks with the pattern that had so far emerged as common on the Iberian Peninsula, with the basilica placed to one side. This Iberian type of forum gave precedence to the temple rather than balancing the temple with the basilica, and probably it should be seen as a provincial development in opposition to the more common Italian and western provincial type, which gave equal importance to the basilica.[51] The forum at Clunia represents the adoption of the more mainstream design conceit. The forum also carries forward the enclosed and self-contained style that is seen on the peninsula during the Augustan period in the reforms of the forum at Emporiae and in the new forum at Conimbriga. The forum at Clunia is a separate entity that builds on these earlier experiments.

The joining of the forum to a second important space arranged in association with the main plaza and on axis with the principal temple can be found in a few western complexes. At the Augustan forum at Alba Fucens in Italy, the macellum is placed to the south of the basilica, perhaps aligned with the main temple to the north of the basilica, in a pattern not unlike that of the *aedes Augusti* at Clunia.[52] However, it must be noted that no other site has yet yielded the arrangement proposed for Clunia, with two distinct sanctuaries separated by the basilica.

Though there are several features in the design of the Clunia forum that can be associated with other developments, there are two unique elements. The tripartite shrine on the east portico has already been discussed. The main temple, as restored, would seem to pick up an older treatment of the facade with its lateral means of access. The most interesting aspect is the small apsidal chamber in the back wall of the cella. In his description of Galba's ascension to power, Suetonius describes how he received the pronouncement that an emperor would emerge from Hispania. The priest of Jupiter interpreted the predictions of a girl of noble birth. He matched her statements to those that were recorded as having been uttered by another speaker two hundred years earlier. These archives were kept in the inner shrine of the sanctuary. All this suggests that the cult building of Jupiter at Clunia functioned as an oracular shrine and had been operating as such long before the arrival of Roman control.

This is not the normal role for the Roman Jupiter. However, it is not clear that Clunia's Jupiter was the Roman god. On the Iberian Peninsula there is good epigraphic evidence that Jupiter is often the Latin form for older

51. Russell 1968, pp. 331–336.
52. Ibid., figs. 15–16; Ward-Perkins 1970, fig. 17.

native deities rather than an imported god.[53] It therefore may be safe to assume that the Jupiter who spoke through his priest to Galba was indeed the old local Celtic god.

The apse area on the temple at Clunia can possibly be paralleled by apsidal structures from Roman Britain. There are not many of these, but at least one, that at Benwell, was dedicated to the Celtic god Antenocitius.[54] The placement of the Benwell temple is not quite the same, since it sits east of the Roman fort rather than within the forum of a Roman town. But like the temple at Clunia, it is a rectangular chamber with an appended apse, though its apse is somewhat larger than the one at Clunia.

While the facade of the Clunia temple made it appear as a normal Italic-style building, the apse end and the exedra of the precinct wall that passed behind the temple and echoed the apse are unusual features. There is the possibility that the exedra was in some manner enclosed. It seems reasonable to assume that these two aspects of the design architecturally reflect the native dimension of the cult, which in many other manifestations had come to appear quite Roman. These spaces may have constituted the oracular spaces, which included an archive of older predictions. The persistence of older religion, sometimes under Latin guise but often in native dress, especially outside of major urban centers, and particularly in the northern regions of the peninsula, has long been recognized.[55] The situation of the main temple at Clunia may indicate that even within a seemingly Roman setting, the native element was both present and powerful.

BELO

The site of Belo (Bolonia) sits on the Strait of Gibraltar, about 15 km to the northwest of Tarifa. The North African coast is visible on a clear day. There is archaeological evidence indicating that the site was occupied as early as the second century B.C.[56] It may have been in response to the dangers of the unpacified portions of Mauritania that Augustus forcibly settled a group of North Africans at nearby Traducta (Tarifa) and introduced a division of Imperial troops into the senatorial province of Baetica.[57]

It was the Emperor Claudius who—in an attempt to secure and stabilize the new Roman province of Mauritania Tingitani as well as to assure the con-

53. Knapp 1984, p. 225; Blázquez 1985b, s.v. Anderoni (Jupiter Anderon), Assaeco (Jupiter Assaecus), Candamio (Jupiter Candamius), Candiedoni (Jupiter Candiedo), Jupiter Cantabrorum, Ladico (Jupiter Ladicus), Tetae (Jupiter Tetae); Chaves Tristán and Marín Ceballos 1981, pp. 28–30.

54. Lewis 1966, pp. 72–73. 55. Blázquez 1981, pp. 179–221.

56. Jacob 1986, p. 142; see also *MCV* 16 (1980), pp. 399, 419.

57. Thouvenot 1940, p. 152. See also Pomponius Mela, 2.6.96; Strabo, 3.1.7; Mommsen and Broughton 1968, pp. 69–70.

tinued trade lines and communication between southern Spain and north-western Africa—created the small town of Baelo Claudia and gave it the rank of a municipium.[58] There was already a village at the site that was prob-ably part of the commercial network in the manufacturing and distributing of the fish sauce *garum*, a network that had developed as early as the fourth century B.C. in this region.[59]

The coastal road from Carteia (San Roque, on the Bay of Algeciras) to Gades passed by the town (Strabo 3.1.8). Several ancient authors made mention of the site. References to the town continued into the late antique period, and as late as the twelfth century A.D. Tzetzes still knew of a Bailo (18.710).[60]

The excavations have revealed a small, regularly laid-out city with streets crossing at right angles (fig. 55).[61] The dominant feature was the forum complex, 115 m × 87 m, which has been completely exposed and examined. At its north end sit four temples arranged on the crest of a low hill. The fo-rum plaza, ca. 45 m × 33 m, spreads out below them to the south, toward the sea. On the sides are porticoes, and at its extreme south end the forum is sealed off by a basilican hall. The east and west sides of the plaza were originally lined with porticoes and tabernae, though in time these were changed on the west side into small temples and shrines. A fountain serves to separate the forum from the temple terrace to its north, though two stair-cases on either side offer easy means of communication between the two sectors. To the west, outside the forum proper, stands the macellum, and to the east, again outside the forum, is a major kardo that runs from the east side of the temple terrace to the beach-side industrial region.[62] To the north of the temple terrace is a second decumanus, which leads to the theater that

58. Pelletier, Dardaine, and Sillières 1987, p. 166; Le Roux, Richard, and Ponsich 1975, pp. 129–140.

59. Jacob 1986, p. 142; Ponsich 1976, pp. 69–79; Ponsich and Tarradell 1965.

60. Pliny, *NH* 3.7; Pomponius Mela 2.6, Antonine Itinerary 407.3 For a complete study of the ancient literary sources see Paris and Bonsor 1923, chap. 1.

61. The earliest archaeological mention is D. Macario Farinas del Corral, *Tratado de las marinas desde Málaga a Cádiz y algunos lugares sus vecinos según fueron en los siglos antiguos* (Ronda, 1663). A Belgian Jesuit, Jules Fergus, visited the site early in the twentieth century and wrote up a report in which he identified some ruins on the beach as a temple to Baal. These have since disappeared; see *Annales de la Société Royale d'Archéologie de Bruxelles* 20 (1921), pp. 149–160. Some of his other findings were placed in the care of his college museum at Orihuela. Other early mentions of the site include an article by E. Romero de Torres in *Bulletin de l'Academie de l'Histoire* (1909), p. 422; and P. Paris in his series *Promenades Archéologiques en Espagne* (Paris, 1910). Major excavations began in 1917 and were published in Paris and Bon-sor 1923. The findings of the excavations of the Casa de Velázquez are published yearly in *MCV* and in major monographic studies: Didierjean, Ney, and Paillet 1986; and Domergue 1973. For a complete listing of all published studies of the site through 1981 see Dardaine 1981, pp. 457–516.

62. Jacob 1986, p. 148.

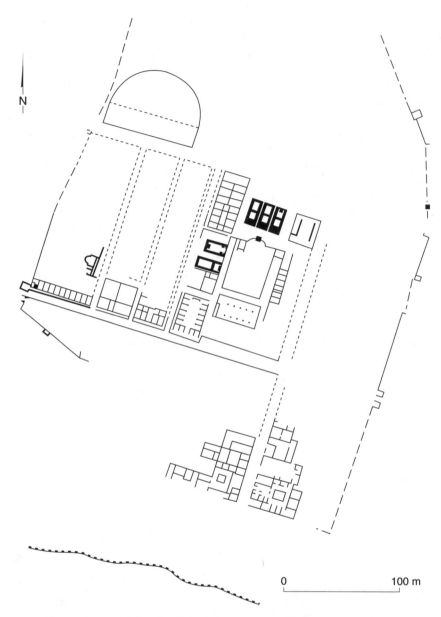

N

0 100 m

Figure 55. Grid plan for Belo (after Jacob 1986, fig. 8; and Pelletier,
Dardaine, and Sillières 1987, fig. 1)

stands to the northwest of the center of the city.[63] The remains as described are those of the second-century A.D. city. However, the excavations have revealed that the urban format represented by these remains was put in place during the mid–first century, and should be considered a result of the Claudian policy in southern Spain.[64]

The site probably began to assume an urban form early in the first century A.D. as a commercial center for the processing and shipping of *garum*.[65] The arrangement of the town and the placement of the parts were determined by the coastal location, the gentle rise of the land, and the need for the industrial quarter to be laid out next to the sea.[66] The town was a major embarkation point for North Africa and also must have functioned as a redistribution site for goods being shipped into the hinterland.[67] There are structural remains on the south side of the forum and on the crest of the hill to the west of Temple A dating to the first half of the first century A.D.[68] The evidence for the massive change to the sector during the Claudian era comes from the east side of the forum. Here an area of shops that had become operational between 20 and 10 B.C. was abandoned in 40 to 60 A.D., when construction on the new forum began and the basilica was started.[69] It was during the mid–first century that the temple terrace was created, the plaza for the forum laid out, the surrounding tabernae constructed, and the basilica built.[70] It is this first phase of construction that is of concern in this chapter. The decumanus behind the basilica, the macellum, the secondary temples on the forum's west side, and the Temple of Isis on the far west of the temple terrace form part of the later reforms to the Claudian design.

Temple Terrace. The early history of the crest of the hill north of the forum is not yet totally clear. There is evidence for structures to the west of Temple A that can be dated to the time of Augustus, but these were not religious (fig. 56).[71] Most likely they were shops. Partially attached to the square back of the fountain is the round or apsidal end of an otherwise demolished building, which may also be of Augustan date.[72] Its function is

63. Dardaine et al. 1987, p. 68. 64. *MCV* 12 (1978), p. 496.

65. Strabo 3.1.8. Pfanner (1990, pp. 71–73) would like to place most of the major construction at Belo to this pre-Claudian period—in fact, pushing it back to a late-Republican building phase, though there is no compelling archaeological reason for doing so.

66. Ponsich 1985, pp. 245–259. 67. *MCV* 15 (1979), pp. 556–557.

68. For the basilica see *MCV* 12 (1978), p. 496; for the south end: *MCV* 8 (1972), p. 576; *MCV* 15 (1979), pp. 556–557; for the area southwest of the basilica: *MCV* 10 (1974), pp. 537–542.

69. *MCV* 18:2 (1982), p. 15; 13 (1977), pp. 499, 511; 11 (1975), p. 518.

70. Pelletier, Dardaine, and Sillières 1987, p. 165.

71. *MCV* 18:2 (1982), pp. 35–37; 10 (1974), pp. 550–555.

72. *MCV* 17 (1981), pp. 412–418, figs. 10–11.

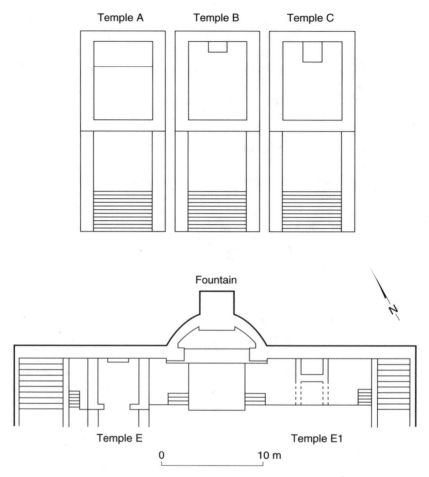

Figure 56. Temple terrace at Belo (after *MCV* 17 [1981], fig. 7)

likewise unknown. The three temples that form a visual grouping and crown the hill were first investigated by Paris and Bonsor and more recently in the early 1980s.

The three temples (pls. 50a, 50b), identified from west to east as A, B, and C, occupy an area of 150 m². As they were initially uncovered, the temples survived up to the top reaches of their podia. The natural rock ledge upon which they sit rises 5 m above the level of the forum. The three temples are aligned so that their fronts form a straight line, and each temple

73. *MCV* 8 (1972), pp. 571–578.

is arranged on the north-south axis so that all three open to the south, toward the sea. There may have been a precinct wall that enclosed the temples.[74]

The podia stand close together, separated about 2 m at the upper molding and about 1 m at the foot. The passageways between the structures stretch back 20 m, and terminate in a masonry wall, which was perhaps a later addition. While they stand on a natural bench, the area south of the temples was fill, which was held in place by the north wall of the forum. There are traces of drainpipes in front of Temples A and C.[75]

When in completed form, the temples must have appeared quite similar. They were probably tetrastyle, pseudo-peripteral temples with engaged side columns. Bits of the rear cella wall with the lower molding for a pilaster exist on Temple B. However, the visual similarity was deceptive. The temples are not exactly the same. They differ in the treatment of the cellas. Temples A and B had small benches at the rear, on which must have stood cult statues. Temple C had evidence of a single statue base against the rear wall. The construction technique for these features was the same in the three buildings: masonry covered in concrete. The treatment of the temples' foundation walls are similar. In part, they rest on the rock of the terrace.[76] The foundations were placed in foundation trenches. The foundations for Temple C go down almost 3 m.[77] The foundation walls are constructed of blocks of stone joined with little mortar,[78] though the arrangement of the masonry in the foundation walls for Temple B is a little more regular, and the stones are a bit smaller.[79] The interior cella measurements are not identical: Temple A, ca. 8.10 m × 5.70 m; Temple B, ca. 8.15 m × 5.40 m; Temple C, ca. 8.50 m × 6.10 m.

The threshold blocks are of a width equal to the thickness of the walls. Though the blocks were heavily worn, it was still possible for Paris and Bonsor to posit double-leafed doors from the trace of bolt holes in them.[80] The superstructure walls were of about the same thickness: 1.50 m for Temples A and B, 1.20 m for Temple C. The difference corresponds to the slightly larger interior space of Temple C. The temples were accessible only from the front, and there is no evidence for direct communication between the three structures other than the shared terrace.

Temple B, the middle temple, sits on the main axis of the forum and is immediately above the fountain, which marks the axis of the forum and serves to physically delimit the forum from the temple terrace above. There

74. Paris and Bonsor 1923, pp. 60–85.
75. *MCV* 17 (1981), pp. 405–421.
76. *MCV* 18:2 (1982), p. 25.
77. *MCV* 17 (1981), pp. 406–407.
78. Temple C: *MCV* 17 (1981), p. 405; Temple A: *MCV* 18:2 (1982), p. 25
79. *MCV* 17 (1981), pp. 411, 414.
80. Paris and Bonsor 1923, p. 74.

are remains of two altars in the small area in front of the temples. These altars were constructed of large stones covered in plaster. A single large stone forms the top of each one. Paris and Bonsor maintained that originally there had been three altars, one of which was robbed out.[81]

The temples were well finished on the outside. The podia had marble revetments. There is fragmentary evidence that the composite order was used, and composite capitals found reused in a structure on the beach may have come from the temples.[82] These reused capitals consist of two blocks, the lower 0.46 m, the upper 0.50 m. They are not identical and further suggest that the temples, though similar, each possessed some degree of individuality. The columns may have stood atop Attic-Ionic bases. Such bases have also been found in reused contexts in the nearby village. The lower torus is ca. 1.15 m and the upper ca. 0.75 m.

Using Vitruvius and Vignola as guides, Paris and Bonsor proposed a height of ca. 11.24 m for the temples. The heads of two lions found on the temple terrace may have been the work of a single hand. The two heads lack water channels and are too large to have formed part of the sima decoration. The flat tops of the heads may indicate that they were part of consoles for a lintel over one of the main doors for one of the temples.[83]

The early development of Belo is still shadowy, but there is little doubt that the interest that the Emperor Claudius took in southern Spain and the subsequent change in status granted the city did much to encourage its urban formation. The terrace on which the temples sit and the retaining wall that separates the temples from the forum date to between A.D. 40 and 60, the same period that saw the building of the east portico and the remodeling of the basilica.[84] The drains found in front of Temples A and C probably served to keep the upper terrace free from stagnant water.

The completion of the temples and the final form of the upper terrace does not seem to have been accomplished until the time of Trajan. The subtle but important stylistic differences among the three temples do indicate that they are not the products of a single short building campaign. Temple C was the earliest to be built, and the initiation of its construction, determined from stratigraphic findings, can be dated to the decades between A.D. 40 and 60, the period of the first building phase.[85] However, the placement of Temple C, off the axis of the forum, would indicate that the design program was intended to encompass three temples, with B serving as the anchor. The finds from the foundation of Temple A provide a *terminus post quem* of A.D. 50–60 for the beginning of its construction. Temple A

81. Ibid., p. 76.
83. Ibid., p. 84
85. *MCV* 17 (1980), p. 419.

82. Ibid., p. 77.
84. *MCV* 18:2 (1982), pp. 20–21.

may have been started toward the end of the building of Temple C, perhaps during the reign of Nero.[86] The sondages to the north of Temple B revealed nothing earlier than Nero's period.[87] It seems that the temples themselves could not have been fully operational before the period of Vespasian, and may well have not functioned fully until the early decades of the second century.

It may have been that the great temple terrace was built in two phases. During the first phase, starting about A.D. 40, the three temples were laid out beginning with Temple C but were conceived of as a unit of three temples. By the beginning of the second century, the three temples stood up to the height of their podia, but now major changes that had begun in the forum area and the eastern extension of the temple platform during the Flavian period were affecting the design. These alterations included the redesign as sacred space of the west side of the forum, the building of the Temple of Isis to the east of the temple terrace, and the consolidation of the temple terrace itself behind a supporting wall with fountain.[88]

Against the north wall of the forum is a large fountain and basin placed on an axial line with the forum and Temple B. Paris and Bonsor described it as being ca. 7 m long. The basin sits ca. 2 m above the level of the forum paving and is semicircular, constructed of small stones set in concrete. A dedicatory inscription appears to date the fountain to the beginning of the second century A.D.[89]

The wall that separates the upper terrace from the forum and against which the fountain stands is carefully constructed of cut and mortared stone blocks. The wall rises above the height of the fountain and continues to a depth of ca. 1.50 m below the level of the pavement. The fountain did not belong to the initial Claudian design of the forum with its two tiers, though something else may have occupied the space.[90] The fountain could have been added as a practical solution to the problem of standing water. The temples standing atop the terrace place stress against the retaining wall. This could have been seen as potentially dangerous in periods of strong rains, when the ground might become saturated. The drains placed in front of Temples A and C appear to date from the first building phase and were probably an attempt to treat the problem. It was during the second great building period—when additional work was done on the terrace, the temples were probably completed, and the forum itself was changed—that the fountain was added to assist with drainage. At this same time, the altars on the terrace and the retaining wall show signs of modification.[91]

86. *MCV* 18:2 (1982), pp. 26–29.
88. Ibid., pp. 30–32.
90. *MCV* 18:2 (1982), p. 20.

87. Ibid., pp. 30–31.
89. Paris and Bonsor 1923, pp. 60–64.
91. Ponsich 1974, pp. 21–27.

The fountain gave focus to the entire forum ensemble. The full development of the forum space during the late first and early second centuries, particularly the north and east sides, must have come about because of the city's growing economic importance as a redistribution point for goods coming in from North Africa.[92] The new macellum built in the west of the city, which replaced the tabernae that had existed in the forum, may testify to the increased economic role of the town at this point.[93]

The conception of the forum and its crowning temple group as first envisioned in the mid–first century was indeed impressive for such a small city. The ensemble of three temples must have been always at the heart of the design, especially since the first temple to be built, Temple C, was not placed on the axial line and therefore ruined the balance of the civic center, something that would not have been allowed. Though the temple terrace went through a major renovation and structural change late in the first century, it does seem reasonable to consider the three temples, the terrace, and the fountain as a single unit, the composition for which ultimately went back to the Claudian period. Changes made may be seen as modifications effected to respond to certain specific structural problems with the terrace. In this sense it is also reasonable to include in the discussion the two small temples on either side of the terrace wall on the north end of the forum, which were not replacements for earlier nonreligious buildings. However, it is not appropriate to consider at this point those temples built in the Flavian renovation of the forum that did replace earlier, nonreligious structures on the west side of the complex.

At the two extreme ends of the north wall were flights of stairs that connected the forum with the terrace. To either side of the north-terrace retaining wall, placed between the fountain and the stairs, though nearer to the stairs, are small buildings. On the west side this structure has been identified as Temple E. It is a distyle shrine on an axial line with Temple A on the terrace above it. A wide flight of steps leads up to a set of narrower steps and then to a porch. There are two *antae*. Inside the cella is a small central podium, and against the back wall, a bench.[94] There are also traces of a parallel structure to the east, Temple E1. It is aligned with Temple C. These two structures were most likely shrines, though how they functioned is not clear. The conduits for the fountain pass beneath the pronaos of Temple E,[95] and it seems reasonable to date the construction of these two buildings to the period when the fountain was created.

Temple E must have been somehow closely associated with Temple A above it. The two bases in the temple were aligned with the main entrance,

92. Ibid., pp. 31–35.

93. Didierjean, Ney, and Paillet 1986; Mierse 1989, pp. 619–621.

94. *MCV* 7 (1971), pp. 405–419. 95. Ponsich 1974, pp. 27–31.

and therefore on axis with the alignment of Temple A. Some fragments of a marble sculpture from Temple E may have come from a cult statue. A private altar with a dedication to Q. Pupius Urbicus from his parents was found in the vicinity but not in situ.[96]

Paris and Bonsor, who were the first to excavate the temple terrace, identified the temples as dedicated to the Capitoline triad. The identification is possible. They sit on a high point of land overlooking the forum and city. They are three similar cult buildings that from a distance probably appeared identical. There are the three required cellas. However, a temple to the Capitoline triad of Jupiter, Minerva, and Juno is most commonly conceived of as a single temple building. Here we have an arrangement of three independent buildings that do not even share an architectural association. Nothing literary, epigraphic, nor cultic has been found to support the attribution.

Paris and Bonsor cited the Capitoline triad grouping at Sbeitla (Sufetula) in modern-day Tunisia as a comparative treatment (pl. 51). Yet these temples are strikingly different in important aspects. First, they do not sit on a high point of land, but rather just occupy one side of the forum. Second, they are not visually similar buildings. Moreover, they are probably later in date than the Belo group.

If indeed the three temples at Belo were intended to serve the Capitoline triad cult, then their design must be considered, for the moment, unique. Their date in the middle of the first century A.D., when the city's status was that of a municipium, would suggest that the notion that only cities that had attained the rank of *colonia* could commission a temple to the Capitoline cult is not quite correct, and that Ward-Perkins's view that such temples were nothing more than physical manifestations of the process of Romanization is much closer to the mark.[97]

ANALYSIS

It is difficult to know how to treat the mid-first-century architectural development on the peninsula. In one sense it seems clear that Claudius, like Tiberius and Caligula, was largely uninvolved with the peninsula, at least directly. We probably should not look for subtle Imperial forces to be at work on most aspects of architecture.

Of course, Clunia's rise to the position of conventus capital probably was directly the result of policy established in Rome.[98] The exploitation of the northwest had begun under Augustus. Gold found in León, particularly sur-

96. Le Roux, Richard, and Ponsich 1975, pp. 129–140.
97. Ward-Perkins 1981, illustration 274.
98. Palol 1982, p. 23.

face occurrences of secondary alluvial and placer deposits, may have sparked a true gold rush in the ancient world in the years following the conquest that would have lasted until the deposits were exhausted and prospectors returned to the primary resources in the mountains.[99] The ancient sources are in agreement that the peninsula was rich in mineral deposits. The evidence is not clear as to how early the mines in this region were in full operation. Possibly Augustus's conquest of this area, a region that had so resisted Roman penetration, was compelled by the desire to exploit the mineral wealth.[100] By the time of Claudius the area may have been in need of some reorganization, which would explain the decision to create the conventus capital at Clunia. Under Vespasian, Asturias and Galicia were given recognition by the creation of a *procurator ducenaria* for the region.[101]

It is certainly possible that the Iberian provinces profited indirectly from Claudius's interest in southern Gaul. Seneca does make the disparaging remark about the Emperor's desire to see all the western provincials in the toga of citizenship.[102] However, nothing indicates that such franchise was extended to the Iberian provincials so early. Certainly the adjustment in the status of Clunia might be considered a political move comparable to the founding of Colonia Claudia Ara Agrippinensis (Cologne), though without the same direct personal interest shown in the choice of name.[103] The two cities were both regional centers, though Clunia was not a veterans' foundation as was Cologne. It is worth noting that the new capital of Lower Germany was established on an orthogonal plan, and it is the construction of the forum at Clunia that seems to create a similar degree of regularity in the Iberian city.[104] The changes at Clunia may have preceded or been contemporary with the conversion of Colchester in southern England from a legionary fortress, established in A.D. 41,[105] to a planned town with a grid, a shift that occurred sometime in the midfifties.[106]

There is little reason to see any specific Imperial involvement with the expansion of Belo during the midcentury. The city no doubt prospered with its *garum* production, which kept the city in commercial contact with the maritime Roman world.[107] The burst of urban building under Claudius re-

99. Lewis and Jones 1970, pp. 167–185.

100. Blázquez 1978, pp. 91–93; Jones and Bird 1972, p. 74. These depend to some degree on the references in Trogus Pompeius (*Iust.* 44. 3. 4–5) and Florus (2. 33. 60).

101. Blázquez 1978, p. 95.

102. Manni 1975, p. 135; Hatt 1970, p. 132.

103. Hatt 1970, p. 130. 104. Grimal 1983, pp. 182–183.

105. Ibid., p. 336, s.v. colonies. 106. Crummy 1985, pp. 78–85.

107. For *garum* production see Ponsich and Tarradell 1965; Martín and Serres 1970. Amphoras for the exporting of *garum* manufactured along the Iberian coast have been found throughout the western Empire; see Blázquez 1967, p. 29 n. 47.

flected in the western provinces both in recently pacified territories and perhaps on the Iberian Peninsula is paralleled by similar developments in Rome itself. After a long era with little public building in the capital under Tiberius and Caligula, Claudius instituted major public-works programs,[108] perhaps to deal with the financial crisis that had arisen in A.D. 33, toward the end of Tiberius's reign.[109] It might be possible to see developments in urbanization on the Iberian Peninsula as in part a result of an official policy that promoted public expenditure on public monuments. However, there is nothing from either the epigraphic or the literary record that provides the names of benefactors for work at Clunia or Belo, and certainly nothing points to Imperial monies being spent.

Clunia's new position as a conventus capital may have influenced the choice of cults for the city center. The excavations have revealed three distinct cultic areas. It seems reasonable to assume that one was for the Imperial Cult. There is no evidence to permit any identification of cult with space. The main temple on the forum could have served the old cult of Jupiter, which was considered too important to be shifted in order to permit the Imperial Cult to occupy the space. The story that Suetonius tells is particularly interesting, for it suggests that the cult was in some way oracular. If the story has any validity, then the cult predates the Roman domination of the region and must have been an earlier native cult. J. M. Blázquez has stressed that Jupiter was the great Indo-European god, and as such was honored in the Celtic areas of the peninsula.[110] Older local high gods were renamed Jupiter,[111] but their cult practices may have retained an element of the pre-Roman divine force. Just such an older cult that included an oracular component could have retained its importance in the new conventus capital. If the design of the apse and exedra spaces at Clunia is in reality similar to that of the apse areas of the Romano-Celtic shrines in Britain at Binwell and Silchester,[112] then classical forms were being adapted to suit the needs of Celtic religion, which lacked a tradition of religious architecture.[113] There is no evidence that on the Iberian Peninsula Claudius saw fit to destroy the older Celtic religious forces that may have begun to become Romanized, as he did the Druid religion in Gaul.[114]

108. Ward-Perkins 1981, pp. 52–56.

109. Thornton 1986, pp. 28–44.

110. Blázquez 1981, p. 197. Jupiter's cult even in the south of Spain may have covered earlier indigenous cults; see Chaves Tristán and Marín Ceballos 1981, p. 28.

111. Knapp 1984, p. 225. 112. Lewis 1966, pp. 72–73.

113. Piggott 1986, pp. 48–62.

114. Suetonius, in *Claudius* 25, records that the Emperor abolished the Druid cults. However, there is no evidence that Druidism had taken root on the Iberian Peninsula, where the Celtic religion was probably the older, pre–La Tène belief system. See Piggott 1986, p. 119.

The arrangement of the three temples on the crest of the hill at Belo is, like the design of the temple of Clunia, an odd feature that has so far not been adequately explained. The design can be paralleled by the triad of temples at Sbeitla; these three prostyle, tetrastyle, pseudo-peripteral temples are placed on one side of the Sbeitla forum. There are clear stylistic associations between the two groupings. The Sbeitla temples are all similar in design and size. They visually form an ensemble, and must have been conceived, like the Belo temples, as a formal grouping, probably for the cult of the Capitoline triad.[115] The forum that they dominate is a roughly square plan, not unlike that at Belo. Belo's role as the departure point for the North African coast must have served to encourage linkages between the Iberian city and North African towns. However, there is nothing that conclusively dates the Sbeitla temples to the late first century A.D., and in fact epigraphic evidence would indicate that the construction of this aspect of the city dates to sometime around A.D. 139.[116] If any relationship did exist between the two sites, the evidence would suggest that the influence went from Belo to Sbeitla.

The old forum at Leptis Magna in Tripolitania (fig. 57), the construction of which began early in Augustus's reign, is dominated by its grouping of three temples on the north side. The cults for two of these are known: Liber Pater, and Roma and Augustus. The third may have been dedicated to Hercules. They were not independent temples for the Capitoline triad. Moreover, though they worked as a grouping, the temples are neither all of the same size, nor physically closely related to one another.[117] They were erected in distinct campaigns and were not really conceived of as an ensemble.[118] Nonetheless, they could have had an impact to some degree, insofar as they could have provided a prototype for the grouping of religious structures across one side of the forum. The builders of Belo's forum and temples could have been familiar with the arrangement at Leptis because it may have been in A.D. 53–54 that the forum plaza at the site was paved and the limestone porticoes added.[119] At the same time that the design for Belo was taking shape, major construction work was ongoing at Leptis. Both sites were ports, and there may have been commercial traffic between them.

Closer to the grouping at Belo both in terms of composition and conception is that to be found on the south end of the forum at Pompeii (fig. 58).

115. Cagnat and Gauckler 1898, p. 14.

116. Ward-Perkins 1981, p. 408, plate 274; Cagnat and Gauckler 1898, p. 14.

117. Bianchi Bandinelli, Caffarelli, and Caputo 1966, pp. 85–90.

118. Ward-Perkins 1981, p. 371.

119. Ibid., p. 373. Bianchi Bandinelli, Caffarelli, and Caputo (1966, p. 85) present a date of 5 B.C. to A.D. 2 for this work on the forum.

Figure 57. Plan of the Old Forum of Leptis Magna (after Bianchi Bandinelli, Caffarelli, and Caputo 1966, p. 84, fig. 235)

Figure 58. Plan of the lower end of the forum at Pompeii (after Vos and Vos 1988, p. 23)

Here, during the rebuilding after the earthquake of A.D. 62, three small, temple-like apsidal halls were reconstructed.[120] These have been identified as the Augusteum (VIII ii 6), the Tabularium (VIII ii 8), and the Curia (VIII ii 10).[121] They formed part of the civic rather than the religious architecture of the city, but their similarities in size, design, and structure, along with their placement in close physical proximity to one another and the fact that all three were in the process of being rebuilt at the time of the eruption, would suggest that they were constructed as an architectural ensemble. In these aspects, they differ from the Leptis Magna temple group and resemble the Belo group.

CONCLUSION

The evidence for a North African prototype for the Belo group is inconclusive at best, and more likely nonexistent. Obviously the program at Pompeii could not have been influential, since it was built after Belo. Moreover, the three apsidal halls there were clearly not of monumental importance and were not intended to occupy the main position on the forum as do the three temples at Belo. That Belo was part of a trade network that included cities on the North African coast seems undeniable, and equally likely, Belo's

120. Vos and Vos 1988, p. 37.
121. Richardson 1988, pp. 270–272.

merchants may have carried the city's *garum* to Campania, but the idea that urban and architectural developments in these regions played a major and influential role in the choices made at Belo lacks credibility. It may be better to suggest that Belo, along with North African cities and Pompeii and other cities on the Iberian Peninsula such as Clunia—cities with some period of Romanization behind them—undertook monumental building projects all at about the same time, the decades of the mid–first century, from perhaps A.D. 37 to 68. The Emperor Claudius could well have been responsible for encouraging some of the building by granting changes in political status to some cities such as Clunia, and the natural disaster of the earthquake caused Pompeii to rebuild, but in most instances the forces stimulating building may have been more benign. In general, Caligula, Claudius, and Nero did not pay overly great attention to the pacified and Romanized provinces, and may have allowed some free rein for development.[122] However, Claudius and later Nero did spend, in some cases quite lavishly, on public works within Rome itself, which could have fostered similar spending by local elites in the provinces.[123] The expenditures made by the elite at Pompeii to recover the city after the earthquake could well have influenced provincial elites to build.

What is significant architecturally at Belo, Leptis, and Pompeii is the creation of architectural ensembles. At both Belo and Leptis, it would seem that during the midcentury concerted efforts were made to create both a homogeneous civic center and one that possessed monumental groupings of buildings that architecturally formed visual units. A similar influence is at work at Pompeii. Such design conceits were not new. Hellenistic architects had understood the power of such visual ensembles. The design for Augustan Conimbriga would suggest that such concepts of architectural unity were understood on the peninsula and in the western provinces in the first quarter of the first century A.D. What is distinct about these midcentury plans is the interest that the architects have in creating large units that also celebrate the autonomy of the parts. Belo's three temples stand as distinct entities on the crest of the hill and at the same time are worked into a complex composition in which each temple establishes a dialogue with the temple next to it and all three form the vertical punctuation for the larger forum ensemble. Their independence from the forum is architecturally clarified by the fountain, which serves to block direct access from the forum to the temple terrace, but their integration into the design is stated by the accent on the longitudinal axis that is made by the alignment of Temple B and the fountain on the midpoint of the forum plaza. The axial line then bisects the basilica on the opposite side, and thus both sides are joined together. In a similar way, the two small shrines, Temples E and E1, are aligned with the

122. Manni 1975, pp. 131–148.
123. Thornton 1986, pp. 28–44; idem 1975, pp. 149–175.

temples above and behind them. It would seem that the strength of this compositional conceit lies in the use of a basic unit of three related structures. At Pompeii and Belo the three were conceived of together, and it may have been the attempt of an architect at Leptis to create a similar sense of unity for the three distinct temples there that resulted in the use of bridges to link the three temples.[124]

There is nothing at Clunia that is comparable to the Belo arrangement, but the three rooms that formed a sacred enclosure on the east side of the forum should be treated as an ensemble, albeit on a more modest scale. Parallels for this feature are no easier to find than for the temple terrace at Belo. The emphasis on the shorter axis is the most distinct feature. This same treatment is known for other temples, beginning with Augustus's Temple of Concord in Rome, which was rebuilt on the same plan by Tiberius, and Vespasian's later Temple of Peace, which may have taken this design feature from the Temple of Divine Claudius.[125] This was never the most common treatment for public sacred buildings in the Roman West. If Palol's newest reconstructions for this shrine are correct, then the center of the complex was stressed both by placement and by means of architectural embellishment. Indeed, the stronger piers at this point would support the notion of a more expanded treatment for the roof of this portion of the building. However, since the shrine was incorporated into a side portico, there was a screen of columns that must have served to counter the emphasis by stressing the visual unification and the integration of shrine with tabernae. The establishment of this type of opposing visual stresses seems to have also been exploited for Vespasian's forum and its Temple of Peace. The date for the construction of the shrine at Clunia is not fixed, and certainly it could have come into being after Vespasian's design had become known.

There may have been a more immediate model available on the peninsula, however, the Augustan forum at Conimbriga. If the reconstruction proposed by Étienne and Alarcão is correct,[126] then a similar tension had been established at this western outpost. The temple was incorporated into the colonnade, and it was the architectural accent given to the entrance that permitted it to retain any degree of autonomy.

On the other hand, if Roth-Congès is correct in her reconstruction of the Augustan forum,[127] then it is hard to see Conimbriga as the design source for the tripartite development at Clunia. Roth-Congès proposed that

124. Bianchi Bandinelli, Caffarelli, and Caputo 1966, p. 85.

125. For the Temple of Concord see Ward-Perkins 1981, p. 39; for the Temple of Peace: ibid., p. 67, fig. 30. See also Donaldson 1965, pp. 15–20.

126. For the debate of the form of the temple and portico of Augustan Conimbriga see chap. 2 supra.

127. Roth-Congès 1987b, pp. 711–751. See also chap. 2 supra.

the second stage of development at Conimbriga was when the first temple was built, and that this occurred during the Flavian period.[128] More recently, M. Pfanner has argued for a slightly earlier date for the change, suggesting that the switch that Roth-Congès proposed actually happened in the mid–first century.[129]

Independent of the forum, there is reason to believe that Conimbriga witnessed developmental changes in the urban fabric during the midcentury, particularly to the south of the forum in the residential and mercantile districts.[130] This general activity may well have been known to builders working in the western and northern regions of the Iberian provinces. If the Étienne and Alarcão reconstruction of the forum at Conimbriga is correct, then the design feature may have become somewhat known outside the immediate area.

The Conimbriga design as interpreted by Étienne and Alarcão with its tripartite elements, though unique at this moment, may have been in reality a standard pattern for forum arrangements in small Augustan foundations in the West that have been lost under later accretions. It may explain the visual similarities between Conimbriga and Mirobriga, a small town south of Conimbriga on the coast of Portugal. The archaeological evidence so far from the forum excavations at Mirobriga suggests a Claudian or Neronian date for the construction, though as will be argued in the next chapter, it is perhaps best considered a Flavian town.[131] If such is possibly the case, then the appearance of the tripartite shrine at Clunia represents a modification of a provincial design motif that had lost its original purpose and was now available to be exploited by architects in need of solutions for new architectural problems.

Certainly an interesting feature of the mid–first century on the peninsula is the evidence for the survival and reconception of older forms. This happens in Romanized centers like Augusta Emerita and Tarraco, where older metropolitan models are now recycled in the provincial capitals to create little versions of the capital out in the hinterland. These are impressive constructions and seem to testify to a kind of coming-of-age in the far West as certain centers aim to manufacture their own ceremonial centers for the practice of, one assumes, Roman civic rituals. At the same time, at Clunia the power of an older cult may dictate that the Roman style of sanctuary be modified to serve local cultic needs. What is most impressive is not that the cult survives, since Romans had no particular need to destroy native religions, but that the older cult still commands the most significant space in the city and the most important temple built there.

128. Roth-Congès 1987b, pp. 727–728.
129. Pfanner 1989, pp. 184–203. 130. Ibid., pp. 193–194.
131. Soren 1982, pp. 29–43. See also chap. 5 infra.

Flavian Extravagance

The latter half of the first century A.D. heralds the start of the second period of intense urbanization on the Iberian Peninsula. In a manner similar to that of Augustus, Vespasian (A.D. 69–79) brought about major changes on the peninsula. He extended the Latin right to all towns, in effect turning *oppida* into municipia and enrolling large numbers of new citizens into the Emperor's tribe, the *Quirina*. Numerous sites with the surname Flavium or Flavia attest to the change in status.[1] Moreover, the period was prosperous. The changes to the religious sectors of the well-established and Romanized cities of Emporiae, Belo, and Conimbriga attest to a secure financial situation and suggest the nature of the political shifts on the peninsula.[2] During this period, the local elites become increasingly more involved in determining architectural forms, particularly as these forms can be used to help give a visual manifestation to the civic hierarchy.

REDESIGNS AND NEW ORGANIZATIONS

Emporiae

Over a period of perhaps thirty years, from the last two decades of the first century A.D. through the first decade of the second century, the Roman forum of Emporiae was embellished with eight small shrines.[3] These were

1. Bonneville et al. 1982, p. 16.
2. There is evidence for more than just religious buildings. Macella were constructed during the Flavian period at Belo and possibly Clunia; Didierjean, Ney, and Paillet 1986; Palol 1987, p. 155.
3. All information for the discussion of the forum temples comes from Aquilué Abadías et al. 1984, chap. 5, "Construccions d'època imperial," pp. 104–109.

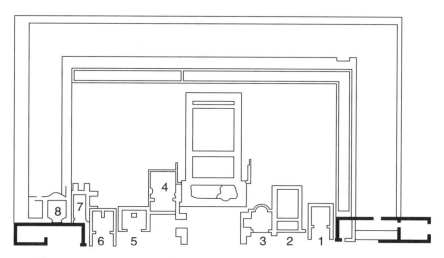

Figure 59. Little temples on the forum at Emporiae (after Aquilué Abadías et al. 1984, fig. 43)

arranged in two groups of four to either side of the main temple (fig. 59). They were built on a line some meters in front of the main temple and served to frame its facade. These are small structures and have been num-bered 1 through 8 reading from east to west.[4]

Initially two temples (1 and 6) were probably constructed as mirror im-ages of one another and placed on either side of the main temple. What remains of these two temples shows them to have been quite similar. They are divided into pronaos (temple 1: 2.75 m × 3.70 m; temple 6: 2.50 m × 3.75 m) and cella (1: 3.65 m × 3.70 m; 6: 3.57 m × 3.85 m). The cella of temple 6 is divided into two halves longitudinally by a short spur wall that comes out of the back wall. The cella of temple 1 is a unified whole. The floors for both structures are of *opus signinum,* and temple 1 still retains some traces of painted wall plaster. The two temples were tetrastyle, though in neither case is the order known. The close similarity in construction and design details suggests that these were conceived of as a framing pair that served also to echo on a smaller scale the tetrastyle facade of the main temple.

Temples 2 and 5 were probably added next. Temple 2 is a larger version of 1; it retains the tetrastyle facade, but is raised on a podium, and the pronaos is smaller (ca. 1.50 m × 4.70 m). A portion of the walls survives and

4. The sizes are temple 1: 4.70 m × 7.45 m; temple 2: 5.85 m × 9.15 m; temple 4: 4.90 m × 7.10 m; temple 5: 5.06 m × 6.40 m; temple 6: 4.70 × 7.45 m; temple 7: 2.60 m × 4.45 m; temple 8: 3.50 m × 3.60 m.

is of *opus incertum*. Temple 5 is not at all similar to 1, 6, or 2. It is a roughly square structure ca. 5.06 m × 6.40 m with rather thick walls (0.75 m). The interior cella space is ca. 4.80 m × 3.75 m, and the large door (ca. 2.50 m) is on the shorter side but opens to the south, as do all the temple doors. There are remains of a base inside of temple 5 slightly to the west of the axis of the door. The structure was built of *opus incertum* and had a floor of *opus signinum*. It had no impressive facade other than perhaps a two-step rise from the level of the forum.

Maintaining a sense of balance, the builders probably next erected temples 3 and 4, the two little temples nearest the main temple. They both touch the exterior of the main temple, and they abut the small temples next to them. Temple 4 follows the plans of 1, 6, and 2, though it is significantly different in details. Rather than tetrastyle it is a prostyle *in antis* temple raised on a high podium. It is a little smaller than 2. It had frontal access via a staircase into the small pronaos (1.85 m × 4.90 m). The paving again is *opus signinum*. Within the cella are the traces of three small altars. Temple 3 presents a dramatic break with any of the sacred structures so far considered in this entire study. The front part of 2 forms the east wall of 3. The north, or back, wall is apsidal, with the apse aligned with the entrance in the south wall. The apse frames a small altar. The line of the west wall is broken by a square niche. The interior space is roughly square (ca. 3.65 m × 4.10 m), with appended apse (ca. 2.25 m) and niche (ca. 1.45 m × 1.65 m) spaces. The construction is *opus incertum* with a flooring of *opus signinum*. As with temple 5, there is no evidence for a colonnaded facade.

Temples 7 and 8 were probably the last to be built and were not added as symmetrical elements. They stand side by side to the far west of the main temple and are part of the structure of the portico, which had defined the temenos of the temple since the Republican period. They are both quite small. The walls of temple 8, which seem thick at 0.70 m, are preserved at points to 0.50 m of height. They were coated with lime and frescoed. Inside of temple 8 stood a small marble altar.

By the start of the second century A.D. the entire east and west open spaces between the ends of the portico and the main temple had been filled in with small temples. These were not all aligned on the same plane, but rather formed an undulating pattern of projecting and receding facades that framed the main temple, which stood the farthest back. Clearly the intent was to maintain a balance in the building of these smaller structures, and at least initially to establish a dialogue between the large temple and the smaller side temples. This dialogue was abandoned early on, though it is not clear why. The great line of temples formed a sacred facade and served to screen the temenos from the south plaza. The main temple must now have appeared to emerge from within a forest of similar structures. However, the physical closeness of all the structures to one another must have rendered

the entire grouping flat and suggested visually something akin to a theater backdrop. The temple fronts were not too unlike the niches that would soon come to dominate the marble style of facade building.

Belo

The work on the triple construction on the hill overlooking the forum continued at Belo into the Flavian period,[5] but a fourth sanctuary was added to the east, a building markedly different from the three-temple grouping. On the forum itself, more and more area was turned over to shrine buildings.

Along the north side of the forum the terrace wall separating the forum plaza from the temple terrace had been modified during the last two decades of the first century by the addition of a fountain, which stood atop an earlier structure.[6] The fountain was part of a massive unit that included a podium built during the Claudian phase[7] and that equally divided the north forum wall into two parts. To either side of the fountain-podium unit, two small rectangular structures were added (E and E1).

The west side of the forum was also transformed (fig. 60). It had been occupied first during the Augustan period and by the middle of the first century was the site of a house.[8] The architects of the Claudian program destroyed the house and laid out the small rectangular structure F (9.35 m × 17.90 m)[9]—perhaps a shrine—next to the north side of which was a narrow passageway, H, which probably joined with a kardo outside the forum proper.[10] It may have been at this same time that the west side of the forum was given a monumental character by the inclusion of a large arch that was somehow related to the facade of F.[11] The arch and the facade of F stood behind or were elements in a colonnaded gallery. In this respect, the west side of the forum may have resembled the triple-shrine design at Claudian Clunia, which was being developed contemporaneously. The Flavian builders redesigned the west side of the forum so that F became one of three shrines (E [next to F],[12] F, and G), and the narrow passageway, H, that had run next to it was now widened, bordered to the north by G, to the south by F, and served as the entrance into the forum from the west side.

5. *MCV* 17 (1981), p. 419.

6. *MCV* 18:2 (1982), pp. 20–23, 35.

7. *MCV* 24 (1988), p. 47. 8. Ibid., pp. 29–33.

9. Measurements for the structures on the west side of the forum come from Pelletier, Dardaine, and Sillières 1987, pp. 165–172.

10. *MCV* 24 (1988), pp. 27–29; *MCV* 23 (1987), pp. 84–88.

11. *MCV* 24 (1988), pp. 38–39; *MCV* 23 (1987), p. 90.

12. In the earlier study of E it was identified as D; see *MCV* 24 (1988), fig. 4; *MCV* 23 (1987), pp. 94–98. It was renamed E by Pelletier, Dardaine, and Sillières (1987, p. 168). The two structures on either side of the fountain are also designated as E and E1.

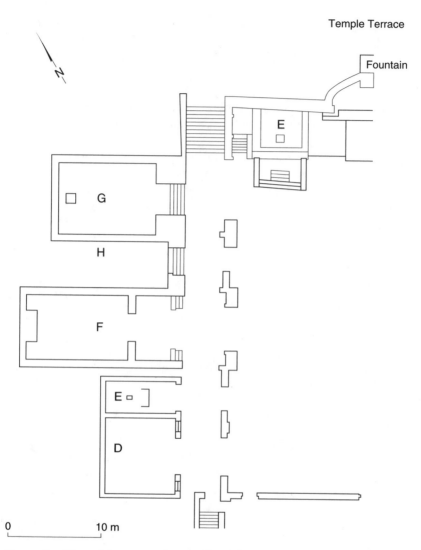

Temple Terrace

Fountain

E

G

H

F

E

D

0 10 m

Figure 60. Plan of the restored west side of the forum at Belo in the late
first century A.D. (after *MCV* 24 [1988], fig. 4)

The three small shrines on the west side dominated, along with H, the west facade of the Flavian forum, and the colonnaded gallery space fronted them. The arch was no doubt retained, and the plaza of the forum itself was paved. The paving covered over a drainage system that ran along the west side of the forum.[13]

It is possible that the Claudian builders had intended to create a series of small shrines on the west side. However, the change in the design of passage H to enlarge it and border it to the north by the new Flavian construction G might well argue that multiple shrines belong to the design ideas of the Flavian period. Shape, more than any other feature, suggests that buildings E, F, and G be considered cultic spaces. F and G (ca. 9.50 m × 14.50 m) are long, rectangular rooms. F has a clear pronaos space. G has an entrance space but not a true pronaos. The interior spaces for E, F, and G hold podia that stand on axis with the entranceways. Little has survived of the superstructure for the spaces; however, some tile fragments that must have been part of the roof were found in F.[14] D, a squarish space to the south of the three shrines, has yielded some fragments of pisé wall construction atop stone foundations below the level of the Flavian structure. This pisé is associated with a floor of *opus signinum*.[15] There is no evidence that Flavian builders were working with pisé walls for the forum. More likely, this pisé construction belongs to a private domestic building of the mid–first century.

The architects at Belo limited changes to the north and west sides of the forum. The south continued to be dominated by the basilica, which had been erected with the building of the forum, and the east side served the commercial needs of the town with six tabernae of roughly equal size, and all smaller than the shrines except for E1.

Sanctuary of Isis. During the last two decades of the first century A.D. and into the beginning of the second century, builders at Belo substantially altered the perimeter of the forum by adding secondary structures. All the while, the work continued on the older Claudian design of the three temples on the crest of the hill. This triadic grouping overlooked the forum, and the two spaces were brought into closer association physically by secondary east and west lateral staircases that accessed the terrace from the forum. Visually the two areas were conjoined by means of the fountain and podium, which were placed on axis with Temple B and which also served to bisect the forum. However, the neatness of this grand urban ensemble was disrupted during

13. *MCV* 23 (1987), pp. 90–91. 14. Ibid., p. 84.
15. Ibid., pp. 95–96.

this same period by the addition of a fourth structure, the Temple of Isis, on the eastern side of the temple terrace (fig. 61).[16]

The building is a rectangular space, ca. 23 m × 16 m.[17] It is aligned on a north—south axis parallel to that of the three temples to the west. It is a different structure from those temples. The exterior walls enclose an interior patio, probably a peristyle. The south, east, and west sides formed an ambulatory space about 3 m wide,[18] and the northern part was divided into three chambers that opened onto the peristyle. In front of the three northern chambers—integrated into the peristyle and occupying a portion of the patio space—are remains of a podium ca. 7.5 m × 4.5 m, fronted by the one remaining step of the staircase to the top. Remains of the podium are of cut and fitted blocks of stuccoed, shelly limestone. Held in place by these walls was a fill of local stone rubble cemented together with mortar.[19] This construction sits on the longitudinal axis of the complex, and was probably aligned with the axis of the main entrance from the south. The ensemble was built around A.D. 80 atop an older, mid-first-century structure that, like the older structures underlying the western portion of the forum, had been built of pisé.[20]

The construction has been interpreted as a sanctuary with a cult building occupying the central position, surrounded on three sides by a portico and backed by three smaller chambers (P-1, P-2, P-3). P-1 and P-2 are almost square rooms, ca. 5 m × 5 m. P-3 is a rectangular room ca. 5 m × 7 m. There is no evidence for a chamber under the central podium of the cult building.[21] There are traces of a floor of *opus terrazzo-signinum* for the sanctuary.[22]

Since the three rear chambers are not large,[23] they must have served for small and private functions. The floors of P-1 and P-2 are of beaten earth, and the finds consist solely of fragments of pottery. P-3 has a more ritualistic look. Four columns with Corinthian capitals delimited a rectangular space that occupied the center and the eastern half of the room. The finds of broken roof tiles and lead plaques would seem to indicate that the columns supported the roof and formed an opening to the sky in this central part of the room. Located within this space was a basin (ca. 1.20 m × 1.10 m) built of stone blocks set atop a socle of tiles covered in stucco but lacking traces of hydraulic mortar. Against the west wall on the interior of P-3 are the remains of a kiosk of some type, the placement of which is roughly aligned

16. *MCV* 7 (1971), p. 406; 19:1 (1983), pp. 403–410; 20 (1984), pp. 441–450; 21 (1985), pp. 349–354.

17. All measurements for this discussion have been taken from the published plan of the ruins in *MCV* 23 (1987), p. 73, fig. 4; they are reported as only approximations.

18. *MCV* 19:1 (1983), p. 408. 19. Ibid.

20. *MCV* 24 (1988), p. 25. 21. Ibid., p. 27.

22. *MCV* 19:1 (1983), p. 408.

23. All details for this description are taken from *MCV* 23 (1987), pp. 71–75.

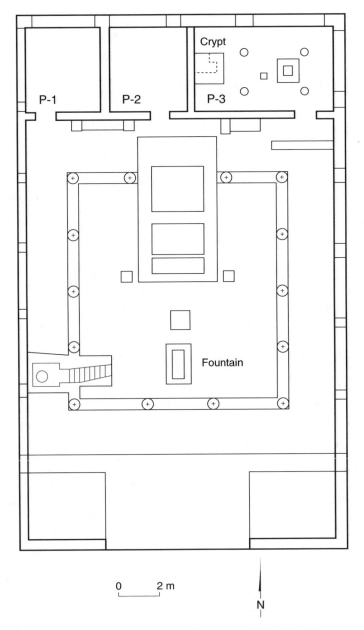

Crypt

P-1 P-2 P-3

Fountain

0 2 m

N

Figure 61. Sanctuary of Isis at Belo (after *MCV* 24 [1984], fig. 2)

with the basin. The kiosk was constructed of stone and roofed with a vault. The interior space is quite tiny, about 1 m², and it was entered from a door on the north side. It may have been a type of crypt. P-1 and P-2 may have been used as living quarters, whereas P-3 could have had a cultic function.

In the open courtyard before the temple are the remains of another basin.[24] For this one there are traces of the conduit system that brought the water from the east to the basin. The importance of this basin is made manifest by its placement on axis with the temple. To the east of the basin are the remains of a hearth.

The marked importance and clear formal significance of water within the sanctuary itself both in the courtyard in front of the temple and possibly in P-3 suggest a ritual function. The most likely cult making major formal use of water was that of Isis,[25] in which the Nilometer was a fundamental element.[26] Moreover, according to Plutarch (*Isis and Osiris*, 20), crypt spaces were an important feature in the ritual of the Isis cult, and the small, isolated kiosk in P-3 could well have served such a function.

A date of A.D. 80 for the construction of the Temple of Isis allows it to be compared with the rebuilt Temple of Isis at Pompeii (fig. 9),[27] the best-known of the Egyptian goddess's Roman cult places. The two share some similarities in general planning. The sanctuaries are closed, separated from the noninitiated by walls. In both, the temple dominates the temenos, which is defined by an enclosing peristyle. The temples sit atop podia and are accessed from the front by means of staircases. The Pompeiian temple has secondary lateral stairs as well. The colonnade of the peristyle screens rooms behind. At Pompeii, a chamber opening off the southeast corner of the peristyle forms a roofless enclosure in which a descending staircase leads to a crypt area that may have served as the container for the Nile water. The design and placement are different from those of P-3 at Belo, but the features of an area open to the sky, a cryptlike space, and a possible water container are similar in both instances. Moreover, a possible domestic quarter for the priest of the cult at Pompeii has also been isolated off of the peristyle, not unlike the placement of P-1 and P-2.

The shared features between the two sanctuaries are slight enough to argue for similarities in cult rather than architectural design. There is nothing about the Iseum at Belo that would indicate that its designers specifically intended to emulate the more opulent shrine at Pompeii. However, the private nature of the dedication of the Pompeiian sanctuary, paid for by one N. Popidius Celsinus, must have been the same at Belo. The cult did not

24. *MCV* 24 (1988), p. 23.
25. The temple has since 1985 been identified as a sanctuary to Isis; *MCV* 21 (1985), fig. 2.
26. Wild 1981.
27. Richardson 1988, pp. 281–285.

function as a state cult. Yet the placement of the Iseum at Belo near the triad of temples and just above and to the east of the forum would seem to indicate that, as at Pompeii, the Egyptian goddess had drawn important local people into her worship, and the location of the shrine testifies to the high esteem in which the cult was held.

Though the sanctuary was constructed physically near the three-temple grouping and was erected during the same years that Temples B and C were being completed and the north and west sides of the forum were being redesigned, the Temple of Isis is a distinct entity. It sits slightly outside the ensemble of forum and temple terrace. It is not really aligned with the line established by the fronts of the podia of Temples A, B, C. It may have been more closely associated with the kardo—the street of columns, according to P. Paris,[28] that ran from the fish-processing area on the waterfront straight up into the monumental quarter of the town. As such, the cult space for the goddess would have been linked to the sea. Considering the international nature of Isis's worship and her association with water, a direct link to the port area was perfectly sensible. Her cultic space was readily accessible to any merchant or traveler in Belo. The Iseum at Belo tied this insignificant southern Iberian town into the international Graeco-Roman commercial world in which the cult of Isis flourished[29] and may signify that the mercantile aspects of this town rendered it somewhat more important than might have been expected.

Conimbriga

The forum and main temple at Conimbriga as developed and built during the years of Augustus's rule served the needs of the community until the time of the Flavian dynasty. Under Vespasian the city assumed a full Roman status and changed its name to Flavia Conimbriga.[30] The Flavian interest was particularly strong in the northwest, where the emperors became concerned with the rich mineral resources of this western fringe, and it was during this period that the lighthouse at La Coruña was built.[31] Conimbriga had reached a level of some provincial importance. It provided a *flamen* for the provincial Imperial Cult in Augusta Emerita in the last quarter of the first century A.D., one M. Junius Latrus.[32]

The old forum was no longer suitable. There were still ties to the old

28. Paris and Bonsor 1923, p. 120. See also Jacob 1986, fig. 8.

29. For a recent discussion of the cult see Martin 1987, pp. 76–78. For the cult on the Iberian Peninsula see Koch 1982, pp. 347–352; García y Bellido 1967; idem 1956, 293–355.

30. Alarcão 1983, p. 93.

31. Montenegro 1975, pp. 7–88; McElderry 1918, pp. 53–102.

32. Alarcão 1983, p. 93.

Celtic Iron Age settlement, which were now to be cut. The architect in charge of the redesign set about the work as though the site were a tabula rasa. Instead of reworking or re-forming the existing complex, he razed everything and conceived a totally new ensemble atop the ruins. There is no evidence for a natural disaster. As was happening in Rome itself, in order to build anew, it was often becoming necessary to destroy existing structures.[33] At the same time the old, pre-Roman portion of Conimbriga was demolished.

The old forum was not totally forgotten in the new design. The general north-south alignment was retained, and the dimensions of the great central plaza remained the same. Portions of the older structures were incorporated into the new foundations of the Flavian buildings, but at no point were these older forms allowed to influence the new designs (fig. 62). Alarcão and Étienne, the excavators of the site, have determined that a modular unit based on a 10-foot unit equal to 2.96 m was employed for the new design.[34] The width-to-length ratio of the new temple was 1:2, while the relationship of the width of the temple to the total length of the temple including stairs and landing was 1:3. The ratio of the width of the temple to the width of the entire sector is 1:4. The ratio of width to length of the forum itself is 2:3. Such calculated relationships imply that the rebuilding of the Conimbriga forum was carefully planned and executed. The Flavian forum does not reflect accidents, accretions, or unplanned experimentation. It was constructed as a coherent architectural monument.

The most dramatic departure from the Augustan design was the dismissal of the autonomous parts. In the Augustan period the forum had served as the civic and administrative center for a small community; now the civic and administrative roles were removed. The tabernae and the basilica were destroyed and over them matching porticoes erected. These were not intended to function in a manner akin to what they replaced; rather, they provided cover and shelter to either side of the plaza and served to focus attention on the temple at the north end.

The central space measures ca. 23.60 m × 26.80 m. It was paved in flagstones. In some areas the paving stones rest directly on the bedrock, held in place with mortar. At the north end, the stones had to be set atop a built-up foundation of small stones set in mortar. At the foot of the north wall is a channel of brick that functioned as a main drain fed by several other channels.

The west, south, and east sides of the forum were lined with porticoes attached to the outer wall of the forum. Portions of the east-side portico rest

33. The architects of the later Baths of Caracalla destroyed and covered over the Gardens of Asinius Pollio to form a platform for the baths; Vermeule 1977, p. 63.

34. The discussion on the Flavian redesign is drawn from Alarcão and Étienne 1977, pp. 88–110.

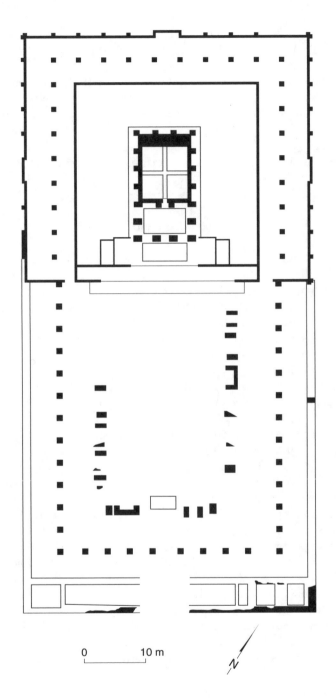

Figure 62. Plan of Flavian forum at Conimbriga (after Roth-Congès 1987, fig. 8)

0 10 m

N

directly atop the Augustan basilica. The tabernae of the west side were knocked down to build the portico. The interior depth of the portico is ca. 5.70 m on the east and west sides and ca. 4.80 m on the south side. The interaxial spacing varies between 3.50 m and 3.70 m. At the north end where the east and west colonnade met with the wall of the cryptoportico beneath the temple platform there were half columns. The walls of the porticoes were decorated with pilasters. The portico order was Corinthian, and a single Attic-Ionic base has been found. Columns stood without plinths to a height from base to abacus of ca. 9.55 m. A fragment from the interior soffit blocks shows that the interior ceiling decoration consisted of a raised floral pattern set in panels. The height to the cornice has been calculated at ca. 11.29 m. The porticoes provided a formal frame for the forum plaza and in no way detracted from the temple, the major element in the new composition.

The south side of the forum is not completely understood. A new monumental gateway was placed on axis with the north-south line of the forum. It provided the main means of access and opened directly opposite the temple. The excavations have not been able to clarify what stood on either side of the gateway. The portal did not emerge directly into the central plaza but rather emptied into the south portico. The colonnade must have masked the actual entrance from the inside of the forum.

All the elements of the forum were subservient to the temple at the north end. Unlike the Augustan temple—which had been completely incorporated into the composition as simply one more unit, albeit the most important—the Flavian temple stood alone and aloof atop a cryptoportico, and surrounded on the east, west, and north sides by porticoes.

As with the old Augustan ensemble, the sacred area was raised above the level of the forum proper on a terrace. Small flights of stairs probably gave access on the east and west sides of the north end of the lower plaza. At the same point were the two doors that led down into the cryptoportico, which supported the surrounding portico. The doors were at the north end of the east and west porticoes of the main forum. Perhaps four stairs descended to the floor of the cryptoportico. The flooring was of tramped earth mixed with white mortar about 10 cm to 12 cm thick. The three passageways had an average width of 7 m. The aisles were divided down the middle by a row of piers set at about 3 m from the wall. They are spaced regularly between 3 m and 3.30 m. There are twenty-six piers, eight to each side and two at the corners. At the midpoint of the south wall and in between columns 4 and 5 of the east and west walls were small exedras. They occupied the interior space that corresponds to the exterior area between two of the buttresses on the outside wall.

The walls and piers were built directly on the bedrock. The exterior walls

are supported with a line of external buttresses, which are placed on the same line as the interior piers. The walls are built of limestone and local tufa laid with mortar. The walls show variations in construction. The lowest level is of mortar and stone chips, which form the bedding for blocks of roughly worked or unworked tufa and limestone. This provides the foundation. Above it are placed worked but irregularly shaped stones. The upper reaches of the walls are finished with smaller, squared stones. The piers are similarly constructed.

The cryptoportico was the substructure for an open portico, which functioned as the backdrop for the temple. It was a double colonnade with brick columns and a third row of pilasters against the back wall. The bases, of limestone, were Tuscan and offered a contrast to the Attic-Ionic bases of the forum porticoes. They were of two diameter sizes: 0.60 m and 0.52 m. The second base stood on a square plinth. Nothing of the capitals has been recovered, but the order was probably Corinthian. The columns should have been stuccoed over. The height to the cornice, a fragment of which has been found, is calculated to have been 7.16 m. The soffit decoration consisted of acanthus consoles separating panels of rosettes into groups of four.

The cryptoportico was a cramped and dark space with limited lighting and ventilation, not suited for crowds. It could not have functioned as a major enclosed architectural feature of the new ensemble. The cryptoportico was a well-known feature in Roman architecture in the West. At Emporiae it had been used in the Republican forum to surround and define the temenos of the temple. The Augustan forum at Conimbriga had a cryptoportico that served as the bridge between the Iron Age *oppidum* and the new Roman settlement. However, the new Flavian cryptoportico did not continue to function in the same manner. It had a simpler function: to lift up the portico that defined the temple temenos.

The temple, on which this cryptoportico and portico focused attention, was the featured architectural element in the ensemble. It sat on the north-south axis atop a square esplanade ca. 30 m × 30 m. The new construction totally replaced the Augustan temple and its side wings.

The podium measured ca. 19 m × 11.80 m. The pronaos interior space was ca. 4.5 m deep by ca. 7.50 m east-west. The cella was ca. 8.70 m north-south by ca. 7.50 m east-west. There was a central staircase that led down from the top of the podium to the esplanade. To either side of the staircase were square platforms at the same height as the top of the podium.

The podium was composed of an outer shell, a wall of large stones of tufa both regularly and irregularly cut. These formed the lower courses hidden under the esplanade. The visible sides of the podium stood to a height of 2 m and were of courses of more regularly cut and fitted stones.

The walls formed the casing for a hollow interior space composed of five

large units. Four are equally sized squares atop which sat the cella. A single large rectangular unit occupied the space under the pronaos. This substructure for the pronaos sat directly atop the Augustan walls, which formed a part of the new foundations. The Augustan underpinnings of the cella portion of the podium were completely trampled down in order to form a secure bed on which to build the new podium. The datable material within the fill was mixed, and ranged from pre-Augustan through pre-Flavian objects. The design of this podium resembled that used in the Republican temples at Emporiae and Saguntum.[35]

The temple had a single central staircase. The architect stabilized this construction on a foundation that rested atop the Augustan cryptoportico. To either side of the staircase were the two platforms that extended from the top level of the podium and perhaps served as statue bases.

Not too much of the superstructure has survived. Alarcão and Étienne have reconstructed the temple as tetrastyle and pseudo-dipteral, largely on the basis of comparisons. The width and depth of the pronaos, as identified from the hollow space below, would have allowed for a tetrastyle facade with an intercolumniation equal to a diameter and a half, equal to one of the units operating in the design of the complex. The same spacing carried around to the sides would have provided for one freestanding column and five engaged pilasters. The width of the outer walls of the podium shell was not wide enough to have actually supported a full peripteros. Based on a few fragments of the superstructure, the excavators have calculated a height from column base to cornice top of 10.77 m. The height of the temple from the top of the podium to the top of the pediment was 13.32 m. Alarcão and Étienne believe that there is a modular relationship between the various heights in the complex. The height of the temple equals four and a half modular units; the distance from the floor of the porticoes on the forum plaza to the top of the temple would equal six units.

The Flavian forum ensemble presented an aspect far different from that of the Augustan forum that it replaced. Where the architect of the earlier forum had sought to integrate and harmonize the necessary units into a composition that stressed the dignity of the parts as well as the homogeneity of the whole, the architect of the Flavian monument strove to create a setting suitable for a single grand structure. The ceremonial quality may have been further emphasized by the numerous statue bases that lined the three sides of the lower plaza. Several of these were of marble, and they must have increased the grandeur of the scene. Certainly statuary had long played a major role in the decorative programs for fora throughout the Empire, but

35. See chap. 1 supra.

by the middle of the first century A.D. they had begun to obscure almost everything else. At Velleia the entire back wall of the basilica was lined with portrait statues of members of the Imperial family. These were in addition to the statues in the plaza itself.[36] At Belo, during the reign of Trajan, sculpture began to decorate the public buildings.[37] It is probably in the late Julio-Claudian or Flavian period that the great decorative program at Augusta Emerita, modeled on that of the Forum of Augustus in Rome, was finally completed,[38] though the actual plans for the program must go back to the initial design for a second forum at the provincial capital. The Julio-Claudian tradition of sculptural embellishment augmented the architecture of the fora and gave to the buildings a sense of splendor while reinforcing their civic importance. The situation at Conimbriga was somewhat different.

At Conimbriga the statue bases, and hence the statues, were placed to either side of the gateway in front of the porticoes, thus restating the axial force of the composition and heightening the ceremonial aspect of the design. They lined the processional route to the temple proper, which towered above everything else at 18.50 m. Its columns had the widest diameter and rose above the height of the columns in either of the two porticoes. Significantly, the architect surrounded the temple with a backdrop of the smallest columns, thereby increasing the visual contrast and stressing the temple's dominance.

The nonreligious uses of the forum were now all completely removed. There were no shops, no basilica, no curia. A similar treatment seems to have been taking place at Belo, where more and more of the forum was being turned over to religious building. But at Belo this has a more ad hoc quality to it, as the older design was modified rather than demolished. The architect for Flavian Conimbriga's forum established a rhythm for movement through the space with colonnades and stairs, and controlled the way in which the ensemble opened up or closed down. One could enter only on the main axis. A monumental gate announced the complex from the outside, but its importance was diminished on the inside because it was hidden behind a screen of columns. The porticoes were large and deep, and the colonnade high enough to properly frame the plaza and effectively shield the enclosed space from the world outside. Moreover, the porticoes provided

36. Vermeule 1977, pp. 75–76.

37. A statue found in the ruins of the basilica has been identified as Trajan, though the identification is not secure, and other statuary must have decorated other portions of the forum; *MCV* 17 (1981), pp. 420–430, figs. 14–20. The statue is now housed in the archaeological museum in Cádiz.

38. Trillmich 1986, pp. 279–304.

a dark background against which the sculpture could be displayed, showing a typical Flavian aesthetic interest in the dramatic potentials of a setting.[39] The darker, lower porticoes must have also supplied the contrast needed to highlight the temple.

The forum at Conimbriga probably reflects similar fora throughout the peninsula. It owes a certain degree of its formal elements to the experiments made elsewhere—at Augusta Emerita and Emporiae and, above all others, the Imperial fora in Rome. The Imperial fora were complexes in which the ceremonial aspects of the architecture stressed by balance, symmetry, and axiality dominated all other uses. However, the forum at Conimbriga exhibited a more complicated design and a more elaborate relationship of the parts than was the case in the early Imperial fora or probably was the case in any of the provincial versions that they spawned. The older forum-temple arrangements, such as at Emporiae or Clunia or Belo, in which the parts have autonomy and integrity and which were indebted to older Republican models with their incorporation of a variety of functions and building types, were replaced at the century's end by this new type of forum with a hierarchical treatment of the parts. Though still the dominant architectural mass in a city, the forum now came to function more for ceremonial than civic purposes and assumed a truly monumental aspect. In the formal design of the forum at Flavian Conimbriga there is a hint of the awesomeness and monumentality that in the next generation would result in the great Forum of Trajan in Rome.

Mirobriga

Even though Conimbriga may have seen a major change in the design and concept of the forum space during the Flavian period, the older Augustan pattern influenced the format of the forum space of the southern Lusitanian town of Mirobriga (Miróbriga, Santiago do Cacem). Here excavations have revealed a small Roman town that succeeded an earlier Iron Age village (fig. 63).[40] The dominant feature of the site is the high point, the Castelo Velho, on which are located the ruins of the forum and three temples, two of Roman date and one an Iron Age structure (fig. 64). The Roman temples were initially identified by Almeida as those of Asklepius and Venus and dated to the third or fourth century A.D.[41] Almeida was also responsible for restoring the so-called Temple of Asklepius as the main structure on the forum.

The forum was a paved rectangular space ca. 32 m × 23 m aligned

39. Hanfmann 1964, discussion of Flavian style.
40. Biers 1981, pp. 30–38. For the earlier studies see Almeida 1964.
41. Almeida 1964, p. 71.

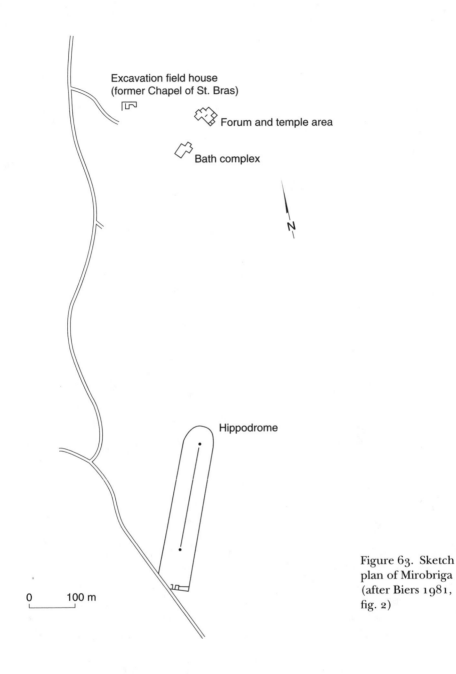

Excavation field house
(former Chapel of St. Bras)

Forum and temple area

Bath complex

N

Hippodrome

0 100 m

Figure 63. Sketch
plan of Mirobriga
(after Biers 1981,
fig. 2)

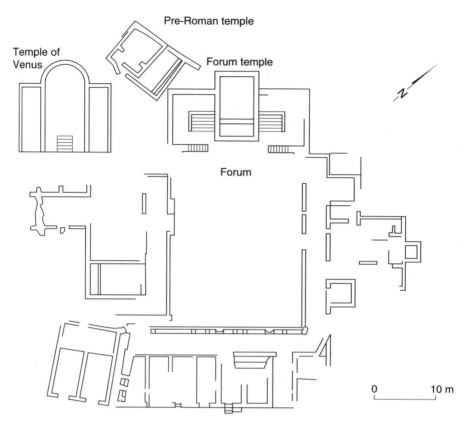

Figure 64. Plan of the forum area at Mirobriga (after *Muse* 16 [1982], p. 36, fig. 1)

roughly on a northwest-southeast axis.[42] The temple and terrace area to the
northeast side are the best understood, though excavations in 1982 have
clarified what may have been a market building on the south side.[43] The re-
cent excavations of the forum area and of the temple region have thrown
into doubt Almeida's interpretations. The temple on the forum looks like a
standard forum temple rather than a special healing sanctuary. Moreover,
the sondages have produced evidence of at least two construction phases for
the forum, the first perhaps Claudian or Neronian.[44] It seems reasonable to
propose that the second phase, which resulted in the present arrangement

42. Biers 1981, pp. 31–34, figs. 3–5.
43. Soren 1982, pp. 36–37.
44. The finds from the sondage on the southern corner yielded scraps of Arrentine and
South Gallic wares, which gave a rather broad period for the first phase of construction; *Muse*

of temple and terrace as restored by Almeida, may well have been Flavian. The final report on the forum excavations has not yet appeared.[45]

Mirobriga was an old settlement. The heart of the Iron Age site could have been on the hill on which the forum is located. Occupation may well date back to the fifth century B.C.[46] The remains of an older, pre-Roman structure with walls built of courses of flat schist mortared with mud have been found on the forum. The structure was well built, and within its area were found a votive offering of pottery and animal remains.[47] This must have been a sacred structure for the Celtic village. Its form is unusual and has permitted the excavators to read it as a late structure, a proto-Roman building—a hybrid structure with cella and pronaos but within a square plan. Its construction has been postulated to be late first century B.C. or early first century A.D.[48] Under this temple are remains of a still earlier, fourth-century B.C. structure, probably also a temple.[49] These earlier temples diverge from the axis established on the forum, but their sacred nature awarded them prestige within the new plan. The area was preserved, as were the ruins of the later of the two structures, and the space was left unbuilt upon, framed by the later Roman temples.

Of the two later Roman temples, that which is on the axis of the forum is the best understood. Almeida reconstructed the temple. It consisted of a cella entered through a pronaos. Flanking it to either side were L-shaped wings (alae). It was built of pale red limestone blocks laid in courses and held with mortar. The blocks averaged 17 cm × 30 cm × 26 cm. This material and technique were used for several structures at the site. The walls are thick, ca. 0.90 m.[50]

The temple sits atop a terrace that dominates the northwest side of the forum. There may have been a basement space beneath the temple. There is an opening 1.88 m wide that leads down 2 m below the level of the reconstructed column bases. The temple is fronted by an elaborate staircase arrangement somewhat reminiscent of a theater stage front (pulpitum). This is a platform structure, behind which the stairs mount from either side, in symmetrical manner, to the temple platform. Two rectangular niches are on the lower level directly in front of the temple, and paired scalloped spaces, one to either side, mask the ascent of the stairs. Although the plan is not exactly symmetrical, it gives an appearance of balance.[51] The construction

15 (1981), p. 33. The excavations under the paving stones in front of the south building in 1982 provided pottery of Claudian and Neronian date; *Muse* 16 (1982), p. 36.

45. Final reports have so far appeared on the general site survey, the circus, and the baths; Biers 1988.

46. Soren 1982, p. 38. 47. Ibid., p. 39.

48. Ibid., p. 40. 49. Soren 1983, pp. 54–59.

50. Biers 1981, pp. 31–33. 51. Ibid., p. 33, figs. 3–5.

technique here is of coursed blocks of stone, somewhat irregular in size and shape. The entire structure must have been covered in stucco.

Almeida based his argument that this temple was dedicated to Asklepius on an inscription, found without context and without any clear association to the ruins of Mirobriga, that references the god and possibly a festival of the Quinquatrus.[52] Whether the festival honored the god, highly dubious since the festival of the Quinquatrus normally honored Minerva or Mars, and whether the celebrations took place at Mirobriga cannot be determined from the inscription itself. The most recent student of the text has questioned whether it has any association with Mirobriga.[53] Similarly, the newest excavations have not lent support to Almeida's interpretation of the sanctuary as built in the third or fourth century. Indeed, the plans of the temple and the plaza appear to be a typical first-century A.D. forum pattern, and the excavated material supports a late-first-century construction date.

A Flavian date for the actual execution of the forum space is not out of line. Mirobriga may have been one of the communities on the peninsula that demonstrably celebrated its change in status brought about by Vespasian's actions. Initially Mirobriga must have been an *oppidum*, as Pliny records (*HN* 4.22.116–118).[54] It would, like other Iberian sites, have assumed its position as a municipium under the Flavians.[55] There is evidence of residents being enrolled in the Quirina tribe[56] and a possible reference to Mirobriga as a municipium.[57] A change in status would have been a cause to engage in the construction of a monumental civic center. The other major civic structure excavated at the site, the east and west baths, may have been begun in the early second century A.D., perhaps as a result of the stimulation provided by the forum-building program.[58]

In the publication of the first season's work at Mirobriga, the excavators questioned Almeida's conclusion that the site was actually a pilgrimage des-

52. Almeida 1964, p. 46. Almeida recorded the inscription: AESCULAPIO / DEO / C. ATTIUS JANUARIUS / MEDICUS PACENSIS / TESTAMENTO LEGAVIT / OB MERITA SPLENDI / DISSIMI ORDINIS / [Q]UOD EI [Q]UINQUATRI / UM PRAESTITERIT / [F]ABIUS ISAS HERES / FAC(iendum) CUR(avit).

53. Jensen 1985, pp. 56–60. MacKendrick (1969, p. 192) and Alarcão (1967, p. 167) accepted Almeida's reading of the inscription.

54. ". . . mirobricenses qui Celtici cognominantur."

55. K. Slane ("Mirobriga and Its History," in Biers 1988, pp. 139–143) does not accept the possible Flavian change in status.

56. Wiegels 1985, p. 6; Mackie 1983, p. 33 n. 11.

57. E. Haley (Departments of Classics and History, McMaster University) brought this source to my attention. Slane (in Biers 1988, p. 142 n. 1) rejects the reading of *CIL* II, 25, line 4 as M(unicipium) F(lavium) M[erobrig(ensis)]. Similar abbreviations on gravestones from elsewhere cannot be read in this manner, and suggest that the formula has a different meaning.

58. W. R. Biers and J. C. Biers, "The Baths," in Biers 1988, p. 112.

tination rather than a true town.[59] However, in the course of the survey work at the site, little evidence of domestic settlement and no findings of a necropolis have led to a reconsideration of Almeida's theory and a tentative identification of the site as some type of pilgrimage destination.[60]

There are some interesting features about the forum complex. It is a self-contained and enclosed space, hierarchically arranged with the temple as the dominant feature. From the present knowledge of the ruins, there is no evidence for a basilican hall, which had become a standard feature in Iberian fora by midcentury but which was also missing in the Flavian remodeling of Conimbriga's forum. This absence is significant enough, in Slane's estimation, to argue against Mirobriga's achievement of municipium rank. It is also the case that, when combined with the other public sectors of the town, the area turned over to public architecture is large, especially for a town with an area of only 2.8 ha. Perhaps the most intriguing feature of the forum is the special place accorded the older, pre-Roman sanctuary—which was treated as hallowed ground and set aside—as an element in the cultic space on the northwest side of the forum.

Tarraco

It is worthwhile here to review the complicated situation at Tarraco as already presented.[61] At the start of the Flavian period Tarraco had begun to assume a grand appearance befitting its rank as a provincial capital. The Augustan forum had been transformed by the addition of a large basilica, which must have provided the closure to one of the short ends. The basilica perhaps enclosed the old altar to Augustus, which had been on the forum since the days of the first Emperor. Opposite the basilica perhaps, probably on axis with the exedra containing the altar, was the forum temple, for which there is no archaeological or epigraphic evidence. This temple should have been planned, if not built, when the forum was started, and is therefore probably of Augustan date and may resemble the octastyle temple portrayed on the Tiberian dupondius issue. As such, it and the massive temple on the forum of the capital of Gallia Narbonesis probably should be seen as architectural rivals.

Late in the reign of Tiberius the first architectural assault on the heights overlooking Tarraco was made. It was here that the temple to Divine Augustus, formally approved in A.D. 15, was to be built eventually. The major construction in this upper terrace was undertaken during the Claudian period. The ceramic evidence from the excavations in the cloister of the cathedral

59. Biers 1981, p. 30.
60. Slane in Biers 1988, pp. 139–141.
61. Chap. 3 supra.

and on the Carrer San Llorenc shows that the development of this region took place sometime in the late Julio-Claudian or early Flavian period. Although there has been a strong push to argue for a Flavian date,[62] the stylistic analysis of the tondi with the heads of Jupiter Ammon (pl. 52) and Medusa allow for a Claudian date for some of these pieces.[63] If these elements did indeed come from the attic story of the porticoes surrounding the temple, then it must be assumed that the mid–first century witnessed a fair amount of work on the upper terrace.

Exactly what was built on this area overlooking the city is not yet fully clarified. There must have been a temple, the temple represented on the Tiberian sesterce, an octastyle structure with a Greek peripteral plan. The remains for this must lie deep under the Gothic cathedral. Was this completed by the Flavian period? Perhaps not. There are fragments (0.75 m) of two composite capitals (Museo Nacional de Arqueología de Tarragona, nos. 108, 114) (pl. 53) that were found in the upper city, along with some of the fragments of the tondi[64] and a bit of an acanthus-scroll frieze probably from an entablature (pl. 55). These are often identified as coming from the Temple of Jupiter,[65] but this temple, referred to by Suetonius (*Galba*, 12.1), is known from epigraphic evidence that has been found solely in the lower city.[66] There is no real reason why it must be on the heights. Furthermore, the Suetonius reference would seem to indicate that it was an old temple, and there is, as of yet, no evidence for any development of the high area prior to the late-Tiberian (?) or midcentury. The temple in Suetonius is just that of Jupiter, and the inscriptions are generic to Jupiter. The temple may have been that which actually stood on the forum; such a practice is well known from the Temple of Jupiter on the forum at Pompeii. The composite capitals could then have come from the Temple of Augustus. According to Recasens i Carreros, they are Flavian,[67] though it must be noted that D. Strong identified the style as being late Julio-Claudian, and as he pointed out, with such a date, the Temple of Augustus on the heights overlooking the city becomes the first monumental temple of the composite order.[68] These composite capitals are actually rather small (diam. at base 0.6 m) for such a major structure, especially if the remains of a large column (diam. 1.78 m) standing atop an attic base are part of the temple. More likely the capitals belonged to the porticoes and not the temple.[69]

62. TED'A 1989, pp. 158–160. 63. Koppel 1990, pp. 332–340.
64. Hernández Sanahuja and Morera Llaurado 1894, p. 18.
65. Puig i Cadafalch, Falguera, and Goday 1934, pp. 331–333, fig. 432.
66. TED'A 1989, p. 155; Alföldy 1975, nos. 28–34.
67. Recasens i Carreros 1984, p. 325; idem 1979, nos. 44, 48.
68. Strong 1960, p. 126.
69. TED'A 1989, pp. 160–163, figs. 8, 10.

Figure 65. Restored view of Tarraco according to Hauschild (after Hauschild 1976b, fig. 1)

A Flavian date for the completion of the upper terrace seems indubitable. It may also be that the fragments of a frieze decorated with an *aspergillum*, an *apex*, and a *culter*—all attributes of sacrifice, sometimes argued to have decorated the Altar of Augustus,[70] but which were found in the upper city— may actually be the last and the most specifically Flavian items in the program. The same type of sacred attributes decorated the frieze of the Temple of Vespasian in Rome.[71]

There is a final reason for considering the upper terrace's plan and design to be pre-Flavian. During the 1970s, Hauschild's excavations in the upper terrace helped to clarify not only the building chronology but also the elements of the precinct design. Extensive fragments of the Roman walls that defined the upper-terrace portico were found in the cathedral cloister and some nearby houses. When traced, the outline revealed that the cathedral sits on the longitudinal axis defined by the enclosed space (fig. 65). Moreover, behind the cathedral, the precinct wall breaks and juts out to form a type of exedra. The axial placement of the cathedral seems a fur-

70. Albertini 1911–1912, no. 121.
71. TED'A 1989, pp. 162–163.

ther argument for the notion that it sits atop the ancient temple. When arranged as planned, the temple would have been further highlighted, at least in the plan, by the exedra space at its rear.[72] These two design features—the longitudinal axiality of the placement of the temple and the exedra behind it—are also known from the forum at Clunia.[73] Clunia was within the province of Tarraconensis of which Tarraco was the capital. The design conceit seems too odd to argue for separate invention. It is hardly likely that the architects for the provincial capital would have copied their ideas from a town in the hinterland. This becomes even more unlikely if those involved in the work at Tarraco were Italian, which Strong has suggested for the carver of the composite capital.[74] The line of influence must have gone from Tarraco to Clunia, and, as has already been discussed, there are good reasons for positing a Claudian date for the start of work on the forum at Clunia.[75]

By the start of the Flavian period what existed at Tarraco was an Imperial Cult space dominated by a temple surrounded by a "pi"-shaped portico perhaps of composite order. Decorating the attic of the portico was an iconographic program modeled on that of the Forum of Augustus in Rome, alternating heads of Jupiter Ammon and Medusa, each framed by a tondo. A similar arrangement was also to be found at Augusta Emerita.[76] Whether the Tarraco arrangement included versions of the caryatids that have been found at Augusta Emerita is not known. No traces of caryatids have yet shown up at Tarraco. The relationship between the program at Tarraco and that at Augusta Emerita cannot be determined. It is clear that several western sites made use of versions of the decorative program from the Forum of Augustus.[77] The seeming contemporaneity of the Tarraco and Augusta Emerita work would suggest that rivalry may have spurred on the production of these formal cult areas, but one was not the response to the other. Though the final form for both the program at Tarraco and that at Augusta Emerita may be Flavian, Gros has argued that the spread of the Imperial iconography drawn from the Forum of Augustus began during the Tiberian period, further suggesting that the impetus for the design of the upper city as an Imperial Cult center should be ascribed to the late twenties or early thirties.[78]

The Imperial Cult area may well be pre-Flavian, but the full complex that

72. Hauschild 1972–1974, pp. 3–44, with Catalan translation in T. Hauschild, *Arquitectura romana de Tarragona* (Tarragona, 1983), pp. 87–129.

73. Cortés 1987, p. 10. 74. Strong 1960, p. 126.

75. Chap. 3 supra.

76. Floriani Squarciapino 1976, pp. 55–62.

77. Bauer 1987, pp. 763–770; Vezàr 1977; M. Budischovsky, "Jupiter-Ammon et Meduse dans les forums du nord de l'adriatique," *Aquileia Nostra* 44 (1973), p. 211.

78. Gros 1987, p. 359 n. 72. Vezàr (1977, p. 46) has dated the same material Flavian.

came to dominate the entire southeast face of the hill, for which the upper terrace became the crowning member, was the creation of the Flavian period and was certainly among the most impressive architectural commissions of the last quarter of the first century A.D. (fig. 66). It comprised three great terraces: an upper terrace with temple; a larger middle terrace; and a lower terrace, which held the circus. Although the dating evidence for the construction of the second terrace is actually rather scarce, pottery fragments from two excavated sites support the contention that it was developed during the early Flavian period, and that the circus was added sometime during Domitian's reign. However, it also would seem that there was some use for the middle-terrace region during the second and third quarters of the first century A.D., which may indicate that even as modest work began on the upper terrace under Tiberius and became more extensive during the midcentury, something was already beginning to be manifested on this lower area.[79] The foundations for the Torre de la Audiencia, which forms one of the south terminal points for the middle forum, cuts through this Tiberian level, which would support the notion that the actual work on the middle terrace is later.[80]

The middle terrace[81] is a large rectangle (fig. 67), ca. 175 m × 318 m. If the two towers that flank the lower edge of the space are added to the measurements, then the width is ca. 342 m. The unit encompasses ca. 5.5 ha, and the central plaza was about 155 m × 266 m, surrounded on three sides by double-storied porticoes ca. 14 m wide on the short sides and ca. 10 m wide on the long north side. It is not clear whether there was a fourth portico separating the stadium from the terrace above. The stadium was joined to the middle terrace via stairways contained in the two end towers, and probably by a central staircase. The porticoes stood atop a cryptoportico, roofed with a barrel vault. The cryptoportico rose to slightly above the level of the plaza, and atop stood the colonnade of the portico. The walls for the cryptoportico as well as for the towers show the use of three different construction techniques, *opus quadratum, opus vittatum*, and *opus caementicium*.[82] The latter technique is often found in the vaulting, the staircases, and the foundations. *Opus vittatum* was employed for secondary constructions, and *opus quadratum* was regularly employed for the door and window frames as well as for foundations. At least two types of *opus quadratum* can be isolated: a well-finished version with pillow blocks laid in regular horizontal courses;

79. TED'A 1989, pp. 180–181. Dupré i Raventós (1987, p. 25) notes that the fill used to support the forum on the south side includes the remains of earlier structures.

80. Dupré i Raventós 1987, p. 29.

81. Unless otherwise noted, all factual and descriptive information for the middle terrace is taken from TED'A 1989, pp. 167–179.

82. Dupré i Raventós 1987, p. 27.

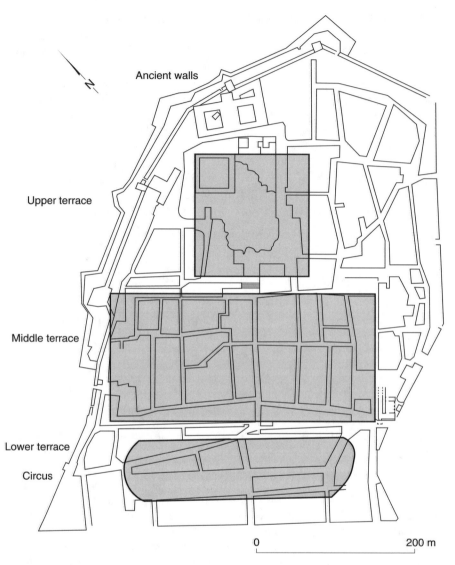

Ancient walls

Upper terrace

Middle terrace

Lower terrace

Circus

0 200 m

Figure 66. Layout of the three terraces at Tarraco (after Hauschild 1977, fig. 1)

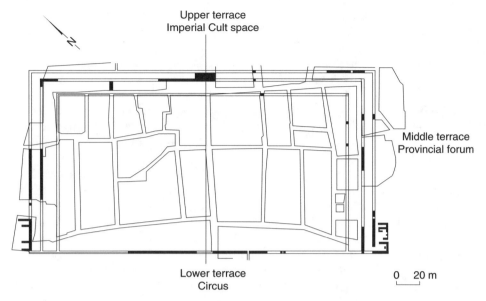

Figure 67. Plan of the middle terrace at Tarraco overlaying present configuration, with remains of walls indicated (after TED'A 1989, fig. 2)

and, elsewhere, where the construction would not be visible, blocks laid in a more irregular fashion. The blocks were laid without mortar. Local limestone is commonly found. The walls were plastered over. The frequency of the use of *opus caementicium* and *opus vittatum* throughout the construction of the middle terrace marks it as different from the upper terrace, where these two techniques are not often found.

The great support terrace wall on the southwest side of the plaza is 350 m of *opus quadratum* resting on a base of *opus caementicium*. In places, the wall stands directly on the bedrock and reaches a height of 20 m. At the extreme northern part of the plaza, where the bedrock level is at its highest, the portico rests on the rock without the intervening cryptoportico. The sophisticated exploitation of the landscape, which in some cases makes use of the existing physical features and in other instances changes them, recalls the similar treatment of the sacred area at Bilbilis.

Enough of the layout for the long walls and the north cryptoportico survives to allow for the reconstruction of axial staircases. A major stairway linked the middle terrace to the smaller upper terrace. This was ca. 30 m wide. A slightly smaller staircase, ca. 23 cm wide, which rested on substructure vaults, joined the middle terrace to the stadium below.

The total ensemble consists of three terraces that together equal

101,044.49 m^2.[83] The upper terrace is 20,176.62 m^2, the middle 55,913.12 m^2, and the lowest 24,954.75 m^2. The top terrace is a rectangular shape deeper than it is wide, ca. 162 m × 133 m. The middle terrace is wider than it is deep. The third terrace consists of a stadium or circus, for which the buttresses still survive in part.[84] The entire ensemble was constructed within the confines of the Republican walls of the city. The temple and the exedra behind marked the axis for the entire complex. The upper and middle terraces are axially aligned, whereas the stadium is slightly off axis to the west. The stadium provided the visual and physical transition between the flatter area and the hillside slope.

Porticoes defined the three sides of the upper and middle terraces. Cortés has reconstructed the intercolumniation for the upper portico, as understood from the analysis of the remains on the north side, as 3.7 m with 103 columns. The back wall of the portico was penetrated by windows with an interaxial spacing of 7.4 m, or two intercolumniations. The width of the portico was 11.09 m, or three intercolumniations. Without the temple for comparison it is impossible to know how the temple measurements affected the metrological formulation for the upper terrace.

The situation of the middle terrace is more involved. The north side of the middle terrace is twice the length of the north side of the upper terrace, ca. 266 m for the inside. The depth of the middle terrace, according to Cortés, is equal to that of the upper, ca. 162 m.[85] The middle terrace was perhaps defined by towers at its four corners, of which two remain, the Torre de Pilatos and the Torre de la Audiencia. There are some traces of what might have been the northwest-corner tower.[86] However, considering that the two standing towers served as means of access to the lower stadium, there was no practical reason for them to be matched by two additional towers since there was nothing to connect with at the extreme ends of the middle terrace. On the west side, the forum came close to the old Republican wall. Fragments of Doric pilasters from the Torre de Pilatos and some other sectors provide an intercolumniation of 3.7 m. Cortés proposes a width of ca. 11 m for the portico, though 14 m has been suggested for the short sides in the TED'A analysis.[87] According to Cortés's calculations, there is a direct continuity with the upper terrace. However, there is evidence for an additional pattern of intercolumniation on the central terrace in the

83. The measurements and metrological analysis are taken from Cortés 1987, pp. 10–13.
84. Humphrey 1986, pp. 339–344.
85. This does not agree with the measurements of 151 m or 175 m given by TED'A 1989, p. 167.
86. Cortés 1987, p. 12. These are not reported in the description of the terrace in TED'A 1989, pp. 167–179.
87. TED'A 1989, pp. 167, 172.

midsection of the west wall that is somewhat larger, ca. 4 m. Cortés suggests that the two sides of the terrace were arranged so that the central portion of the portico had ten intercolumniations of ca. 4 m flanked on each side by twelve of the smaller intercolumniations. The surviving pilasters provide height measurements: column height of ca. 3.7 m, with base and plinth ca. 0.61 m, and the Doric capital ca. 0.52 m, for a total of ca. 4.83 m and an additional ca. 0.52 m for the cornice. The width of the pilasters varies from 0.66 to 0.69 m. Obviously the details probably were somewhat different since the pilasters were covered in stucco. Cortés's analysis of the metrological aspects of the design reveals that there are relationships that seem to govern the parts of the framing elements of the composition.[88] Unfortunately, lacking any of the major structures from the two terraces, it is impossible to understand how all the parts of the complex were integrated.

Tarraco may have been the capital of a province, but it was not a large city, perhaps ca. 60 ha, the same as Narbo. It was larger than Emporiae or Barcino, but smaller than Corduba at 70 ha or Carthago Nova at 80 ha and certainly smaller than the Gallic capital of Lugdunum at 140 ha.[89] Within that 60 ha, some 10.5 ha were dedicated to public space, 17.5 percent of the total area, most of which comprised the great complex of the upper city.[90] The ensemble was of patent importance to the city.

That the Roman remains at Tarraco climbed the slope of a hill and were distributed on three distinct levels has been understood since the last century.[91] The excavations since the 1970s have clarified the form of the terraces and the specific architectural relationships between the upper and middle levels. Alföldy's epigraphic analyses of the remains of statue bases from the two spaces have established the foundation for an understanding of how the complex functioned.[92] With the establishment of the Imperial Cult, Tarraco became the center for the *concilium provinciae*.[93] Among its other duties, the *concilium* attended to the cult of Roma and Augustus.[94] In the province of Tarraconensis, the *concilium* comprised representatives of the conventus units into which the province had been divided for administrative purposes. These representatives met once a year at Tarraco, and as Alföldy has shown, they honored both the institution and their conventus

88. It should be noted that the TED'A group were opposed to performing a metrological analysis on the two spaces, considering the specific level of archaeological knowledge at this time; TED'A 1989, p. 168.

89. Tarradell 1971–1972, pp. 95–101.

90. Cortés 1987, p. 9. 91. TED'A 1989, pp. 142–149.

92. The fundamental collection is Alföldy 1975, in particular the analyses (pp. 474–477). This work has been augmented with the analyses in Alföldy 1978; idem 1979, pp. 177–275; idem 1984, pp. 193–237.

93. Alföldy 1975, nos. 24, 25, 27, 36.

94. *OCD*, s.v. concilium.

with statues of the genius of the conventus erected in the upper terrace pre-
cinct of the Temple of the Divine Augustus.[95] Such a setting served to rein-
force the political message of the institution, which linked the province to
the emperor, and moreover, did so at even the lower administrative levels.
There were, in addition, statues of gods, particularly those with imperial af-
filiations such as Iuno Augusta, placed in this sacred area,[96] and these were
also to be seen associated with emperors' images.[97] The statuary on this top
tier was probably not commissioned by individuals or even by the commu-
nity of Tarraco, but rather by the *concilium provinciae*.[98] The imperial aspect
of the top terrace was further emphasized by the iteration of the icono-
graphic program of the Forum of Augustus in the decoration of the archi-
tecture of the precinct.

In terms of numbers, neither statues of gods nor those of rulers dominate
the corpus of surviving statue bases. Most common were the honorific stat-
ues to members of the elite of Tarraco.[99] The great plaza below the temple
precinct held many of these works. This may have been the actual forum of
the *concilium provinciae*.[100] Here the members of the senatorial class of the
city, both men and women,[101] were honored. Based on the evidence drawn
from inscriptions throughout Tarraconensis, it may be possible to suggest
that the dedicators could include the city itself, the local *ordo*, the decuri-
onate, and members of the *seviri Augustales*.[102]

Many of the statues honored the senators as *flamines*. Also members of
the equites were honored with statues on the large forum that celebrated
their position within the flaminate. The dedicators of senatorial statues in
this most public area tend to be corporate bodies. Knights are more fre-
quently honored by individuals, family members, freedmen, and friends.[103]

The private aspect of dedications of honorific statuary and of statuary in
general was the rule for those statues in the forum in the lower city. Though
here again rank must have counted, since there is no evidence for statuary
erected to honor members of the *seviri Augustales* in these public spaces.
Moreover, statuary to the *seviri Augustales* must have always resulted from
private commissions.[104]

95. Alföldy 1979, p. 192.

96. Ibid., p. 194; idem 1975, no. 36: Iunoni Aug(ustae).

97. Alföldy 1979, p. 204; idem 1975, nos. 73, 74, 76, 77.

98. Alföldy 1979, p. 206.

99. Ibid., p. 209. Alföldy's total body of inscriptions identified as honorific has been ques-
tioned by Curchin (1987, pp. 160–162), who believes that some of the inscriptions should not
be considered honorific and that some are funerary.

100. Alföldy 1973.

101. Alföldy 1979, p. 212; idem 1975, nos. 136 and 146.

102. Alföldy 1979, p. 210. 103. Ibid., p. 218.

104. Ibid., pp. 222–224.

The great program of public sculpture honoring individuals associated with Tarraco began only under the Flavians, and continued for the next century.[105] The architecture designed at Tarraco served as the appropriate backdrop against which to place these public pronouncements of individual merit, earned in part by successful service to the community and in part by birth. The architecture that provided the frame for the statuary also became the physical manifestation of the *cursus honorum*, a statement of pride in the Roman order.

The concepts of order and of the hierarchy of power relationships that seem bound to the sculptural program that is framed by the great architectural ensemble may have been further underscored by the choice of order for the porticoes. The upper portico was probably in the composite order,[106] an order that, it has been suggested, carried clear affiliations with conquest and Romanization.[107] On the other hand, the great plaza below was, at least in part, decorated with the Doric order, preserved in the pilasters.[108] If the Doric order of the pilasters on the inside of the portico was reiterated on the exterior colonnade, then the enclosing device of the great plaza was distinct from that used for the temple precinct. The intent could have been more than merely decorative. The original portico of the forum at Emporiae that surrounded the Republican temple was Doric, and the design of Tarraco may have been a subtle restating of the older Republican tradition born in the northeast region.[109]

The involved and complicated design and decorative programs for the terraces at Tarraco may be reflective of several forces at work in the city. As provincial capital and largest city in the province of Tarraconensis, Tarraco was one of the major cities in the western provinces. It may not have been physically large in comparison with other western cities, but it was important. The titles and honorific system used on the statue bases raised to its elites show that it was following the same socialization and ranking system as the capital of Gallia Narbonensis, Narbo,[110] a city with which it no doubt maintained administrative contacts and perhaps some rivalry.

Architectural experiments at Narbo may have engendered a response at Tarraco. Unfortunately, not enough of Narbo survives to argue for specific associations. There seems little reason to believe that the grand architectural developments during the Tiberian and Claudian periods in the cities

105. Ibid., p. 230.

106. TED'A 1989, p. 162.

107. Onians 1988, pp. 41–58.

108. TED'A 1989, p. 170.

109. During the Augustan period the forum portico at Emporiae was changed to Ionic, and there is no evidence that a memory of the earlier arrangement survived. For general discussion of Doric and Tuscan elements in the architecture of the northeast, see Gimeno 1989, pp. 101–139.

110. Alföldy 1979, pp. 179, 215.

of Tarraconensis went unnoticed in the capital. Representatives from Clunia who served in the *concilium provinciae* must have been responsible for the statue of the genius of the conventus erected early on in the embellishment process of the terraces and known from the surviving base.[111] The dramatic design experiments at Bilbilis, the spatial divisions associated with cult at Clunia, the terracing at Uxama—all can be seen in the ensemble at Tarraco.

The terraces at Tarraco climb the side of a hill and dominate the landscape, as does the complex at Bilbilis. It is not clear whether views out to the landscape were considered, as seems to have been the case at Bilbilis. The strong Hellenistic accent so prominent at Bilbilis is still evident here at Tarraco, though the casual aspect of Bilbilis's design has been replaced with a markedly hierarchical format arranged in an axial alignment, which seems to owe more to the design conceits of Cos or Lindos than to Pergamon. In fact, Hauschild has noted that the windows of the upper terrace can be paralleled by a similar treatment in the portico of the Temple of Bel at Palmyra, also a creation of the first century A.D.[112] At Clunia there is evidence that two large spaces separated by the transverse basilica made up the forum. These were cultic spaces, and their separation was of importance, though how they are to be seen in relationship to one another is not clear. At Tarraco, the hierarchical aspect of spatial configuration is dominant and becomes obvious when the program dictating the placement of civic sculpture is considered.

The social component of the design at Tarraco is perhaps the most interesting feature. At Tarraco we can fully appreciate how these spaces were to function. The restrictions that must have been operative on the placement of statues, and the particular rules that must have governed the social status of the dedicator in relationship to placement, are perhaps reflective of the very cosmopolitan makeup of late-first-century and second-century Tarraco. The city was a mecca for many who immigrated from elsewhere in the Empire,[113] and who, if they were rich enough and had the proper connections, could seek to play some role in the civic life of the capital.[114] Wealthy and important aristocrats from the cities within the province may well have had temporary residences in the capital, particularly if they were serving in the *concilium provinciae*.[115] Six senators with Imperial careers and with Tarraco as their *patria* can be attested for the late first and early second century A.D.[116]

The social order in Tarraco was flexible. As provincial capital it had resident aliens who were there for temporary assignment as Imperial officials or soldiers, but who might have elected to stay at the end of the assignment

111. Alföldy 1975, no. 27.
113. Étienne and Fabré 1979, pp. 97–115.
114. Alföldy 1984, pp. 193–238.
115. Étienne and Fabré 1979, pp. 111–112.
116. Syme 1981b, pp. 280–281.

112. Hauschild 1977, p. 212.

and become part of the civic culture. It had a traditional elite, probably stretching back to the old pre-Roman aristocracy, that had been no doubt infused with new blood over the centuries. It also attracted those from elsewhere in the province who hoped to make their fortunes in the urban setting of a mercantile center. Within this mixture there were the freedmen who became the *seviri Augustales*. The architectural ensemble and the associated sculptural programs permitted each of these social segments to play a public role within a highly prescribed arrangement in which the social hierarchy was both maintained and restated.

The complexity of the social situation at Tarraco dictated the need for such a grandiose urban ensemble for the expression of civic and social pride of place. In this respect the city was quite different from Saguntum, where the traditional elite had never opened up[117] and where there was no need for such dramatic displays to visually manifest the order and integrate the parts. What is perhaps most astounding is the choice to center the identity of Tarraco around the Imperial Cult.

At Saguntum the foundation myth that clearly gave the city a pre-Roman origin was kept alive.[118] It may have inspired coin types of the early Imperial period and was recorded by Livy (21.7.2), Strabo (3.4.6), Pliny (*HN*, 16.216), Silius Italicus (*Pun.* 1.271), and Appian (*Iber.* 7). The myth was still available to Isidor (*Orig.* 15, 1, 68). For Saguntum, no matter how the city responded to Romanization, the initial identity was conceived in pre-Roman terms. Tarraco seems to have taken the exact opposite approach. The sense of historical continuity for Tarraco would seem to have begun with the institution of the unofficial Imperial Cult, represented by the altar. This is what is celebrated on the great series of sesterces that honor the initiation of construction on the Temple of Augustus. This association of the city with the Imperial house is further emphasized in the middle of the first century with the dedication of the Imperial sculpture of members of the Julio-Claudian family in the lower forum.[119] The great Flavian ensemble, crowned by the Tiberian-Claudian Temple of Divine Augustus, developed this association to its fullest, celebrating the achievement of the civic elite within the setting of Imperial approval and order.

NEW CONSTRUCTIONS

Corduba

Corduba (Córdoba) was one of the most important cities on the Iberian Peninsula. Already in the first century B.C. it was producing poets, though

117. Alföldy 1984, pp. 220–224. 118. Ibid., p. 225 n. 99.
119. Koppel 1985a, pp. 841–854.

of questionable quality.[120] It was the capital of Hispania Ulterior during the Republic and of Baetica in the new divisions created by Augustus. The city had been an Iberian center. The Iberian settlement may have been on the nearby "Colina de los Quemados," where the scatter of Iberian material indicates that the site may have extended over about 300,000 m². The population was probably moved down to the present location of the city on the banks of the Guadalquivir by the conquering Roman armies sometime in the late third century B.C.[121] A new Roman foundation, probably a colony, was established by M. Claudius Marcellus in 169–168 B.C. or 152–151 B.C.[122]

As a provincial capital, a cultural and intellectual center, and a major city in the wealthiest and culturally most developed region of the peninsula, Corduba should have been graced with monumental architecture. It must have equaled, if not surpassed, the splendor of Tarraco and Augusta Emerita. The city did boast a forum by 113–112 B.C., when Calpurnius Piso Frugi held court in it.[123] The Corduba forum was therefore older than or contemporary with the forum at Emporiae, which is the oldest extant forum on the peninsula.[124] There was a basilica, probably on the forum, by the time of the civil wars between Caesar and Pompey.[125]

It is not easy to determine how the city developed architecturally during the great era of building on the peninsula during the first half of the first century A.D. The archaeological record for the south is not as complete as for elsewhere on the peninsula for this period. Augustus relinquished control of Baetica to the Senate, establishing it in a position like that of Gallia Narbonensis. Marcus Agrippa may have been a patron of the city.[126] Augustus visited Corduba in 15–14 B.C., an event recorded in the numismatic record.[127] The city's complete name, Colonia Patricia, has been ascribed by some to Augustus, though Knapp favors Caesar. He has argued that the name is a reference to Caesar's own patrician origin.[128]

Unfortunately, the continued occupation and importance of the site over the centuries have resulted in little of the city's Roman architectural heritage surviving the onslaughts of development.[129] It is not possible to reconstruct the appearance of the city in the mid–first century A.D., and it is, there-

120. Cicero, *Arch.*, 10–26.

121. Marcos Pous and Vincent Zaragoza 1985, p. 245. The name Corduba (Córdoba) is probably pre-Roman; Knapp 1983, p. 7.

122. Knapp 1983, pp. 10–11. 123. Cicero, *Verr.* 2.4.56.

124. Chap. 1 supra 125. *B Alex.* 52.2.

126. There is a questionable inscription recorded in the eighteenth century that associated Agrippa with Corduba; J. F. Masdeu, *Historia crítica de España* (Madrid, 1784) nn. 396–397; Knapp 1983, p. 30.

127. Grant 1946, p. 220. 128. Knapp 1983, p. 29.

129. For the problems of modern archaeological work in the city see Marcos Pous and Vincent Zaragoza 1985, pp. 231–252.

A. Possible fora
B. Possible Roman
 gates

N

0 100 m

Figure 68. Probable orientation of streets and buildings in Roman Corduba (after Marcos Pous and Vincent Zaragoza 1985, fig. 1)

fore, impossible to conduct a valid comparison between Corduba and any one of the other western provincial capitals. It has been established that the city was walled. There was a grid plan, perhaps dating back to the original foundation. A second orthogonal plan was used when the city was extended, perhaps under Augustus (fig. 68).[130] There is evidence for at least two *vici*, the *vicus Hispanus* and the *vicus forensis*. It has been proposed that the latter was the neighborhood of the forum proper, which, based on the find spot

130. Knapp 1983, pp. 30, 54–56.

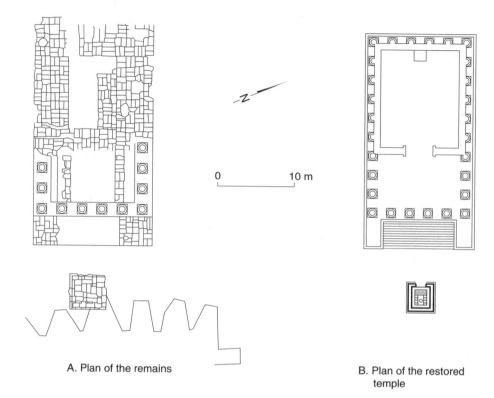

A. Plan of the remains

B. Plan of the restored temple

Figure 69. Temple at Corduba (after *HA*, p. 345, fig. 156)

of the inscription, would place the forum in the region today bounded by the streets Cruz Conde, Ramírez de Arellano, Góngora, and Cabrera.[131]

The identification of the forum is helpful, for it provides the assurance that the one major Roman structure so far unearthed in Corduba, the temple on the Calle Claudio Marcelo, was not the forum temple. The ruins are outside what must have been the forum area, though close to it. The temple was a separate sanctuary (fig. 69). Whether it was part of a secondary forum or had a physical relationship to the main forum similar to that of the Imperial Cult temple at Clunia cannot be determined at this point.[132]

The temple was built at the foot of a slope that forms where the Calle Claudio Marcelo and the Calle Calvo Sotelo come together. To compensate

131. Ibid., p. 56. For a discussion of the evidence for religious architecture in Corduba see Jiménez Salvador 1989–1990, pp. 77–86.
132. For Clunia see chap. 4 supra.

for the incline, a massive underpinning—a platform independent of the actual foundations—was built. This was composed of a series of wedge-shaped walls that open like a fan (pl. 56). The walls were constructed of rough stones. The interstices between the walls were filled in and a flat surface for building created.[133]

The foundation for the temple proper was raised atop the platform. Unfortunately, because the site was heavily quarried for stone during the Visigothic and Arabic periods, the remains were found in an unusual state of disarray.[134] The foundations were constructed of a local stone. The walls of the superstructure had a core of concrete that also supported the front staircase. The interior and exterior were revetted in marble, and all the decorative elements were carved from marble.[135]

The foundations sink to a depth of more than 10 m at points (pl. 57). The podium proper stood 3.5 m high. The columns were 9 m from plinth to abacus. The capitals added another meter. García y Bellido calculated the height from ground level to the apex of the pediment to have been 18 m. The temple width was estimated to be 16 m and the length 32 m.[136]

The ceramic finds from the area beneath the podium stairs, which included black glazed Campanian ware, can be dated to ca. 100 B.C. Also in the same region were found fragments of Ibero-Roman wares, Arrentine fabric, and South Gallic pieces.[137] The temple and its great platform therefore replaced some type of earlier occupation or use of the area. The datable material found in the fill of the subfoundation platform is Flavian. The Flavian date for the fill material agrees with the date that A. Blanco-Freijeiro gave for the decorative pieces from the temple based on stylistic analysis. He noted the summary treatment of the two Corinthian capitals recovered from the excavations (pls. 58a, 58b). The emphasis is on the deeply undercut passages in the volutes and leaves, which produce effects of chiaroscuro. The trait is Flavian, though Blanco-Freijeiro argues that it did continue to be used until the Trajanic period. The fragments of bead-and-reel that decorate the architrave blocks can be paralleled by examples from Hadrian's villa at Tivoli, and the lesbian cymation also on the architrave blocks is similar to that used on the Forum of Trajan.[138]

The combined stratigraphic evidence and stylistic findings would indicate

133. For the history of the discovery of the temple and the history of excavations see Jiménez Salvador 1989–1990, pp. 82–86; idem 1987, pp. 388–391; Ibáñez Castro 1983, pp. 316–323; S. de los Santos Jener, *Historia de Córdoba* (unpublished, 1955), cited in Ibáñez Castro 1983; García y Bellido 1970; idem 1964, pp. 155–165. The columns now standing at the site were reerected.

134. García y Bellido 1964, p. 162.

135. Ibid., p. 163. 136. Ibid., pp. 162–163.

137. García y Bellido 1970, area no. 1; idem 1964, p. 164.

138. Blanco-Freijeiro 1970, p. 122.

that the temple must have been started during the Flavian period. It may
have been at that time that the great substructure construction was built.
The temple may have gone up somewhat later and perhaps was not com-
pleted until the second quarter of the second century.

The temple's grand staircase was preceded by a square altar, 4.5 m per
side. García y Bellido believed that it was a walled enclosure open to the sky
and with a small offering table inside, something like the Ara Pacis.[139] Frag-
ments of marble decoration of pilaster capitals of Corinthian order were
found in a sondage dug on the altar's north side. The exterior must have
been finished with marble revetments and architectural detailing. The dat-
able evidence would suggest a slightly earlier date for the altar. Most of the
material from the altar sondages dates to the first half of the first century
A.D.[140] The altar or an earlier version may have stood on the site as early as
the time of Augustus. Augustan coins were found, including some with the
city's name: PATRICIA.

García y Bellido and Blanco Freijeiro believed that the temple and asso-
ciated altar were dedicated to the Imperial Cult. A dedication to Trajan was
favored by Blanco Freijeiro since the building seems to have been com-
pleted during the Spanish Emperor's reign, and Trajan hailed from nearby
Italica. García y Bellido thought that Nerva was the more likely candidate.
An inscription found at Cuesta del Espino, some 20 km outside of Corduba
and known since the eighteenth century,[141] records the Emperor's atten-
tions to the city, though it refers to nothing specific:

IMP. NERVA. CAES
AVG. PONT. MAXIM
TRIB. POTEST. II. COS. II[I]
PROC. PAT. PATRIAE
CORD. RESTITVIT

More recently, Knapp has taken exception to García y Bellido's claim that
the inscription records Nerva's restoration of Corduba following the civil
wars. He maintains that it was a milestone marker, having nothing directly
to do with Corduba.[142]

139. García y Bellido 1964, p. 163.

140. García y Bellido 1970, nos. 3, 4, 5, 6.

141. The inscription still existed in the nineteenth century, but it has since been lost; Gar-
cía y Bellido 1964, p. 165.

142. Knapp 1983, pp. 31–32, 109 n. 174. Knapp's interpretation of the inscription is de-
pendent on Hübner's analysis of the inscription. Knapp restores the text as: Imp(erator) Nerva
Caes(ar)/ Aug(ustus) Pont(ifex) Maxim(us)/ Trib(unicia) Potest(ate) Co(n)s(ul) II [I]/
Proc(onsul) Pat(er) Patriae/ (viam vetustate) cor(r)(uptam)/ restituit.

Not too much of the superstructure of the temple exists, but García y Bellido did attempt a reconstruction based on the available evidence, a reconstruction still largely accepted (pl. 59). He argued that the temple was pseudo-dipteral and of the Corinthian order. Fragments of two Corinthian capitals were found on the side walls that support the conjectures. It was probably hexastyle with eleven columns along the long sides. All the columns were fluted. The architrave was decorated with bead-and-reel and lesbian cymation patterns, and an acanthus scroll decorated the entablature frieze (possibly similar to the Temple of Augustus at Tarraco). García y Bellido maintained that the temple was similar to the Maison Carrée in Nemausis (Nîmes), and he used the Gallic temple as the model.[143]

The temple must have been a major commission. Its imposing size, the extensive preconstruction work that had to be undertaken to prepare the site, the value of the materials, and the high quality of the craftsmanship seen in the surviving decorative elements affirm the temple's significance. There is an archaistic quality about the temple with its old-fashioned, pseudo-peripteral plan. Though the sculptural aspects of the capitals seem Flavian or later in the play of light and dark, the Attic-Ionic bases have a profile more akin to their Hellenistic forebears with tori of different diameters and listels that give emphasis to the scotia (pl. 60). These are quite different from the bases on the earlier Augustan temples of Barcino and Augusta Emerita. The architrave decorations come from the standard Hellenistic-Roman repertoire, and the acanthus scroll of the entablature (pl. 61) is known from the Maison Carrée and possibly the Temple of Augustus at Tarraco. The thickening and thinning of the acanthus stems establishes a rhythm not unlike that seen in the earlier examples. Even the capitals suggest something of the older Augustan forms from which they ultimately derive: the leaf stems are double channeled, and there is a sense of the leaf moving away from the drum of the capital before the actual flip at the top. These traits also seem related to the treatment of the acanthus on the Maison Carrée.

The possible stylistic association between the Corduba temple and the Maison Carrée may be more than mere coincidence. The Maison Carrée was one of the earliest temples dedicated or rededicated to the municipal cult of Roma and Augustus. The cult flourished even during Augustus's own lifetime, and was precursor to the Imperial Cult, at least in those regions where the Imperial Cult was permitted to take root during the reign of Tiberius. When Tiberius allowed the Imperial provinces to promote the Imperial Cult,

143. García y Bellido 1964, pp. 162–163. The maquette on view in the Museo Arqueológico de Córdoba and illustrated here in pl. 59 provides a three-dimensional reconstruction of the temple in part based on García y Bellido's analysis and reconstruction; Marcos Pous and Vincent Zaragoza 1983, pp. 23–26.

he expressly forbade the practice of the cult in the Senatorial provinces of Baetica and Narbonensis. Whether the cult existed in Baetica on a municipal level, as it seems to have done in Narbonensis, is not known, but Tiberius had no intention of officially sanctioning its spread.[144]

It fell to Vespasian to finally sanction the cult's spread on a provincial scale into Baetica. The reasons for the change in policy can only be guessed at, but it may have been a move by the Senate to honor the Emperor, who had finally brought peace after the troubles of A.D. 68, or it may have been Vespasian's way of reminding the Senate who actually did have control over the Empire.[145] What is clear is that the cult did take hold in Baetica, and the new Flavian dynasty was duly honored.[146]

The choice of the Maison Carrée, a temple from one of the main cities of the other western Senatorial province, to serve as the model for the temple at Corduba—if indeed the temple was as similar to the Maison Carrée as García y Bellido believed—could well have been intentional on the architect's or the commissioner's part. It would have served to separate Baetica's capital from the other two Iberian provincial capitals. Moreover, it restated a long-standing association between the two most Romanized provinces outside of Italy. Syme has suggested that there was a particular bond between Baetica and Gallia Narbonensis that was strengthened through the marriage ties between leading families. The wife of the future Emperor Trajan, himself from Italica, was from Nemausis (Nîmes).[147] The evocation of the Maison Carrée, one of the first manifestations of the Imperial Cult—albeit on a municipal level—in the West, allowed the Cordobans to announce their affiliation with Gallia Narbonensis, a reference by one province to another. It recognized the special relationship between the two Senatorial provinces. It avoided direct competition with Augusta Emerita and Tarraco, both of which already had created ensembles dedicated to the cult. It was also an older, more conservative temple form as befitted an older, more Romanized area. Vespasian's official policy was intended to promote the new Flavian dynasty's sense of piety toward the older Julio-Claudian dynasty. He completed the Temple to the Deified Claudius in Rome.[148] There is no reason to believe that Vespasian was directly concerned with the building of

144. According to Tacitus (*Ann.* 4.37), Tiberius refused permission to an embassy from Baetica for the building of a temple to himself and Livia, "Per idem tempus Hispania Ulterior, missus ad senatum legatis oravit, ut exemplo Asiae delubrum Tiberio matrique eius extrueret. . . . 'Certerum ut semel recepisse veniam habuerit, ita omnes per provincias effigie numinum sacrari ambitiosum, superbum; et vanescet Augusti honor, si promiscis adulationibus vulgatur.'" Étienne 1958, pp. 415–417, 453; Thouvenot 1940, p. 297.

145. Étienne 1958, p. 453.

146. There are inscriptions honoring Vespasian and Titus at Munigua; Étienne 1958, pp. 453–455.

147. Syme, 1979d, p. 773. 148. Étienne 1958, pp. 440–447.

the temple at Corduba, but its design and form and possible associations would have suited the policies of the new Emperor.

Munigua

The boldness of the design conception at Tarraco was matched by a contemporary sanctuary construction in southern Spain, in the province of Baetica, at a site today known as El Castillo de Mulva (Villanueva del Río y Minas). The remains climb the slope of a hill and have been explored since the eighteenth century.[149] The epigraphic findings of these early investigators identified the remains as *Municipium Flavium Muniguense*.

Munigua was a small town within a mining district about 60 km northeast of Hispalis (Sevilla). It had received its grant of municipium and begun its massive urban building project under the Flavians. The profits from the mines no doubt paid for the extensive building projects.[150] Excavations have been ongoing at the site since the late 1950s under the auspices of the German Archaeological Institute in Madrid.

Habitation at Munigua may date back to the fourth century B.C., when the area was home to a Turdetanian population.[151] Under Tiberius the town attained the rank of a *peregrinum oppidum*.[152] The Flavian grant of municipium status must have stimulated the building boom, as had earlier happened at Bilbilis.

Munigua consists of two parts: a lower city with forum area and houses, and an upper city with a series of structures set atop terraces that climb the side of a hill in a carefully manipulated composition that terminates in a crowning structure (fig. 70). The terraces were constructed with heavy supporting walls that defined compartments that in turn were filled in to form the building platforms.[153] There were five levels, and the complex opened to the east. The approach to the sanctuary grouping was through the lower town and its forum. A double-storied stone portico marked the transition between the forum and the sanctuary group. The portico opened to the east, toward the forum. To the north of the portico stood a high platform topped with a temple structure. To the south was an aedicula.

When completed, the forum (pl. 62) consisted of a terrace on which were constructed a centrally placed tetrastyle temple surrounded by an

149. The names of the early explorers are known: Sebastián Antonio de Cortés, José de Cuente Zayos, and Thomas Andrés de Gusseme. Carriazo 1969, pp. 272–281; Grünhagen 1959, pp. 275–277.

150. For the importance of mines see McElderry 1918, pp. 53–102.

151. Carriazo 1969, pp. 272–281.

152. W. Grünhagen in *AA* 75 (1960), pp. 213–218.

153. Grünhagen 1959, p. 277.

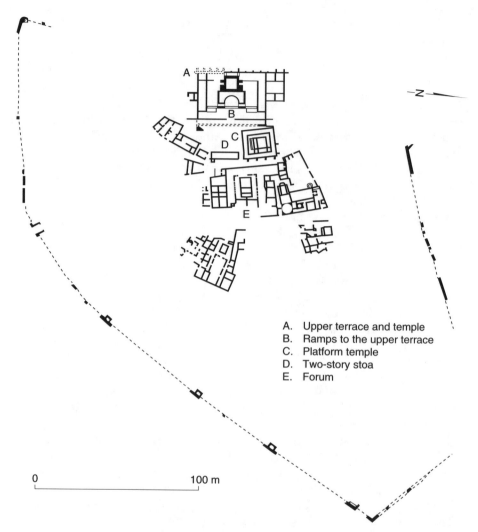

A. Upper terrace and temple
B. Ramps to the upper terrace
C. Platform temple
D. Two-story stoa
E. Forum

Figure 70. Plan of the upper and lower cities at Munigua (after Hauschild 1984, fig. 1)

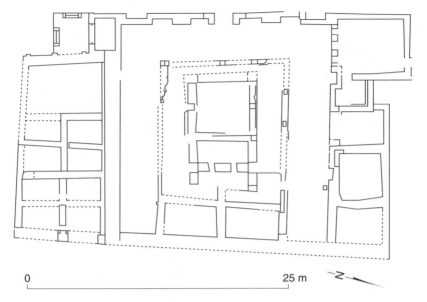

Figure 71. Plan of the forum in the lower city at Munigua (after Hauschild 1986, fig. 2)

ambulatory and colonnade (fig. 71).[154] The alignment was east-west, and the temple opened to the east. The back wall of the colonnaded walkway was articulated with small niches in which were found marble statue bases. A series of rooms formed the south side of the complex and were probably originally part of a basilican hall and formal entrance into the forum complex from the southwest. The north side was also broken into a series of rooms of varying sizes. Except for one of the rooms, which opened into the central courtyard and served to frame an equestrian statue,[155] the functions for these spaces are rather unclear, though it has been argued that one of them was a curia. The remains of the forum and its associated buildings are in yellow brick. The north side of the cella of the temple is preserved enough to recognize pilasters in brick, and one pilaster capital, also of yellow brick, has been found. The basilica has also yielded fragments of brick pilasters. This same type of decoration was found on the exterior east wall of the terrace.[156] Fragments of marble revetment have been found in the

154. For a general description of the forum remains see Hauschild 1986, pp. 325–335.
155. W. Grünhagen in *MM* 17 (1976), p. 227.
156. Hauschild 1986, p. 336.

excavations, and marble statue bases held up public sculpture. Though the forum probably went through more than one stage, its fully developed conception is Flavian.[157]

The exit from the forum's southwest corner, which was an architecturally significant entrance or exit into or out of the space, placed one at the southern end of the portico that separated the forum and lower city from the terraced hill construction. The first colonnaded hall built here went up in the early Imperial period, covering over older buildings.[158] The portico was based on a stoa design with the back wall and two short side walls closed and the east side open with a colonnade (fig. 72). The back wall consisted of piers constructed of large blocks of a shelly limestone, and in between the piers, the spans were filled with smaller, hand-sized stones mortared together.[159] Hauschild has noted that the building technique is known from other first-century A.D. structures at Carmona and Belo in Baetica.[160] This first portico was erected over earlier structures, and so was not the oldest building on the site. These first structures may have been among the houses that seem to have existed in the lower city during the first century A.D.[161] The portico may have been the first public structure to be raised in the region, but it must have been followed shortly thereafter by the earliest version of the forum, since one of the entrances to the forum seems designed to accommodate the portico, which itself opens to the east, toward the forum. The single-storied portico predates the platform temple to its north and the aedicula to its south.

The aedicula was added to the south end of the portico during the first half of the second century A.D., probably following the construction of the Flavian forum but before the building of the platform temple or the second story to the portico.[162] The aedicula was conceived in two parts: a prostyle structure holding up a pediment, which preceded and framed an interior niche. The entire unit opened to the east, onto the small plaza defined by the southwest entrance to the forum and the porticoed hall.[163] A small, inscribed granite altar[164] stood within the prostyle section in front of the actual niche, which probably held a statue. There was also a second inscription found in association with the aedicula that may indicate that the dedication of the space was to Mercury.[165] The columns were granite with marble Corinthian capitals. These held up a pediment.[166] The mixing of building

157. Ibid., p. 338.
158. Hauschild 1968, p. 278.
159. Ibid., p. 266.
160. Ibid., p. 277.
161. Hanel 1989, pp. 204–238; Vegas 1984, pp. 181–196; Hauschild 1984, pp. 159–179; idem 1969b, pp. 185–197.
162. Hauschild 1968, p. 287.
163. Ibid., pp. 272–273.
164. FERRONI/ LIBERTVS/ EX.VOTO/ POSVIT; Hauschild 1968, p. 274.
165. MERCVRIO/ L.FVLVIVS.GE/ AVGV; Hauschild 1968, pp. 274–276 n. 15.
166. T. Hauschild in *AA* (1968), pp. 358–368.

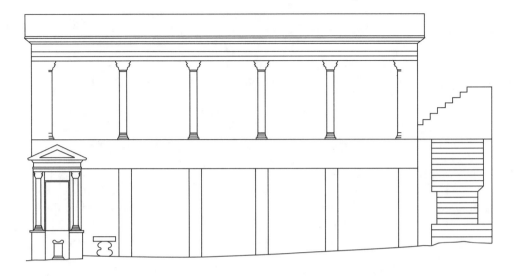

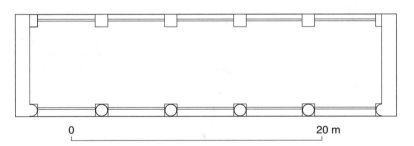

Figure 72. Elevation and plan of the two-story stoa with aedicula at Munigua (after *MM* 9 [1968], figs. 4 and 7)

materials has also been noted for the forum, where marble podia stood within the brick structure and a granite socle was employed for a statue base.[167] The marble for the capitals may well have come from the quarries at Estremoz in Lusitania (modern Portugal).[168] Hauschild has argued that the capitals themselves are second-century A.D. versions of a late-Augustan type; they show no evidence of drill work and differ markedly from the work

167. For the granite block in room 6 on the north side see Hauschild 1986, p. 328.
168. Hauschild 1968, p. 282.

being done in the provincial capital of Corduba, suggesting that this was the product of a local workshop steeped in older decorative traditions.[169] The development of small temple-like aediculae can be noted in Roman architecture from the middle of the first century A.D. They decorate the Porta Maggiore in Rome[170] and are a motif found in third- and fourth-style Pompeiian painting.[171] However, on the Iberian Peninsula only one other similar structure is known: the little temple from the bridge at Alcántara in Lusitania, dated Hadrianic.[172] Outside the aedicula proper, to the north, was a stone table, which somehow belonged with the structure.

The portico, and later its associated aedicula, provided the architectural termination of the lower city—with which its facade interacted—and the demarcation of the sanctuary precinct that rose behind it. Both the portico and the aedicula faced east onto a small plaza that also served as the artery into the southwest corner of the forum. The dedication of the aedicula to the god Mercury may have been because of the commercial aspects of the space.

North of the portico was a raised platform that stood higher than the level of the first story of the portico (pl. 63). A staircase that ran between the north wall of the portico and the south wall of the platform provided access from the level of the forum to the top of the platform. The platform held a temple. The remains of a temenos wall and temple are of small stones laid in thick mortar with brick bands. The design is of two embedded rectangles. The temenos defines the larger rectangle. Between the temenos wall and the temple proper is a narrow sunken space about 1.75 m wide. The temple podium itself rises above this level ca. 1.20 m. Three steps give access to the top of the podium. The temple was divided into a pronaos and cult room. The building of the platform temple probably dates to the first half of the second century A.D., around the same time that the second-story open colonnaded terrace was added to the portico.[173] By the mid–second century the lower town was effectively separated from the hillside sanctuary grouping by an impressive architectural ensemble consisting of a small temple raised atop a high platform podium and a double-storied portico with a second floor open on the two long sides and offering views to the lower town and the hillside sanctuary.[174] The open second story must have served to break the wall-like impact of the design, and to allow some visual continuity between the parts of the design. The area of the open plaza defined by the edge of the forum and the portico may have first been appre

169. Ibid., pp. 283–285.
170. Ward-Perkins 1981, pp. 52–56, plate 21.
171. Ling 1991, chaps. 4, 5. 172. Hauschild 1968, p. 281.
173. Ibid., pp. 278, 287; idem 1969a, pp. 400–407.
174. Hauschild 1968, p. 269.

Figure 73. Plan of the upper terrace group at Munigua
(after *MM* 19 [1978], fig. 1; and Coarelli 1987a, fig. 2,
taken from Raddatz 1973)

ciated in the Flavian period, when statues of the three Flavian emperors
were erected.[175] The public space became a physical manifestation of the
city's new rank.

The platform temple and the portico probably replaced public structures
of the earlier first century A.D.[176] During the earlier building phase the hill-
side itself may have held domestic structures—the remnants of the old na-
tive town, perhaps.[177] The arrangement would not have been unlike that
during the first phase at Conimbriga or Mirobriga.

Behind the walls of the portico and platform temple rose the hillside ter-
races. To the southwest of the portico and aedicula was a ramp that offered
access to the next level (fig. 73). The hillside group was a self-contained
composition that must have been conceived of separately from the platform
temple and portico below. The ramp at the southwest was probably matched
by a means of access that connected the temenos of the platform temple
with the hillside group.

175. Grünhagen 1986, pp. 322–323.
176. Hauschild 1971, pp. 61–71. 177. Ibid., pp. 61–63.

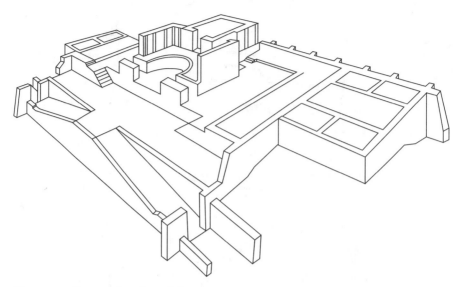

Figure 74. Perspective view of the upper terrace at Munigua from the north side looking west (after Grünhagen 1959 and *MM* 9 [1968], fig. 2)

The hillside group consisted of a rectangular area, 54.53 m × 35.20 m, on the summit and western slope of the hill overlooking the town. It maintained the eastern focus of the lower complexes.[178] The southwest ramp gave entrance to the southeast corner of the complex, and the area behind the platform temple provided entrance to the northeast corner. At these two points facing ramps 3 m wide ascended, forming a triangular composition (fig. 74). They met at the midpoint of the composition and defined the axis. At this point was a T-shaped terrace that formed the front for the temple of the sanctuary. It was widest where the ramps ended, and narrowed as it moved to the west toward the temple. The temple itself did not have direct access down to this terrace but stood above it on a terrace 2.10 m higher (pl. 64). Two small staircases, located at the southwest and northwest corners of the terrace, provided the means to mount to the next level. The staircases changed the movement through the space. The ramps climbed toward the axis; the stairs moved away. These lower platforms and ramps sat on a massive substructure constructed of stone and brick and heavily but-

178. Unless otherwise cited, the general description of the hillside group is drawn from Grünhagen 1959, pp. 275–282; and from W. Grünhagen, "Die Ausgrabungen des Terrassenheiligtums von Munigua," in *Neue deutsche Ausgrabungen im Mittelmeergebiet und im Vorderen Orient* (Berlin, 1959), p. 331.

tressed on the west side.[179] Drainage for the hillside complex was provided by canals on the north and south sides, along with rectangular collection basins built into the structure.[180]

The top level contained the temple, aligned axially and surrounded by a "pi"-shaped structure that enclosed the north, west, and south sides and stood on a platform 0.60 m above the level of the patios to either side of the temple proper. The findings of curved bricks and some remains of arches suggest that this was an arcaded gallery.

Three separate parts made up the temple itself. The facade on the eastern side was an exedra that formed part of the composition of the terrace below since it marked the terminal point of the axis defined by the meeting of the two opposing ramps. The cult chamber of the temple sat ca. 2.10 m above the level of the exedra on a high podium. The space defined by the exedra could be entered via passageways to the north and south that connected to the patios defined by the arcaded galleries. There was no direct connection between the exedra and the cult chamber. The temple was T-shaped. The front of the T was the pronaos, the interior of which defined the apsidal space of the exedra. The pronaos and the cult room sat atop a higher podium and had to be accessed by means of stairs that flank the exterior two sides of the cult chamber in a manner reminiscent of the Temple of Serapis at Emporiae, the Augustan temple on the forum at Emporiae, and the temple on the forum at Clunia. The stairs gave entrance via the rear to the side wings of the pronaos. Remains of niches (0.30 m deep) and pilasters in the fragment of the north wall of the pronaos may indicate that the entire pronaos was similarly decorated. Only the lower parts of the two longitudinal walls of the cella survive. These show that the exterior was divided by pilasters into small, repeated units. The interior may have been similarly divided.

Outside of the sanctuary proper there are remains for some additional structures, which were probably hidden from the inside by the arcaded gallery. To the south is a structure sometimes designated as a fountain. To the north there may have been houses for staff. These additional structures are not within the defining walls of the hillside group and do not disrupt the strongly accented axial movement and the accompanying bilateral symmetry that pervade all aspects of the design.

The complex was constructed in concrete, with quarried stone used for the matrix. There was regular brick banding. The flooring for the ramps was *opus signinum*.[181] The hillside group along with the platform temple was perhaps sheathed in colored marble revetments. Fragments of these marble

179. Coarelli 1987a, p. 94. 180. Ibid., p. 95.
181. Hauschild 1971, pp. 63–65.

panels have been found in the exedra, the patios, the passageways, the cella of the main temple, and the area of the platform temple.[182] Initially thought to be imports from elsewhere in the Empire, recent analyses of the fragments have shown that they came from Iberian sources.[183]

The most striking feature about Munigua is the close resemblance that the hillside terrace sanctuary bears to the great Republican sanctuary of Fortuna Primagenia at Praeneste (Palestrina). The similarities were first pointed out by W. Grünhagen in his 1959 analysis of the site.[184] They have been regularly commented upon over the intervening decades, and most recently F. Coarelli has devoted an article to an in-depth evaluation of the stylistic ties.[185] Even a cursory comparison of the two complexes will reveal the obvious connections.[186] Both dominate hillsides, since the designers exploited the actual slopes by creating layers of terraces that carry the visitor up and deeper into the complex at each level. For both there is a marked architectural transition between the lower space of the town proper and the sanctuary terraces, and yet the fora are raised on terraces and therefore are architectural elements in the sanctuary ensemble. Massive substructures support the architectural elements and push them up and out from the slope itself. "Pi"-shaped porticoes provide the framing device for the cult areas and define large patio or plaza areas created atop the terraces. The most striking similarity is, of course, the composition of opposing ramps that define the sides of a triangle and meet at the apex. The meeting point also highlights the axis of each complex. The compositional similarities in plan, along with the specific similarities of execution—the ramps—cannot be accidental. The architect for Munigua must have been required to create a complex that echoed that at Praeneste.

It is also true that there are significant differences. Everything at Munigua is rectangular or square. The parts are all right-angle forms. This is in marked contrast to the interplay of right-angled and curvilinear shapes that enlivens the design of Praeneste. The only curving portion of the Munigua plan is the exedra before the temple proper, which, it could be argued, mimics the theatrical area before the tholos at Praeneste, but which in reality seems quite different since it is not a theatrical space. Perhaps even more telling is the treatment of the upper sanctuary, the cult region proper. At Praeneste this is a tholos preceded by a rectilinear courtyard and the curved

182. Grünhagen 1959, pp. 275–282. The fragments from the platform temple I saw on a visit to the site in the spring of 1985.

183. Grünhagen 1978, pp. 290–306. Pliny may have known of sources for colored marbles in Baetica; *HN* 3.30

184. Grünhagen 1959, p. 280. 185. Coarelli 1987a, pp. 91–100.

186. For the most accessible overview of the Sanctuary of Fortuna at Praeneste see Coarelli 1987b, pp. 35–84.

theater area just discussed. At Munigua, the cult building is a standard temple unusual only in the treatment of the access stairs to the pronaos and the T-shaped plan. The temple is framed by the "pi"-shaped portico, which itself stands above the level of the resulting patios. The temple is joined at its back wall to the portico, and so does not stand completely free within the temenos, but in essence the design is a modified version of the forum temple arrangement known throughout the peninsula. Moreover, the access to the cult terrace is from stairways at the two far sides rather than from an axially placed staircase as at Praeneste. These differences are more significant than might at first appear. They not only reveal modifications to the Praeneste prototype, but suggest the source of the modifications.

Grünhagen and Coarelli have noted that the design of the Sanctuary of Hercules at Tivoli[187] also played a role in the development of the plan for Munigua.[188] The influences are slightly more subtle than those from Praeneste. There is the same creation of an upper terrace defined by a "pi"-shaped portico. The terrace is divided into two halves by the axial placement of the temple, which is joined at the back wall to the portico itself. The temple opens onto an exedra—the one pronounced round portion of the plan. The cult terrace is approached via flanking staircases at the far sides of the terrace. The differences between the treatment of the upper terrace at Munigua and the single platform of the Sanctuary of Hercules seem less significant than those between Munigua and Praeneste. The Munigua exedra is physically joined to the temple, with no separating space as at Tivoli. The side stairways are placed laterally parallel to the upper terrace, rather than perpendicular as at Tivoli. These points of distinction may have more to do with the nature of the site, the smaller scale of Munigua offering the architect less space in which to create effects.

The architect for Munigua grafted the platform sanctuary design of Tivoli onto the hill-slope terrace plan of Praeneste. The resulting complex is a not unsuccessful blending of the two. There are subtle changes that permit the Munigua design to possess its own integrity: the tension created by the approaching ramps and the opposing stairways, which change the movement through the spaces; the inclusion of the exedra into the temple proper while also being connected to the lower terrace, which creates an ambiguity of spatial relationships.

Inscriptions found at Munigua testify to cults of *Fortuna Crescens Augusta* and *Hercules Augustus*.[189] The epithet *Crescens*, as Coarelli has explained, is used only for Jupiter, and in particular *Juppiter puer*, a cult also known at

187. Coarelli 1987b, pp. 85–112.
188. Coarelli 1987a, p. 95; Grünhagen 1959, p. 280.
189. Fernández-Chicarro de Dios 1972–1974, pp. 337–410.

Praeneste. In fact, Coarelli would maintain that the epithet is Praenestine.[190] In a similar manner, Coarelli argues that the *Hercules Augustus* can be tied to the Hercules Victor Sanctuary at Tivoli. In an Iberian context, Hercules automatically is associated with *Hercules Gaditanus*. There is a second association, however, that links Hercules, Iberia, and Italy together: the myth of the cattle of Geryon. The story was known to first-century Latin writers— for example, Horace (*Carm.* 3, 14) and Virgil (*Ann.* 7, 662; 8, 202)—who seem to reference Hercules's exploits in the west as taking place in Iberia. This is the victorious Hercules celebrated at Tivoli.[191] As seems clear from the inscriptions, both of these cults had also become associated with the Imperial Cult. The sanctuary at Munigua was the Imperial Cult site, and included within it were these particular manifestations of the cult. At Tivoli, the local college of the *Herculanei* was transformed under Augustus or Tiberius to the *Herculanei Augustales*.[192] The Imperial Cult aspect of the Munigua sanctuary may be architecturally stated in the T-shaped design of the temple. This form could have come from either of two sources, one Iberian, the other Italian. There were three temples on the Iberian Peninsula that had this form: the Temple of Jupiter on the forum at Clunia, the forum temple at Emporiae, and the Temple of Serapis in the Greek city of Neapolis at Emporiae. Ultimately, these all link stylistically to the Temple of Divine Julius on the Roman Forum in Rome.[193] The tie between Julius Caesar in the guise of Hercules and the Iberian Peninsula seems to be played on by Horace (*Carm* 3, 14). The connection may have been revived under Domitian, who seems to have commissioned a statue of Hercules and Geryon for his reconstructed *Porticus Philippi* in Rome, about which Martial appears to have commented.[194] This type of more immediate revival might have prompted the architect or commissioners of the Munigua sanctuary to consider not an archaic reference in the temple design but a more immediate one—in this case, the Pompeiian Temple of Vespasian (fig. 10), the founder of the Flavian dynasty, who had been responsible for the promotion in rank that Munigua now enjoyed and who had officially sanctioned the movement of the Imperial Cult into the province of Baetica. This temple closely resembles that at Munigua with its pronounced pronaos and almost square cult chamber.[195]

The design prototype for the temple proper may have been contemporary to the building of the Munigua sanctuary, but the sources for the complete sanctuary were not. There are links that allow the Imperial Cult aspect

190. Coarelli 1987b, p. 97. 191. Coarelli 1987a, p. 98.
192. Ibid.
193. For the discussions of each of these temples see the appropriate sections supra.
194. Rodríguez Almeida 1986, pp. 9–15.
195. Coarelli 1987a, p. 96. For the temple of Vespasian see Vos and La Rocca 1976.

of the Munigua sanctuary to be related to first-century A.D. cultic developments at Praeneste and Tivoli, but cult associations do not explain the patently archaistic architectural conceits employed.

The most telling aspect of the design at Munigua may be the connection with Tivoli. By the end of the first century A.D. and through the first half of the second century A.D., there was resident at Tivoli a community of important and well-to-do Spaniards, mostly from Baetica.[196] Whether these individuals cut ties with their place of origin, as Syme suggests, cannot be determined with certainty. However, they may have provided the physical join between the old Latin sanctuaries and Munigua. Their villas offered easy access to the sanctuary at Tivoli, and Tivoli is not that far from Praeneste. Several of these noteworthy Spaniards were within the inner circle of the Flavian rulers[197]—for example, P. Manilius Vopiscus, a friend of Domitian, whose son, P. Manilius Vopiscus Vicinillianus, was consul ordinarius in 114; and L. Minicius Natalis[198] and M. Accenna Saturninus, proconsuls for Baetica.[199] The father and son L. Cornelius Pusio and L. Cornelius Pusio, who had a villa outside of Tivoli, may have been related to the important family of the Cornelii Balbi of Gades (Cádiz).[200] The connection is of some interest because of the association between the Balbii and the cult of Hercules and the major revitalization of the cult place of Hercules Gaditanus that took place sometime in the early second century A.D. and is celebrated on coins of Hadrian.[201] Coarelli thinks that the design features of the sanctuary of Munigua may well be the result of the direct intervention of Spanish, Baetican senators resident at Tivoli, and in particular of L. Cornelius Pusio, who was consul under Vespasian, was related to the Balbii, and probably had a particular interest in the cult of Hercules, for which he may have been *cura fani Herculis* at Tivoli.[202]

ANALYSIS

Patronage. The difference in the conception of the plan for each of the Flavian sites is perhaps the most noteworthy feature of the architecture. Though both Munigua and Tarraco exhibit the same interest in grandeur and splendor, the Munigua complex harks back to the Republican sanctu-

196. Syme 1982–1983, pp. 241–263; idem 1983, p. 265.
197. Coarelli 1987a, p. 99.
198. *PIR*, ser. 2, pt. 2, no. 292, Étienne 1965, p. 62.
199. *PIR*, ser. 2, vol. 1, no. 24; *CIL* XIV, 3585.
200. Castillo 1982, pp. 465–519.
201. Macrobius, *Saturnalia*, 3.6.16; J. F. Rodríguez Neila, *Los Balbos de Cádiz* (Seville, 1975); Coarelli 1987a, p. 99.
202. Coarelli 1987a, p. 99.

aries of Latium, whereas Tarraco retains more of the Hellenistic quality earlier explored at Bilbilis. The model for Tarraco seems more that of the Sanctuary of Asklepius on Cos than any Italian model. On the other hand, the fora at Emporiae, Conimbriga, and Belo display no obvious concern with grandeur, but rather a desire to increase the sacred nature of the space.

Tarraco was a provincial capital and an old and important city—the location of a cult to the Divine Augustus since the late first century B.C. and seat of the provincial cult since A.D. 15. A temple to the Divine Augustus had been started on the crest of the hill overlooking the town sometime in the midtwenties, and by the Claudian period had reached the stage for the sculptural programs to be started. The revival of Augustan forms in the choice of sculptural motifs and themes can be found not only at Tarraco but also at Augusta Emerita during the same period, and elsewhere in the West. There is a Greek flavor that informs much of this material: the peripteral temple at Augusta Emerita; the probable peripteral temple at Tarraco; the caryatids in relief modeled on those of Erectheum from Augusta Emerita, which serve to associate these cult spaces with Athens; and the references to Jupiter Ammon found in the tondi decoration of Augusta Emerita and Tarraco. Granted, some of these are also elements in the iconographic program at the Forum of Augustus, but when combined with the strong Greek quality of the peripteral temple form, it seems perverse to not consider that the architects for these new western cult spaces were thinking in terms of the sanctuaries to the Imperial Cult in the great Hellenistic centers of Alexandria, Pergamon, and Aphrodisias. The designers are clearly trying to integrate architecture and sculpture into an ensemble that overwhelms the viewer in a manner not unlike what has recently been revealed for the Julio-Claudian Sebasteion at Aphrodisias.[203] Understandably, the complicated sculptural program of this eastern creation is not found on the Iberian Peninsula. Instead, the designers looked to the more conservative pattern that the Emperor himself chose for Rome.

The Flavian contribution was to place the temple and temenos with its sculptural program into a much larger complex. It became the architectural and iconographic focus in an ensemble that was essentially a political statement. The Flavian design for Tarraco's terraces must be seen as a continuation of a line of architectural development and experimentation begun by the architect of Bilbilis. It was at the insignificant site overlooking the Jalón that Hellenistic design conceits were allowed to hold sway over the complex. The reasons for the choice are not clear, but the result was to inspire the pattern at Tarraco.

At Tarraco the irregularity so important at Bilbilis has been lost. Instead

203. Smith 1990, pp. 89–100; idem 1988, pp. 50–77; idem 1987, pp. 88–138.

order reigns, and the terraces climb in a symmetrically aligned manner. The pattern is ultimately also Hellenistic, but this time more like that of the sanctuary on the island of Cos. Like Cos's design, colonnades in a "pi" shape define terrace platforms, and the culmination of the ascent is the temple. Why Cos should have informed the design choice for Tarraco is impossible to say. Cos had suffered from an earthquake in 6–5 B.C. and was possibly under repair during the first century A.D., though the evidence for such is not particularly strong.[204] Tiberius did, however, accord the sanctuary a special status.[205]

The design choice at Tarraco is probably better understood as the result of the influence of Tarraco's leading citizens. Because of its position as a capital and its role as a major port, Tarraco had a heterogeneous population. There were residents from all over the peninsula and from elsewhere in the Empire. Moreover, many of its leading families had ties with leading families in Rome. To rise in Tarracan society was less a matter of birth than of achievement and wealth. These factors must have kept the city from becoming a parochial enclave, and surely opened it to influences from outside. The idea of a Hellenistic structural arrangement may have been fostered by the impressive results at Bilbilis, but the actual decision to build in this fashion on the scale that was needed at Tarraco must have been caused by two forces: (1) competition with Augusta Emerita and the need to set apart the Tarraco sanctuary from the other provincial Imperial Cult sanctuaries with which it shared an iconographic program; and (2) the desire to emulate the kinds of Imperial Cult spaces that had arisen in the Greek East, with which Tarraco's leading citizens had some familiarity. After all, the Mytilene decree—which, in essence, initiated the cult of the Emperors—was inscribed at Tarraco.[206]

The complex at Munigua is the equal of that at Tarraco from the point of view of scale, but the sources are entirely different. Munigua was not a capital, nor was it an important commercial center. It was a mining town. It had neither political nor cultural importance. It is comparable to Saguntum or Bilbilis, and, as in these two towns, the cost of construction must have been borne by the elite, which must not have been too large a group. The forum at Munigua seems to have been designed to accommodate nearby important houses.[207] It is not yet clear that the sanctuary that rises above the

204. S. M. Sherwin-White, *Ancient Cos: An Historical Study from the Dorian Settlement to the Imperial Period* (Göttingen, 1978), pp. 340–346; L. Marricone, "Scavi e ricerche a Coo (1935–1943): Relazione preliminare," *Bollettino d'Arte* 35 (1950), pp. 54–75; R. Herzog and P. Schatzman, *Kos*, vol. 1, pt. 1, *Asklepion* (Berlin, 1932).

205. H. Berve, "Sanctuaries of Asclepius," in H. Berve and G. Gruben, eds., *Greek Temples, Theaters, and Shrines* (New York, n.d.), pp. 67–69.

206. Chap. 3 supra.

207. J. L. Jiménez Salvador, *Arquitectura forense en la Hispania romana* (Zaragoza, n.d.), p. 72.

town is the direct result of local patronage. Indeed, if we accept the notion that the vehicle by which the influences of Republican sanctuaries in Latium came to Munigua was the Baetican aristocrats resident in Tivoli, then the complex may actually be the result of outside forces. It is not impossible that the mining wealth from Munigua paid for some of the elite Spaniards to live at Tivoli, and the sanctuary may have been their gift to the town. It also seems possible that Baetican nobles were looking for a sanctuary site in Baetica at which to celebrate their provincial affinity. These were Romans looking for a Roman vocabulary who seized upon the forms of the Republican sanctuaries of Latium.

Design Influences. The differences between Tarraco and Munigua cannot be ignored. They are the result of two distinct sources of influence. What is the same about both is the bravado with which they were executed. At both sanctuaries the full potential of the design is realized. Neither sanctuary is a copy of the prototype. Both are freely adapted from models. At Tarraco we find the complicated proportional association of the terraces to one another, something totally lacking at Cos. The movement through the spaces at Munigua is a constantly shifting experience that moves the visitor sometimes toward the axis and at other times away from it. This is quite the opposite of the enforced movement through the sanctuary of Fortuna at Praeneste, where everything becomes centered on the axis.

The designs for both Tarraco and Munigua are representative of the opening up of the Iberian Peninsula to new sources of design ideas. Ultimately, these new designs must reflect a growing sophistication on the part of the patrons, the elites of the peninsula. The smaller Flavian monuments at Emporiae, Belo, and Conimbriga may not immediately appear to rival the grand compositions, and yet there is some sense of interaction with the wider world of the Empire. At both Emporiae and Belo the forum space becomes more and more crowded with sanctuaries. These small-scale constructions—chapels and shrines at Emporiae, shrines and a fourth temple at Belo—increase the sacred character of what had been a civic as well as sacred space. The construction of a macellum outside of the forum at Belo assists with the change by removing the need for the tabernae on the forum to remain as shops.[208] A similar transformation may have been happening at Clunia.[209] The developments on the Iberian Peninsula may have inspired similar changes to fora in North Africa. During the second century at the cities of Thuburbo Maius, Bulla Regia, Althiburos, and Gigthis there is evi-

208. Mierse 1989, pp. 619–621.
209. Palol 1989–1990, pp. 37–57, "el edificio flaviano."

dence for the crowding of structures on the forum.[210] The old forum at Leptis Magna—which saw major building early in the first century A.D. when the Temple of Roma and Augustus (dated A.D. 14–19) and the Temple of Liber Pater were grouped with the older Temple E (5 B.C.–A.D. 2) to form a wall of sanctuaries—did not see a true proliferation of shrines until the late first and early second centuries when the Temple of Magna Mater was erected, a Trajanic temple went up, and a shrine to Antoninus Pius was dedicated.[211]

Relationships between architectural and design patterns in Iberian cities and North African cities are best understood as parallel lines of development, at least during the first century A.D. What appears to be happening at Belo and Emporiae and the North African cities is a process of architectural agglutination, but it would appear to be an organic process rather than something imposed from without. There may be something different at Conimbriga. Though the excavators of Conimbriga have argued that the forum was a fully articulated space with temple and secondary structures in its first, Augustan phase, this hypothesis has not been universally accepted.[212] Gros has argued that the real forum did not emerge until the Flavian period, when the break with the Iron Age community was dramatically made.[213] In this aspect, the site of Conimbriga probably resembles the other Flavian Lusitanian site of Mirobriga, which also witnessed a seeming break with the past during the Flavian building program on the forum. At Conimbriga this was done in part by changing the structural layout of the forum. The stairs that had connected the forum with the older community were removed, and the interior of the forum space was redesigned in a clear hierarchical fashion with emphasis placed on the new temple. Moreover, the space now became a self-contained unit following a pattern noted for other civic fora that were transformed more and more into Imperial spaces.[214] The older architectural forms were not modified as at Belo or Emporiae; they were demolished.

A similar process of destruction and building afresh has been noted for the old forum at Volubilis in ancient Tingitane (Morocco).[215] Here what may have been older sanctuaries of native origin were removed and the area was regularized with porticoes and perhaps a parallel arrangement of four identical linked, small shrines raised on a common podium. It has been argued

210. Ben Baaziz 1987, pp. 221–236. For Althiburos see Merlin 1913; for Bulla Regia: Merlin 1908, pp. 25–26; for Thuburbo Maius: Lézine 1963, pp. 120–131.

211. Bianchi Bandinelli, Caffarelli, and Caputo 1966, pp. 84–86; Haynes 1959, pp. 84–89.

212. Roth-Congès 1987b, pp. 711–751.

213. Gros 1986, p. 116. 214. Martin 1972, pp. 903–933.

215. Lenoir, Akerraz, and Lenoir 1987, pp. 203–219.

that this design, perhaps similar to one also found at Banasa, may have been the result of influences from the design of military *principia* (*Lagerfora*) being used during the later first century A.D. in the Roman urbanization of Britain.[216] There is no direct relationship between what happens at Conimbriga and what occurs on the other side of the Strait of Gibraltar, but there is a parallel concept at work: the creation of hierarchically organized self-contained spaces, defined by porticoes and centered on temple structures. This type of design may have been intended to stress the discontinuity with the older order.

Interestingly, the experiments in planning and design that took place on the Iberian Peninsula during the second half of the first century and culminated in the great Flavian projects see the closest continuity with the mid-second-century A.D. developments in Augst (Basel).[217] Here by the Antonine period a great peripteral temple surrounded by a "pi"-shaped portico and standing atop an artificial platform commanded the central space of the city. The terraced platform and the peripteral temple set within a portico bring to mind the designs of Tarraco and Munigua. The forum itself is not that different from the forum at Conimbriga, a self-contained unit with a free-standing temple at one end enclosed by a "pi"-shaped portico that also defined the plaza before the temple. The major difference was the inclusion of a transverse basilica opposite the temple. However, even this feature can be paralleled. It too seems to have had an extending niche, an exedra in the back wall that may not have been too different from that of the basilica on the lower forum at Tarraco. It well may be the case that many of the features that become such standard elements in Roman towns of North Africa, Gaul, and Germany by the second century were first developed on the Iberian Peninsula during the first century.

Construction Techniques. Quite separate from the plans and designs of the Flavian period is the development of more involved construction forms. At Munigua, the back wall of the lower story of the portico seems to be a variation on what is sometimes called *opus africanum*—the use of supports composed of large blocks of stone that separate panels of smaller material, usually stone. The technique was Phoenician, developed during the early Iron Age.[218] It had passed into areas under Phoenician control, and can be seen in the houses at Kerkouane and in some of the buildings of the Greek

216. Euzennat and Hallier 1986, pp. 73–103.
217. Grimal 1983, s.v. Augst; Ward-Perkins 1981, pp. 220–221
218. E. Stern, "The Many Masters of Dor: Part II, How Bad Was Ahab," *BAR* 19:2 (March–April 1993), p. 24.

site of Selinunte in Sicily.[219] It may have come to the Iberian Peninsula with the arrival of the Phoenicians. Hauschild notes that the construction technique can be found in two other Baetican structures, both early Imperial: remains near the Puerta de Sevilla at Carmona, and the outside wall of the theater at Belo.[220]

The use of marble for structural elements and as the veneer becomes for the first time common on the peninsula. At Ebora, the earlier, probably Augustan, temple was finished with granite columns set atop marble bases and holding aloft marble Corinthian capitals.[221] The use of marble at Ebora in Lusitania breaks with the older practice in the region of using stucco to finish architectural details. Though the capitals of the temple at Ebora can be stylistically related to examples from the early first century A.D.— the Temple of Mars Ultor, the Gate of Augustus at Nîmes, the theater at Orange—the fact that they are marble suggests that they are later, perhaps in an archaizing style. Marble probably began to find common usage in the public architecture of the peninsula during the later Julio-Claudian period. The architectural decorative detailing from Pancaliente and Calle de Sagasta from Augusta Emerita, which probably decorated the Augustan sanctuary of that city, is in marble and has been dated Julio-Claudian.[222] By midcentury, the marble decoration was in place or being put up in the Sanctuary of Augustus at Tarraco. By the Flavian period, marble seems to be in abundant use. The porticoes at Conimbriga were revetted in marble, and all the architectural decoration known from the temple at Corduba is in marble.[223]

The lower forum at Munigua may actually provide the best evidence for decorative possibilities for Flavian constructions. There are remains of marble revetments on some parts and stucco on others. The yellow brickwork used for some of the construction also included brick pilasters, which must have been covered over in stucco. The statues, however, stood on marble bases.[224]

One of the most interesting coloristic aspects in the lower city at Munigua may have been the intentional creation of bichromatic effects. In both the

219. M. Hassine Fantar, "Presencia púnica en el Cabo Bueno: Kerkouane," *RdA* 6:50 (June 1985), pp. 12–20.

220. Hauschild 1968, p. 277.

221. Chap. 2 supra; Hauschild 1988, pp. 208–220. Hauschild is unwilling to be more committal than the early Imperial period for the date of the temple's construction, but he does note that the capitals can be stylistically paralleled by examples that cover the entire first century A.D.

222. Barrera Antón 1984, nos. 3–18.

223. Alarcão and Étienne 1977, p. 105. The excavators of Conimbriga are not sure that the temple itself was decorated with marble (pp. 92–93).

224. Hauschild 1986, pp. 328, 336, 337.

lower forum and the aedicula appended to the portico behind the forum granite elements were juxtaposed with marble.[225] This was also the situation for the temple at Ebora. Certainly the granite may have been plastered over, as had been the earlier practice, and as was done in Augusta Emerita when the peristyle temple was redecorated sometime in the second half of the first century.[226] Augustus must have appreciated the impact of black granite against white marble when he set up the Egyptian black granite obelisks in Rome. More immediate influence on developments in Flavian Iberia may have come from the example of Domitian's palace in Rome, where colored marbles were lavishly employed.[227] Munigua also supplies evidence for similar application of colored surfaces on the peninsula. Fragments of colored wall treatments have been found in the upper sanctuary, and it has been shown that there is a good likelihood that the sources for these incrustations were on the peninsula itself. The Munigua evidence is the most abundant for the moment, and may indicate that the extravagant use of colored stone revetments for public structures was a peninsular response to Flavian decorative treatments. On the other hand, the finding of traces of colored marble veneers at Bilbilis could be indicative that the experimentation actually goes back to at least the midcentury.[228] By the end of the first century A.D. the peninsula itself could have been providing the raw materials for much of the public building, with local sources for colored stones, quality granite from quarries near Augusta Emerita and in the east, and good marble from Estremoz.

Cults. The massive sanctuary-building programs of the latter half of the first century A.D. may be indicative of a change in cultic associations. Gros has suggested that the emergence of secondary shrines on the forum at Emporiae, which by the Flavian period rivaled the main temple, probably indicates the triumph of the Imperial Cult over the earlier cult of Jupiter. It is known from the epigraphic evidence at the site that the cult of *Divus Augustus* was indeed honored on the forum.[229] At Clunia, the great Temple to Jupiter was juxtaposed with possibly two sanctuaries dedicated to the Imperial Cult.[230] Galba's supporters may have been wrapping the new Emperor in the mantle of the god for the sake of legitimacy when they promoted the story of the oracle of Clunia[231] in a manner to be used later effec-

225. For the aedicula see Hauschild 1988, p. 215; for the forum, idem 1986, p. 327.

226. Barrera Antón 1984, no. 20.

227. M. Anderson and L. Nista, *Radiance in Stone: Sculpture in Colored Marble from the Museo Nazionale Romano* (Rome, 1989), pp. 11–20.

228. Grünhagen 1978, pp. 290–306. For Bilbilis, see chap. 3 supra.

229. Gros 1986, p. 114. 230. Chap. 4 supra.

231. Ibid.

tively by Vespasian.[232] Nowhere was the architectural statement of Imperial *auctoritas* made more dramatically than at the redesigned forum at Conimbriga. Whether the Flavian sanctuary was the first to boast a temple, as Gros has suggested,[233] or was the expansion of a midcentury design, as both Roth-Congès and Pfanner have hypothesized, or was the transformation of the Augustan temple-forum arrangement restored by the excavators[234] is of little consequence. All agree that the Flavian design broke with the earlier pattern and visually severed any ties with the pre-Roman community, concentrating all attention on the majesty of the Emperor as represented in the temple.[235]

There is no epigraphic evidence for such a change happening at Belo, but the finding of the statue of the Emperor Trajan in the basilica may point to the presence of Imperial imagery in the area. There may well have been representations of the Flavian dynasty in the lower sector at Munigua.[236] And Imperial images were found outside of the basilica in the lower forum at Tarraco.[237] By the century's end, Domitian would have himself been equated with Jupiter, thus leaving little doubt about the formal conflation of the two cults.[238]

The promotion of the Imperial Cult was no doubt tied to the active Romanization of provincial regions. However, within the world of the Flavian emperors it may have had more immediate purposes. It served to tie this second dynasty to the first Imperial dynasty, and it secured a sense of peaceful succession. There is no evidence for any direct Imperial monies paying for the development of the cult on the peninsula during the Flavian period. It is worth wondering whether the archaistic aspects of the temple at Corduba, which seem to reflect features of the Augustan Maison Carrée in Nîmes, in some way might not be related to Domitian's architectural program of rebuilding Julio-Claudian structures and thereby associating the two dynasties.[239] On the other hand, as Étienne has pointed out, there was initially in the numismatic iconography of Vespasian a certain echo of older Republican sensibilities, which was tempered by associations with Augustus.[240] However, it does seem reasonable to suggest that some of that Republican quality might have informed the choice of older, Republican sanctuary

232. Scott 1936, chap. 1, "Vespasian's *Auctoritas et Maiestas*," pp. 1–19.

233. Gros 1986, p. 116. 234. Pfanner 1989, pp. 184–203.

235. This is based on the evidence of the sculptural finds in the cryptoportico; Leveque and Leveque 1976, p. 237.

236. Grünhagen 1986, pp. 309–323.

237. Koppel 1986, pp. 10–12. 238. Scott 1936, pp. 133–138.

239. Eva D'Ambra in a public lecture at Middlebury College, March 10, 1993. For a general overview of Flavian attempts to tie together the dynasties see Scott 1936, p. 51.

240. Étienne 1958, pp. 447–451.

designs as the prototypes for Munigua's hillside sanctuaries. Interestingly enough, Munigua claimed poverty in an appeal to the Emperor Titus against the ruling of a previous proconsul of Baetica that required the city to make payment to a Servillius Pollio. The Emperor, though rejecting the appeal, did remit some fifty thousand sesterces and the interest that would normally have been due Servillius Pollio.[241] Under such circumstances, could the great complex have been some type of public offering of thanks paid for by members of the elite of Munigua?

CONCLUSION

What seems to emerge during the second half of the first century is a growing role played by local elites in determining architectural choices. As has already been suggested, the Iberian elite resident in Tivoli could have played an active role in encouraging the particular design form chosen for Munigua's great sanctuary complex. But at Tarraco, Conimbriga, and Munigua the real motivation becomes evident from the statue bases. The local elites used the new architectural ensembles as backdrops for the display of public sculpture, no doubt portraits of themselves and members of their families. The complexes and associated sculptural programs move in a crescendo beginning on the local level at places like Munigua and Conimbriga, where the images are of the local elite families, to the great hierarchical composition at Tarraco, where statue placement announces subtle status rankings within the social stratification of the capital and within the province as a whole.

By the Flavian period certainly members of elite families and no doubt anyone eager to break out of the confines of a provincial lifestyle took opportunities to spend time in Rome. There is good evidence of a community of expatriate young men from the peninsula resident in the capital, of which Seneca, Lucan, and Martial are the best known.[242] The importance that civic embassies to the Imperial court had assumed by the time of the Flavian dynasty would surely indicate that a certain number of young men of leading families must have spent time in the capital or elsewhere in the Roman world, where they would have had the opportunity to see the architectural splendors of Rome and the East.[243] These embassies did not come just from the provincial capitals. The small town of Sabora in Baetica sent an official embassy to plead its case before Vespasian.[244]

241. Millar 1977, p. 441; H. Nesselhauf, "Zwei Bronzeurkunden aus Munigua," *MM* 1 (1960), pp. 142–148.

242. Griffin 1972, pp. 1–24. 243. Millar 1977, pp. 375–384.

244. Ibid., pp. 235–236; *ILS* 6092; Abbott and Johnson 1926, no. 61.

By the Flavian period the Iberian Peninsula was a fully integrated member of the Roman Empire, and the architectural designs that came to dominate the towns and cities of the peninsula in the last decades of the first century A.D. testify to this fact. They show clear evidence of sophisticated architectural choices that served local needs as well as provided a visual display of Romanness. Moreover, they were probably paid for through local resources—monies of the local elites in many cases. They reflect the high degree of self-confident Romanness, which no doubt permeated the elite classes and which led to the production of major writers, an aristocratic group resident at Tivoli, and eventually two emperors in the next century.

CHAPTER SIX

The Emperors from the Peninsula

By the end of the first century A.D. elites from the Iberian Peninsula had made a place for themselves in the larger Empire. A group of influential individuals with villas at Tivoli had family ties back to their towns and cities in Baetica and Tarraconensis. The epigraphic record is not complete enough to allow us to know if their apparent status in Italian society was matched in their home cities or whether they had exchanged local influence to play a role in the larger Imperial world.[1]

Somewhat more certain is the situation for the equites from the peninsula. During the late first and early second centuries, knights from Iberian towns were posted throughout the Empire.[2] The military and administrative *cursus honorum* for these men resulted in time being spent abroad. The epigraphic record is better here and tells of high-ranking individuals from the Iberian region who found themselves serving on the Rhine frontier,[3] in the east in Cappadocia,[4] in Syria,[5] and in Dacia.[6]

Roman senators from the peninsula began to appear in the Curia in Rome along with other senators from the western provinces during the second half of the first century A.D. Under Nerva, Trajan, and Hadrian the number of senators of provincial origin steadily increased, as did their percentage in

1. Syme 1988, pp. 94–114.

2. As early as the first century B.C. there were cosmopolitan residents on the peninsula, individuals whose careers had taken them around much of the Empire; see discussion of Gnaeus Domitius Calvinus in Ripoll Perelló 1990, pp. 194–200.

3. *CIL* II, 4188. 4. *CIL* II, 2213.

5. *IGR* III, 128.

6. *CIL* II, 1178. For a general overview see Pflaum 1965, pp. 87–121.

the total body of the Senate.[7] Of these new provincial senators, the Iberian group formed a strong unit by the time of Nerva, and they may have influenced Nerva's decision to adopt Trajan. Italica looms large as the *patria* for the greatest number of them.[8] The Baetican senators may have been closely knit and tightly united.[9] Iberian blood was to run through the veins of most of the emperors of the Antonine line.[10]

Particular individuals within the Iberian group may have had substantial political power. Lucius Licinius Sura[11] from Tarraconensis rose under Domitian to command legions in Germany and eventually to serve as governor of Gallia Belgica. He possibly was the force that persuaded Nerva to adopt Trajan. He wrote speeches for Trajan (*SHA: Hadrian*, 3.11) and was honored in Tarraco.[12] He was a friend of Pliny's (*Ep.* 4.30; 7.27) and a patron of Martial (6.64; 7.47:1–2), which could be an indication of some type of provincial association among these *novi homini* from the provinces.

The political clout of the Iberian group was no doubt due in part to the wealth of the individual members. By the start of the second century A.D. the Iberian provinces were economically stable, and individuals were profiting handsomely. The archaeological evidence supports the literary tradition of the agricultural and mineral wealth of the peninsula. Oil from the villas of Baetica was exported throughout the Mediterranean, as far east as Egypt and Greece, with much of it stocking the shops of Rome.[13] Some of the Iberian elite were involved in commercial enterprises, if Haley's analysis of the commercial concerns of the family of T. T. Manilii from Tritium holds true for other elite families.[14]

Many of the elite from the peninsula chose to remain at home and not seek advancement in the capital. They reaped the benefits of their wealth in a local setting and were duly recognized by their cities and in some cases, eventually, even by the emperor, who by the end of the first century could be involved in the local governing of cities by the appointing of individuals as curators.[15]

7. The basic study is by Lambrecht (1936), who argued (p. 103) that with Domitian the percentage was 22 percent and by Trajan it was 43 percent. Étienne (1965, pp. 57–58) has proposed slightly different percentages: under Nerva, 35.76 percent; under Trajan, 45.02 percent; and under Hadrian, 46.73 percent.

8. Étienne 1965, pp. 74–82.

9. Castillo García 1984, pp. 239–250.

10. Faustina the Elder, the wife of Antoninus Pius, was from a consular family from the peninsula, and her brother, Annius Verus, was the father of Marcus Aurelius. Berenger 1965, pp. 29–31.

11. For Sura see *OCD*, s. v. Sura; Berenger 1965, discussion remark by Étienne, p. 42.

12. *ILS* (1952) 6456. 13. Broughton 1979, pp. 153–160.

14. Haley 1988, pp. 141–156.

15. Curchin 1990, pp. 35–36; Alves Dias 1978, pp. 263–271.

This background information introduces three important issues that played roles in the architectural experience of the second century on the peninsula. First, on the part of those individuals most likely to be in a position to patronize building there was an awareness of architectural developments happening elsewhere in the Roman world. This has already been argued to have been an aspect that affected Flavian architectural explorations. During the second century the numbers of elite with such knowledge probably increased. Second, much more wealth must have stayed on the peninsula. The elites who remained behind spent lavishly, and so too one must assume that some figures, such as L. Licinius Sura, returned to the peninsula from time to time and spent money. Moreover, money was flowing into the peninsula in payment for the oil and *garum* and other products being shipped out. The elite married among themselves, thus keeping the combined wealth within the local area. The result was a local source of architectural patronage, nowhere seen to better advantage than in the second-century addition to the city of Italica with one luxury town house after another.[16] Third, there was a clear desire to embellish cities. For this activity the resources of the private citizenry were pushed into the service of the community as a whole, in a manner akin to that which was happening throughout the Empire. Private patronage, financial resources, sophisticated tastes, cosmopolitan awareness—all were to contribute to the formation of monumental architecture on the Iberian Peninsula during the first four decades of the second century A.D.

TRAJANIC RESTORATIONS, RENOVATIONS, AND CONSTRUCTIONS

Several of the temples so far considered were restored or embellished during the second century A.D. There is little evidence of work that is of specifically Trajanic date. However, the importance of a man like L. Licinius Sura, who was powerful both at home in Tarraco and in Rome, should warn us not to pass too quickly over the Trajanic period. L. Licinius Sura put up an arch outside of Tarraco at Bará[17] and could have been one of those who helped defray the costs of the great Flavian building projects in the city, which actually continued into the first decades of the second century A.D.[18]

Alvarez Martínez has argued that during the second century Augusta Emerita expanded.[19] Although nothing specifically Trajanic has been iso-

16. García y Bellido 1965, pp. 7–26.
17. Alföldy 1978, col. 611.
18. Koppel 1985a, p. 850. 19. Alvarez Martínez 1985, p. 40.

lated, the evidence is of general prosperity, reflected in the construction of luxury houses.[20] Many of these show rich interior decorative appointments.[21]

Bilbilis

Bilbilis has actually yielded evidence of specifically Trajanic reforms made to the sanctuary. The terracing arrangement surrounding the forum and the temple region was somehow remodeled, though the details of the alterations are at present still unclear.[22] More certain would appear to be the change made to the temple itself, which was given a hexastyle facade that replaced the older tetrastyle front.[23] The general nature of these changes would seem to have been intended to increase the overall grandeur of the sanctuary and its setting. They could reflect the impact of the Flavian designs from the provincial capital at Tarraco.

Ausa

Sometime in the late first century or early second century A.D. a small temple was erected on a high spot in the native settlement of Ausa (Vic). The town itself may have come into existence only at this time and was more of a *vicus* than an *urbs*.[24] Among the acts of the town council was to honor Lucius Licinius Secundus, a freedman of L. Licinius Sura, and an important figure in Barcino.[25] The town was in the province of Tarraconensis, and the Ausetani were one of the native peoples of the Catalan region. There is nothing to indicate that either the town or the temple was in any way the result of Imperial interest.

The town was insignificant, and the temple was appropriately modest. It has survived, in part, because it was incorporated into a medieval structure, the Castel de Montcada, in which the cella served as a patio (fig. 75). The fortress was dismantled only in 1882, at which time the temple was discovered.[26] Portions of the podium and cella walls, a corner pilaster from the porch, one capital, and some fragments of the entablature survived the centuries.[27] The temple was partially restored at the turn of the century under

20. Balil Illana 1976, pp. 75–91.

21. Barrera Antón 1985, pp. 101–110.

22. Martín-Bueno 1987, p. 107.

23. Martín-Bueno, Jiménez Salvador, and Cancela 1985c, p. 840; Martín-Bueno and Cisneros Cunchillos 1985b, p. 877.

24. Molas i Font 1982b, pp. 290–291.

25. Keay 1989, p. 78.

26. Serra y Campdelacreu 1959, pp. 243–249.

27. Gudiol i Cunill 1959, pp. 250–258.

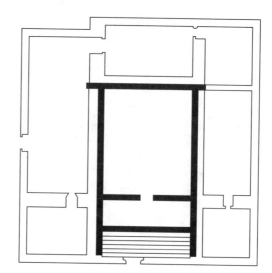

Figure 75. Plan of the Castel de Montcada with temple inside (after Molas i Font 1982a, fig. 83)

the direction of J. Serra y Campdelacreu, and later, in 1930, the pronaos colonnade was reerected (pl. 65).

Puig i Cadafalch, A. de Falguera, and J. Goday described the remains and offered an analysis of the temple in the 1934 version of *L'arquitecture romana a Catalunya*.[28] The cella is ca. 9 m × 10.90 m on the interior, ca. 10.10 m × 12.10 m on the exterior. The pronaos had an interior of ca. 9 × 4 m.[29] The construction is of local stone worked as large blocks along with smaller mortared stones. Puig i Cadafalch identified the technique as *opus emplecton*. There is some evidence for stones being clamped into place.[30] The walls would have been covered with stucco, and the superstructure stood atop a podium ca. 1.5 m high.[31]

Nothing of the colonnade for the pronaos survived. Puig i Cadafalch and J. Gudiol i Cunill argued that the temple must have been hexastyle with an intercolumniation of 1.20 m. No excavated remains support the reconstruction, but Puig i Cadafalch maintained that a tetrastyle facade with an intercolumniation of 2.46 m would have been inappropriate for such a small temple, making it a distyle type.[32]

Based on the evidence of the remaining corner pilaster, Gudiol i Cunill

28. Puig i Cadafalch, Falguera, and Goday 1934, "El temple de Vich," pp. 107–111.
29. Gudiol i Cunill 1959, p. 252. 30. Ibid., p. 256.
31. Ibid., p. 253.
32. Puig i Cadafalch, Falguera, and Goday 1934, "El temple de Vich," p. 107; Gudiol i Cunill 1959, p. 255.

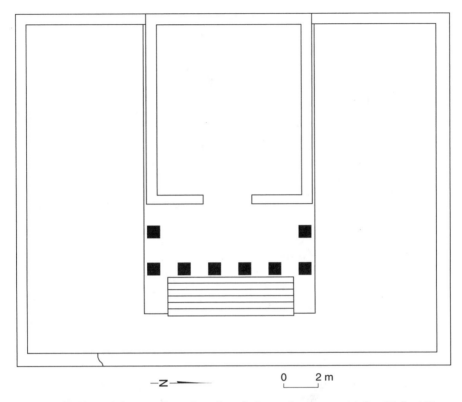

Figure 76. Plan of the temple at Ausa in relation to its temenos (after Molas i Font 1985, p. 170)

postulated that the columns stood on Attic-Ionic bases, and that with capital and base, the order rose to 6.35 m.[33] The fragments of the frieze show it to have been undecorated other than with a simple molding. A corner portion of the pediment that had survived allowed Gudiol i Cunill to reconstruct the raking cornice, from which he was able to propose a total height of the temple of 11.50 m.[34]

The temple stood in a small precinct. The excavations of 1984 revealed that the wall of the temenos passed only about 2 m in front of the lowest step of the podium (fig. 76). The entire temenos, which was wider to the sides, occupied only ca. 525 m² even though it probably was a major site of the new town.[35]

33. Gudiol i Cunill 1959, p. 252. 34. Ibid., p. 256.
35. Molas i Font and Ollich i Castanyer 1985, pp. 163–170.

A date of construction for the temple cannot be established with certainty. Puig i Cadafalch noted a stylistic similarity between the pilaster capital and the capitals of the arch of L. Licinius Sura at Bará,[36] which would indicate a date in the late first or early second century A.D. The excavations of the 1980s did not succeed in refining the date span.[37]

Almost all commentators on the temple have noted the unusual building technique employed for the cella walls, which did remain intact in the rear of the cella (pl. 66). The walls are constructed with regularly spaced piers made of large blocks of cut and worked stones in an alternating arrangement of square and rectangle, a kind of header-stretcher pattern. Between the piers are mortared walls of smaller, regularly cut blocks. This is the technique that Puig i Cadafalch referred to as *opus emplecton* and that is perhaps better known as *opus africanum*. Ma. Molas i Font, the most recent excavator of the temple, has shown that this technique was particularly favored by North African builders during the second century A.D. and can be seen in the walls of the cellas of the capitolia at Dougga, Thuburbo Maius, and Sbeitla.[38]

Opus africanum may have been revived on the peninsula during the Flavian period. A version of it appears to have been used for the walls of some structures at Munigua.[39] The style is not a truly Roman invention. It is a revival of an older, Punic building style with roots in the Phoenician homeland, where it is often identified as Phoenician-Israelite construction. It appears in a variety of major structures, and though in its initial form it may be a bit more rustic than in its more refined Roman version, the technique has a clear source.[40] The building technique came west with the Phoenicians, and it is quite likely that it was among the stone construction styles used on the Iberian Peninsula in the areas under Phoenician influence. The revival of the style in North Africa need not have been what prompted the revival on the Iberian Peninsula, which well may have had local models to use. However, Ausa was not located in the area under previous Phoenician influence, and for the moment the direct link to North Africa posited by Molas i Font must be accepted as equally valid, if not even perhaps a little stronger.

The temple at Ausa was small as befitted a *vicus* that was probably never more than a hub for a rural, agricultural area. The site was probably not even occupied until the Augustan era. The native peoples, the Ausetani, perhaps can be identified as a group as early as the sixth century B.C., and

36. Puig i Cadafalch, Falguera, and Goday, "El temple de Vich," p. 107.
37. Sanmartí i Grego and López i Mullor 1982, p. 264; Molas i Font 1982b, p. 290.
38. Molas i Font 1982a, p. 88. 39. Chap. 5 supra.
40. For a recent find at Tell Dor see E. Stern, "The Many Masters of Dor. Part 2: How Bad Was Ahab?" *BAR* 19:2 (March–April 1993), p. 24, with illustration.

sites around Ausa do show evidence of earlier habitation.[41] By the second century B.C. one of the settlements was striking coins.[42] The settlement at Vic proper was probably the result of the Augustan reorganization of the West. Nothing of the earliest settlement has survived, and the temple may be the first real example of monumental architecture on the site.

There is no evidence for a cult, though there is an association of the medieval castle with Hercules that could possibly be a memory of the Roman cult, but such a cult seems unusual for what may have been the town's most important temple.[43]

HADRIANIC RESTORATIONS, RENOVATIONS, AND CONSTRUCTIONS

Gades

The old Punic sanctuary of Melqart-Heracles in the Phoenician foundation at Gades (Cádiz) was somehow transformed during the Hadrianic period.[44] The specifics of the changes are not at all clear, but that something did happen is acknowledged by a series of coin reverses of Hadrianic date. These have types that focus on the image of Heracles and may reproduce statues at the sanctuary.

There is nothing out of the ordinary about changes being made to an old and established sanctuary. By the second century reverse coin types often feature schematic renderings of important sanctuaries.[45] However, these coins were not local issues. They were struck by the mint at Rome and, as such, suggest that the Emperor was at least familiar with the sanctuary. Such is not unlikely. The *patria* of the Aelii was nearby Italica, and Hadrian's mother may have been from Gades.[46]

An Imperial interest in the sanctuary of Melqart-Heracles did not begin with Hadrian. Local coinage of Gades struck under Augustus seems to associate the Emperor with the shrine.[47] The Emperor Augustus may have used the Heracles myth, particularly the story of the cattle of Geryon, as part of his political propaganda in the West.[48] Heracles, and specifically the Heracles of Gades—the Heracles Gaditanus—seems to have been an element in Hadrian's official propaganda as well. Among the scenes shown on the Hadrianic tondi now preserved on the Arch of Constantine are those that repre-

41. Molas i Font 1982a, pp. 19–25.
42. Villaronga 1979, p. 132; Molas i Font 1982a, pp. 43–47.
43. Gudiol i Cunill 1959, p. 257.
44. García y Bellido 1963b, pp. 70–153.
45. Price and Trell 1977.
46. *OCD*, s.v. Hadrian.
47. Mierse 1993b, pp. 38–40.
48. Knapp 1986, pp. 104–122.

sent Hadrian hunting and making sacrifices following the hunt. The four deities to whom Hadrian makes his sacrifices have been identified as Silvanus, Diana, Apollo, and Heracles. M. F. Boatwright has suggested that the four gods were particularly chosen because of their associations with the West, and thus the scenes fit into the larger Hadrianic program of Imperial propaganda.[49] Bulle went so far as to identify the Heracles as the Heracles Gaditanus, thus tying the image to a specific locale—the old Semitic world of North Africa and southern Spain.[50] The image of the seated Heracles on the tondo has little in common with the Heracles figures reproduced on the coin reverses. Moreover, there is little to support Bulle's contention either from archaeology or from literary testimonia. We simply do not know how the cult statue portrayed Heracles Gaditanus. Yet, if Boatwright's general assertion about the western associations of the tondi is correct, then Bulle could also be correct: The Heracles Gaditanus is being specifically invoked in the scene.

The conflation of Heracles with Melqart is particularly interesting when it is given an Iberian setting. There is a particular labor of Heracles that places the hero squarely on the Iberian Peninsula: the rustling of the cattle of Geryon. The story first appears in Hesiod (*Theogony*, 287–294) and then occurs in various versions in the works of several other Greek authors.[51] Although there is no general agreement as to the exact location at which the fight took place between the hero and Geryon, it was acknowledged to have occurred in the southern part of the peninsula, near Gades.

The story may have been invented to justify Greek penetration into the far West.[52] Indeed, Heracles' return trip to Greece with the cattle offered many landfalls for the hero along the south coasts of Spain and France that could be profitably turned into legendary foundations. The interesting feature of the story was its western locus. By the second century, the characters of the story, as well as the story itself, had become a means of referencing the Iberian Peninsula. Under Domitian's reign a sculptural group showing the fight was erected in the Porticus Philippi in Rome and drew a response from the Iberian poet Martial.[53]

During the second century in some of the old cities of the Greek East writers of the Second Sophistic movement and of romance novels began to exploit the local myths and legends as subjects for their works. These pieces, both romance novels and formal orations, attempted to evoke a distinct past,

49. Boatwright 1987, p. 201. 50. Bulle 1919, pp. 148–151.

51. Pindar, frag. 169; Herodotus, 4.8; Plato, *Gorg.* 39 p484B, *Tim.* p243; Dio. Sic. 4.17–21; Dio Hal 1.39–42. See discussion in Knapp 1986, pp. 104–106. According to Rose, Geryon was originally placed in western Greece and moved to Spain only when Greeks came to know the far West; H. J. Rose, *A Handbook of Greek Mythology* (New York, 1959), pp. 30–33.

52. Knapp 1986, pp. 104–106.

53. Rodríguez Almeida 1986, pp. 9–15.

the pre-Roman world of the eastern Mediterranean. These Greek writers had their counterparts in some sculptors, who in these same decades created some of the most ambitious large-scale public sculptural displays in the ancient world. Often these also highlighted local, legendary figures, ancient founders of cities, whose only importance was in that action. Both writers and sculptors were engaged in reviving figures with quite particular local and parochial ties.[54]

It might be worth considering that something similar was occurring in the old Phoenician area of southern Iberia by the same period. Here three pre-Roman figures, all with specific associations to the area, could be used in a sophisticated referencing system. Geryon was the native prince, Heracles the Greek hero, and Melqart the Phoenician god. Melqart and Heracles had already become one long before this period, and so a reference to Heracles Gaditanus was in essence an evocation of all of the pre-Roman culture of the south. In the Greek East, when this was done in great sculptural ensembles, usually it was used as a means of enmeshing the reigning Emperor into the legendary past of the city as in the great gate at Perge.[55] Something quite similar could have been taking place in the sanctuary at Gades. The coin reverses would then show sculpted figures of Heracles that were part of a new ensemble placed somewhere in or near the sanctuary. The obverse, with its head of Hadrian, served as a reminder of the Emperor's presence. In the sculpted groupings, his figure was no doubt included.

Tarraco

Hadrian is directly credited with making repairs to the Temple of Augustus at Tarraco (*SHA: Hadrian* 12, 31). He stayed at the provincial capital during the winter of 122–123,[56] and it was during this visit, no doubt, that the repairs were ordered. The text does not specify the nature of the repairs. Recasens i Carreras has identified the Corinthian capital (pl. 54) found in the upper city, often identified as coming from the Temple of Augustus, as Hadrianic in date.[57] This suggests that some of the work was on the colonnades.

Italica

By far the best-understood urban site of the second century A.D. is the new city of Italica. Under Hadrian, the city, which had been a municipium, asked

54. Mierse 1993a, pp. 289–294.
55. Akurgal 1985, pp. 329–333; M. Boatwright, "The City Gate of Plancia Magna in Perge," in E. d'Ambra, ed., *Roman Art in Context* (Englewood Cliffs, N.J., 1993), pp. 189–207; C. C. Vermeule, *Roman Imperial Art in Greece and Asia Minor* (Cambridge, Mass., 1968), p. 255.
56. Alföldy 1978, col. 611.
57. Recasens i Carreras 1984, pp. 326–327; TED'A 1989, p. 160.

to be accorded the rank of *colonia* (Avl. Gell. 16, 13, 4). It was the *patria* of both the Ulpii and Aelii and therefore could have had a special relationship with the first provincial Emperors.

It was not a large city. García y Bellido estimated that it had a population of between eight and ten thousand. It did, however, occupy a fair amount of land, ca. 30 ha, three times the size of Barcino,[58] and it had one of the largest amphitheaters in the Roman world.

Originally the city had been centered on the two hills of San Antonio and Los Palacios, but at some point the urban nucleus expanded out to the north from Los Palacios to form the "Nova urbs." García y Bellido has argued that this expansion occurred under Hadrian, basing his conclusion on Dio Cassius's account (69.5.2–3; 16.1) of Hadrian's beneficence to provincial cities.[59] There is a record of an embassy from Italica calling on the Emperor during his stay at Tarraco and requesting favors (*SHA: Hadrian* 12.4). There is nothing that archaeologically would discount a second-century date for the additions, and there is some epigraphic evidence supporting both change in status[60] and the notion that Hadrian took some interest in the city.[61]

Syme declaimed against any strong Hadrianic association with the city. He acknowledged the legitimacy of the note in Hadrian's biography that the Emperor had spent some time in the city at the age of fifteen (*SHA: Hadrian* 1.3), but he was adamant that the Emperor had not been born in the city and was not particularly attached to it.[62] Syme thought that the Emperor was most likely embarrassed by his countrymen. According to Hadrian's biographer, the Emperor was particularly brusque with the embassy from Italica when it arrived as requested by the Emperor at Tarraco.[63] Yet, Dio Cassius's point that Hadrian did make gifts to his city (69.10.1) should probably not be taken too lightly.

The city that developed (fig. 2), with or without the involvement of the Emperor, spread out to the gently rolling land north of Los Palacios. This new sector was to be largely a residential area with large, well-appointed houses along with the amphitheater and bath complexes. The walls that encircled the older city were expanded to include this new north quarter. Whether these walls should be assigned to the initial move or to later in the

58. García y Bellido 1965, p. 11. 59. García y Bellido 1979, p. 21.
60. García y Bellido 1965, p. 9.
61. García y Bellido 1979, pp. 74–75.
62. Syme 1965, p. 246.
63. It should be noted that the text is damaged at this point, and the reading is therefore suspect. The word is "Italici," which has been taken to be "Italicenses"; *SHA: Hadrian* 12.4. See R. Syme in *JRS* 54 (1964), p. 142.

century when southern Iberia was threatened by invasions of nomads from North Africa is not certain.[64]

The new area was laid out in an orthogonal pattern with a main kardo crossed by secondary decumani. The topography resulted in the insulae being at various heights. Naturally occurring gullies provided the collection channels for the sewer system.[65] In general, two houses occupy every insula, though there are exceptions for the smaller blocks near the walls. The houses are each separated from one another by double walls, and on this point the contractors followed the building ordinances set down for the rebuilding of Rome after the great fire.[66]

The Temple. Into this regularized plan was set a major temple and associated precinct. It was placed on the highest spot in the new quarter.[67] Since the evidence for the "Nova urbs" suggests one building campaign perhaps lasting several decades, it seems likely that the temple complex was part of the initial plan for this new region. The reality of this ensemble became clear only during the excavations of the 1980s.[68]

The complex is at the lower portion of the hill of Los Palacios, on which the older Republican temple, perhaps a capitolium, had been built.[69] This area, the "Vetus urbs," was the Republican and early Imperial city, and here, too, work was ongoing as the city expanded northward. A bath complex was constructed and decorated with a major sculptural program of life-sized statues of Trajan, Hadrian, and deities.[70]

The precinct consists of a temple surrounded totally by colonnades (fig. 77). The exterior walls were penetrated at three points: a main entrance at the east side, and smaller, secondary entrances at the northeast and southwest corners. The complex occupies two insulae. It is axially aligned east-west, parallel to the decumani. It is bounded on the north and south by decumani and on the east by the Kardo Maximus. A decumanus runs up to the main entrance, and technically bisects the precinct and the temple longitudinally. There were three fountains placed around the exterior of the complex, one at the corner formed by the crossing of the Kardo Maximus and the south decumanus, one at the crossing of the south decumanus and the kardo that bounded the west side, and the third at the crossing of the west

64. Luzón Nogue 1982, p. 43.
65. Ibid., pp. 25–26; García y Bellido 1979, pp. 77–81.
66. Luzón Nogue 1982, p. 31; Suetonius, *Nero*, 16; Tacitus, *Annales*, 15.43.
67. J. F. Montero in León 1988, p. 98.
68. For the history of the excavations see León 1988, pp. 11–13.
69. See chap. 1 supra.
70. García y Bellido 1979, pp. 107–108.

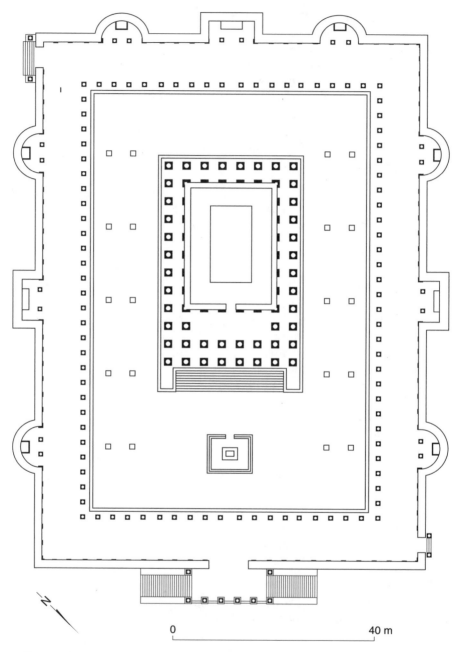

0　　　　　　　　　　　　40 m

Figure 77. Plan of the restored Trajaneum at Italica (after León 1988, plate 8)

kardo and the north decumanus. These were all constructed of *opus cae-menticium* and brick.[71] The ensemble was well drained with a sewer system.[72]

The precinct may have been architecturally announced to its north by an arch or tetrapylon, for which the substructure concrete still survives. This structure stood at a crossing of the Kardo Maximus and a decumanus. The arch served to accommodate a change in the levels of the crossing streets at this point, but it would also have been a physical warning of a change in the nature of the architecture in the region from domestic to public. Tetra-pylons are a well-known feature of Roman urban design by the second century A.D. and are known from elsewhere on the peninsula.[73]

A portico around all four sides of the interior defined the plaza of the precinct. In the middle of the plaza sat the temple. The complex could be entered from the north and south sides via small doors and from the east through the main entrance. The primary entrance was placed along the Kardo Maximus and established the bisecting decumanus, which was also the longitudinal axis of the complex. The lack of an exit on the west side for the decumanus would argue against its having been formally allowed to en-ter the complex.

The ensemble stands above the level of both the kardo and the decu-manus. Access through any of the entrances was via stairs. The staircases for the main entrance were designed as formal features. They parallel the movement of the Kardo Maximus. Two opposing stairways ascended to a platform, at which point the movement changed to the longitudinal axis of the precinct. The entire entrance unit was ca. 31.10 m × 6.80 m.[74]

The site has been severely robbed out, and only the traces of the plan and the substructure and foundation survive, along with isolated elements of the superstructure. The basic fabric for much of the construction is a com-bination of cut stone, brick, and *opus caementicium*.[75] In some areas the con-crete was laid over a bed of mortared stone.[76] The abundant finds of marble fragments suggest that most of the functional, supporting structure was ve-neered. Local stone was used for most of the structural, supporting areas, and the stone is particularly common in second-century constructions in Italica.[77] The combination of concrete with stone and brick is common in the early second-century building in the "Nova urbs."[78] The bricks are of three sizes, and there may well have been a brick factory in Italica at this point.[79]

71. León 1988, pp. 18–19. 72. Ibid., pp. 35–38.

73. For general use of arches see MacDonald 1986, pp. 75–86. For the tetrapylon at Cappara see Floriano 1944, pp. 270–286.

74. León 1988, pp. 22–24. 75. Ibid., p. 49.

76. Ibid., p. 53.

77. Ibid., p. 23; Bendala Galán 1973, pp. 263–274.

78. León 1988, p. 49, comparing the baths.

79. León 1977–1978, pp. 146–147.

The concrete itself is particularly absorbent, a trait of Hadrianic and Trajanic concrete in Italica.[80] Though the actual stones used in the building have disappeared, many left impressions in the concrete fill. They came in a variety of sizes, but averaged 1 m × 0.50 m × 0.50 m.

The east side contained the formal entrance. The three other sides were marked by the inclusion of apses and rectangular exedras that broke through the exterior walls. On each wall were two apses framing an exedra. The exedra on the west side was placed on axis with the temple and entrance. These defined small, somewhat secluded areas off of the main gallery. The interior diameter of the semicircular apses was ca. 8.50 m. The measurements for the interior of the rectangular spaces was ca. 9.60 m × 7.10 m. The function for these spaces is not clear from the archaeological record. The exedra on the south side was filled with *opus caementicium* to a height of 3.60 m. This was the exception. The other eight spaces were free. The concrete fill on the south side could have been intended to function as extra support—a buttress—for the south portico and gallery.[81] The superstructures of the nine spaces were probably statue niches.

One column base has survived from the north portico, and it is assumed that the four sides were colonnaded and formed a peribolos for the temple. Among the finds were fragments of green *cipollino* marble and Carystian marble, which must have been used in the portico. There also have been found sections of *opus sectile* flooring from the interior of the galleries. White marble from Luni was used for the column bases and capitals, and covered the temple and the altar. The cornice blocks were of local marble. There is a qualitative difference between the Italian and the Iberian marbles. P. León, excavator of the site, suspects that local marble was used for those areas less visible. The main entrance facade on the Kardo Maximus had a colonnade of red-gray marble on the platform above the stairways.

Lying on the longitudinal axis established by the bisecting decumanus are the remains of the temple. It was placed slightly farther to the west side within the precinct proper and was oriented toward the east. In front of the temple's east facade was an altar on axis with the temple and the precinct entrance. The platform that sustained the temple is of *opus caementicium*. The *opus caementicium* was a fill over which blocks of stone were raised. Among the excavation finds was a Hadrianic *as* from the temple region and a Trajanic coin from one of the drains in the temple area. The temple was built atop virgin soil.

The excavations have freed a large, formal complex that was certainly conceived as a major element in the "Nova urbs." It was placed in the most

80. León 1988, p. 49; see also Roldán Gómez 1987, pp. 89–122.

81. All details of construction, unless otherwise noted, are taken from León 1988, pp. 32–79.

privileged position of the new city and disrupted the normal rhythm of insulae and kardo-decumanus movement. The complex was further articulated by a grand arch slightly to its north. The ensemble was raised above the level of the surrounding streets and could be accessed through a grand formal entranceway that served also to separate it from the rest of the city. Although the substructure, foundations, and supporting structures were built of local and inexpensive materials, the complex was sheathed in white and colored marbles, some of which were imported.

There is enough of the structure remaining to permit some stylistic analysis, albeit basic. The portico was decorated with both a freestanding colonnade, which held an entablature, and interior pilasters against the back wall. Marble bases were simple but do have a profile of two tori separated by scotiae and a raised fillet band. They stood atop plinths and had a diameter of ca. 0.79 m and a height of 1.24 m or 1.31 m with plinth. The columns of the portico were unfluted, and the pilasters had a type of coffering pattern. The temple columns were fluted. The order for both temple and portico was composite.[82]

León has argued that the profile for the bases is comparable to that for the columns of the propylea of the Pantheon. Similarly, she has noted that the treatment of the capitals can be compared with the work on the capitals of the Pantheon. They exhibit a tendency to develop the horizontal aspect of the leaves. The use of the drill to hollow out deep and wide channels and thereby create a plastic effect is the same in both monuments. The bud in the abacus conforms to the design found in the Pantheon capitals. There are some fragments of the soffit blocks and the architrave from the Italica structure. These indicate that the cornice was undecorated except for simple moldings. The altar, on the other hand, was given a richly articulated cornice molding of acanthus-leaf consoles above a row of lesbian leaf forms, a motif that León observed in two other Hadrianic monuments: the Temple of Venus and Roma in Rome, and the Piazza d'Oro at Tivoli.[83]

In his reconstruction of the temple and precinct, Francisco Javier Montero has noted that the juxtaposition of the semicircular and rectangular spaces on the gallery walls is an important diagnostic feature. Two well-documented Hadrianic monuments display the same treatment: the stoa and library in Athens, and the Pantheon. Furthermore, the use of polychromed marble column shafts framed by white marble bases and capitals is also employed for the columns of the Stoa and Library of Hadrian at Athens.[84]

The design of the stoa and library offers some close parallels to the com-

82. León 1988, pp. 64–66, figs. 1, 2, 3; plates 51–94.
83. Ibid., p. 79.
84. J. F. Montero in León 1988, pp. 92–93.

plex in Italica. It too is a rectangular enclosed space, symmetrical along its longitudinal axis. It had a single main entrance that opened onto a large plaza surrounded by colonnades with a total of one hundred columns.[85] Hidden behind the screen of columns on the two long sides were exedrae. The design for the stoa in turn recalls that of Vespasian's Temple of Peace in Rome.[86] The exedrae are all rectangular in the stoa. The placement of exedra spaces behind a screen of columns in a portico is an architectural idea that can be traced back to the Forum of Augustus. It was successfully employed in Vespasian's Temple of Peace, and later in the exterior portions of the Baths of Trajan. What makes the situation at Italica so interesting is the intentional alternation of semicircular apse spaces with rectangular units.

The same alternation is found in the interior of Hadrian's Pantheon in Rome. The relationship can only be one of visual similarity, since the exedra niches of the Italica complex play a possible structural role in the design.[87] However, the polychromatic treatment of the colonnade and gallery of the Italica portico was matched by that of the interior of the Pantheon. The porch colonnade of the Pantheon displayed the same use of white marble capitals and bases to frame colored shafts.[88]

Montero has proposed that the colonnades surrounding the central temple followed the same pattern as the hundred columns of the colonnades of the stoa in Athens, thirty for each long side, twenty for each short side, with the corner columns counted twice. The columns, inclusive of base and capital, had a height of ca. 6.36 m. Based on the traces surviving, the structure enclosed by the colonnades was a large temple. Montero has proposed a facade of ca. 28 m, one of the largest in the West (fig. 78). At 28 m it would have been too wide for a hexastyle porch, and Montero has proposed an octastyle facade with an intercolumniation of 3.5 m and a column height of 10.9 m. The large size of the temple has led Montero to conclude that it was a peripteral temple, similar to those at Augusta Emerita, Ebora, and Barcino.[89]

There seems little reason to doubt the validity of the design associations that join the Italica complex to the stoa and library in Athens. The basic layouts are too similar to be mere accidents. The specific coloristic interplays used in the colonnades suggest that the architect for one was aware of the other. In a similar vein, the design conceit of alternating rectangular and semicircular niches must be considered in some way associated with the Pantheon plan. Yet neither of these two comparisons is valid for the ensemble as an entirety. The Italica complex was designed to frame a large temple.

85. Sisson 1925. 86. Ward-Perkins 1985, p. 269.
87. For the role of the niches in the Pantheon, see MacDonald 1982, pp. 107–109.
88. MacDonald 1982, pp. 97–98.
89. J. F. Montero in León 1982, pp. 93–94.

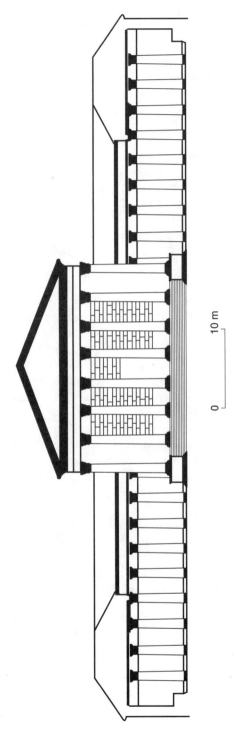

Figure 78. Restored facade and surrounding colonnade of the Temple of Trajan at Italica (León 1988, pp. 96–97)

0 10 m

Montero's rationale for an octastyle temple seems reasonable, but there is not sufficient archaeological evidence for the proposed peristyle reconstruction. One can agree that the size of the remains could have supported a peristyle, but on the Iberian Peninsula the peristyle temple type appears to have its own distinct history.[90] Prototypes existed from the Augustan period in Ebora, Barcino, and Augusta Emerita, and possibly from the Tiberian period in Tarraco. But the peristyle temple type was popular with Hadrianic builders elsewhere in the Empire. It was used for the Temple of Zeus at Aizanoi,[91] and for the Temple of Trajan at Pergamon,[92] and Hadrian used it for his Temple to Venus and Roma in Rome.[93] A peristyle temple type would not have been out of place for a Hadrianic temple on the Iberian Peninsula.

The closest parallel to the Italica complex is probably the Trajaneum at Pergamon. The two share in common the enclosed plaza space defined by colonnaded stoas. The Trajaneum in Pergamon is enclosed on only three sides; the fourth side—the south side—was open to the cliff. As at Italica, the plaza was itself a terrace that bridged an uneven area. The south side had to be supported by means of a great retaining wall. Unlike the design for the Italica complex, where the adjustment to the landscape was made in the substructure so that the interior of the plaza was probably even, the design of the Trajaneum reveals the variance in levels of height between the east and west stoas and the north stoa. But the basic construction is dependent on *opus caementicium* with cut-stone blocks at Pergamon as at Italica. In both, the stoas serve to enclose and separate the freestanding temple, which defines the main axis of the ensemble.[94]

León has identified the Italica sanctuary as dedicated to the Cult of the Divine Trajan. Within its confines was found an inscription dedicated by M. Cassius Caeilianus that references the *flamen perpetuus divi Traiani*.[95] Marble hands survive from a colossal acrolithic statue of the Emperor that stood in the temple.[96] Remains of similar colossal statues of Trajan and Hadrian have been unearthed in the excavations at Pergamon.[97] Montero has observed that the Italica complex must have crowned a rise in a manner not unlike that of a Greek temple sitting atop an acropolis and dominating an archaic city.[98]

The Trajaneum at Pergamon was probably built in two phases. Construction was initiated during Trajan's lifetime as early as A.D. 112. But Trajan

90. Chap. 2 supra.

91. Naumann 1979.

92. Akurgal 1985, p. 82, fig. 108a.

93. Ward-Perkins 1981, fig. 59.

94. Radt 1988, pp. 243–246.

95. A. Blanco in León 1988, pp. 105–108.

96. León 1988, p. 82, figs. 96, 97, 98.

97. Radt 1988, p. 240.

98. J. F. Montero in León 1988, p. 98.

never visited Pergamon, and the work lagged, only to receive new impetus after Hadrian's visit of 123.[99] Hadrian's visit to Pergamon followed his stay in Tarraco. It appears reasonable that it was during the Emperor's stay at Tarraco that official sanction was given for the new sanctuary at Italica. The construction period of the Italica complex would have paralleled the second phase of work at the Trajaneum at Pergamon. The similarities that tie together the Stoa and Library of Hadrian at Athens, the Pantheon in Rome, the Trajaneum at Pergamon, and the Trajaneum at Italica suggest that these were all being created during the same period and that design ideas were floating back and forth from one project to another.[100]

ANALYSIS

The developments on the Iberian Peninsula during the first half of the second century A.D. show the growing interdependence and regional interpenetration that mark the cultural development of the High Empire. However, they represent the last period of major temple building on the peninsula.[101] The specific features of this final phase raise four issues worth further consideration. (1) The situation of the temple at Ausa is the continuation of a type of temple that first takes shape on the peninsula in the late first century—the rural shrine. (2) The expansion of Italica and the placement of the great complex into the new city offers insight into urbanization during the High Empire. Italica was not the only city to witness such massive expansion during this period. (3) The traces of possible North African building techniques in the building of the temple at Ausa demonstrate the existence of some level of contact between these two provincial areas of the Empire. (4) The design of the massive Hadrianic complex at Italica reflects the Emperor's own architectural interests.

Rural Shrines. The appearance of the small temple at Ausa does raise a question as to whether this is best understood as a small urban sanctuary or a shrine designed primarily to serve the needs of the surrounding rural communities. Ausa did operate as a town. It had a council, and there is epigraphic evidence that the council honored certain individuals. Yet there is little archaeological evidence to show that Ausa ever developed into a

99. Radt 1988, pp. 239–243.

100. For date of the Pantheon see MacDonald 1982, p. 96.

101. There is a later temple at the Portuguese site of Milreu that may represent a type of development belonging to the restoration and new order of the third century, but for the moment it is not easily tied to the sequence so far treated, and will not be considered in this study. For an analysis of the temple at Milreu, see Hauschild 1964.

sizable city, and no archaeological evidence to suggest that when the temple was built it had even begun that process. Rather, the temple was perhaps the only substantial structure in the town.

As such it would have functioned as the focus for rituals and devotions for the farm folk in the nearby countryside. Roman rural shrines have their origin in the Hellenistic period in southern Italy.[102] By the time of Augustus, they had become a familiar feature of the landscape. Virgil describes an ideal shrine dedicated to Augustus on the banks of the Mincio (*Georgics* 3.13–15). Picard has defined these rural shrines as they took shape in Gaul as possessing a temple or main religious structure, baths, a forum, and theater. They provided all the necessary architectural apparatus for state cult and ritual.[103]

Not enough of the area around the temple at Ausa has been excavated to determine whether the other items—theater, baths, forum—were also present. But at Mirobriga, everything except for the theater was there, and perhaps the stadium made up for the lack of a theater.[104] Both Mirobriga and Ausa may represent an important, albeit still not well understood, sanctuary type that emerged on the peninsula, as in Gaul, during the first century A.D. and reached its height during the late second and third centuries A.D.[105] There is no clarity as to the cults for these sanctuaries. In Gaul they seem to have incorporated earlier, pre-Roman shrines to Celtic deities,[106] and the continuation of Celtic religious practice into the first period of Romanization in Gaul is well known.[107] Such could have been the case on the Iberian Peninsula as well; there is some evidence for either a revival or survival of pre-Roman gods on the peninsula during the second century A.D.[108] It is also quite possible that these rural sanctuaries were centers for the promotion of the Imperial Cult. They would have assisted with its spread throughout the West and taken it out of the solely urban centers.[109]

If indeed the temple-sanctuaries at Mirobriga and Ausa are best understood as centers for the surrounding agricultural communities, then these are manifestations of the second phase of Romanization. The first phase was dominated by the conquest and establishment of urban centers based on imported Roman models among the conquered. By the second century A.D., these forms had taken root and the focus shifted out to the countryside.

102. Morel 1976, pp. 255–266.
103. Charles-Picard 1983, pp. 415–423.
104. Chap. 5 supra. See also Mierse 1990c, pp. 708–709.
105. Aeberhardt 1985, pp. 47–59.
106. Fouet 1984, pp. 153–173. 107. Planson 1985, pp. 203–210.
108. The evidence is epigraphic; Lambrino 1965, pp. 223–242.
109. Charles-Picard 1983, pp. 415–422.

Urban Developments. The major urbanization of the second century was to be found on the edges of the Empire. Here were the new military towns such as Timgad (Thamugadi) in the North African interior.[110] These outposts with their military underpinnings were carefully planned and heavily regularized, an extreme form of the urbanization practiced during the first century A.D. This was not the urbanization on the Iberian Peninsula during the second century. As with the rural sanctuaries, by the second century the first phase of Romanization on the peninsula was well over. What happened at Italica was the expansion of an already existing Roman town by the incorporation of previously virgin territory into the urban matrix.

The "Nova urbs" of Italica was grafted onto a preexisting urban armature. The new city, although it follows the traditional orthogonal plan, nonetheless reveals idiosyncrasies that are distinct to Italica. The terrain is not flat, and so there is a shifting in the heights of the insulae, a shifting that required adjustments be made to the substructure of the Trajaneum. The streets were wide, on average 14 m, making them wider than those at Pompeii, Ostia, or Herculaneum.[111] They were wider than those in the new foundation of Timgad. The central portion of this new area was residential, turned over to large homes. This quarter was anchored by the amphitheater at the north end, a bath complex to the west, and the Sanctuary of Trajan to the south. There was still a large area enclosed within the wall that has not yet been excavated, which probably housed the less affluent.

The Sanctuary of Trajan had been earlier identified as the forum of the city.[112] Its placement on the Kardo Maximus would allow such a designation, and a decumanus does empty into it. In some ways it follows the development of fora on the peninsula. It is a closed, self-contained unit, like the Augustan fora at Conimbriga and Emporiae. But evidence of forum construction in the second century A.D. from elsewhere in the West suggests that such a type was not common any longer. The forum at Augusta Raurica (Augst) has the streets passing through public space as in the older Republican forum at Emporiae. At Timgad, though the street does not pass directly into the forum, the arrangement of the structures is not so tightly controlled and hierarchically aligned as in the complex at Italica.[113] The design for the Trajaneum at Italica, although it may recall Augustan fora from the peninsula, seems out of place against contemporary fora from the West.

The sanctuary stands on virgin soil, and so cannot be understood as

110. Raven 1993, pp. 72–75; J. B. Ward-Perkins, *Cities of Ancient Greece and Italy: Planning in Classical Antiquity* (New York, 1974), p. 29.

111. García y Bellido 1979, p. 79.

112. Roldán Gómez 1987, p. 90 n. 4; p. 105, fig. 7.

113. Ward-Perkins 1981, pp. 220–221, fig. 134 (Augst); fig. 262 (Timgad).

a restructuring of an older, existing complex. There is nothing to suggest that the remains are older than the first quarter of the second century A.D. It seems more reasonable to assume that the forum for the city lay in the "Vetus urbs" and that the Trajaneum was specifically dedicated to the Imperial Cult. Yet its placement did allow it to function architecturally in a manner not unlike a traditional forum. It was the biggest complex in the new city, and it was tied to the plan of the new city. In fact, it is so carefully tied to the plan that it is hard to believe that it was not conceived with the expansion from the outset. Since the fora of smaller towns on the peninsula had become the centers for the Imperial Cult, it makes sense that smaller fora may have shared features with this specially designed space. Similar to corresponding features of the fora at Emporiae and Conimbriga are the enclosed and self-contained nature of the design, the pronounced longitudinal axiality, and the hierarchical arrangement of the parts.

The new planning features that are exhibited at Italica may ultimately be traced back to Nero's rebuilding of Rome. But what happens at Italica may have become a model for what other provincial western cities would do when given the chance. A comparison of Italica with the North African city of Volubilis proves instructive. The city of Volubilis (in modern Morocco) was old. It was the second capital to Juba II before it became one of the major cities of the Roman West. Late in the second century, the city was expanded to the northeast and a new residential quarter was added.[114] The new area breaks the axis of the old city grid, and on this point appears to differ from the plan for the new portion of Italica, where the Kardo Maximus from the old city was brought down into the new. Yet the new district of Volubilis is anchored by structures. To the northeast is the Tangiers gate, at the termination of the Decumanus Maximus. Where the old and new Decumanus Maximus diverge, the Arch of Caracalla highlights the shift. The houses are lavish and are set on insulae. Moving from south to north along the old Decumanus Maximus, the great complex of capitolium, basilica, and forum have been placed in such a way as to announce the changing nature of the urban landscape. These are the same kinds of features noted for Italica: the architectural announcement of the changing nature of the urban environment with the tetrapylon, the anchoring of the new pattern with large public structures strategically placed, and the creation of a largely residential region for an affluent group of people. The urban designers for both sites had to cope with uneven terrain.[115]

The Volubilis pattern is more sophisticated than that at Italica, but they both represent a move beyond the rigid urban construct of the late Republican and Augustan periods. The planners at these sites are beginning to

114. Étienne 1960, p. 143. 115. Ibid., p. 12.

consider more and more the potential of the landscape itself. MacDonald has written of the growing understanding of the urban armature on the part of Roman planners. They found ways to articulate changes in the direction of streets, to bridge height differences, and to establish dialogues among the various public buildings of the city. Italica may have been one of the first such experiments.[116]

North African Connections. There is, however, evidence that the relations between Iberia and North Africa continued and perhaps increased during these decades. There were formal political and economic ties that fostered the sharing of architectural forms and concepts. The comparison to a North African site can be more than just instructive, for there do appear to be important points in common about how space is treated and arranged. Already by the Flavian period the fora of cities like Emporiae and Belo saw major changes as the numbers of small, secondary shrines proliferated and began to clutter the space. These new shrines destroyed the highly structured and tightly defined hierarchical arrangements of the Republican and Augustan eras. The same types of changes can be seen in several North African fora.[117] Such similarities may have no real significance and may suggest nothing more than the continued use and redefinition of the forum space. There is, however, evidence for formal political and economic ties between the two regions that cannot be ignored.

Syme isolated two of the twenty-eight proconsuls for North Africa under Hadrian as coming from the peninsula. One, L. Minicius (ILS 1029), probably hailed from Barcino. The other, L. Roscius Aelianus Maecius Celer, could not be placed in any specific locality.[118] In the economic realm it seems clear that Tarraco functioned as a major port for the arrival and redistribution of North African goods, in particular fine wares and kitchen ceramics.[119] The commercial relations between North Africa and Tarraco probably began in the Augustan period and must have been a major feature of the economic life of the city by the second century to judge from the quantities of North African pottery that have been turned up. About a quarter of the fine tableware in the city was supplied by North African potters.[120] Moreover, African wares spread out of Tarraco and into other towns in the province.[121] The direct economic connection between Tarraconensis and

116. MacDonald 1986, pp. 5–17.
117. Consider Bulla Regia, Thuburbo Maius, Gigthis, and the Old Forum at Leptis Magna; see Ben Baaziz 1987, pp. 221–236. Bianchi Bandinelli, Caffarelli, and Caputo 1966, pp. 85–88.
118. Syme 1984a, pp. 1303–1315.
119. Aquilué 1992, pp. 25–26. 120. Ibid., p. 26.
121. Aquilué Abadías 1987, pp. 210–222.

North African centers of pottery production or shipping could explain why Tarraconensis shows manifestations of a North African building style at Ausa. Interestingly, among the pottery finds from the excavations of the temple at Ausa, there is no mention of North African types.

A single wall does not prove a cultural connection between two parts of the Empire, especially since the style can also be explained as the result of Iberian forces: the rediscovery of the Phoenician building style in the old Punič areas of the peninsula. On the other hand, Tarraconensis, and Ausa in particular, is a fair distance from any area under direct Phoenician control or even influence. Although sites in the south like Munigua or Gades might have seen fit to celebrate their older, pre-Roman past by using an older building technique or revitalizing an older, pre-Roman cult that had Phoenician ties, there is little reason why a native town in Tarraconensis would have chosen the same archaism to celebrate its past. The Ausetani had no links to the Phoenician world. By the second century A.D. the linkage between the coastal areas of Baetica and Tarraconesis was trade, Baetican oil and *garum* going to the ports of southern France and Italy.[122] It seems out of place in Tarraconensis to look for a renewed sense of Iberian identity manifested in an architectural style ultimately derived from the Near East, but a builder in Tarraconensis might well have lifted from his Baetican neighbor a building technique for its own sake, devoid of any potential iconographic meanings.

The walls of the temple at Ausa appear to be too distinct and the technique too well understood to be an accidental discovery. They are the work of masons who either knew or were being instructed in the technique. Molas i Font has stressed the unusual nature of the small temenos in which the temple sits. There is little room between the front of the temple and the end of the temenos defined by its wall. A similar arrangement can also be seen in the relationship of the temple to the temenos on the platform-temple structure at Munigua (pl. 63). This particular planning device is known for some temples in North Africa.[123] At Volubilis the temenos of the capitolium is a small area into which the temple is placed, and the wall of the basilica ends it in an architecturally brutal manner.

The African temples that can be compared with the Ausa temple—the capitolium at Dougga for the similarity of wall construction, the capitolium at Volubilis for the small temenos—as well as the fora that exhibit the same pattern of increased cluttering with shrines noted for Emporiae and Belo and the urban expansion of Volubilis, are all later in date than the Iberian

122. Broughton 1979, pp. 153–160.

123. Molas i Font and Ollich i Castanyer 1985, pp. 164–165; Molas i Font 1982a, p. 84. In neither discussion does Molas i Font actually mention the North African temples that she has in mind.

examples.[124] It could be that there are earlier examples in North Africa that have yet to be identified that served as the prototypes for the later Iberian and North African works. It is also quite possible that the first manifestation of changes in urban design, forum-space use, temple-temenos arrangement, and wall-construction techniques occurred on the Iberian Peninsula and from there spread to North Africa.

Quite apart from the official political connections and trade networks that could have joined North Africa to Iberia, which admittedly are limited, there is another means by which architectural ideas could have moved between the two regions: contact among the elites. The upper level of North African society, like the upper crust throughout the Roman world, spent lavishly during the first and second centuries to embellish their cities. North African cities profited from the bequests of wealthy sons and daughters.[125] During the second century North African elites were also entering the Roman Senate, and though their numbers were low beside those of the Gallic and Iberian senators,[126] one must nonetheless assume that there was interaction among these people, interaction that could have influenced the nature of the patronage back in North Africa. The largest contingents of Iberian senators came from Baetica and coastal Tarraconensis, and these are both regions that demonstrate cultural and economic ties with North Africa.

The Influence of the Emperor. The Emperor Hadrian was an amateur architect, a man who played with forms and spaces, and in that aspect he differed from all other Roman emperors. No discussion of a major monument of the Hadrianic age can ignore the issue of the influence of the Emperor's personal style and taste on the design and execution of the work.[127]

There is no epigraphic evidence or literary reference to tie the Emperor to the Trajaneum at Italica. If Syme is correct, then it is best to see Hadrian as keeping a distance from the town of his family. Yet the Trajaneum is an impressive monument that shares too many features with other Hadrianic structures to be left out of a consideration of Hadrian's architectural influence, and it is difficult to argue that the Emperor was totally unaware that it was being built.[128]

The features that it shares with the other monuments could be the result

124. Thouvenot 1979, pp. 325–348; Cagnat and Gauckler 1898.

125. M. G. A. Guzzo, "Una grande famiglia de Lepcis in rapporto con la ristrutturazione urbanistica della città (I sec. a. c.–I sec. d. c.)," in *Architecture et société*, pp. 377–385.

126. Étienne 1965, pp. 56–58.

127. For Hadrian as architect see *SHA: Hadrian*, 16.10. See also Boatwright 1987, p. 31; J. Toynbee, *The Hadrianic School: A Chapter in the History of Greek Art* (Cambridge, 1934), p. xxiii.

128. It should be noted that the Trajaneum in Italica was unknown to Syme.

of the exchange of architectural ideas among builders and need not reflect at all Imperial interest. However, there are a couple of subtle aspects of the design that do seem to speak more specifically to the taste of the Emperor. The semicircular niches that are found on three of the sides were probably vaulted, though the archaeological evidence is today totally lacking. They are small spaces, and by the second century, such spaces were commonly vaulted. If the vaulting was in the form of segmental or pumpkin domes, which cannot be ascertained from the remains, then the conceit was particularly Hadrianic.[129] In a similar way, the simple architectural moldings that have been found may be reflective of Hadrianic moldings from the capital, the so-called Augustan revival style that marked the early works of the Emperor in Rome.[130]

Neither of these two points would merit attention since they have no or minimal archaeological support. However, when taken into consideration with another feature, they do begin to suggest that the design and execution of the Trajaneum may well have been informed by the Imperial personality. The Italica complex is hardly a complicated structure, and little about it can be compared with the sophisticated geometrical constructions of the villa at Tivoli with its involved system of interrelationships of parts to whole.[131] Yet an investigation of the measured drawings of the Italica ensemble as supplied in the excavation report reveals some interesting relationships. The entire complex is planned according to simple geometry and can be divided into large quadrants along both the length and breadth (fig. 79). The longitudinal quadrants are established along the midpoints of the semicircular apses and the rectangular exedrae. The two groups of quadrants are not equal, those on the long side being larger than those on the small side. Nor is the rhythm the same for both sets. The quadrants defining the short side have a steady A-A-A-A rhythm. The quadrants on the long sides are unequal (measured from the outer walls), the outer two units being smaller than the inner two and giving a rhythm of B-C-C-B.

The diameter of the circle defined by the interior of the semicircular apse spaces can be inscribed within the square defined by the rectangular exedrae. This diameter also seems to define the space from the back wall of the gallery to the interior face of the colonnade. Thus the niche spaces are all related to one another and to the gallery that fronts them. Moreover, the diameter of the apses is also related to the units that define the width of the plaza. The circle defined by the exterior of the apse forms a unit of measurement—D—ten of which equal the width of the precinct from the outer wall of one apse to the outer wall of the other aligned apse.

129. Brown 1964, pp. 55–59. 130. Strong 1953, pp. 118–151.
131. Jacobson 1986, pp. 69–85.

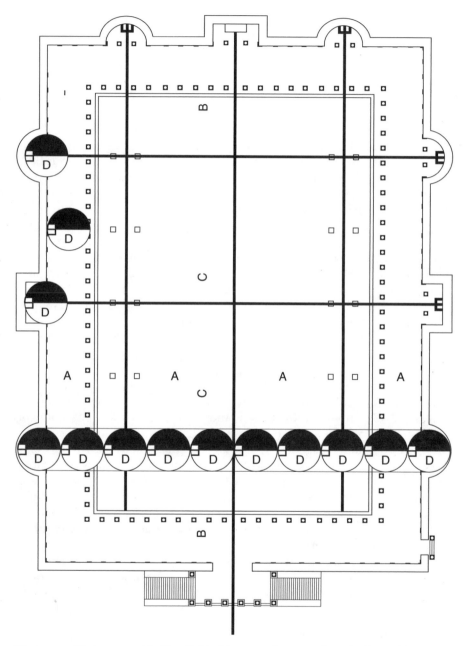

Figure 79. Trajaneum at Italica divided into quadrants and marked with hemi-cycle divisions (plan after León 1988, plate 8; quadrants and hemicycles divisions, Mierse)

These findings suggest that the architect for the complex employed a simple system of related units to bring order to the entire ensemble. When the simple moldings and the possible use of segmented domes are brought into the discussion, then the possibility that the Emperor Hadrian himself took some interest in this building project cannot be ruled out.

CONCLUSION

The architectural remains of the Trajanic and Hadrianic periods are nowhere near as abundant as those for the earlier eras. In part this may reflect the fact that by the second century the process of Romanization had ceased to be an active element in the peninsula. There was little need. After almost three centuries the Romanization of the Iberian regions was quite thorough, and only a few areas still remained hostile. Even the countryside had begun to reflect the change. It is against such a backdrop that the revival of older forms could take place. These were not revivals as a badge of nationalism or non-Roman identity; rather, they were part of the process by which regional identity and Roman identity were merged. Revivals offered no challenge to Rome. The residents of the peninsula had little reason to want to defy Rome. By the beginning of the second century the elites of the peninsula were players on the larger stage of Empire. The peninsula had produced writers of merit during the first century, and now it produced a line of rulers.

What was engaged in during these decades was a refining process. Cities expanded. New buildings no longer represent the first manifestation of the new order of Empire or Imperium; they now reflect the integration of the Empire. Architectural ideas flowed with ease throughout this world, along with the materials that were moved from one end to the other. Architects and builders were playing with sophisticated ideas of how to enlarge the urban armature of the city, how to relate the parts to the whole, how to establish the dialogue between buildings.[132] By century's end the aedicular or marble style, which had first developed in Asia Minor, would be well established on the peninsula and can be seen in the new *scaena frons* for the theater at Augusta Emerita.[133]

However, there are already signs of problems on the peninsula. They are not immediately noticeable in the architecture, but they have been noted in the archaeological findings along both the Catalan and south coasts.[134]

132. See Mierse 1988, p. 70.
133. Almagro Basch 1965, pp. 43–52.
134. There are some who believe that the problems are already present in the Flavian period; Aquilué Abadiás 1987b, pp. 205–208 and the introductory comments by S. Keay.

By the middle of the century, the coastal areas well may have been in decline. The imports from North Africa diminished, and by the end of the second century at Belo, the macellum ceased to function as a market.[135] At Emporiae the forum may have been in the process of decay.[136] The paucity of large-scale, new monumental works erected during the Trajanic and Hadrianic periods could be an indication that the economic well-being of the peninsula was already being stretched. If such is the case, then we might do well to see the expansion of Italica, with its new massive temple complex, as something that did indeed result because of direct Imperial interest. Such an Imperial involvement would explain why the complex possesses some features most commonly associated with the Emperor's own architectural works.

Whatever the reason—economic decline or accident of excavation—the fact remains that following the Trajaneum at Italica there are no more temples built on the peninsula.[137] Perhaps something happens at Augusta Emerita. It depends on how one reads the silver *anaglyphum*. Otherwise there is nothing to work with until the third century and the small temple at Milreu in southern Portugal.[138] But this is not an urban temple at all; it belongs to an entirely new world, that of the villa culture that comes to dominate the peninsula in the third and fourth centuries,[139] and is outside the scope of this study.

135. Didierjean, Ney, and Paillet 1986. Whether the decline in the quality of building technique reflects a citywide economic slump or merely the economical view of the patron is not clear; see Mierse 1989, pp. 619–621.

136. Aquilué Abadías et al. 1984, pp. 110–111.

137. For a general overview of the new status of the peninsula at the start of the third century A.D. see J. Arce, "La crisis del siglo III en Hispanica y las invasiones bárbaras," *Hispania Antigua—Revista de Historia Antigua* 8 (1978), p. 257.

138. Hauschild 1989–1990, p. 74; idem 1964.

139. Cruz Fernández Castro 1982.

Conclusion

The later second and third centuries presented troubled times for the residents of the Iberian Peninsula. There were severe disruptions of life, including economic shifts and marauding bands from North Africa and later from the east. The recovery produced a new social order, one in which cities played a less important role. Unlike in Gaul, where several cities revived to become major centers in the late antique period, most of the cities on the Iberian Peninsula declined in population and prosperity.[1] The third-century circuits at Barcino and Caesaraugusta testify to the shrinking of the city back to the old Augustan boundaries, and the walls around Conimbriga that cut through houses are grim reminders of the unstable situation during the period. New temples simply were not built, and there is no evidence that standing temples were even kept in repair.

Hallowed Ground. The treatment of the temples and the sites on which temples had sat in the decades and centuries following the disruptions of the late second and third centuries evidences two distinct responses that themselves have much to do with the way in which the sites were conceived. Truly sacred space tends to survive vicissitudes. It is a conservative aspect of the landscape,[2] and as early Christians understood, it is easier to appropriate someone else's sacred space than it is to eradicate it.[3] On the Iberian Peninsula, more often than not the urban temples tend not to have inter-

1. Tsirkin 1987, pp. 256–257
2. Cerrillo, Ongil Valentín, and Souceda Pizarro 1984, pp. 41–53.
3. The role of sacred spaces has been studied in many cultural contexts; see Eliade 1974, pp. 367–388; idem 1959, pp. 20–68.

ested the early Christians. The Christian basilica at Emporiae was built in the lower city in an area without religious affiliations. The temples at Ausa, Ebora, Augusta Emerita, and Barcino were all saved not by transformation into churches but by incorporation into palaces.

The exceptions are themselves telling. The site of the great temple at Tarraco, at the top of the terrace composition, eventually became the site for the city's cathedral. In a similar vein, the mosque at Corduba sits over the Visigothic cathedral, which is in turn probably built atop the city's main temple. At both Tarraco and Corduba the sacredness of the specific sites is no doubt older than the arrival of the Romans. There may have been no architectural feature present on the specific spot, since sacred locus seems to have been more important than architectural embellishment for the native peoples, but at both sites Roman sacred architecture was erected over sites with earlier sacred associations. At Mirobriga the evidence is more compelling. Here the older, pre-Roman locus was marked off, given a physical space of its own, and it retained some evidence of being hallowed even as the rest of the site adopted a Roman form. Even into the modern period, a small chapel marked the entire site of Mirobriga, which had otherwise been abandoned. Such was possible at Tarraco and Corduba and Mirobriga because the sites had pre-Roman histories. The specific loci being accorded a sacred status probably had been accorded such a position before the Romans arrived. At Augusta Emerita, Barcino, and Ebora the occupations began only with the Roman-period settlement.

The tendency for native communities to relocate themselves during the late Republic and early Imperial periods resulted in a separation of people from their traditional sacred landscape. New communities, even largely native settlements like Ausa, did not see in the land the sacred nature that had probably been a feature of their older locations. The process of Romanization added yet another layer that separated people from land and brought into play an entirely different set of concerns that had not belonged to the pre-Roman native experience. The resulting orthogonal plans with carefully delineated forum districts and secondary sacred areas could incorporate the older hallowed locations as at Tarraco, Corduba, or Mirobriga, but when the Roman plan was laid out ex nihilo there was little chance that pre-Roman sensibilities would have an impact on the plan. After all, these Roman designs were intended to create visual homogeneity and provide the setting for Roman life and ritual. Only in a case like that of Bilbilis, where the community stayed put and redesigned the older setting in light of the new forms, could the two comfortably be brought together and the pre-Roman sacred spot be incorporated into a Roman civic design, and here too, the site retained its sacred associations into the modern era; a small *ermita* was built in the region.

The force of Romanization on the peninsula was particularly strong, and even though there was no official reason to refuse to accommodate older sacred landscape elements, over time the new social needs may have deprived them of any strong meaning. One senses this at Conimbriga. Initially the forum was designed to allow for the mingling of the new Roman setting and the surviving Iron Age village. Yet in the Flavian renovations, the linkage was totally cut, and the forum lost any physical contact with the non-Roman history of the site. Indeed, the ancient sacredness that may have first informed the choice of location for the forum itself disappeared, and with the abandonment of the town of Conimbriga, the site too was abandoned. There was no little shrine built here as at Bilbilis or Mirobriga.

Romanization could and did bring order to the peninsula. The cities assumed a similarity and the architecture a repetitiveness that ultimately must have offered a degree of familiarity to anyone moving around the peninsula. The formal spaces like the fora were designed to accommodate particular civic ceremonies and activities. What Romanization could not provide was a sense of sacred tie to the land itself. It robbed the native inhabitants of a sense of direct connection to the landscape.

Iberian Style. It seems a mistake to look for a readily identifiable Iberian style of architecture during the Roman period. The peninsula was not a culturally homogeneous region at the time the Romans first arrived. Nor did the process of Romanization spread at an equal rate over all the peninsula. The bulk of cities always remained in Baetica and the east coastal areas of Tarraconensis.[4] There were probably three distinct regions: a coastal band moving from east to south and incorporating all of Baetica; a central zone, the old Celtiberian area; and a north coast section. The east and south coasts had lost most traces of their pre-Roman identity by the end of the first century B.C. The old Celtiberian area never totally abandoned its past, and in fact may have been part of the Celtic revival of the third century A.D.[5] The north coast was never Romanized. Arguing for a stylistic unity here is like looking for one in Roman Anatolia. Both these regions had too much pre-Roman diversity and too much variation in the process of Romanization, both of which had impacts on the forms that Roman architecture took there.

Although there is no constant presence, every now and then the pre-Roman stratum peeks through the Roman veneer. At Clunia the Temple to Jupiter is probably the temple to a pre-Roman god whose pre-Roman shrine was oracular. The architectural vocabulary is pure Roman, but the design with the apse and exedra suggests modifications in the design to suit particular cult needs. Similar types of adaptation are known for the Roman

4. Galsterer 1971. 5. Tsirkin 1987, p. 263.

temple at Aizanoi in central Anatolia.[6] There was still power in the cult of Melqart-Heracles at the start of the second century A.D., though how that translated into an impact on architectural design is not evident. At both Munigua and Belo there are the traces of *opus africanum*, which in these settings, unlike at Ausa, may indicate an intentional harking back to pre-Roman, Phoenician forms. In fact, the very design of Munigua, for all it owes to Republican sanctuary architectural programs in Latium, might also be seen as the ultimate "high place" temple in good Semitic tradition.

These connections to the past are at best tenuous and probably tendentious on my part. They are too few to argue for a strong pre-Roman sensibility informing much of the design or execution of sacred architecture during the Roman period. It is better to consider the process slightly differently. Romanizing forces coming onto the peninsula from outside had no trouble subsuming local sacred areas or cults or building practices when those elements did not interfere with the real purpose of Romanizing a non-Roman population, which was to create an overall homogeneous population willing to live and prosper under Roman rule. During the late Republic and even into the rule of Augustus, there was a struggle between the Romanizing forces and the local elites for cultural hegemony at specific sites. One senses this in the redesign of the lower city at Emporiae, which is so self-consciously Hellenistic Greek. As the forum—this novel and clearly unknown space—took shape on the hill overlooking Neapolis, the citizens of the older Greek city responded by making the lower city fully Greek.

The struggle between older conservative elements and the Romanizing forces came to an end with the incorporation of the local elites into the new Roman order. Ultimately it was the elites of the Iberian cities and towns, both the native elite and the transplanted elite, who created the environment in which Romanization was able to penetrate into the fiber of Iberian society. By the end of the Augustan age, it was this group of individuals and families that formed the core of patrons for architecture in the second half of the first century and the second century A.D. The modifications and adaptations that they caused to be made to otherwise Roman forms reflect not so much the presence of older Iberian sensibilities as the response of the local elites to the particular needs of the communities of which they were part.

Local Societal Needs. The local elites who paid for the building programs throughout most of the peninsula were ultimately the individuals who shaped the changing forms of architecture over the century from the reign of Tiberius to that of Hadrian. As direct Imperial interest in the peninsula

6. Laffi 1971, pp. 3–53; Weber 1969, pp. 182–201.

waned with the death of Augustus, local involvement became the single most powerful force. It is first seen in the possibly defensive posture taken at Emporiae in the late first century B.C. And it is suitable that it should be at a Greek site in which the inhabitants no doubt had a sense of their own history that the first response was mounted. It must have been difficult for natives of Iberian or Celtiberian or Celtic heritage to formulate a real response, since their own cultural heritage had not produced a distinctive enough artistic vocabulary on which to draw. Unlike the La Tène Celtic culture in Gaul, which had at least the unification of Druid cult to rally around, the native groups on the Iberian Peninsula lacked such a cultural identity. The celebration of older Semitic cults on the coinage of cities from the south coast during the early years of Augustus's reign was probably an attempt to rouse a local sense of self.

Yet as the elites came to see their own position tied to that of Rome and of the Emperor, they worked to produce a local identity within the matrix of Roman order. This can be seen at Saguntum, where the local Babii family paid for the forum and no doubt approved the addition to the space of the secondary shrine to Apollo and Diana. The move could be seen as a subtle reference not only to the Emperor but also to the city's traditional association with the Artemis of Ephesus. It was the particular needs of the elites, however, that most directly inspired the architectural choices at Conimbriga and Tarraco during the Flavian period. The new fora with emphasis on a hierarchy of the parts were designed to underscore the privileged position of those who paid for them. It was the elites who were responsible for attending to the sacred rituals of the Imperial Cult, which occupied architecturally and ritualistically the central position in these plans. Here were the areas in which the elites could expect to be seen during their lifetimes in a context of rank and status, and here is where they would be honored in perpetuity after their deaths.

What emerges in the investigation of temple architecture on the peninsula from Augustus to Hadrian is the strength of local needs to nullify the impact of any imposed design. The agent that effects the change is the local elite. This can be seen in the stylistic choices that are made regarding details. Under Augustus cities are laid out, fora designed, buildings erected, all in good Roman form, and yet throughout the peninsula one finds the presence of modified peripteral temples, a type rarely encountered in the West. The choice for these must reflect a local preference that is bowed to even by army engineers, and indeed the peripteral temples remain an item on the peninsula even into the reign of Hadrian. In the architectural detailing there is evidence of two stylistic trends, one metropolitan, the other from southern Gaul, and the two compete for patrons on the peninsula. The Augustan period may represent a time of imposed architectural unification,

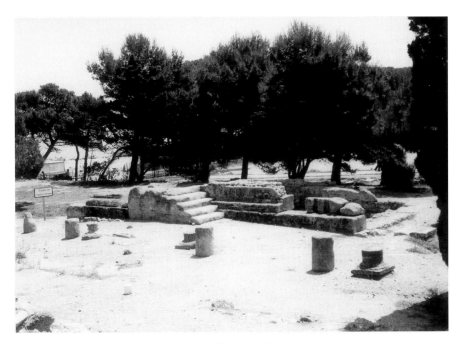

Plate 1. Photograph of the Temple of Serapis (Mierse)

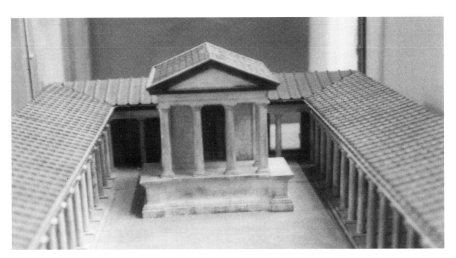

Plate 2. Photograph of the model of the Serapis precinct (Mierse)

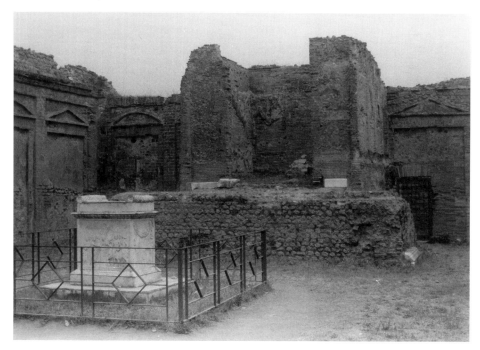

Plate 3. Photograph of the front view of the Temple of Vespasian at Pompeii (Mierse)

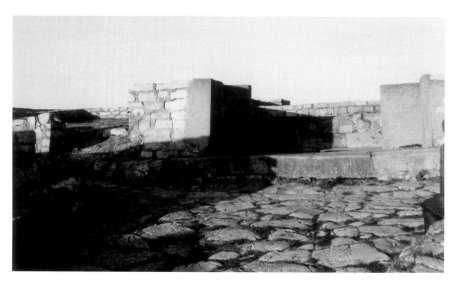

Plate 4. Photograph of the temple front at Azaila (Mierse)

but the details suggest that even here local choices were informing design decisions. By the middle of Tiberius's reign, the power of Hellenistic forms had been rediscovered by builders on the peninsula, and the discovery was direct. There is no evidence that a simultaneous investigation of this material was ongoing in Italian or Gallic settings. Iberian patrons and architects were casting about for their own vocabulary. In fact, the peripteral temples of the Augustan period and the markedly Hellenistic elements of the succeeding period would indicate that Iberian patrons and builders began looking to coastal Asia Minor just as they began to formulate a response to the program of Augustan Romanization. The intentional lifting of design ideas from the old centers of the Greek East underlies much of what is done from Tiberius to Hadrian. With the erection of the temple to Trajan at Italica under Hadrian, the provincial prejudice toward eastern Greek prototypes meets with Imperial preference, and one wonders if this temple was not an element in Hadrian's larger Greek-revival projects.[7]

Significance. Ultimately, one must ask if there is any real significance to the patterns that have emerged in this study. Is there meaning to the choices of style, to the shift in patronage, to the nature of outside influences? Does the study raise any larger issues? The investigation of a specific architectural form over several centuries in one particular Roman provincial region offers us some insights into the process of Romanization.

It is a mistake to see the Romanization of the West as simply the conquest of native peoples and the imposition of a Roman lifestyle on them. It is also wrong to see it as an unchanging process. It was not so much a process as a state of mind, and the real shift happened when the recipients of Romanization themselves became its agents. One can argue that up through the Augustan age the Romanization process was a forced conversion. Under Augustus what had succeeded in remaining native seems to be totally annihilated. But perhaps by that point, after two centuries, what had not succumbed ceased to have real meaning. Like it or not, power was in the Roman setting. What Augustus permitted, and what succeeding emperors allowed to happen, was for the local elites to become the arbiters of Romanization. And they took the role seriously.

The local elites and probably the local society as a whole determined the nature of the influences that were to be allowed to inform the Romanization process. What happened on the peninsula is not the same as what happened in Gaul or in North Africa. The choices made were different, and the outcomes produced were distinct. Though there is a Roman stamp to every-

7. See Weber 1969, pp. 182–201.

thing, there is also a quality unique to each site. Though there is no Iberian provincial Roman style, there is an Iberian response to the process of Romanization, and the response can be seen in the architecture.

Throughout the first century A.D., the century of peninsular reaction to Romanization, new sacred spaces were created. These could incorporate older sacred areas, or they could be totally new spaces. Whether they were in part old or were totally new, these spaces were conceived of as Roman and served a distinctly Roman function. The great forum-temple designs were a means of giving visual manifestation to a cosmological concept. They were a physical manifestation of social reality. Within the Flavian designs at Conimbriga and Tarraco, the social order for the town, which was in microcosm the social hierarchy of the Empire, was visually stated. At the top was the Emperor, represented by his cult; around him the highest echelons of society who formed the flaminate; below them the wealthy free and freedmen; below them the citizens; and, lower, the slaves. All had a place in the Imperial plan, all had a place in the architecture.

The patently political aspect of Roman temple building on the Iberian Peninsula rendered the architecture and the architectural setting meaningless once the Imperial order fell apart. What was designed depended on an idea, an abstract concept of the balance of the parts. It could be celebrated in a grand setting, so long as the notion itself had validity. By the end of the second century, the order on which this concept had been built no longer existed. A sacred spot could retain its hallowed associations no matter the change in political realities so long as the people who resided in the area kept alive a memory of the sacredness of the space. Such ties had no meaning when the sacredness of a spot or a space or a building was dependent on an idea. The death of the idea meant the end of the architectural item. This is why the world of post-third-century Iberia does not witness grand temple building, and it is why there is no real evidence that what still stood received any attention.

PLATES

Plate 5. Photograph of the cella and the platform of the temple at Azaila (Mierse)

Plate 6. Photograph of the street at Azaila (Mierse)

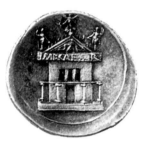

Plate 7. Coin from mint at Rome of
Roman Curia (courtesy of American
Numismatic Society)

Plate 8. View of the restored portico in the civic sector of the Augustan-period
forum at Emporiae (Mierse)

Plate 9. Photograph of caryatid from the forum at Augusta
Emerita (Museo Nacional de Arte Romano, Mérida)

Plate 10. Photograph of *clipeus* with Jupiter Ammon head from Augusta Emerita (Museo Nacional de Arte Romano, Mérida)

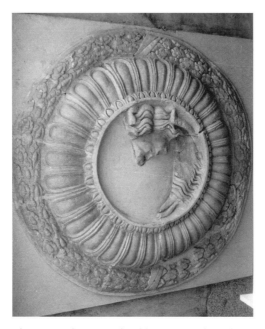

Plate 11. Photograph of fragment of tondo with Medusa head from Augusta Emerita (Museo Nacional de Arte Romano, Mérida)

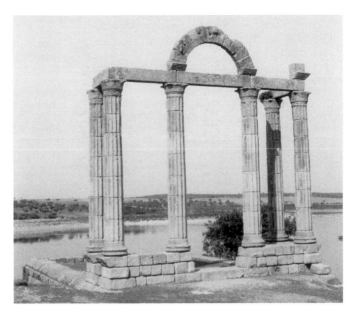

Plate 12. Photograph of the remains of the temple at
Augustobriga (Mierse)

Plate 13. Photo-
graph of the
podium of the
"Temple of
Diana" at
Augusta Emerita
(Mierse)

Plate 14. Photo-
graph of the
podium of the
temple at Barcino
(Mierse)

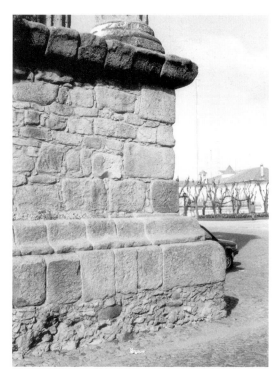

Plate 15. Photo-
graph of the
podium of the
temple at Ebora
(Mierse)

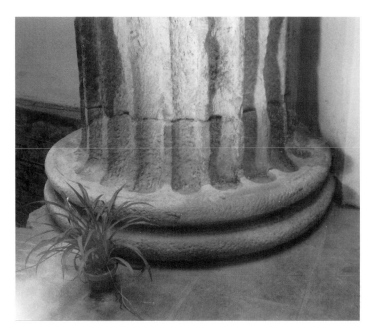

Plate 16. Photograph of the bases from the temple at Barcino (Mierse)

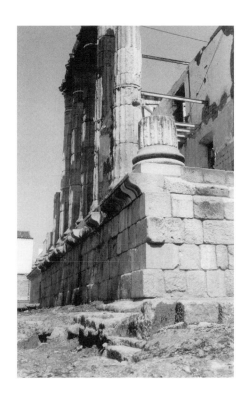

Plate 17. Photograph of the bases from the "Temple of Diana" at Augusta Emerita (Mierse)

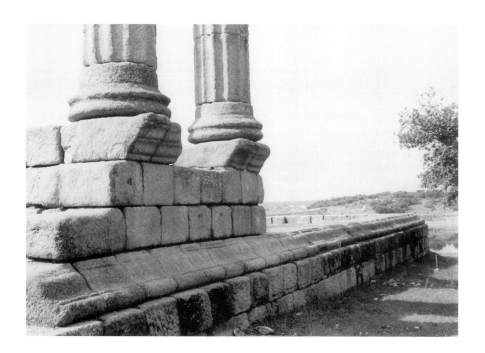

Plate 18. Photo-
graph of the
bases from the
Augustobriga
temple (Mierse)

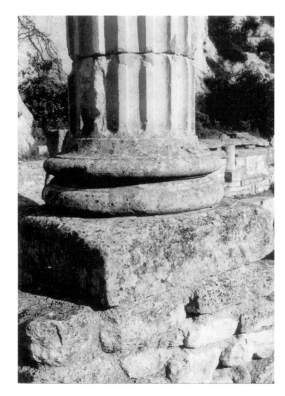

Plate 19. Photo-
graph of the bases
from the Temple
of Valetudo in
Glanum (Mierse)

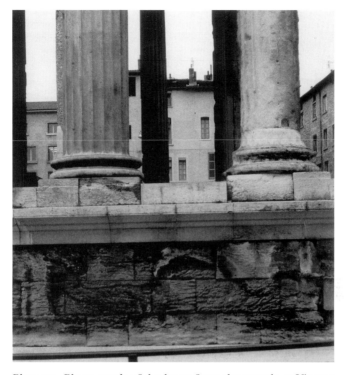

Plate 20. Photograph of the bases from the temple at Vienne (Mierse)

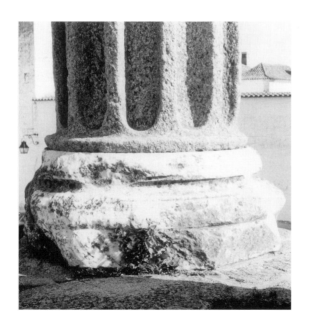

Plate 21. Photograph of the bases from the temple at Ebora (Mierse)

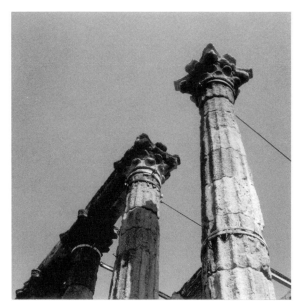

Plate 22. Photograph of the columns of the "Temple of Diana" at Augusta Emerita (Mierse)

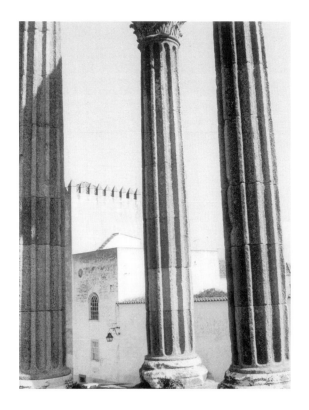

Plate 23. Photograph of the columns of the temple at Ebora (Mierse)

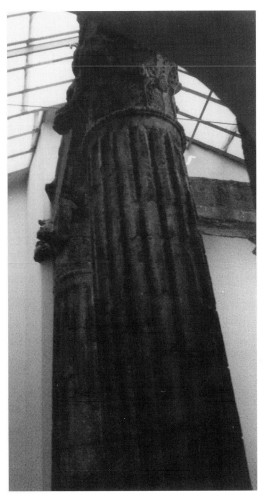

Plate 24. Photograph of the columns of the
temple at Barcino (Mierse)

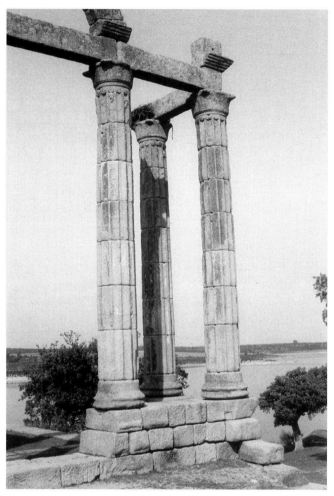

Plate 25. Photograph of the columns of the temple at
Augustobriga (Mierse)

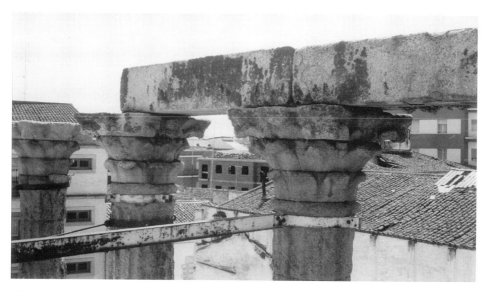

Plate 26. Photograph of the capitals from the "Temple of Diana" at Augusta Emerita (Mierse)

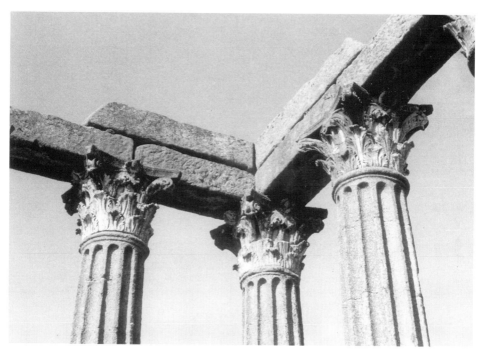

Plate 27. Photograph of the capitals of the temple at Ebora (Mierse)

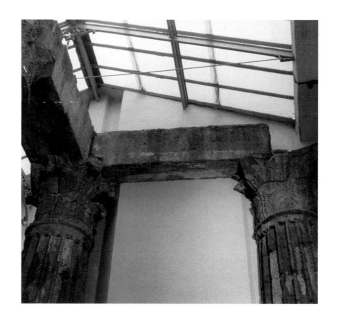

Plate 28. Photo-
graph of the
capitals of the
temple at Barcino
(Mierse)

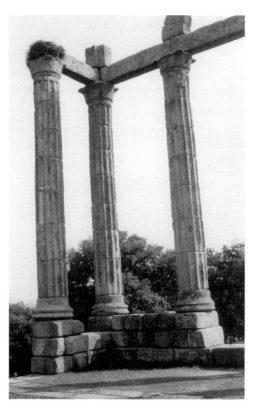

Plate 29. Photo-
graph of the
capitals of the
temple at
Augustobriga
(Mierse)

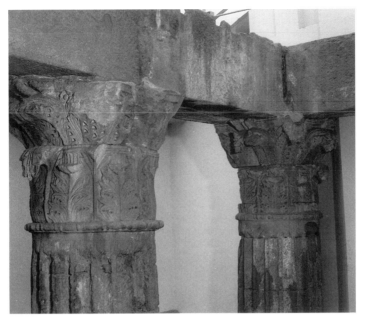

Plate 30. Photograph of the capitals from the temple at Barcino (Mierse)

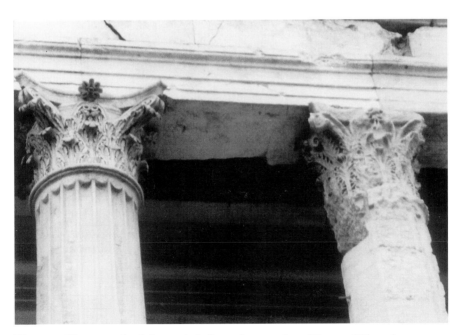

Plate 31. Photograph of the capitals from the temple at Vienne (Mierse)

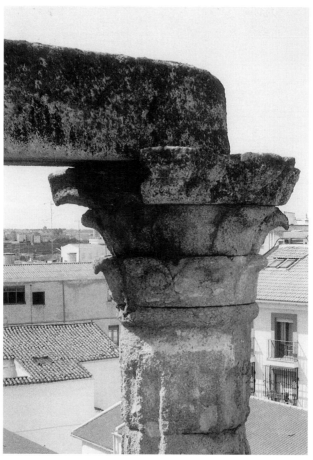

Plate 32. Detail of the capitals from the "Temple of Diana" at Augusta Emerita (Mierse)

Plate 33. Coin reverse image of the Altar of the Three Gauls at Lugdunum (courtesy of American Numismatic Society)

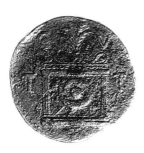

Plate 34. Coin reverse image of altar at Tarraco from Tarraco mint (courtesy of American Numismatic Society)

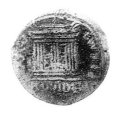

Plate 35. Coin reverse image of altar at Augusta Emerita from Augusta Emerita mint (courtesy of American Numismatic Society)

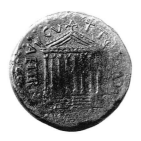

Plate 36. Coin reverse image of temple on high podium from Tarraco mint (courtesy of American Numismatic Society)

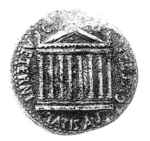

Plate 37. Coin reverse image of temple on low podium (peristyle) from Tarraco mint (courtesy of American Numismatic Society)

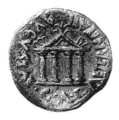

Plate 38. Coin reverse image of temple from mint at Augusta Emerita (courtesy of American Numismatic Society)

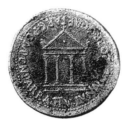

Plate 39. Coin reverse image of temple from mint at Caesaraugusta (courtesy of American Numismatic Society)

Plate 40. Seated Augustus, obverse of the coin with high podium temple from Tarraco mint (courtesy of American Numismatic Society)

Plate 41. Seated Tiberius, obverse from coin of the Civitatis series from mint at Rome (courtesy of American Numismatic Society)

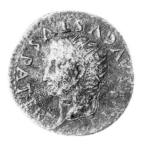

Plate 42. Profile head of Augustus, obverse of the coin with low podium temple (courtesy of American Numismatic Society)

Plate 43. Augustus image from the Divus Augustus type from mint at Rome (courtesy of American Numismatic Society)

Plate 44. Photograph of the south side of Bilbilis (Mierse)

Plate 45. Photograph of theater and temple platform at Bilbilis (Mierse)

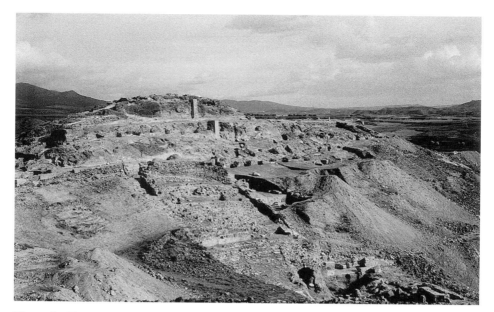

Plate 46. Photograph of the supports for the terracing at Bilbilis (Mierse)

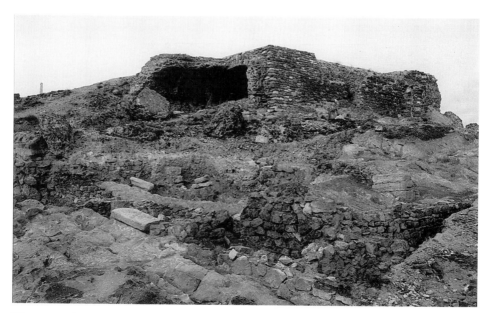

Plate 47. Photograph of the vault at Bilbilis (Mierse)

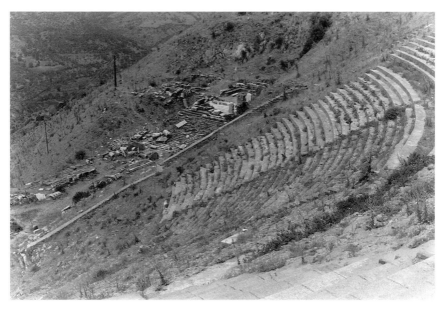

Plate 48a. Photograph of the west side of Pergamon with theater and sanctuary platform (Mierse)

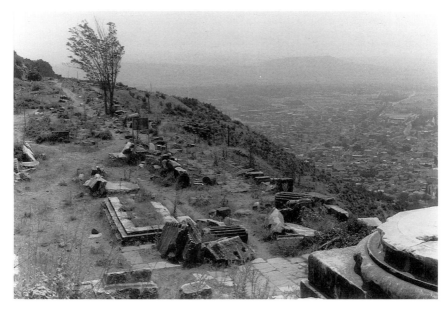

Plate 48b. Detail of sanctuary platform and vista.

Plate 49. Photograph of the remains of the podium of the temple on the forum at Clunia (Mierse)

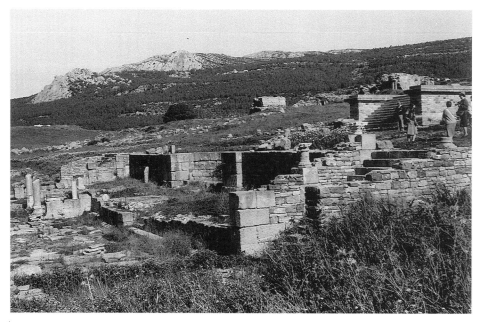

Plates 50a. Photographs of temples A, B, and C at Belo (Mierse)

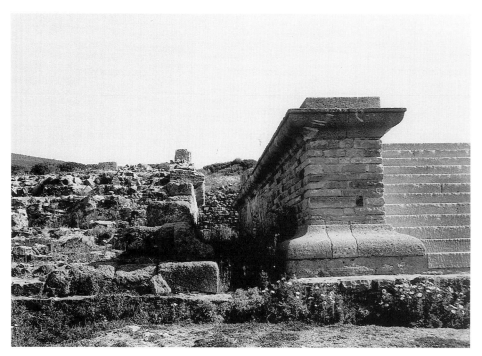

Plate 50b. Temples B and C

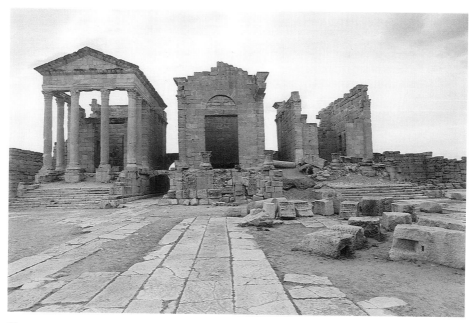

Plate 51. Photograph of the temples on the forum at Sbeitla (courtesy of Roger Ulrich)

Plate 52. Photograph of the tondo with head of Jupiter Ammon from Tarraco (Mierse)

Plate 53. Composite capital from Tarraco (Mierse)

Plate 54. Corinthian capital from Tarraco (Mierse)

Plate 55. Fragment of an acanthus-scroll entablature ornament from Tarraco (Mierse)

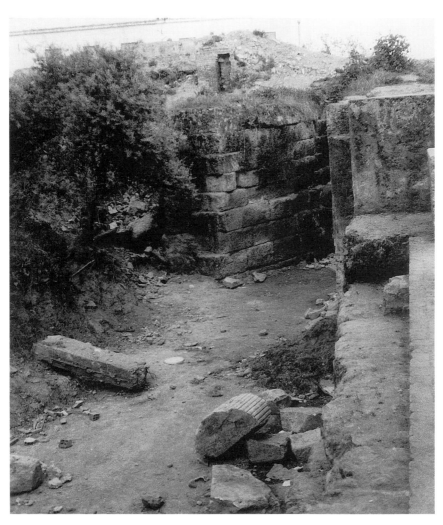

Plate 56. Photograph of the lower platform structure at Corduba (Mierse)

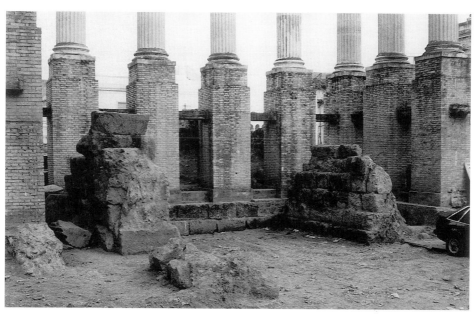

Plate 57. Photograph of the restored columns at Corduba (Mierse)

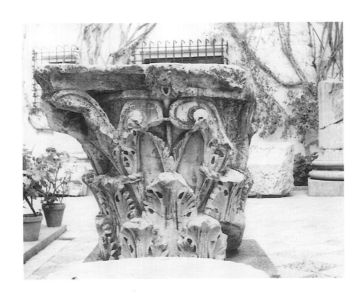

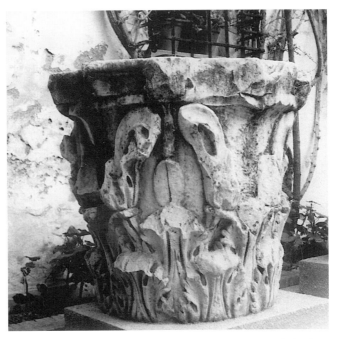

Plates 58a/b. Photographs of the Corinthian capitals in the archaeological museum at Córdoba (Mierse)

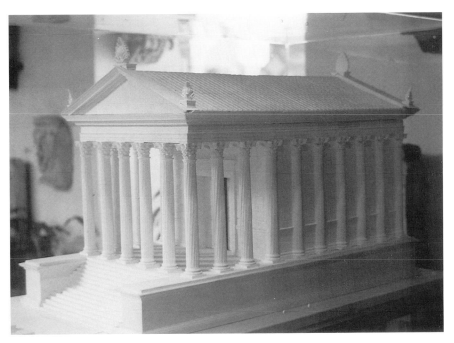

Plate 59. Photograph of the reconstructed maquette of the temple at Corduba, based on García y Bellido, in the archaeological museum at Córdoba (Mierse)

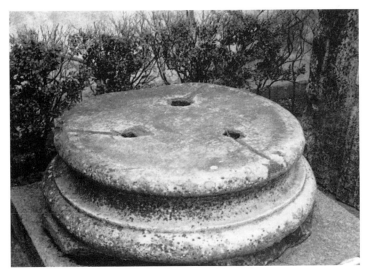

Plate 60. Photograph of a column base in the archaeological museum at Córdoba (Mierse)

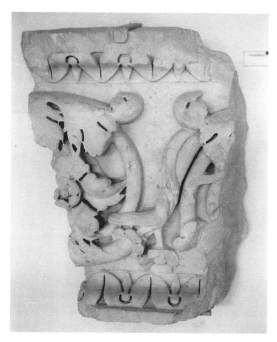

Plate 61. Photograph of the acanthus-scroll
fragment in the archaeological museum at
Córdoba (Mierse)

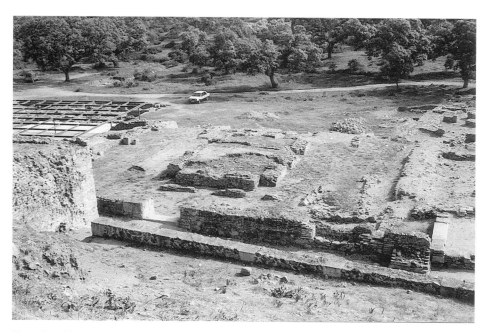

Plate 62. Photograph of the forum at Munigua (Mierse)

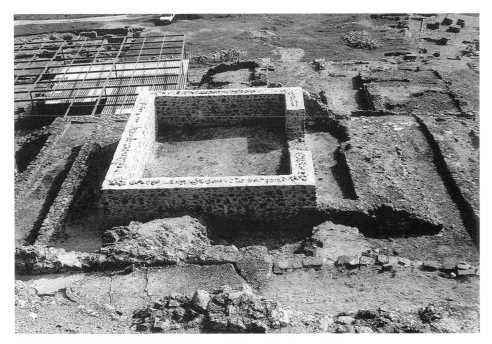

Plate 63. Photograph of the platform temple at Munigua (Mierse)

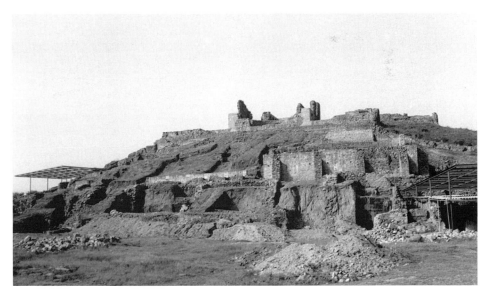

Plate 64. Photograph of terrace sanctuaries at Munigua (Mierse)

Plate 65. Photograph of the present state of the remains of the temple at Ausa (Vic) (Mierse)

Plate 66. Photograph of the section of *opus africanum* in the back wall of the temple at Ausa (Mierse)

BIBLIOGRAPHY

Abad Casal, L., and C. Aranegui Gascó. 1993. "The Roman Towns of the Levantine and Balearic Regions." In *Hispano-Roman Town*, pp. 84–107.

Abbott, F. F., and A. C. Johnson. 1926. *Municipal Administration in the Roman Empire*. Princeton.

Aeberhardt, A. 1985. "Sanctuaires ruruax et pre-urbanisation en Charente." *Caesardunum* 20, pp. 47–59.

Agorreta, Ma. J. 1984. "Asentamientos de época romana en Navarra." In *ArqEsp*, vol. 5, pp. 57–70.

Akurgal, E. 1985. *Ancient Civilizations and Ruins of Turkey, from Prehistoric Times until the End of the Roman Empire*. 6th ed. Istanbul.

Alarcão, J. 1988. *O dominio romano em Portugal*. Sintra.

———. 1983. *Portugal romano*. N.p.

———. 1967. "On the Westernmost Road of the Roman Empire." *Archaeology* 20:3, pp. 174–177.

Alarcão, J., and R. Étienne. 1977. *Fouilles de Conimbriga*. Vol. 1, *L'architecture*. Paris.

———. 1973. "L'architecture de cryptoportiques." In *Les cryptoportiques*, pp. 371–405.

Alarcão, J. de. 1993. "The Roman Towns of Portugal." In *Hispano-Roman Town*, pp. 206–223.

———. 1990. "A urbanização de Portugal nas épocas de César e de Augusto." In *Stadtbild*, pp. 43–58.

Albertini, E. 1911–1912. "Sculptures antiques du Conventus Tarraconensis." *AIEC* 4, pp. 35–123.

Alföldy, G. 1984. "Drei städtische Eliten im römischen Hispanien." *Gerión* 2, pp. 193–237.

————. 1979. "Bildprogramme in den römischen Städten des Conventus Tarraconensis—Das Zeugnis der Statuenpostamente." In *García y Bellido,* vol. 4, pp. 177–275.

————. 1978. *RE,* supp. 15, s.v. Tarraco.

————. 1977. *Los Baebii de Saguntum.* Valencia.

————. 1975. *Die römischen Inschriften von Tarraco.* Madrider Forschungen, no. 10. Berlin.

————. 1973. *Flamines Provinciae Hispaniae Citerioris.* Anejos de *AEspA,* no. 6. Madrid.

Almagro, M. 1985. "Vicisitudes de las ruinas de Segóbriga y problemas de su estudio y conservación." In *Arqueología de las ciudades modernas,* pp. 15–33.

————. 1967. *Ampurias: Guide de fouilles et du musée.* Barcelona.

————. 1962. *Excavaciones en la Palaiapolis de Ampurias.* EAE, no. 27. Madrid.

————. 1955. *La necrópolis de Ampurias.* Barcelona.

————. 1952. *Las inscripciones ampuritanas griegas, ibéricas y romanas.* Barcelona.

————. 1951. *Las fuentes escritas referentes a Ampurias.* Barcelona.

————. 1945. "Excavaciones de Ampurias: Últimos hallazgos y resultados." *AEspA* 18, pp. 64–69.

————. 1943. *Ampurias: Guía de las excavaciones.* Barcelona.

Almagro Basch, M. 1986. *Segóbriga: Guía del conjunto arqueológico.* Madrid.

————. 1976. "La topografía de Augusta Emerita." In *Ciudades augusteas,* vol. 1, pp. 189–212.

————. 1965. *Guía de Mérida.* Madrid.

————. 1962. "Las campañas de excavaciones de 1957 a 1961." In *Excavaciones in Ampurias,* EAE, no. 9 (Madrid), pp. 3–15.

Almeida, F. de. 1964. *Ruínas de Miróbriga dos Celtas.* Edicão de Junto Distrital de Setubal.

Altherr-Charon, A. 1977. "Origine des temples à trois cellae de bassin méditerranéen est: état de la question." *L'Antiquité Classique* 46, pp. 389–440.

Alvarez Burgos, F. 1979. *Catálogo general de la moneda hispánica desde sus orígenes hasta el siglo V.* Madrid.

Alvarez García, A. 1985. *Topografía antigua de la ciudad de Zaragoza.* Estudios de la arqueología urbana, no. 1. Zaragoza.

Alvarez i Pérez, A., and E. de. Bru de Sala. 1983–1984. "Els marbres de Paros i Naxos. La seva utilització a Empúries." *Ampurias* 45–46, pp. 294–301.

Alvarez Martínez, J. M. 1993. "Roman Towns in Extremadura." In *Hispano-Roman Town,* pp. 128–159.

————. 1985. "Excavaciones en Augusta Emerita." In *Arqueología de las ciudades modernas,* pp. 35–53.

————. 1984. *Consideraciones sobre la Mérida prerromana.* Badajoz.

————. 1983. *El puente romano de Mérida.* Monografías emeritenses, no. 1. Badajoz.

————. 1982. "El foro de Augusta Emerita." In *Homenaje,* pp. 53–69.

————. 1977. "Informe sobre las excavaciones realizadas en el 'Templo de Diana' (Mérida), octubre, 1972–junio, 1973." In NAH, no. 5 (Madrid), pp. 91–95.

————. 1976. "El templo de Diana." In *AE,* pp. 43–53.

————. 1975. "Una escultura en bronce de 'Genius Senatus' hallada en Mérida." *AEspA* 48, pp. 141–151.

————. 1971. "El genio de la Colonia Augusta Emerita." *Habis* 2, pp. 257–261.

Alves Dias, M. M. 1978. "M. Fabius Paulinus and L. Numisius Montanus." *MM* 19, pp. 263–271.

Alzinger, W. 1974. *Augusteiche Architektur in Ephesos*. Österreichischen Archäologischen Institut in Wien, vol. 16. Vienna.

Aquilué, J., J. M. Nolla, and E. Sanmartí. 1986. "Das römische Forum von Ampurias (L'Escala, Alt Empordà, prov. Gerona)." *MM* 27, pp. 225–234.

Aquilué, J., R. Mar, and J. Ruiz de Arbulo. 1983. "Arquitectura de la Neápolis ampuritana: Espacio y función hacia el cambio de era." *Informació Arqueològica* 40, pp. 127–137.

Aquilué, X. 1992. "Comentaris entorn a la presència de les ceràmiques de producció africana a Tàrraco." In *Miscel.lània,* pp. 25–33.

————. 1987. "Aportacions al coneixement de la terrassa superior de Tàrraco a l'època alt-imperial." *Butl.letí Arqueològic* 5, nos. 4–5 (1982–1983), pp. 165–186.

Aquilué, X., X. Dupré, J. Masso, and J. Ruiz de Arbulo. 1991. *Tarraco, guía arqueológica*. Tarragona.

Aquilué Abadías, J. 1987b. *Las cerámicas africanas de la ciudad romana de Baetulo (Hispania Tarraconensis)*. BAR International Series, no. 337. Oxford.

————. 1984. "Las reformas augusteas y su repercusión en los asentamientos urbanos del nordeste peninsular." In *ArqEsp*, vol. 5, pp. 95–113.

Aquilué Abadías, X. 1987a. "Algunas consideraciones sobre el comercio africano: Tres facies características de la cerámica común africana de época alto-imperial." *Ampurias* 47, pp. 210–222.

Aquilué Abadías, X., and X. Dupré i Raventós. 1986. *Reflexions entorn de Tàrraco en època tardo-republicana*. Forum: Temes d'històrias i d'arqueologia tarragonines, no. 1. Tarragona.

Aquilué Abadías, X., J. R. Mar Medina, J. M. Nola i Brufau, J. Ruiz de Arbulo Bayona, and E. Sanmartí i Grego. 1984. *El fòrum romà d'Empuries (Excavaciones de l'any 1982): Una aproximació arquéologica al procés històric de la romanització al nord-est de la península ibérica*. Barcelona.

Aranegui, C. 1990. "Sagunto." In *Stadtbild*, pp. 241–250.

————. 1986. "Algunas construcciones preaugusteas de Sagunto." In *Los asentamientos,* pp. 155–162.

Aranegui, C., E. Hernández, and M. López Piñol. 1987. "El foro de Saguntum: La planta arquitectónica." In *Los foros,* pp. 73–97.

Aranegui Gascó, C. 1992a. "Evolución del área cívica saguntina." *JRA* 5, pp. 56–68.

————. 1992b. "Testimonios del vino saguntino, entre otras cuestiones." In *Miscel.lània,* pp. 35–43.

Arias de Miranda, J. 1868. *Noticia de la antigua ciudad de Clunia*. Madrid.

Arteaga, O., and M. Blech. 1986. "La romanización en las zonas de Porcuna y Mengíbar (Jaén)." In *Los asentamientos,* pp. 89–99.

Asís Escudero y Escudero, F. de. 1981. "Los templos en las monedas antiguas de Hispania." *Numisma* 31, pp. 153–203.

Aubet Semmler, M. E. 1985. "Los fenicios en España: Estado de la cuestión y perspectivas." *Aula Orientalis* 3, pp. 9–30.

————. 1984. "La aristocracia tartésica durante el período orientalizante." *Opus* 3, pp. 445–468.

Audin, A. 1964. *Essai sur la topographie de Lugdunum.* Lyon.

Audin, A., and P. Quoniam. 1962. "Victoires et colonnes de l'autel federal des Trois Gaules—donées nouvelles." *Gallia* 20, pp. 103–116.

Audin, P. 1985. "L'équipement des villes entre Gironde et Loire d'August à Claude." *Caesardunum* 20, pp. 61–82.

Badian, E. 1958. *Foreign Clientelae (264–70 B.C.).* Oxford.

Balil, A. 1968. "Economía de la Hispania romana." In *Estudios de Economía Antigua de la Península Ibérica* (Barcelona), pp. 289–370.

———. 1964. *Colonia Iulia Augusta Paterna Faventia Barcino.* Madrid.

———. 1961. *Las murallas romanas de Barcelona.* Madrid.

Balil Illana, A. 1976. "Sobre la arquitectura doméstica en Emerita." In *AE*, pp. 75–91.

Barrera Antón, J. L. de la. 1985. "Algunas notas sobre estucos romanos emeritenses." In *Diputación Provincial de Badajoz* (Badajoz), pp. 101–110.

———. 1984. *Los capiteles romanos de Mérida.* Monografías emeritenses, no. 2. Badajoz.

Barton, I. M. 1981. "Capitoline Temples in Italy and the Provinces (especially Africa)." In *ANRW* 2.12.1, pp. 259–342.

Bassegoda Nonell, J. 1974. *El templo romano de Barcelona.* Barcelona.

Bauer, H. 1987. "Nuove ricerche sul foro di Augusto." In *L'urbs: Espace urbain et histoire* (Rome and Paris), pp. 763–770.

Bedon, R. 1985. "Les incidences de la réorganisation urbaine a l'époque d'Auguste sur la population des Trois Gaules." *Caesardunum* 20, pp. 83–101.

Beltrán, A. 1986. "Los asentamientos ibéricos ante la romanización en el valle del Ebro: Los casos de Celsa, Azaila, y Botorrita." In *Los asentamientos*, pp. 101–109.

———. 1984. "Nuevas aportaciones a la cronología de Azaila." *Boletín Museo de Zaragoza* 3, pp. 120–131.

———. 1976a. "Caesaraugusta." In *Ciudades augusteas*, vol. 1, pp. 219–262.

———. 1976b. "Las monedas romanas de Mérida: Una interpretación histórica." In *AE*, pp. 93–105.

———. 1974. *Aragón y los principios de su historia.* Zaragoza.

———. 1966. "Sobre la cronología de Azaila (Teruel)." In *9. CNA, Valladolid, 1965* (Zaragoza), pp. 308–309.

———. 1964. "Notas sobre la cronología del poblado del Cabezo de Alcalá en Azaila (Teruel)." *CA* 23–24, pp. 79–86.

———. 1961. "El río Ebro en la antigüedad clásica." *CA* 17–18, pp. 65–79.

———. 1953. "Los monumentos en las monedas hispano-romanas." *AEspA* 26, pp. 39–66.

Beltrán, A., and A. Tovar. 1982. *Contrebia Belaisca (Botorrita, Zaragoza).* Vol. 1, *El bronce con alfabeto "Ibérico" de Botorrita.* Zaragoza.

Beltrán, A., J. M. La Carra, and A. Canellas. 1976. *Historia de Zaragoza.* Zaragoza.

Beltrán Lloris, M. 1990. "El valle medio del Ebro y su monumentalización en época republicana y augustea (Antecedente, Lepida-Celsa y Caesaraugusta)." In *Stadtbild*, pp. 179–206.

———. 1985. *Celsa.* Zaragoza.

———. 1983. *Los orígenes de Zaragoza y la época de Augusto: Estado actual de los conocimientos.* Zaragoza.

———. 1979. "La cerámica campaniense de Azaila. Problemas de cronología del valle medio del Ebro." *CA* 47–48, pp. 141–232.

———. 1976. *Arqueología e historia de las ciudades antiguas del Cabezo de Alcalá (Teruel).* Zaragoza.

Beltrán Lloris, M., A. Montalac Carrillo, J. Paz Peralta, and M. del C. Aguarod Otol. 1985. "La arqueología urbana en Zaragoza." In *Arqueología de las ciudades modernas,* pp. 57–116.

Beltrán Martínez, A. 1985–1986. "Las excavaciones de *Contrebia Belaisca:* Síntesis cronológico cultural." *Velia* 2–3, pp. 265–274.

———. 1983. "Las excavaciones en el gran edificio de adobe del Cabezo de las Minas, Botorrita, en 1983." *Boletín Museo de Zaragoza* 2, pp. 22–225.

———. 1982a. "Excavaciones arqueológicas en Contrebia Belaisca (Botorrita, Zaragoza) 1980." In NAH, no. 14 (Madrid), pp. 319–339.

———. 1982b. "El yacimiento de Cabezo de las Minas." *RdA* 2:13, pp. 6–18.

———. 1982c. "El gran edificio de adobe de Contrebia Belaisca (Botorrita): Hipótesis y estudio de la cuestión." *Boletín Museo de Zaragoza* 1, pp. 95–108.

———. 1980. "La significación de los tipos de las monedas antiguas de España y especialmente los referentes a monumentos arquitectónicos y escultóricos." *Numisma* 30, pp. 123–152.

———. 1976. "La antigüedad." In *Historia de Zaragoza* (Zaragoza), pp. 13–89.

Beltrán Martínez, A., and A. Tovar. 1982. *Contrebia Belaisca (Botorrita, Zaragoza).* Vol. 1, *El Bronce con alfabeto "ibérico" de Botorrita.* Zaragoza.

Ben Baaziz, S. 1987. "Les forums romains en Tunisie, 'Essai de Bilan.'" In *Los foros,* pp. 221–236.

Bendala Galán, M. 1990. "El plan urbanístico de Augusto en Hispania: Precedentes y pautas macroterritoriales." In *Stadtbild,* pp. 25–42.

———. 1989–1990. "Capitolia Hispaniarum." *Anas* 2–3, pp. 11–36.

———. 1982. "Excavaciones en el Cerro de los Palacios." In *Itálica (Santiponce, Sevilla),* EAE, no. 121 (Madrid).

———. 1975. "Un templo en Itálica de época republicana." In *13. CNA, Huelva, 1973* (Zaragoza), pp. 861–868.

———. 1973. "Tablas de juego en Itálica." *Habis* 4, pp. 263–274.

Berenger, J. 1965. "La notion du Principat sous Trajan et Hadrien." In *Les empereurs,* pp. 27–44.

Bertacchi, L. 1980. "Architettura e mosaico." In *Da Aquileia a Venezia* (Milan), pp. 99–336.

Berthelot, A. 1934. *Festus Avienus, Ora Maritima.* Paris.

Beurlier, E. 1890. *Essai sur le culte rendu aux empereurs.* Paris.

Bianchi Bandinelli, R., E. V. Caffarelli, and A. G. Caputo. 1966. *The Buried City: Excavations at Leptis Magna.* New York.

Biers, W. 1981. "Investigations at Mirobriga, Portugal, in 1981." *Muse* 15, pp. 30–38.

———, ed. 1988. *Mirobriga: Investigations at an Iron Age and Roman Site in Southern Portugal by the University of Missouri-Columbia, 1981–1986.* BAR International Series, no. 451. Oxford.

Blake, M. E. 1959. *Roman Construction in Italy from Tiberius through the Flavians.* Washington, D.C.

Blanco Freijeiro, A. 1982. "Miscelánea arqueológica emeritense." In *Homenaje,* pp. 23–32.

———. 1976. "Posibles vestigios del culto a Hércules en Caesaraugusta." In *Ciudades augusteas,* vol. 2., pp. 99–104.

———. 1970. "Vestigios de Córdoba romana." *Habis* 1, p. 122.

Blanco-Freijeiro, A., and R. Corzo Sánchez. 1976. "El urbanismo romano de la Bética." In *Ciudades augusteas,* vol. 1, pp. 137–162.

Blázquez, J. M.1985a. "La ciudad de Cástulo." In *Arqueología de las ciudades modernas,* pp. 117–156.

———. 1985b. *Diccionario de las religiones prerromanas de Hispania.* Madrid.

———. 1982. "Religión y urbanismo en Emérita Augusta." *AEspA* 55, pp. 89–106.

———. 1981. "El sincretismo en la Hispania romana entre las religiones indígenas, griegas, romanas, fenicias, y mistéricas." In *La religión,* pp. 179–221.

———. 1978. *Historia económica de la Hispania Romana.* Madrid.

———. 1976a. "Bronces de la Mérida prerromana." In *AE,* pp. 11–18.

———. 1976b. "Ciudades hispanas de la época de Augusto." In *Ciudades augusteas,* vol. 1, pp. 79–136.

———. 1972–1974. "Propaganda dinástica y culto imperial en las acuñaciones de Hispania." *Numisma* 22–24, pp. 311–329.

———. 1968. *Tartessos y los orígenes de la colonización fenecia en occidente.* Salamanca.

———. 1967. "Estructura económica de la Bética al final de la república romana y a comienzos del imperio (años 72 a. C.—100)." *Hispania, Revista Española de Historia* 27, pp. 7–62.

———. 1962. "Estado de la romanización de Hispania bajo César y Augusto." *Emerita* 30:1, pp. 71–130.

Blázquez, J. M., and M. P. García-Gelabert. 1986. "El iberismo en la ciudad de Cástulo." In *Los asentamientos,* pp. 43–54.

Blázquez, J. M., and J. Valiente Malla. 1981. *Cástulo.* Vol. 3. of *Excavaciones arqueológicas en España.* Madrid.

Blázquez Martínez, J. M., M. P. García-Gelabert Pérez, and F. López Pardo. 1984. "Evolución del patrón de asentamiento en Cástulo. Fases iniciales." In *ArqEsp,* vol. 4, pp. 241–252.

Blech, M. 1982. "Minerva in der republikanischen Hispania." In B. von Freytag gen Lörighoff, D. Mannsperger, and F. Prayon, eds., *Praestant Interna: Festschrift für Ulrich Hausmann* (Tübingen), pp. 136–145.

Boatwright, M. F. 1987. *Hadrian and the City of Rome.* Princeton.

Boersma, J. 1982. "Large-sized Insulae in Italy and the Western Provinces." *Bulletin Antieke Beschaving, Annual Papers on Classical Archaeology* 57, pp. 38–51.

Boethius, A. 1978. *Etruscan and Early Roman Architecture.* Harmondsworth.

———. 1948. *Roman and Greek Town Architecture.* Göteborg.

Bohn, R. 1896. *Die Theater-Terrasse: Altertümer von Pergamon.* Vol. 4. Berlin.

———. 1889. *Altertümer von Aegae. Jahrbuch des kaiserlich en deutschen archäologischen Instituts.* Berlin.

Bonneville, J.-N. 1985. "Cultores Dianae et Apollinis (Saguntini)." *Saguntum* 19, pp. 55–277.

Bonneville, J.-N., R. Étienne, P. Rouillard, P. Sillières, and A. Tranoy. 1982. "Les villes romaines de la péninsule ibérique." In *Les villes dans le monde ibérique: Actes du colloque de Talence, 27–28 novembre 1980,* Editions du Centre National de la Recherche Scientifique, no. 15 (Paris), pp. 11–23.

Borobio Soto, Ma. J., and F. Morales Hernández. 1984. "Distribución de poblamiento de época romana imperial en una zona de la provincia de Soria." In *ArqEsp,* vol. 5, pp. 41–56.

Bosch-Gimpera, P. 1966. "Les soldats ibériques agents d'hellénisation et de romanisation." In *Mélanges d'archéologie, d'epigraphie, et d'histoire offerts à Jérôme Carcopino* (Paris), pp. 141–148.

———. 1932. *Etnología de la Península Ibérica.* Barcelona.

———. 1929. *La cultura ibérica del Bajo Aragón.* Barcelona.

Bosch-Gimpera, P., and J. de C. Serra Rafols. 1929. "Emporión." In *IV. Internationaler Archäologischer Kongress* (Barcelona), n.p.

Botet y Sisó, J. D. 1879. *Noticia histórica y arqueológica de la antigua ciudad de Emporión.* Madrid.

Bowersock, G. 1965. *Augustus and the Greek World.* Oxford.

Brendel, O. 1931. *Ikonographie des Kaiser Augustus.* Nuremberg.

Brogan, O. 1973. "The Coming of Rome and the Establishment of Roman Gaul." In S. Piggott, G. Daniel, and C. McBurney, eds., *France before the Romans* (London), pp. 192–219.

Broise, P. 1976. "L'urbanisme vicenal aux confins de la Viennoise et de la Seguanaise." In *ANRW* 2.5.2, pp. 602–629.

Broughton, T. R. S. 1979. "Oil-Producing Estates in Roman Baetica." In *García y Bellido,* vol. 4, pp. 153–160.

Brouquier-Reddé, V. 1992. *Temples et cultes de Tripolitaine.* Paris.

Brown, F. 1980. *Cosa, the Making of a Roman Town.* Ann Arbor.

———. 1964. "Hadrianic Architecture." In L. F. Sandler, ed., *Essays in Memory of Karl Lehmann,* Marsyas Studies in the History of Art, supp. 1 (New York), pp. 55–59.

Bulle, H. 1919. "Ein Jagddenkmal des Kaisers Hadrian." *Jahrbuch des [kaiserlichen] deutschen archäologischen Instituts* 34, pp. 148–151.

Burnett, A. M., M. Amandry, and P. P. Ripollès. 1992. *Roman Provincial Coinage.* Vol. 1, *From the Death of Caesar to the Death of Vitellius.* London and Paris.

Cabré, J. 1945. *Cerámica de Azaila.* Corpus Vasorum Hispanorum. Madrid.

———. 1943. "La cerámica céltica de Azaila (Teruel)." *AEspA* 15, p. 449–63.

———. 1940–1941. "La acrópolis de Alcalá, Azaila (Teruel)." *AEspA* 14, pp. 232–235.

———. 1929. "Azaila." In *IV. Congreso Internacional de Arqueología* (Barcelona), pp. 1–38.

———. 1926. "La cerámica pintada de Azaila." *Archivo Español de Arqueología y Arte* 2:6, pp. 211–221.

———. 1925. "Los bronces de Azaila." *Archivo Español de Arqueología y Arte* 1:3, pp. 297–315.

Cagnat, R., and P. Gauckler. 1898. *Les monuments historiques de la Tunisie.* Part 1, *Les monuments antiques: Les temples païens.* Paris.

Calvo, I. 1916. *Excavaciones en Clunia.* Memorias de la Junta Superior de Excavaciones y Antigüedades, no. 3. Madrid.

Canto, A. Ma. 1990. "Las tres fundaciones de Augusta Emerita." In *Stadtbild,* pp. 289–298.

———. 1985. "Die *Vetus Urbs* von Itálica." *MM* 26, pp. 136–148.

———. 1981. "Notas sobre los pontificados coloniales y el origen del culto imperial en la Bética." In *La religión,* pp. 141–153.

Capdevila, S. n.d. *Tarragona, Guía histórico-arqueológica.* Tarragona.

Carpenter, R. 1951. Review of *Hispania Graeca,* by A. García y Bellido. *AJA* 55, pp. 57–58.

———. 1926. "Vitruvius and the Ionic Order." *AJA* 30, pp. 259–269.

———. 1925. *Greeks in Spain.* Bryn Mawr College Notes, no. 6. Bryn Mawr, Pa.

Carriazo, J. de. 1969. "El descubrimiento de Munigua y la espiral de oro del Cerro de Montorcaz." *MM* 20, pp. 272–281.

Carrington, R. C. 1933. "Notes on the Building Materials of Pompeii." *JRS* 23, pp. 131–132.

Castillo, C. 1982. "Los senadores béticos. Relaciones familiares y sociales." In *Epigrafia e ordine senatorio,* vol. 2 (Rome), pp. 465–519.

———. 1974. "Städte und Personen der Baetica." In *ANRW* 2.3, pp. 601–654.

Castillo García, C. 1984. "Los senadores de la Bética: Onomástica y parentesco." *Gerión* 2, pp. 239–250.

Castro López, M. 1984. "Una aportación al estudio del poblamiento romano de la campaña del Alto Guadalquivir." In *ArqEsp,* vol. 5, pp. 115–127.

Ceán Bermúdez, J. A. 1832. *Sumario de las antigüedades romanas que hay en España.* Madrid.

Cerrillo, M. de Cáceres, Ma. I. Ongil Valentín, and Ma. I. Sauceda Pizarro. 1984. "Religión y espacio aproximación: Una arqueología de la religión." In *ArqEsp,* vol. 1, pp. 41–53.

Chamorro, J. 1987. "Survey of Archaeological Research on Tartessos." *AJA* 91, pp. 197–232.

Charles-Picard, G. 1983. "Les centres civiques ruraux dans l'Italie et la Gaule romaine." In *Architecture et société,* pp. 415–423.

———. 1964. "Glanum et les origines de l'art romano-provençal. Seconde partie: Sculpture." *Gallia* 22, pp. 1–21.

———. 1963. "Glanum et les origines de l'art romano-provençal. Première partie: Architecture." *Gallia* 21, pp. 111–121.

———. 1957. *Les trophées romains: Contribution à l'histoire de la religion et de l'art triomphal de Rome.* Paris.

———. 1954. *Les religions de l'Afrique antique.* Paris.

Chaves Tristán, F., and Ma. Cruz Marín Ceballos. 1981. "Numismática y religión romana en Hispania." In *La religión,* pp. 27–44.

Chic García, G. 1985. "Aspectos económicos de la política de Augusto en la Bética." *Habis* 16, pp. 277–299.

Clavel-Lévéque, M., and P. Lévéque. 1982. "Impérialism—et sémiologie: L'espace urbain à Glanum." *MEFRA* 94:2, pp. 675–682.

Clerbert, J.-P. 1970. *Provence antique.* Vol. 2, *L'époque gallo-romaine.* Paris.

Coarelli, F. 1987a. "Munigua, Praeneste, e Tibur: I modelli laziali di un municipio della Baetica." *Lucentum* 6, pp. 91–100.

————. 1987b. *I santuari del Lazio in età repubblicana.* Rome.

————. 1984. *Lazio: Guide archeologiche Laterza.* Bari.

————. 1983. "Architettura sacra e architettura privata nella tarda Repubblica." In *Architecture et Société*, pp. 191–217.

————. 1981. *Roma: Guide archeologiche Laterza.* Bari.

Cortés, R. 1987. "Los foros de Tarraco." In *Los foros*, pp. 13–24.

Corzo Sánchez, R. 1982. "Organización del territorio y evolución urbana en Itálica." In *Itálica (Santiponce, Sevilla)*, EAE, no. 121 (Madrid), pp. 299–319.

Coulton, J. J. 1976. *The Architectural Development of the Greek Stoa.* Oxford.

Crespo, García, and López Rozas, J. 1984. "Algunas cuestiones sobre los modelos de asentamiento ibérico en la cuenca alta del río Víboras. Martos (Jaén)." In *ArqEsp*, vol. 4, pp. 207–222.

Crummy, P. 1985. "Colchester: The Mechanics of Laying Out a Town." In F. Grew and B. Hobley, eds., *Roman Urban Topography in Britain and the Western Empire*, CBA Research Report no. 59 (London), pp. 78–85.

Cruz Fernández Castro, Ma. 1982. *Villas romanas en España.* Madrid.

Cunliffe, B. 1995. "Diversity in the Landscape: The Geographical Background to Urbanism in Iberia." In *Social Complexity*, pp. 5–28.

Curchin, L. 1991. *Roman Spain: Conquest and Assimilation.* London.

————. 1990. *The Local Magistrates of Roman Spain.* Toronto.

————. 1987. "Demography and Romanization at Tarraco." *AEspA* 60, pp. 159–171.

Dalty, A. 1977. "Curia ordines." In *Recherches d'architecture et d'urbanisme antiques sur les curies provinciales du monde romain* (Brussels), pp. 343–346.

Dardaine, S. 1981. "Index des publications parues sur le site archéologique de Belo (Bolonia, Término de Tarifa, Provincia de Cádiz)." *MCV* 17, pp. 457–516.

Dardaine, S., J. Lancha, A. Pelletier, and P. Sillières. 1987. "Belo: Le Temple d'Isis et le forum." *MCV* 23, pp. 65–105.

Deneauve, J. 1979. "Les structures romaines de Byrsa." In S. Lancel et al., eds., *Mission arquéologique française à Carthage. Byrsa I: Rapports préliminaires des fouilles (1974–1976)*, Collection de l'École Française de Rome, no. 41 (Rome), pp. 41–55.

Devreker, J., and M. Waelkens. 1984. *Les fouilles de la Rijksuniversiteit te Gent a Pessinonte, 1967–1973, I: Hommage à Pieter Lambrechts.* Bruges.

DeWitt, N. 1940. *Urbanization and Franchise in Roman Gaul.* Lancaster.

Didierjean, F., C. Ney, and J.-L. Paillet. 1986. *Belo.* Vol. 3, *Le Macellum.* Madrid.

Dolç, M. 1954a. "El nombre de Bílbilis." *CA* 5, pp. 49–60.

————. 1954b. "Semblanza arqueológica de Bílbilis." *AEspA* 27, pp. 179–211.

————. 1953. *Hispania y Marcial: Contribución al conocimiento de la España antigua.* Barcelona.

Domergue, C. 1973. *Belo.* Vol. 1, *La stratigraphie.* Madrid and Paris.

Donaldson, T. L. 1965. *Architectura Numismatica: Ancient Architecture on Greek and Roman Coins and Medals.* Chicago.

Drinkwater, J. F. 1983. *Roman Gaul: The Three Provinces, 58 B.C.–A.D. 260.* Ithaca.

Duncan-Jones, R. P. 1985. "Who Paid for Public Buildings in Roman Cities." In F. Grew and B. Hobley, eds., *Roman Urban Topography in Britain and the Western Empire*, CBA Research Report no. 59 (London), pp. 28–33.

————. 1982. *The Economy of the Roman Empire.* 2d ed. Cambridge.

————. 1974. "The Procurator as Civic Benefactor." *JRS* 64, pp. 79–85.

Dupré, N. 1985. "Les villes ibéro-romaines de la vallée de l'Ebre du II. s. avant J.C. au milieu du I. s. après J.C." *Caesardunum* 20, pp. 281–291.

Dupré i Raventós, X. 1995. "New Evidence for the Study of Urbanism of Tarraco." In *Social Complexity,* pp. 355–371.

————. 1990. "Un gran complejo provincial de época flavia en Tarragona: Aspectos cronológicos." In *Stadtbild,* pp. 319–327.

————. 1987. "Forum Provinciae Hispaniae Citerirois." In *Los foros,* pp. 25–30.

Durán i Sanpere, A. 1957. *Noticia y guía de las excavaciones de la calle de los Condes de Barcelona. Foro romano, basílica paleocristiana. Edificaciones posteriores.* Barcelona.

Dyson, S. 1985. *The Creation of the Roman Frontier.* Princeton.

————. 1980–1981. "The Distribution of Roman Republican Family Names in the Iberian Peninsula." *Ancient Society* 11–12, pp. 257–299.

————. 1975. "Native Revolt Pattern in the Roman Empire." In *ANRW* 2.3, pp. 138–175.

Eliade, M. 1974. *Patterns in Comparative Religion.* New York.

————. 1959. *The Sacred and the Profane: The Nature of Religion.* New York.

Espinosa, U. 1983. "Iuridici de la Hispania citerior y el patrón en Calagurris." *Gerión* 1, pp. 305–325.

Étienne, R. 1981. "Culte imperial et architecture a propos d'une inscription de Lacipo (Bétique)." *Zeitschrift für Papyrologie und Epigraphik* 43, pp. 135–142.

————. 1965. "Les sénateurs espagnols sous Trajan et Hadrien." In *Les empereurs,* pp. 55–86.

————. 1960. *Le quartier nord-est de Volubilis.* Paris.

————. 1958. *Le culte impérial dans la Péninsule Ibérique d'Auguste à Diocletian.* Paris.

Étienne, R., and G. Fabré. 1979. "L'immigration à Tarragone, capital d'une province romaine d'occident." In *García y Bellido,* vol. 4, pp. 97–115.

Euzennat, M., and G. Hallier. 1986. "Les forums de Tingitane: Observations sur l'influence de l'architecture militaire sur les constructions civiles de l'Occident romain." *Antiquités Africaines* 22, pp. 73–103.

Eydoux, H. 1985. Review of *Les villes dans le monde ibérique. Bulletin Monumental* 143:4, p. 362.

Farinas del Corral, D. Macario. 1663. *Tratado de las marinas desde Málaga a Cádiz y algunos lugares sus vecinos según fueron en los siglos antiguos.* Ronda.

Fatas Cabeza, G. 1982. "El bronce de Contrebia." *RdA* 2:12, pp. 6–17.

————. 1971–1972. "De la extensión y el poblamiento casco urbano de Caesaraugusta." *CA* 35–36, pp. 191–216.

Faust, M. 1975. "Die Kelten auf der iberischen Halbinsel: Sprachliche Zeugnisse." *MM* 16, pp. 195–207.

Fernández-Chicarro de Dios, C. 1972–1974. "Epigrafía de Munigua." *AEspA* 45–47, pp. 337–410.

Ferreira de Almeida, C. A. 1970. "Algumas notas sobre o processo da romanização da zona de entre Douro e Ave." In *Actas las Jornadas Arqueológicas,* vol. 2 (Lisbon), pp. 381–387.

Filloy Nieva, I., and E. Gil-Zubillaga. 1984. "Avance al estudio del poblamiento durante el Bronce Final: Edad de Hierro en Treviño Occidental." In *ArqEsp*, vol. 4, pp. 7–28.

Fioriani, G. 1968. "Problemi architettonici del Foro di Caesare." In *Studi di Topografia Romana* (Rome), pp. 91–103.

Fishwick, D. 1987. *The Imperial Cult in the Latin West.* Leiden.

———. 1982. "The Altar of Augustus and the Municipal Cult of Tarraco." *MM* 23, pp. 223–233.

———. 1978. "The Development of Provincial Ruler Worship in the Western Roman Empire." In *ANRW* 2.16.2, pp. 1201–1253.

———. 1972. "The Temple of the Three Gauls." *JRS* 62, pp. 46–52.

Fita, F. 1884. "Excursiones epigráfias." *BRAH* 4, p. 104.

———. 1883. "Templo de Serapis en Ampurias." *BRAH* 3, pp. 124–129.

Floriani Squarciapino, M. 1982. "Cultura artística de Mérida romana." In *Homenaje*, pp. 33–52.

———. 1976. "Ipotesi di lavoro sul gruppo di sculture da Pan Caliente." In *AE*, pp. 55–62.

Floriano, A. 1944. "Excavaciones en la antigua Cappara (Cáparra, Cáceres)." *AEspA* 17, pp. 270–286.

Fouet, G. 1984. "Le sanctuaire gallo-romaine de Valentine (Haute-Garonne)." *Gallia* 42, pp. 153–173.

Frank, T. 1938. *An Economic Survey of Ancient Rome.* 4 vols. Baltimore.

Fuchs, G. 1969. *Architekturdarstellungen auf römischen Münzen.* Berlin.

Galsterer, H. 1988. "Municipium Flavium Irnitanum: A Latin Town in Spain." *JRS* 78, pp. 78–90.

———. 1971. *Untersuchungen zum römische Städtwesen auf der iberischen Halbinsel.* Berlin.

Ganzert, J., and V. Kockel. 1988. "Augustusforum und Mars-Ultor-Tempel." In *Kaiser Augustus*, pp. 149–199.

García Iglesias, L. 1979. "Sobre los municipios Flavios de Lusitania." In *García y Bellido*, vol. 4, pp. 81–85.

García Merino, C. 1987. "Noticias preliminares sobre el foro Uxama, Argaela (Osma, Soria)." In *Los foros*, pp. 147–151.

———. 1970. "La ciudad romana de Uxama." *BSAA* 36, pp. 397–399.

García y Bellido, A. 1980. *Arte ibérico en España.* Madrid.

———. 1979. *Colonia Aelia Augusta Italica.* Madrid.

———. 1971. "El recinto mural romano de Evora Liberalitas Iulia." *Conimbriga* 10, pp. 1–8.

———. 1970. *Los hallazgos cerámicos del área del templo romano de Córdoba.* Madrid.

———. 1968. *El urbanismo en España: La edad antigua.* Madrid.

———. 1967. *Les religions orientales dans l'Espagne romaine.* Leiden.

———. 1965. "La Itálica de Hadrián." In *Les empereurs*, pp. 7–26.

———. 1964. "Novedades arqueológicas: El templo romano de Córdoba." *Oretania* 16–18, pp. 155–165.

———. 1963a. "Das Artemision von Sagunt." *MM* 4, pp. 87–98.

———. 1963b. "Hercules Gaditanus." *AEspA* 36, pp. 70–153.

————. 1962. "Excavaciones in Augustóbriga (Talavera la Vieja, Cáceres)." In NAH, no. 5 (Madrid), pp. 235–237.

————. 1961. "Crónica de arte y arqueología: El templo romano de Córdoba." *Boletín de la Academia de Ciencias, Bellas Letras, y Nobles Artes* 32, pp. 213–217.

————. 1956. "El culto de Sarapis en la Península Ibérica." *BRAH* 139, pp. 293–355.

————. 1949. *Los escultores romanos de España y Portugal.* Madrid.

————. 1943. *La Dama de Elche y el conjunto de piezas arqueológicas reingresadas en España en 1941.* Madrid.

Genty, P.-Y., C. Olive, C. Raynaud, and J.-C. Roux. 1979. "Recherches sur l'habitat romain à Nîmes: Les fouilles de la rue Saint-Laurent." *Bulletin Annuel, École Antique de Nîmes—Nîmes Bibliothèque Municipale* 14, pp. 111–131.

Gil Farrés, O. 1946. "La ceca de la Colonia Augusta Emerita." *AEspA* 19, pp. 209–248.

Gimeno, J. 1989. "Tipología y aplicaciones de elementos dóricos y toscanos en Hispania: El modelo del N.E." *AEspA* 62, pp. 101–139.

Gimeno Pascual, J. 1983. "Barcino Augustea: Distribución de espacios urbanos y áreas centrales de la ciudad." *Boletín del Museo Arqueológico Nacional (Madrid)* 1:1, pp. 9–30.

Giuliani, C. F. 1973. "Contributi allo studio della tipologia dei criptoportici." In *Les cryptoportiques,* pp. 79–115.

Gjerstad, E. 1944. "Die Ursprungsgeschichte der römischen Kaiserfora." *Opuscula Archaeologica* 3, pp. 40–72.

Gómez-Pantoja, J. 1987. "Another Rhetor from Calagurris." *Faventia* 9:2, pp. 79–84.

González Navarrete, J. A. 1987. *Escultura ibérica de Cerrillo Blanco, Porcuna, Jaén.* Jaén.

Goudineau, C. 1983. "Marseilles, Rome, and Gaul from the Third to the First Century B.C." In P. Garnsey, K. Hopkins, and C. R. Whittaker, eds., *Trade in the Ancient Economy* (Berkeley), pp. 76–86.

Granados, J. O. 1987. "Notas sobre el estudio del Foro de la Colonia Barcino." In *Los foros,* pp. 61–72.

Grant, M. 1950. *Aspects of the Principate of Tiberius: Historical Comments on the Colonial Coinage Issued outside Spain.* Numismatic Notes and Monographs, no.116. New York.

————. 1946. *From Imperium to Auctoritas: A Historical Study of the Aes Coinage of the Roman Empire, 49 B.C.—A.D. 14.* Cambridge.

Griffin, M. 1972. "The Elder Seneca and Spain." *JRS* 62, pp. 1–19.

Grimal, P. 1983. *Roman Cities, with a Descriptive Catalogue of Roman Cities.* Trans. M. Woloch. Madison, Wisc.

Gros, P. 1990. "Théatre et culte impérial en Gaule Narbonnaise et dans la Péninsule ibérique." In *Stadtbild,* pp. 381–390.

————. 1987. "Un programme augustéen: Le centre monumental de la colonie d'Arles." *Jahrbuch des [kaiserlichen] deutschen archäologischen Instituts* 102, pp. 339–390.

————. 1986. "Sanctuaires traditionnels, capitoles et temples dynastiques: Ruptures et continuités dans le fonctionnement et l'aménagement des centres religieux urbains." In *Los asentamientos,* pp. 111–120.

————. 1981. "Qui était l'architecte de la Maison Carrée?" *Les monuments de Nîmes: Les Dossiers des Histoire et Archéologie* 55 (July–August), pp. 36–43.

————. 1976a. *Aurea templa: Recherches sur l'architecture religieuse de Rome à l'époque d'Auguste.* Rome.

————. 1976b. "Helléisme et romanisation en Gaule Narbonnaise." In *Hellenismus in Mittelitalien,* vol. 1, pp. 300–315.

————. 1973. "Traditions hellénistiques d'orient dans la décor architectonique des temples romains de Gaule Narbonnaise." In *Atti del Colloquio sul tema: La Gallia Romana,* Accademia Nazionale dei Lincei, no. 158 (Rome), pp. 167–180.

Gros, P., and P. Varene. 1984. "Le forum et la basilique de Glanum: Problèmes de chronologie et de restitution." *Gallia* 42, pp. 21–52.

Grünhagen, W. 1986. "Ein Porträt des Domitian aus Munigua." *MM* 27, pp. 309–323.

————. 1978. "Farbiger Marmor aus Munigua." *MM* 19, pp. 290–306.

————. 1959. "Excavaciones del Santuario de Terrazas de Munigua." In *5. CNA, Zaragoza, 1957* (Zaragoza), pp. 275–282.

Guadán, A. de. 1980. *La moneda ibérica: Catálogo de numismática ibérica e ibéro-romana.* Madrid.

————. 1969. *Las monedas de plata de Emporión y Rhode.* Barcelona.

————. 1956. *Las leyendas ibéricas en las drachmas ampuritanas.* Madrid.

Gudiol i Cunill, J. 1959. "Descripció del temple romà." *Ausa* 3:29, pp. 250–258.

Guitart, J. 1986. "The Rediscovery of Ancient Barcelona." In *Homage to Barcelona: The City and Its Art, 1888–1936* (London), pp. 111–114.

Guitart Durán, J. 1993. "The Roman Town in the Region of Catalonia." In *Hispano-Roman Town,* pp. 12–53.

Guitart i Durán, J., and P. Padrós i Martí. 1990. "Baetulo: Cronología y significación de sus monumentos." In *Stadtbild,* pp. 165–178.

Gurt, M. 1985. *Clunia.* Vol. 3, *Hallazgos monetarios: La romanización de la Meseta Norte a través de la circulación monetaria en la ciudad de Clunia.* Madrid.

Gutiérrez Behemerid, Ma. A. 1983. "El capitel corintizante: Su difusión en la Península Ibérica." *BSAA* 49, pp. 73–104.

————. 1982. "Sobre la sistematización del capitel corintio en la Península Ibérica." *BSAA* 48, pp. 25–44.

Guyon, J., P. Aupert, C. Dieulafait, G. Fabre, J. Gallagher, M. Janon, J.-M. Pailler, J. L. Pallet, C. Petit, R. Sablayrolles, D. Schaad, J.-L. Schenk, and F. Tassaux. 1991. "From Lugdunum to Convenae: Recent Work on Saint-Bertrand-de-Comminges (Haute-Garonne)." *JRA* 4, pp. 89–122.

Haley, E. 1988. "Roman Elite Involvement in Commerce: The Case of the Spanish TT. Mamilii." *AEspA* 61, pp. 141–156.

Hanel, N. 1989. "Römische Öl- und Weinproduktion auf der iberischen Halbinsel am Beispiel von Munigua und Milreu." *MM* 30, pp. 204–238.

Hanfmann, G. M. A. 1964. *Roman Art.* Greenwich, Conn.

Hanfmann, G. M. A., and W. Mierse. 1983. *Sardis from Prehistoric to Roman Times.* Cambridge, Mass.

Hanson, J. A. 1959. *Roman Theater-Temples.* Princeton, N.J.

Hardy, E. G. 1912. "Three Spanish Charters and Other Documents." In *Roman Laws and Charters* (Oxford), pp. 7–60.

Harrison, R. 1988. *Spain at the Dawn of History.* London.

Hatt, J. J. 1970. *Histoire de la Gaule Romaine (120 avant J.-C.–451 après J.-C.).* Paris.

Hauschild, T. 1994. "Évora: Vorbericht über die Ausgrabungen am römischen Tempel, 1989–1992." *MM* 35, pp. 314–335.

———. 1993. "Traditionen römischer Stadtbefestigungen der Hispania." In *HA*, pp. 217–232.

———. 1989–1990. "Arquitectura religiosa romana en Portugal." *Anas* 2–3, pp. 57–76.

———. 1988. "Untersuchungen am römischen Tempel von Évora, Vorbericht 1986/87." *MM* 29, pp. 208–220.

———. 1986. "Munigua, Ausgrabungen an der Stützmauer des Forums—1985." *MM* 27, pp. 325–343.

———. 1984. "Munigua, Vorbericht über die Grabungen in Haus 1 und Haus 6, Kampagne 1982." *MM* 25, pp. 159–179.

———. 1982. "Zur Typologie römischer Tempel auf der iberischen Halbinsel. Peripterale Anlagen in Barcelona, Merida, und Evora." In *Homenaje*, pp. 145–156.

———. 1977. "La terraza superior de Tarragona, una planificación axial del siglo I." In *Segovia: Symposium de Arqueología Romana* (Barcelona), pp. 209–212.

———. 1976a. "Problemas de construcciones romanas en Mérida." In *AE*, pp. 107–110.

———. 1976b. "Tarraco en la época augustea." In *Ciudades augusteas*, vol. 1, pp. 213–218.

———. 1972–1973. "Römischen Konstruktionen auf der oberen Stadtterrasse des antiken Tarraco." *AEspA* 45–46, pp. 3–44.

———. 1971. "Munigua, exploraciones en el área de la ciudad, al este del foro." In NAH, nos. 13–14 (Madrid), pp. 61–71.

———. 1969a. "Excavaciones en Munigua en el año 1966." In *10. CNA, Mahon, 1967* (Zaragoza), pp. 400–407.

———. 1969b. "Munigua, Untersuchungen im Stadtgebiet östlich von Forum." *MM* 10, pp. 185–197.

———. 1968. "Munigua, die doppelgeschossige Halle und die Ädikula im Forumgebiet." *MM* 9, pp. 262–288.

———. 1964. *Der Kultbau neben den römische Ruinkomplex bei Estoi in der Provincia Lusitania*. Berlin.

Haynes, D. E. L. 1959. *An Archaeological Guide to the Pre-Islamic Antiquities of Tripolitania*. Tripoli.

Heilmeyer, W. D. 1970. *Korinthische Normalkapitelle: Studien zur Geschichte der römischen Architektur-dekoration*. Berlin.

Hernández Hervás, E. 1988. *El teatro romano de Sagunto*. Valencia.

Hernández Sanahuja, B. 1944. "El templo de Octavio en Tarragona." *Boletín Arqueológico—Tarragona* 44:4, pp. 25–36.

———. 1884. *Opúsculos históricos, arqueológicos y monumentales*. Tarragona.

Hernández Sanahuja, B., and E. Morera Llauradó. 1894. *Historia de Tarragona desde los más remotos tiempos hasta la época de la restauración cristiana*. Vol. 1. Tarragona.

Hill, G. F. 1931. *Notes on the Ancient Coinage of Hispania Citerior*. American Numismatic Notes and Monographs. New York.

Houston, G. 1985. "Tiberius on Capri." *Greece and Rome* 32:2, pp. 179–196.

Hübner, E. 1888. *La Arqueología de España*. Barcelona.

Humphrey, J. 1986. *Roman Circuses: Arenas for Chariot Racing.* Berkeley, Calif.

Ibáñez Castro, A. 1983. *Córdoba Hispano-romana.* Córdoba.

Jacob, P. 1986. "Baelo Claudia et son contexte." In *Los asentamientos,* pp. 141–153.

———. 1985. "La ville en zone ibérique au moment de la conquête romaine." *Caesardunum* 20, pp. 293–305.

Jacobson, D. 1986. "Hadrianic Architecture and Geometry." *AJA* 90, pp. 69–85.

Jensen, R. 1985. "The So-Called Temple of Aesculapius at Mirobriga." *Muse* 19, pp. 56–60.

Jiménez, A. 1977. "Arquitectura romana de la Bética: 1. Introducción al estudio de las fortificaciones." In *Segovia: Symposium de arqueología romana* (Barcelona), pp. 223–238.

———. 1975. "De Vitruvio a Vignola: Autoridad de la tradición." *Habis* 6, pp. 253–293.

Jiménez Salvador, J. L. 1989–1990. "Arquitectura religiosa romana en Córdoba—Colonia Patricia: Panorama y perspectivas." In *Anas* 2–3, pp. 77–86.

———. 1987a. "Los modelos constructivos en la arquitectura forense de la Península Ibérica." In *Los foros,* pp. 173–177.

———. 1987b. "Templo romano de la calle Claudio Marcelo en Córdoba." In *Anuario Arqueológico de Andalucía I, 1985* (Seville), pp. 388–391.

———. n.d. *Arquitectura forense en la Hispania Romana: Bases para el estudio.* Zaragoza.

Johannowsky, W. 1976. "La situazione in Campania." In *Hellinismus in Mittelitalien,* pp. 267–299.

———. 1973. "Note sui criptoportici pubblici in Campania." In *Les cryptoportiques,* pp. 145–165.

Jones, R. F. J., and D. G. Bird. 1972. "Roman Gold-Mining in North-west Spain, II: Workings on the Río Duerna." *JRS* 62, pp. 59–74.

Julian, C. 1908–1926. *Histoire de la Gaul.* Paris.

Keay, S. 1995. "Innovation and Adaptation: The Contribution of Rome to Urbanism in Iberia." In *Social Complexity,* pp. 291–338.

———. 1990. "Processes in the Development of the Coastal Communities of Hispania Citerior in the Republican Period." In T. Blagg and M. Millett, eds., *The Early Roman Empire in the West* (Oxford), pp. 120–150.

———. 1989. *Roman Spain.* Berkeley.

Kellum, B. 1986. "Sculptural Programs and Propaganda in Augustan Rome: The Temple of Apollo on the Palatine." In R. Winkes, ed., *The Age of Augustus: Conference Held at Brown University, Providence, Rhode Island, 1982* (Louvain-la-Neuve and Providence), pp. 169–176.

Knapp, R. 1986. "*La Vía Heraclea* en el occidente: Mito, arqueología, propaganda, historia." *Emerita* 54:1, pp. 104–122.

———. 1984. "The Epigraphic Evidence for Native and Roman Religion in Iberia." In *Praktika* (Athens), pp. 220–230.

———. 1983. *Roman Cordoba.* Berkeley.

———. 1978. "The Origins of Provincial Prosopography in the West." *Ancient Society* 9, pp. 187–222.

———. 1977. *Aspects of the Roman Experience in Iberia, 206–100.* Valladolid.

Koch, M. 1982. "Isis und Sarapis in Carthago Nova." *MM* 23, pp. 347–352.

Koppel, E. M. 1990. "Relieves arquitectónicos de Tarragona." In *Stadtbild*, pp. 332–340.

———. 1988. *La "Schola" del "Collegium Fabrum" de Tarraco y su decoración escultórica.* Bellaterra.

———. 1986. "Las esculturas romanas de Tarraco." *Forum: Temes d'historia i d'arqueologia tarragonines* 4, pp. 1–16.

———. 1985a. "El foro municipal de Tarraco y su decoración escultórica." In *17. CNA, Logroño, 1983* (Zaragoza), pp. 841–856.

———. 1985b. *Die römischen Skulpturen von Tarraco.* Madrider Forschungen, no. 15. Berlin.

Krencker, D., and M. Schede. 1936. *Der Tempel in Ankara.* Berlin and Leipzig.

Kurent, T. 1979. "The Vitruvian Symmetria Mean 'Modular Sizes.'" *Lingüistica* 19, pp. 65–79.

Laffi, U. 1971. "I terreni del tempio di Zeus ad Azanoi." *Anthenaeum* 49, pp. 3–53.

Laffranchi, L. 1910. "Gli assi ed i dupondi commemorativi di Augusto e di Agrippa." *Rivista Italiana di Numismatica* 1, pp. 1–11.

Lambrechts, P. 1936. "Trajan et le recrutement du Sénat." *L'Antiquité Classique* 5, pp. 105–114.

Lambrino, S. 1965. "Les cultes indigènes in Espagne sous Trajan et Hadrien." In *Les empereurs*, pp. 223–242.

Lancel, S., G. Robine, and J.-P. Thuillier. 1980. "Town Planning and Domestic Architecture of the Early Second Century B.C. on the Byrsa, Carthage." In J. G. Pedley, ed., *New Light on Ancient Carthage* (Ann Arbor), pp. 13–27.

La Rocca, E. 1988. "Der Apollo-Sosianus-Tempel." In *Kaiser Augustus*, pp. 121–135.

Lehmann, P. W. 1954. "The Setting of Hellenistic Temples." *JSAH* 13:4, pp. 15–20.

Lenoir, M., A. Akerraz, and E. Lenoir. 1987. "Le forum de Volubilis: Elements du dossier archéologique." In *Los foros*, pp. 203–219.

León, M. del. 1977–1978. "Notas sobre técnica edilicia en Itálica." *AEspA* 50–51, pp. 143–152.

León, P. 1990. "Ornamentación escultórica y monumentalización en las ciudades de la Bética." In *Stadtbild*, pp. 367–380.

———. 1988. *Traianeum de Itálica.* Seville.

León Alonso, P. 1993. "The Hispano-Roman Town in Andalusia." In *Hispano-Roman Town*, pp. 12–53.

———. 1986. "Itálica: Problemática de la superposición de Santiponce al yacimiento." In *Arqueología de las ciudades modernas*, pp. 213–230.

Le Roux, P., J. C. Richard, and M. Ponsich. 1975. "Un document nouveau sur Belo (Bolonia, province de Cadix): L'inscription de Q. Pupius Ubricus." *AEspA* 48, pp. 129–140.

Leveque, P., and M. Leveque. 1976. *Fouilles de Conimbriga.* Vol. 2, *Epigraphie et sculpture.* Paris.

Levick, B. 1967. *Roman Colonies in Southern Asia Minor.* Oxford.

Lewis, M. J. T. 1966. *Temples in Roman Britain.* Cambridge.

Lewis, P. R., and D. B. Jones. 1970. "Roman Gold-Mining in North-west Spain." *JRS* 60, pp. 167–185.

Lézine, A. 1968. *Carthage-Utique: Études d'architecture et d'urbanisme.* Paris.

———. 1963. *Architecture romaine d'Afrique: Recherches et mise au point.* Publications de l'Université de Tunis, 1re série: Archéologie, Histoire, no. 9.

———. 1961. *Architecture punique: Recueil des documents.* Tunis.

Ling, R. 1991. *Roman Painting.* Cambridge.

———. 1985. "The Mechanics of the Building Trade." In F. Grew and B. Hobley, eds., *Roman Urban Topography in Britain and the Western Empire,* CBA Research Report no. 59 (London), pp. 14–25.

Lippold, G. 1927. "Skulpturen aus Spanien." *AA,* pp. 77–83.

Loperraez, J. 1788. *Descripción histórica del obispado de Osma.* Madrid.

López Landa, J. M. 1946. *Bilbilis y sus amigos.* Zaragoza.

Luzón Nogue, J. M. 1982. *La Itálica de Adriano.* 3d ed. Barcelona.

———. 1973. *Excavaciones en Itálica: Estratigrafía en el Pajar de Artillo.* EAE, no. 78. Madrid.

Lyttelton, M. 1974. *Baroque Architecture in Classical Antiquity.* London.

MacDonald, W. 1986. *The Architecture of the Roman Empire.* Vol. 2, *An Urban Appraisal.* New Haven.

———. 1982. *The Architecture of the Roman Empire.* Vol. 1, *An Introductory Study.* New Haven.

———. 1976. *The Pantheon: Design, Meaning, and Progeny.* Cambridge, Mass.

Macías Liáñez, M. 1913. *Mérida monumental y artística.* Barcelona.

MacKendrick, P. 1969. *The Iberian Stones Speak.* New York.

Mackie, N. 1983. *Local Administration in Roman Spain, A.D. 14–212.* Oxford.

MacMullen, R. 1959. "Roman Imperial Building in the Provinces." *HSCP* 64, pp. 207–235.

Magallón Botaya, M. de los Angeles. 1982. "Bilbilis y la red viaria romana." In *Papels bilbilitanos: Primer encuentro de estudios bilbilitanos* (Calatayud), pp. 77–83.

Magdinier, A.-G., and P. Thollard. 1987. "L'enceinte romaine d'Orange." In *Les enceintes,* pp. 77–96.

Maiuri, A. 1973. *Alla ricerca di Pompei preromana (Saggi stratigrafici).* Naples.

Mangas, J., and D. Plácido, eds. 1994. *Avieno: Ora maritima description orbis terraephaenomena.* Testimonia Hispaniae Antiqua, no. 1. Madrid.

Manni, E. 1975. "Dall'avvento di Claudio all'acclamazione di Vespasiano." In *ANRW* 2.2, pp. 131–148.

Mansuelli, G. 1971. *Urbanistica e architettura della Cisalpinà romana fino al III. sec. e. n.* Latomus Collection, no. 111. Brussels.

Mar, R., and J. Ruiz de Arbulo. 1990. "El foro de Ampurias y las transformaciones augusteas de los foros de la Tarraconense." In *Stadtbild,* pp. 145–164.

———. 1988. "Sobre el ágora de Emporión." *AEspA* 61, pp. 39–60.

———. 1987. "La basílica de la Colonia Tarraco: Una nueva interpretación del llamado Foro Bajo de Tarragona." In *Los foros,* pp. 31–44.

Marañón, G. 1956. *Tiberius: A Study in Resentment.* London.

Marcos Pous, A., and A. M. Vincent Zaragoza. 1985. "Investigación, técnicas y problemas de las excavaciones en solares de la ciudad de Córdoba y algunos resultados topográficos generales." In *Arqueología de las ciudades modernas,* pp. 231–252.

———. 1983. *Novedades de arqueología cordobesa: Exposiciones "Bellas Artes 83."* Córdoba.

Martín, G., and M. Gil-Mascarell. 1969. "La romanización en el campo de Liria." *Saitabi* 19, pp. 23–54.

Martín, G., and M. Serres. 1970. *La factoría pesquera de Punta de l'Arenal y otros restos romanos de Javea (Alicante)*. Valencia.

Martin, L. 1987. *Hellenistic Religions: An Introduction*. Oxford.

Martin, R. 1973. "Les cryptoportiques: Problème des origines." In *Les cryptoportiques*, pp. 23–44.

———. 1972. "Agora et Forum." *MEFRA* 84, pp. 903–933.

Martín-Bueno, M. 1993. "The Hispano-Roman Town in the Ebro Valley." In *Hispano-Roman Town*, pp. 108–127.

———. 1990. "Bilbilis." In *Stadtbild*, pp. 219–240.

———. 1987. "El foro de Bílbilis (Calatayud, Zaragoza)." In *Los foros*, pp. 99–111.

———. 1982a. "Aspectos arqueológicos de la función religiosa de Caesaraugusta." *Boletín Museo de Zaragoza* 1, pp. 149–163.

———. 1982b. "Nuevos datos para los enterramientos rituales en la muralla de Bílbilis (Calatayud, Zaragoza)." *Bajo Aragón, Prehistoria* 4, pp. 96–105.

———. 1982c. "Teatro romano de Bílbilis (Calatayud, Zaragoza)." In *Actas del Simposio: El teatro en la Hispania romana (Institución Cultural "Pedro de Valencia")* (Badajoz), pp. 79–89.

———. 1981a. "Apuntes monumentales en la Municipium Augusta Bilbilis." In *Papels bilbilitanos* (Calatayud), pp. 29–37.

———. 1981b. "La inscripción a Tiberio y el centro religioso de Bílbilis (Calatayud, Zaragoza)." *MM* 22, pp. 244–254.

———. 1975. *Bílbilis: Estudio histórico-arqueológico*. Zaragoza.

———. 1973. "Bílbilis: Noticia de las excavaciones en 1971." In *12. CNA, Jaén, 1971* (Zaragoza), pp. 591–602.

———. 1972. "Notas sobre la urbanística de Bílbilis (Calatayud)." *Estudios del Seminario de Prehistoria, Arqueología, e Historia de la Facultad de Filosofía y Letras de Zaragoza* 1, pp. 105–117.

Martín-Bueno, M., M. L. Cancela Ramírez de Arellano, and J. L. Jiménez Salvador. 1985a. "Municipium Augusta Bilbilis." In *Arqueología de las ciudades modernas*, pp. 255–270.

———. 1983a. "Municipium Augusta Bilbilis (Calatayud, Zaragoza—resumen)." In *Coloquio: Investigación y técnicas de los trabajos arqueológicos sobre ciudades modernas superpuestas a la antiqua* (Zaragoza), n.p.

Martín-Bueno, M., and M. Cisneros Cunchillos. 1985b. "Aproximación al estudio de materiales de construcción romanos de Bílbilis (Calatayud, Zaragoza)." In *17. CNA, Logroño, 1983* (Zaragoza), pp. 875–879.

Martín-Bueno, M., and J. L. Jiménez. 1983b. "Municipium Augusta Bilbilis: Un nuevo ejemplo de adopción de esquemas preconcebidos en la arquitectura romana altoimperial." *MCV* 19:1, pp. 63–78.

Martín-Bueno, M., J. L. Jiménez Salvador, and M. L. Cancela. 1985c. "Aportaciones al conocimiento del centro religioso del culto imperial en Bílbilis." In *17. CNA, Logroño, 1983* (Zaragoza), pp. 837–840.

Martínez, C., and F. Muñoz Muñoz. 1984. "Sobre el poblamiento romano en la comarca de Los Vélez (Almería)." In *ArqEsp*, vol. 5, pp. 129–146.

Mau, A. 1899. *Pompeii: Its Life and Art*. Trans. F. Kelsey. London.

McElderry, R. K. 1918. "Vespasian's Reconstruction of Spain." *JRS* 8, pp. 53–102.

Mélida, J. R. 1929. *Arqueología española*. Madrid.

———. 1925. *Catálogo monumental de España: Provincia de Badajoz*. Madrid.

Menéndez-Pidal Alvarez, J. 1976. "Algunas notas sobre la restauración y atención prestadas a los monumentos emeritenses." In *AE*, pp. 199–216.

Merlin, A. 1913. *Forum et maisons d'Althiburos*. Direction des Antiquités et Arts, Notes et Documents, no. 6. Paris.

———. 1908. *Le temple d'Apollon a Bulla Regia*. Direction des Antiquités et Arts, Notes et Documents, no. 1. Paris.

Mertens, J. 1985. "Les débuts de l'urbanisation dans le nord de la Gaule." *Caesar-dunum* 20, pp. 261–269.

Mesquita de Figueiredo, A. 1913. "Monuments romains de Portugal." *Revue Archéologique* 21, pp. 347–370.

Mierse, W. 1994. "Ampurias: The Urban Development of a Graeco-Roman City on the Iberian Coast." *Latomus* 53:4 (October–December), pp. 790–805.

———. 1993a. "The Interplay between Religion, Politics, and Entertainment in the Graeco-Roman World: Archaeological and Literary Evidence, Part II." In *Proceedings of the 16th Congress of the International Association for the History of Religions* (Rome), pp. 289–294.

———. 1993b. "Temple Images on the Coinage of Southern Iberia." *Revue Belge de Numismatique* 139, pp. 37–57.

———. 1990a. "Augustan Building Programs in the Western Provinces." In K. Raaflaub and M. Toher, eds., *Between Republic and Empire: Interpretations of Augustus and His Principate* (Berkeley), pp. 308–333.

———. 1990b. "Augustan City Walls in the West." *JRA* 3, pp. 358–360.

———. 1990c. Review of *Mirobriga: Investigations at an Iron Age and Roman Site in Southern Portugal*, ed. W. Biers. *AJA* 94, pp. 708–709.

———. 1989. Review of *Belo*, vol. 3, *Le Macellum*, by F. Didierjean, C. Ney, and J.-L. Paillet. *AJA* 93, pp. 619–621.

———. 1988. Review of *The Architecture of the Roman Empire*, vol. 2, *An Urban Appraisal*, by W. Mac Donald. *Archaeology* 41 (July–August), p. 70.

Millar, F. 1977. *The Emperor in the Roman World (31 B.C.–A.D. 337)*. Ithaca.

Miret, M., J. Sanmartí, and J. Santacana. 1986. "La evolución y el cambio del modelo de poblamiento ibérico ante la romanización: Un ejemplo." In *Los asentamientos*, pp. 79–88.

———. 1984. "Distribución espacial de núcleos ibéricos: Un ejemplo en el litoral catalán." In *ArqEsp*, vol. 4, pp. 173–186.

Mitchell, S. 1987. "Imperial Building in the Eastern Provinces." *HSCP* 91, pp. 333–365.

Molas i Font, Ma. D. 1982a. *Els Ausetans i le ciutat d'Ausa*. Vic.

———. 1982b. "El temple romà de Vic i la ciutat d'Ausa: Novetats arqueològiques i cronologia." *Ausa* 10, pp. 275–291.

Molas i Font, Ma. D., and I. Ollich i Castanyer. 1985. "L'aplicació d'un programa del temple romà de Vic." *Cypsela* 5, pp. 163–170

Mommsen, T. 1968. *The Provinces of the Roman Empire: The European Provinces*. (Selections from the *History of Rome*, vol. 5, book 8, ed. T. R. S. Broughton.) Chicago.

———. 1887. *The History of Rome: The Provinces, from Caesar to Diocletian*, part 1. Trans. W. P. Dickson. New York.

Montenegro, A. 1975. "Problemas y nuevas perspectivas en el estudio de la Hispania de Vespasiano." *Hispania Antigua: Revista de Historia Antigua* 5, pp. 7–88.

Montenegro Duque, A., and J. M. Blázquz. 1982. *España romana: La conquista y la explotación económica (218 a. de J.C.–414 d. de J.C.).* Vol. 2 of *Historia de España.* Madrid.

Morel, J.-P. 1976. "Le sanctuaire de Vastogirardi (Molise) et les influences hellénistiques en Italie centrale." In *Hellenismus in Mittelitalien,* pp. 255–266.

Moreno de Vargas, B. 1633. *Historia de la ciudad de Mérida.* Mérida; reprint, Cáceres, 1974.

Museo Nacional de Arte Romano. 1988. *Museo Nacional de Arte Romano: Mérida.* Madrid.

Nash, E. 1961. *Bildlexikon zur Topographie des antiken Roms.* Tübingen.

Naumann, R. 1979. *Der Zeustempel zu Aizanoi.* Berlin.

Navascués, J. M. de. 1968. "Salamanca in Roman Times: An Onomastic Study." *Classical Folia* 22, pp. 214–263.

———. 1929. *Tarragone.* Barcelona.

Nogales Basarrate, T. 1990. "Bronces romanos en Augusta Emerita." In *Los bronces,* pp. 103–115.

Nony, C. J. 1969. "Une nouvelle interpretation de bronzes d'Azaila." *MCV* 5, pp. 5–30.

Ona González, J. L. 1984. "El poblamiento rural de época romana en una zona de la ribera de Navarra." In *ArqEsp,* vol. 5, pp. 71–93.

Onians, J. 1988. *Bearers of Meaning: The Classical Orders in Antiquity, the Middle Ages, and the Renaissance.* Princeton.

Ors Pérez-Peix, A. d'. 1941. "Sobre los orígenes del culto al emperador en la España." *Emerita* 9, pp. 197–359.

Ortego, T. 1980. *Tiermes. Guía de conjunto arqueológico. Ciudad rupestre celtibérico-romana.* Madrid.

Ortego y Frías, T. n.d. *Guía de Numancia.* Madrid.

Ostrow, S. 1990. "The *Augustales* in the Augustan Scheme." In K. A. Raaflaub and M. Toher, eds., *Between Republic and Empire: Interpretations of Augustus and His Principate* (Berkeley), pp. 364–379.

———. 1985. "*Augustales* along the Bay of Naples: A Case for Their Early Growth." *Historia* 34:1, pp. 64–101.

Packer, J. E. 1969. "Roman Imperial Building (31 B.C.–A.D. 138)." In C. Roebuck, ed., *The Muses at Work: Arts, Crafts, and Professions in Ancient Greece and Rome* (Cambridge, Mass.), pp. 36–59.

Pallarés, F. 1970. "La topografia e le origini di Barcellona romana." *Rivista di Studi Liguri* 34–37 (= *Omaggio a Fernand Benoit,* vol. 4), pp. 60–102.

Palol, P. de. 1989–1990. "Los edificios de culto en la ciudad de Clunia." *Anas* 2–3, pp. 37–56.

———. 1987. "El foro romano de Clunia." In *Los foros,* pp. 153–163.

———. 1985a. "La ciudad de Clunia." In *Arqueología de las ciudades modernas,* pp. 305–311.

———. 1985b. "Clunia, cabeza de un convento jurídico de la Hispania Citerior o Tarraconense." In *Historia de Burgos,* vol. 1 (Burgos), pp. 395–428.

———. 1982. *Guía de Clunia.* 5th ed. Valladolid.

————. 1978. *Guía de Clunia.* 4th ed. Valladolid.

————. 1974. *Guía de Clunia.* 3d ed. Valladolid.

————. 1969. *Guía de Clunia.* 2d ed. Valladolid.

————. 1965. *Guía de Clunia.* 1st ed. Valladolid.

————. 1959. *Clunia Sulpicia: Ciudad romana, su historia y su presente.* Burgos.

Palol Salellas, P. de. 1976. "Perduración de las ciudades augusteas: La zona norte y la meseta." In *Ciudades augusteas,* pp. 263–285.

Pamplona, J. J. 1957. "Breve nota de un yacimiento inédito en Botorrita." *CA* 9–10, pp. 147–150.

Paris, P., and G. Bonsor. 1923. *Fouilles de Belo (Bolonia, Province de Cadix), 1917–1921.* Vol. 1, *La ville et ses dépendances.* Bordeaux.

Passini, J. 1987. "El conjunto urbano de Tritium Autrigonum." *Gerión* 5, pp. 281–287.

Pelletier, A., S. Dardaine, and P. Sillières. 1987. "Le forum de Belo: Découvertes récentes." In *Los foros,* pp. 165–172.

Pellicer, M. 1969. "La cerámica ibérica del Cabezo de Alcalá de Azaila." *CA* 33, pp. 63–88.

Pena, M. J. 1984. "Apuntes y observaciones sobre las primeras fundaciones romanas en Hispania." *Estudios de la Antigüedad* 1, pp. 47–85.

————. 1981. "Contribución al estudio del culto de Diana en Hispania, I: Templos y fuentes epigráficas." In *La religión,* pp. 49–57.

Pena Gimeno, M. J. 1973. "Artemis-Diana y algunas cuestiones en relación con su iconografía y su culto en Occidente." *Ampurias* 35, pp. 109–134.

Pérez González, C., and C. Fernández Ibáñez. 1984. "Relaciones entre tres importantes asentamientos del norte de España: Pisoraca-Julióbriga-Flavióbriga." In *ArqEsp,* vol. 5, pp. 21–40.

Perret, V. 1956. "Le capitole de Narbonne." *Gallia* 14:1, pp. 1–22.

Pfanner, M. 1990. "Modelle römischer Stadtentwicklung am Beispiel Hispaniens und der westlichen Provinzen." In *Stadtbild,* pp. 59–116.

————. 1989. "Zur Entwicklung der Stadtstruktur von Conimbriga: Ein methodischer Beitrag zur Städteforschung." *MM* 30, pp. 184–203.

Pflaum, H. G. 1965. "La part prise par les chevaliers romaines originaires d'Espagne a l'administration impériale." In *Les empereurs,* pp. 87–122.

Piggott, S. 1986. *The Druids.* New York.

Pinon, P. 1985. "La notion de plan 'programmatique' et son application en la ville gallo-romaine." *Caesardunum* 20, pp. 187–197.

Planson, E. 1985. "Le santuaire des Bolard-Nuit-Saints-Georges (Côtes d'Or)." *Caesardunum* 20, pp. 203–210.

Pons de Icart, L. 1572. *Libro de las grandezas y cosas memorables de la metropolitana insigne y famosa ciudad de Tarragona.* Lérida; reprint, Tarragona, 1980.

Pons i Brun, E. 1984. "Los orígenes acerca de la interdependencia 'pueblo-territorio' en la llanura del Empordà (Girona)." In *ArqEsp,* vol. 4, pp. 29–42.

Ponsich, M. 1985. "Exemples d'urbanisme antique respondant aux conditions géopolitiques du site." *Caesardunum* 20, pp. 245–259.

————. 1976. "A propos d'usine antique de salaisons à Belo (Bolonia-Cadix)." *MCV* 12, pp. 69–79.

————. 1974. "La fontaine publique de Belo." *MCV* 10, pp. 21–37.

Ponsich, M., and M. Tarradell. 1965. *Garum et industries antiques de salaisons dans la Méditerranée occidentale*. Bibliothèque de l'École des Hautes Études Hispaniques, no. 36. Paris.

Prayon, F. 1982. "Projektierte Bauten auf römischen Münzen." In B. von Freytag gen Lörighoff, D. Mannsperger, and F. Prayon, eds., *Praestant Interna: Festschrift für Ulrich Hausmann* (Tübingen), pp. 319–330.

Presedo, F. J., J. Muñéz, J. Ma. Santero, and F. Chaves. 1982. *Carteia I*. EAE, no. 120. Madrid.

Price, M., and B. Trell. 1977. *Coins and Their Cities: Architecture on the Ancient Coins of Greece, Rome, and Palestine*. London.

Price, S. 1984. *Rituals and Power: The Roman Imperial Cult in Asia Minor*. Cambridge.

Puig i Cadafalch, J. 1927–1931. "El temple romà de Barcino: Descoberta d'elements de conisa." *AIEC* 8, pp. 87–97.

———. 1921–1926. "Les excavacions d'Empúries." *AIEC* 7, pp. 81–84.

———. 1915–1920. "La colonització grega." *AIEC* 6, pp. 694–712.

———. 1913–1914. "Excavacions d'Empuries." *AIEC* 5:2, pp. 838–847.

———. 1911–1912. "Els temples d'Empuries." *AIEC* 4, pp. 303–322.

———. 1908. "Les excavacions d'Empuries: Estudi de la topografía." *AIEC* 1, pp. 150–194.

Puig i Cadafalch, J., A. de Falguera, and J. Goday. 1934. *L'arquitectura romana a Catalunya*. Barcelona.

Pujol Puigvehí, A. 1989. *La población prerromana del extremo nordeste peninsular*. 2 vols. Bellaterra.

Raddatz, K. 1973. *Mulva I: Die Grabungen in der Nekropole in den Jahren 1957 und 1958*. Madrider Beiträge, no. 2. Madrid.

Radt, W. 1988. *Pergamon: Geschichte und Bauten, Funde und Erforshung einer antiken Metropole*. Cologne.

Rakob, F. 1980. "Numidische Königsarchitektur in Nordafrika." In H. G. Horn and C. Rüger, eds., *Die Numider: Reiter und Könige nördlich der Sahara* (Cologne and Bonn), pp. 119–172.

Ratté, C., T. Howe, and C. Foss. 1986. "An Early Imperial Pseudodipteral Temple at Sardis." *AJA* 90, pp. 50–63.

Raven, S. 1993. *Rome in Africa*. 3d ed. London.

Recasens, M. 1966. *La ciutat de Tarragona*. Barcelona.

Recasens i Carreras, M. 1984. "Los edificios públicos de la Tarragona romana a través del estudio de sus capiteles: Ensayo cronológico." In T. F. C. Blagg, R. F. J. Jones, and S. J. Keay, eds., *Papers in Iberian Archaeology*, part 1, BAR International Series no. 193 (i) (Oxford), pp. 320–327.

———. 1979. "Los capiteles romanos del Museu Nacional Arqueològic de Tarragona." *Butlletí Arqueològic* (Tarragona) 5:1, pp. 43–143.

Remigo, S. 1846. *Descubrimiento de Clunia*. Madrid.

Richardson, J. S. 1986. *Hispaniae: Spain and the Development of Roman Imperialism, 218–82 B.C.* Cambridge.

Richardson, L. 1988. *Pompeii: An Architectural History*. Baltimore.

———. 1957. "Cosa and Rome: Comitium and Curia." *Archaeology* 10, pp. 49–55.

Richmond, I. A. 1931. "Five Town Walls in Hispania Citerior." *JRS* 21, pp. 86–100.

————. 1930. "The First Years of Emerita Augusta." *Archaeological Journal* 87, pp. 98–116.

Ripoll i Perelló, E. 1990. "Orígenes de la ciudad romana de Ampurias." *Gerión* 8, pp. 194–200.

————. 1985. "Ampurias, una ciudad sin continuidad en el tiempo." In *Arqueología de las ciudades modernas,* pp. 315–319.

————. 1983. *Els Grecs a Catalunya.* Barcelona.

————. 1982a. *Ampurias, descripción de las ruinas y museo monográfico.* Barcelona.

————. 1982b. *Ampurias, guía itineraria.* Barcelona.

————. 1981. *Guía del Museo Arqueológico de Barcelona.* Barcelona.

————. 1971–1972. "Notas acerca de los orígenes de la ciudad romana de Ampurias." *Ampurias* 33–34, pp. 364–365.

Roberti, M. 1985. "Architecture et urbanisme." *Histoire et Archéologie* 95 (June) (= *Aquilée romaine et paléochrétienne*), pp. 40–49.

Robertson, A. 1962. *Roman Imperial Coinage in the Hunter Coin Cabinet.* Oxford.

Rodà, I. 1991. *Inscriptions romaines de Catalogne.* Vol. 3. Barcelona.

Rodà de Mayer, I. 1981. "Las dedicatorias a divinidades en la Barcelona romana." In *La religión,* pp. 122–131.

Rodríguez Almeida, E. 1986. "Geryón, Marcial y la Porticus Philippi del Campo Marcio." *Gerión* 4, pp. 9–15.

Rodríguez Hidalgo, J. M., and S. Keay. 1995. "Recent Work at Italica." In *Social Complexity,* pp. 395–420.

Roldán, J. M. 1974. *Hispania y el ejército romano.* Salamanca.

Roldán Gómez, L. 1987. "Técnica edilicia en Itálica: Los edificios públicos." *AEspA* 60, pp. 89–122.

Roldán Hervas, J. M. 1972. "El elemento indígena en las guerras civiles en Hispania: Aspectos sociales." *Hispania antigua* 2, pp. 77–123.

Rolland, H. 1946. *Fouilles de Glanum (Saint Remy de Provence).* Suppl. of *Gallia.* Paris.

Roth-Congès, A. 1992. "Nouvelles fouilles à Glanum (1982–1990)." *JRA* 5, pp. 39–55.

————. 1987a. "Fouilles et recherches récentes sur le forum de Glanum." In *Los foros,* pp. 196–201.

————. 1987b. "L'hypothèse d'une basilique à deux nefs à Conimbriga et les transformations du forum." *MEFRA* 99:2, pp. 711–751.

————. 1983. "L'acanthe dans le décor architectonique protoaugustéen en Provence." *Revue Archéologique Narbonnaise* 16, pp. 103–134.

Rouillard, P. 1979. *Investigaciones sobre la muralla ibérica de Sagunto.* Valencia.

Rouquette, J.-M. 1987. "L'enceinte primitive de la colonie romaine d'Arles." In *Les enceintes,* pp. 97–102.

Royo Guillén, J. 1984. "Habitat y territorio durante la Edad del Hierro en el Valle de la Huecha, Zaragoza." In *ArqEsp,* vol. 4, pp. 65–95.

Rubio, M. 1954. "La arquitectura en Bílbilis." *CA* 4, pp. 141–143.

Rüger, C. 1968. "Römische Keramik aus dem Kreuzgang der Kathedrale von Tarragona." *MM* 9, pp. 237–258.

Ruiz de Arbulo, J. 1992. "Tarraco, Carthago Nova y el problema de la capitalidad en Hispania Citerior republicana." In *Miscel.lània,* pp. 115–130.

Ruiz de Arbulo Bayona, J. 1984. "Emporión y Rhode: Dos asentamientos portuarios en el golfo de Roses." In *ArqEsp,* vol. 4, pp. 115–140.

Ruiz Rodríguez, A., and M. Molinos Molinos. 1984. "Elementos para un estudio del patrón de asentamiento en las campiñas del Alto Guadalquivir durante el horizonte pleno ibérico (un caso de sociedad agrícola con estado)." In *ArqEsp,* vol. 4, pp. 187–206.

Ruiz Zapatero, G., and V. M. Fernández Martínez. 1984. "Patrones de asentamiento en el Bajo Aragón protohistórico." In *ArqEsp,* vol. 4, pp. 43–63.

Russell, J. 1968. "The Origin and Development of Republican Forums." *Phoenix* 22, pp. 304–336.

Sáenz de Buruaga, J. A. 1976. "La fundación de Mérida." In *AE,* pp. 19–32.

Salcedo Garcés, F. 1983. "Los relieves de armas del teatro de Mérida." *Lucentum* 2, pp. 243–283.

Sánchez-Albornoz, C. 1949. "Proceso de la romanización de España desde los Escipiones hasta Augusto." In *Anales de historia antigua y medieval de la Universidad de Buenos Aires* (Buenos Aires), pp. 5–35.

Sánchez Real, J. 1989. "Las lucernas de la exploración arqueológica del jardín del claustro de la catedral de Tarragona." *MM* 30, pp. 253–295.

———. 1985. "La exploración de la muralla de Tarragona en 1951." *MM* 26, pp. 91–121.

———. 1969. "Exploración arqueológica en el jardín de la catedral de Tarragona." *MM* 10, pp. 276–295.

Sande, S., and J. Zahle. 1988. "Der Tempel der Dioskuren auf dem Forum Romanum." In *Kaiser Augustus,* pp. 213–223.

Sangmeister, E. 1969. *Die Kelten in Spanien.* Madrider Forshungen, no. 3. Berlin.

Sanmartí i Grego, E. 1992. "Identificació iconogràfica i possible atribució d'unes restes escultòriques trobades a la Neàpolis emporitana al simulacrum del Serapis d'Empòrion." In *Miscel.lània,* pp. 145–154.

———. 1988. "Datación de la muralla griega meridional de Ampurias y caracterización de la facies cerámica de la ciudad en la primera mitad del siglo IV a de J.-C." *REA* 90:1–2, pp. 99–121.

———. 1987. "El foro romano de Ampurias." In *Los foros,* pp. 55–60.

———. 1978. *La cerámica campaniense de Emporión y Rhode.* Monografías Emporitanes, no. 4. 2 vols. Barcelona.

Sanmartí i Grego, E., P. Castanyer i Masoliver, and J. Tremoleda i Trilla. 1992. "Nuevos datos sobre la historia y la topografía de las murallas de Emporion." *MM* 33, pp. 102–112.

———. 1990. "Emporion: Un ejemplo de monumentalización precoz en la Hispania republicana (Los santuarios helenísticos de su sector meridional)." In *Stadtbild,* pp. 117–144.

Sanmartí i Grego, E., and A. López i Mullor. 1982. "Excavaciones al temple romà de Vic: Campanya de 1980." *Ausa* 10, pp. 261–273.

Sapéne, B. 1966. *Saint-Bertrand-de-Comminges, Lugdunum Convenarum.* Toulouse.

Schulten, A. 1948. *Tarraco.* Barcelona.

———. 1922a. *Fontes Hispaniae Antiquae.* Vol. 1, *Avienius Ora Maritima.* Barcelona and Berlin.

————. 1922b. *Mérida, das spanisches Rom.* Barcelona.

————. 1914–1931. *Numantia: Die Ergebnisse der Ausgrabungen.* 4 vols. Munich.

Schultz, H. 1985. *The Romans in Central Europe.* New Haven.

Scott, J. 1936. *The Imperial Cult under the Flavians.* Stuttgart.

Seager, R. 1972. *Tiberius.* London.

Sear, F. 1985. *Roman Architecture.* Ithaca.

Sentenach y Cabanas, N. 1918. *Excavaciones en Bílbilis: Cerro de Bámbola (Calatayud), 1917.* Madrid.

Serra Vilaró, J. 1932. *Excavaciones en Tarragona.* Madrid.

Serra y Campdelacreu, J. 1959. "Descubrimiento del templo romano de Vich en 1982." *Ausa* 3:29, pp. 243–249.

Silberberg-Peirce, S. 1986. "The Many Faces of the Pax Augusta: Images of War and Peace in Rome and Gallia Narbonensis." *Art History* 9:3, pp. 306–323.

Simon, E. n.d. *Ara Pacis Augustae.* Tübingen.

Sisson, M. A. 1925. *The Stoa of Hadrian at Athens.* Papers of the British School at Rome, no. 11.

Smith, D. J. 1984. Review of *La Galice romaine: Recherches sur le nord-ouest de la péninsule ibérique dans l'antiquité,* by A. Tranoy. *AJA* 88, pp. 286–287.

Smith, R. R. R. 1990. "Myth and Allegory in the Sebasteion." In C. Roueche and K. Erim, eds., *Aphrodisias Papers: Recent Work on Architecture and Sculpture, JRA* Supplementary Series, no. 1 (Ann Arbor), pp. 89–100.

————. 1988. "*Simulacra gentium:* The *Ethne* from the Sebasteion at Aphrodisias." *JRS* 78, pp. 50–77.

————. 1987. "The Imperial Reliefs from the Sebasteion at Aphrodisias." *JRS* 77, pp. 88–138.

Solier, Y. 1973. "Note sur les galeries souterraines de Narbonne." In *Les cryptoportiques,* pp. 315–324.

Solier, Y., M. Janon, and R. Sabrié. 1986. *Narbonne (Aude). Les monuments antiques et médiévaux. Le Musée Archéologique et le Musée Lapidaire.* Narbonne.

Soren, D. 1983. "The Castelo Vehlo." In W. Biers, "Mirobriga: The 1983 Season," *Muse* 17, pp. 54–59.

————. 1982. "The Forum Area." In W. Biers, "Excavations at Mirobriga, the 1982 Season," *Muse* 16, pp. 29–43.

Souceda Pizarro, I. 1984. "Religión y espacio, aproximación a una arqueología de la religión." In *ArqEsp,* vol. 1, pp. 41–54.

Stanley, F. H. 1990a. "Geographical Mobility in Roman Lusitania: An Epigraphical Perspective." *Zeitschrift für Papyrologie und Epigraphik* 82, pp. 249–269.

————. 1990b. "Foreigners in Roman Lusitania." *Acta Archaeologica Academiae Scientiarum Hungaricae* 42–43, pp. 73–75.

————. 1989. "Roman Provincial Influence: An Onomastic Study of the Alentejo Region of Lusitania." *Beiträge zur Namenforschung* 24:1–2, pp. 1–54.

————. 1988. "The Augustan Revival of the Lusus Troiae: A Municipal Result?" *Augustan Age* 8, pp. 54–58.

Strong, D. 1982. *Roman Art.* Harmondsworth.

Strong, D. E. 1960. "Some Early Examples of the Composite Capital." *JRS* 50, pp. 119–128.

————. 1953. "Late Hadrianic Architectural Ornament in Rome." *Papers of the British School at Rome* 21, pp. 118–151.

Strong, E. 1907. *Roman Sculpture*. London.

Stylow, A. U. 1990. "Apuntes sobre el urbanismo de la Corduba romana." In *Stadtbild*, pp. 259–282.

Sureda Carrión, N. 1976. "La Bética en época de Augusto." In *Ciudades augusteas*, vol. 2, pp. 45–51.

Sutherland, C. H. V. 1941. "Divus Augustus Pater." *Numismatic Chronicle* 41, pp. 97–116.

————. 1934. "Aspects of Imperialism in Roman Spain." *JRS* 24, pp. 31–42.

Sutherland, C. H. V., and R. A. G. Carson. 1984. *The Roman Imperial Coinage*. London.

Sydenham, E. A. 1917. "Divus Augustus." *Numismatic Chronicle* 17, pp. 258–278.

Sydenham, E. A., and H. Mattingly. 1923. *The Roman Imperial Coinage*. London.

Syme, R. 1988. "Spaniards at Tivoli." In *Roman Papers*, vol. 4, pp. 94–114.

————. 1984a. "Hadrianic Proconsuls of Africa." In *Roman Papers*, vol. 3, pp. 1303–1315.

————. 1984b. "History or Biography: The Case of Tiberius." In *Roman Papers*, vol. 3, pp. 937–952.

————. 1984c. "La richesse des aristocraties de Bétique et de Narbonnaise." In *Roman Papers*, vol. 3, pp. 977–985.

————. 1983. "Spanish Pomponii: A Study in Nomenclature." *Gerión* 1, pp. 249–266.

————. 1982–1983. "Spaniards at Tivoli." *Ancient Society* 13–14, pp. 241–263.

————. 1981a. "The Early Tiberian Consuls." *Historia* 30, pp. 189–202.

————. 1981b. "Rival Cities, Notably Tarraco and Barcino." *Ktema* 6, pp. 271–285.

————. 1979a. "A Governor of Tarraconensis." In *Roman Papers*, vol. 2, pp. 732–741.

————. 1979b. "People in Pliny." In *Roman Papers*, vol. 2, pp. 694–723.

————. 1979c. "Pliny's Less Successful Friends." In *Roman Papers*, vol. 2, pp. 477–495.

————. 1979d. "Pliny the Procurator." In *Roman Papers*, vol. 2, p. 773.

————. 1978a. "Piso and Veranius in Catullus." In *Roman Papers*, vol. 1, pp. 300–304.

————. 1978b. "Seianus on the Aventine." In *Roman Papers*, vol. 1, pp. 305–314.

————. 1965. "Hadrian the Intellectual." In *Les empereurs*, pp. 243–254.

————. 1938a. "Caesar, the Senate, and Italy." *Papers of the British School at Rome* 14, pp. 9–12.

————. 1938b. "The Origin of Cornelius Gallus." *Classical Quarterly* 32, pp. 39–44.

————. 1938c. Review of *Rom: Herrschertum und Reich im zweiten Jahrhundert*, by W. Weber. *Historische Zeitschrift* 158, pp. 554–561.

————. 1937. "Who Was Decidius Saxa?" *JRS* 27, pp. 127–137.

Taracena, B. 1946. "El palacio romano de Clunia." *AEspA* 19, pp. 29–69.

Tarradell, M. 1971–1972. "L'extensió urbana de Tàrraco comparada." *Boletín Arqueológico* (Tarragona) 4, pp. 95–101.

Tchernia, A. 1983. "Italian Wine in Gaul at the End of the Republic." In P. Garnsey, K. Hopkins, and C. R. Whittaker, eds., *Trade in the Ancient Economy* (Berkeley), pp. 87–104.

TED'A. 1989. "El foro provincial de Tarraco: Un complejo arquitectónico de época flavia." *AEspA* 62, pp. 141–191.

Teichner, F. 1994. "Évora. Vorbericht über die Ausbrabungen am römischen Tempel (1986–1992). Stratgraphische Untersuchungen und Aspekte der Stadtgeschichte." *MM* 35, pp. 336–358.

Teja, R. 1973. "Las 'villas' de Hispania y Capadocia en el siglo IV y su entorno económico social." In 12. *CNA, Jaén, 1971* (Zaragoza), pp. 611–624.

Thornton, M. K. 1986. "Julio-Claudian Building Programs: Eat, Drink, and Be Merry." *Historia* 35, pp. 28–44.

———. 1975. "The Augustan Tradition and Neronian Economics." In *ANRW* 2.2, pp. 149–175.

Thornton, M. K., and R. I. Thornton. 1990. "The Financial Crisis of A.D. 33: A Keynesian Depression?" *Journal of Economic History* 50:3–4, pp. 655–662.

Thouvenot, R. 1979. "L'urbanisme romain dans le Maroc antique." In *García y Bellido*, vol. 4, pp. 325–348.

———. 1940. *Essai sur la province romaine de Bétique.* Paris.

Todd, M. 1985. "Forum and Capitolium in the Early Empire." In F. Grew and B. Hobley, eds., *Roman Urban Topography in Britain and the Western Empire,* BA Research Report no. 59 (London), pp. 56–66.

Tran Tam Tinh, V. 1964. *Le culte d'Isis a Pompei.* Paris.

Trapote, Ma. del C. 1965. *Los capitales de Clunia: Hallazgos hasta 1964.* Monografías clunienses, no. 2. Valladolid.

Trell, B. 1984. "The Coins of the Phoenician World—East and West." In W. Heckel and R. Sullivan, eds., *Ancient Coins of the Graeco-Roman World,* The Nickle Numismatic Papers (Calgary), pp. 117–138.

Trillmich, W. 1995. "Gestalt und Ausstattung des 'Marmorforums' in Mérida: Kenntnisstand und Perspektiven." *MM* 36, pp. 269–291.

———. 1993. "Hispanien und Rom aus der Sicht Roms und Hispaniens." In *HA*, pp. 41–70.

———. 1990a. "Apuntes sobre algunos retratos en bronce de la Hispania romana." In *Los bronces,* pp. 37–50.

———. 1990b. "Colonia Augusta emerita, die Hauptstadt von Lusitanien." In *Stadtbild,* pp. 299–318.

———. 1986. "Ein historisches Relief in Mérida mit Darstellung des Agrippa beim Opfer: Ein Rekonstruktionsversuch." *MM* 27, pp. 279–304.

Tsirkin, J. B. 1987. "The Crisis of Antique Society in Spain in the Third Century." *Gerión* 5, pp. 253–270.

Ulrich, R. 1994. *The Roman Orator and the Sacred Stage: The Roman "Templum Rostratum."* Brussels.

———. 1993. "Julius Caesar and the Creation of the Forum Iulium." *AJA* 97:1, pp. 49–80.

Van Berchem, D. 1967. "Sanctuaires d'Hercule-Melqart: Contribution à l'étude de l'expansion phénicienne en méditerranée." *Syria* 44, pp. 73–109.

Van Nostrand, J. J. 1933–1940. "Roman Spain." In T. Frank, ed., *An Economic Survey of Ancient Rome* (Baltimore), pp. 119–224.

Varene, P. 1981. "Le trace de l'enceinte gallo-romaine du Haut-Empire." In *Les*

monuments de Nîmes, Les Dossiers de Histoire et Archéologie, no. 55 (July–August), pp. 22–35.

Vegas, M. 1984. "Munigua, Haus 6, datierende Funde aus dem Räumen und aus dem Brunnen." *MM* 25, pp. 181–196.

Vermeule, C. 1977. *Greek Sculpture and Roman Taste.* Ann Arbor.

Vezàr, M. 1977. *Aventicum.* Vol. 2, *Un temple de culte impérial.* Avenches.

Villaronga, L. 1979. *Numismática antigua de Hispania.* Barcelona.

———. 1977. *Los tesoros de Azaila y la circulación monetaria en el valle del Ebro.* Barcelona.

Viscogliosi, A. 1988. "Die Architektur-Dekoration der Cella des Apollo-Sosianus-Tempels." In *Kaiser Augustus,* pp. 136–148.

Vives y Escudero, A. 1924–1926. *La moneda hispánica.* 4 vols. Madrid.

von Blanckenhagen, P. 1954. "The Imperial Fora." *JSAH* 13:4, pp. 21–26.

von Hesberg, H. 1990a. "Bauornamentik als kulturelle Leitform." In *Stadtbild,* pp. 341–366.

———. 1990b. "Córdoba und seine Architekturornamentik." In *Stadtbild,* pp. 283–288.

Vos, A. de, and M. de Vos. 1988. *Pompeii, Ercolano, Stabii: Guide archeologiche Laterza.* 2d ed. Bari.

Vos, M. de, and E. La Rocca. 1976. *Guida archeologica di Pompei.* Verona.

Wade Mead, C. 1980. *Ruins of Rome: A Guide to the Classical Antiquities.* Rustan, La.

Waelkens, M. 1986. "The Imperial Sanctuary at Pessinus: Archaeological, Epigraphical, and Numismatic Evidence for Its Date and Identification." *Epigraphica Anatolica: Zeitschrift für Epigraphik und historische Geographie Anatoliens* 7, pp. 225–236.

Walthew, C. 1982. "Early Roman Town Development in Gallia Belgica: A Review of Some Problems." *Oxford Journal of Archaeology* 1:2, pp. 225–236.

Ward-Perkins, J. 1981. *Roman Imperial Architecture.* Harmondsworth.

Ward-Perkins, J. B. 1979. "Taste, Tradition and Technology: Some Aspects of the Architecture of the Late Republic and Early Imperial Central Italy." In G. Köpcke and M. Moore, eds., *Studies in Classical Art and Architecture: A Tribute to Peter Heinrich von Blanckenhagen* (New York), pp. 197–204.

———. 1973. "The Cryptoportico: A Practical Solution to Certain Problems of Roman Urban Design." In *Les cryptoportiques,* pp. 51–56.

———. 1970. "From Republic to Empire: Reflections on the Early Roman Provincial Architecture of the Roman West." *JRS* 60, pp. 1–19.

Weaver, P. R. C. 1972. *Familia Caesaris: A Study of the Emperor's Freedmen and Slaves.* Cambridge.

Weber, H. 1969. "Der Zeus-Tempel von Aezani: Ein panhellenisches Heiligtum der Kaiserzeit." *Athenische Mitteilungen* 84, pp. 182–201.

Wiegels, R. 1985. *Tribusinschriften des römischen Hispanien.* Berlin.

Wightman, E. M. 1985. *Gallia Belgica.* Berkeley.

Wild, R. 1981. *Water in the Cultic Worship of Isis and Sarapis.* Études Préliminaires aux Religions Orientales dans l'Empire Romaine, no. 87. Leiden.

Will, E. 1973. "Les cryptoportiques de forum de la Gaule." In *Les cryptoportiques,* pp. 325–342.

Wilson, A. J. N. 1966. *Emigration from Italy in the Republican Age of Rome.* Manchester.

Woods, D. 1975. "The Temple of Augustus—Tarragona." In *Classica et Iberica: A Festschrift in Honor of the Reverend Joseph M. F. Marique, S.J.* (Worcester, Mass.), pp. 345–352.

———. 1969. "Carteia and Tartessos." In *Tartessos y sus problemas: V. Symposium Internacional de Prehistoria Peninsular, Jerez, 1968* (Barcelona), pp. 251–256.

Woods, D., F. Collantes de Terán, and C. Fernández-Chicarro. 1967. *Cartea.* EAE, no. 58. Madrid.

Wuilleumier, P. 1953. *Lyon, metropole des Gaules.* Paris.

Zanker, P. 1990. *The Power of Images in the Age of Augustus.* Ann Arbor.

———. 1969. *Das Forum Augustum.* Tübingen.

———, ed. 1976. *Hellenismus in Mittelitalien: Kolloquium in Göttingen, von 5. bis 9. Juni 1974.* 2 vols. Göttingen.

INDEX

Compositor: G&S Typesetters
Printer/Binder: Data Reproductions
Text: Baskerville
Display: Baskerville